NORTHERN LIGHT

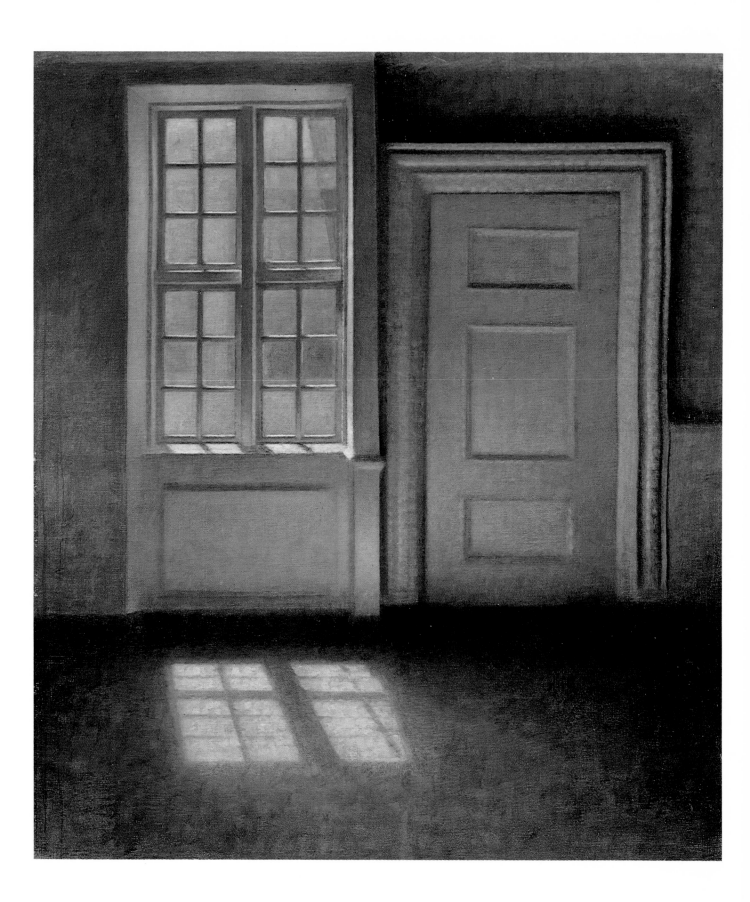

NORTHERN LIGHT

Realism and Symbolism in Scandinavian Painting
1880–1910

Kirk Varnedoe

THE BROOKLYN MUSEUM

Published for the exhibition
Northern Light:
Realism and Symbolism in Scandinavian Painting,
1880–1910

Corcoran Gallery of Art
Washington, D.C.
September 8 – October 17, 1982

The Brooklyn Museum
New York
November 10, 1982 – January 6, 1983

The Minneapolis Institute of Arts
Minnesota
February 6 – April 10, 1983

Second Edition, 1982
Front cover:
Edvard Munch
Summer Night's Dream (The Voice) 1893 *(Detail)*
Sommernatt (Stemmen)
Oil on canvas, 96.0 × 118.5 cm. (37¾ × 46½ in.)
Collection: Munch-Museet, Oslo
Cat. no. 66

Frontispiece:
Vilhelm Hammershøi
Study of a Sunlit Interior 1906
Stue. Solskinsstudie
Oil on canvas, 55.0 × 47.0 cm. (21⅝ × 18½ in.)
Collection: Davids Samling, Copenhagen
Cat. no. 33

Back cover:
Björn Ahlgrensson
Glowing Embers at Dusk 1903
Skymningsglöden
Tempera on canvas, 83.0 × 120.0 cm. (32⅝ × 47¼ in.)
Collection: Göteborgs Konstmuseum
Cat. no. 1

© 1982 The Brooklyn Museum.

Designed and published by The Brooklyn Museum,
Division of Publications and Marketing Services, Eastern
Parkway, Brooklyn, New York 11238. Printed in the USA
by CLR, Inc., New York.

*Northern Light: Realism and Symbolism in
Scandinavian Painting, 1880–1910 was made
possible by a major grant from Robert Wood
Johnson Jr. Charitable Trust, with additional
support from Royal Caribbean Cruise Line A/S,
Storebrand Insurance Company, Ltd., The
Tiedemann Group, Leif Hoegh & Co. A/S, Nordic
American Banking Corporation, Stolt-Nielsen,
Inc., and Wilh. Wilhelmsen.*

*Northern Light was organized by The Brooklyn
Museum and was a project of Scandinavia Today,
an American celebration of contemporary
Scandinavian culture sponsored and administered
by The American-Scandinavian Foundation, and
made possible by support from Volvo, Atlantic
Richfield Company, the National Endowment for
the Humanities, and the National Endowment for
the Arts.*

*Scandinavia Today was organized with the
cooperation of the Governments of Denmark,
Finland, Iceland, Norway, and Sweden through
the Secretariat for Nordic Cultural Cooperation
and with the aid of a grant from the Nordic
Council of Ministers.*

Library of Congress Cataloging in Publication Data

Varnedoe, Kirk, 1946–
　Northern Light.

　Exhibition held: Corcoran Gallery of Art,
Washington, D.C., Sept. 8–Oct. 17, 1982;
Brooklyn Museum, New York, November 10, 1982–
Jan. 6, 1983; Minneapolis Institute of Arts,
Minnesota, February 6–Apr. 10, 1983.
　Bibliography: p.
　1. Painting, Scandinavian—Exhibitions.
2. Realism in art—Scandinavia—Exhibitions.
3. Symbolism in art—Scandinavia—Exhibitions.
4. Painting, Modern—19th century—Scandinavia
—Exhibitions. 5. Painting, Modern—20th cen-
tury—Scandinavia—Exhibitions. I. Corcoran
Gallery of Art. II. Brooklyn Museum.
III. Minneapolis Institute of Arts. IV. Title.
ND707.5.R43V37　1982　　759.8　　82-71937
ISBN 0-87273-094-8

Contents

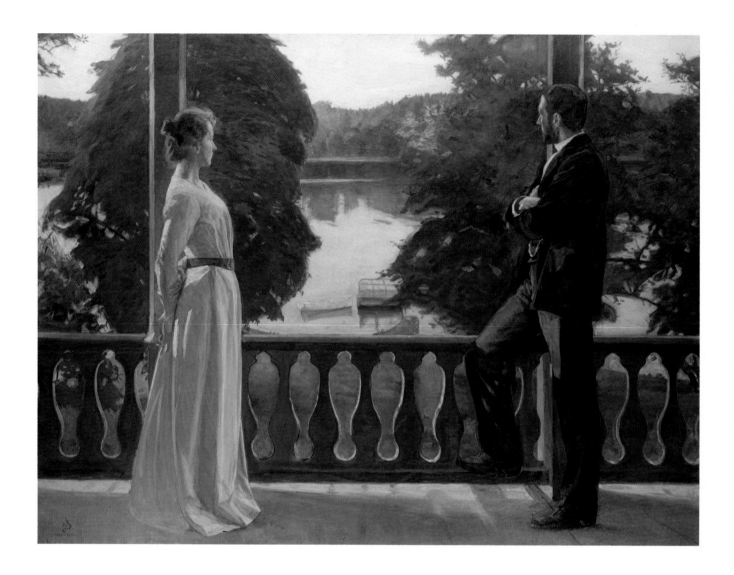

Richard Bergh
Nordic Summer Evening 1899-1900
Nordisk Sommarkväll
Oil on canvas, 170.0 × 223.5 cm. (67 × 86 in.)
Collection: Göteborgs Konstmuseum
Cat. no. 5

Preface

THERE is little doubt that *Scandinavia Today* will have a receptive audience in the United States. The contributions of the five Nordic nations to contemporary society—particularly their sense of humanity and democracy—are strongly felt in this country. As greatly as Americans admire the Scandinavian nations, however, they are not as familiar with their rich traditions as they might like to be. As national sponsors of *Scandinavia Today*, we hope to provide some access to those traditions through our participation in *Northern Light: Realism and Symbolism in Scandinavian Painting, 1880–1910.*

Although the end of the last century was as rich a period for art in Scandinavia as it was in the rest of the Western world, the Nordic countries have not received the attention they deserve in most histories of late nineteenth-century painting. As a result, many of the artists in *Northern Light* are unknown outside their homelands. We think you will be as surprised, enchanted, and gratified by the sweep of these artists' vision as we have been. Rich and complex, their work captures a sense of the Nordic world at that hour of transition into the twentieth century.

We trust that this publication and the exhibition on which it is based will provide an insight into the extraordinary contribution that Scandinavian art has made to our modern world. Our companies have long understood the vital role that international understanding plays in our own corporate affairs and in the affairs of the world. By helping to promulgate a sense of Nordic art, we hope to further the course of international understanding.

Pehr G. Gyllenhammar
Managing Director and Chief Executive Officer Volvo Group

Robert O. Anderson
Chairman, Atlantic Richfield Company

Foreword

Michael Botwinick

Director,
The Brooklyn Museum

THE field of late nineteenth-century painting has been so extensively surveyed in recent years that it is unusual to be able to present a whole area of completely fresh, unfamiliar work of high quality from that period. *Northern Light: Realism and Symbolism in Scandinavian Painting, 1880–1910* gives us such an opportunity.

The somewhat special approach that was taken in organizing the exhibition should be made clear. Any survey of thirty active years of painting in five different countries will necessarily be limited. But while *Northern Light*, with ninety-four paintings representing the work of thirty-six artists, is selective in the obvious sense, our focus is more sharply defined. It was evident from the earliest consultation with our colleagues that an exhibition composed of selections made by curators in each of the five countries, broadly surveying the five national schools with a goal of arithmetic evenhandedness, while inviting for its dictionary-like qualities, would in the end do a great disservice to the art. Thus, while Kirk Varnedoe and his co-curator, Sarah Faunce, benefited from the guidance and generous cooperation of our colleagues in Scandinavia, the selection was approached without the obligation to be all-inclusive. Given the responsibilities that rest on the shoulders of the directors and curators of the national collections to encourage a balanced understanding of their respective national patrimonies, this approach required a considerable amount of courage and discipline. The exhibition often contradicts national notions regarding paintings, artists, and relative importance. Certain artists of recognized merit—Erik Werenskiold of Norway, Ernst Josephson and August Strindberg of Sweden, and Hugo Simberg and Magnus Enckell of Finland—do not appear. In some cases, as in the regrettable absence of Jens Ferdinand Willumsen of Denmark, insurmountable conservation problems made it impossible for an artist's key pieces to travel. In general, however, the final selection reflects Professor Varnedoe's approach—to isolate works of particular styles and themes so that they might, as a group, offer a broad sampling of the artists of the period even as they illuminate the patterns of development he sees as central to Northern painting of the period.

Despite the risks involved in this approach, there are, in our judgement, even greater rewards. *Northern Light* brings sharply to the forefront the central issues of the interrelationship between Naturalism and Symbolism. It elucidates the ways in which later Realism announced and laid the groundwork for Symbolism, and the manner in which Symbolism, in turn, expanded the concerns and pictorial strategies of later Realism. The exhibition also points out how, in the North as in many parts of Europe, important strains in the development of late nineteenth-century art bypassed the familiar formal innovations of the French avant-garde to arrive at modern form by other routes. The combination of tenacious Naturalism with the increasingly charged psychological and nationalistic concerns of *fin-de-siècle* Europe produced a special kind of powerful and poetic imagery that is prominent in this exhibition and that neither needs external justification nor respects our established categories and chronologies.

We are grateful to the Robert Wood Johnson Jr. Charitable Trust for its major grant and to Royal Caribbean Cruise Line A/S; Storebrand Insurance Company, Ltd; The Tiedman Group; Leif Hoegh & Co. A/S; Nordic American Banking Corporation; Stolt-Nielsen, Inc.; and Wilh. Wilhemsen for their grants in support of the exhibition. *Northern Light* is a part of *Scandinavia Today*, a nationwide celebration of Scandinavian culture. We are grateful to Volvo and the Atlantic Richfield Company, and to the National Endowment for the Humanities and the National Endowment for the Arts, for their national sponsorship of *Scandinavia Today*. We are particularly thankful to SAS, Finnair, and Icelandic Air, official carriers of *Scandinavia Today*.

The American Scandinavian Foundation has administered *Scandinavia Today*. Under the leadership of its President, Patricia McFate, the foundation has supported and guided the enormously complex negotiations and planning at the national level and has been of particular

help to us. Brooke Lappin, National Program Director of *Scandinavia Today*, has charted the difficult waters of an international celebration with a patience and thoughtfulness that has been daily and severely tested but never broken. Albina DeMeio has been a constant resource.

We must recognize that the project would not have been possible without the committed cooperation of our colleagues in Scandinavia. We very much want to thank Kristen Hallson of the Icelandic Cultural Ministry; Valgeir Arsaelson of the Icelandic Foreign Office; and Selma Jónsdóttir, Director of the National Gallery of Iceland in Reykjavík. We are grateful to Salme Sarajas-Korte of the Fine Arts Academy of Finland; to Director Olli Valkonen, Curator Tuula Arkio, and Assistant to the Director Marjatta Levanto of the Art Museum of the Ateneum in Helsinki; and to Mrs. Aivi Gallen-Kallela Siren.

We would like to thank Director Per Bjorstrom and Curator Gorel Cavalli-Bjorkman of the National Swedish Art Museums; Ulf Linde, Director of the Thiel Gallery; Bjorn Fredlund, Director of the Gothenburg Art Gallery; and Dag Widman of Prince Eugen's Waldemarsudde. Our thanks also to Curators Magne Malmanger, Tone Skedsmo, and Oscar Thue of the National Gallery in Oslo; Jan Askelund, Director of the Bergen Picture Gallery; and Alf Bøe, Director of the Munch Museum. We are most grateful to Ole Wildt Pedersen and Jacob Kjaer of the Cultural Ministry of Denmark; Hanne Finsen, Director of the Hirschsprung Collection; Knut Voss, Director of the Skagen Museum; and Rostrup Boyesen, Director of the Royal Museum of Fine Arts in Copenhagen. We would particularly like to thank Knut Berg, Director of the National Gallery in Oslo, and Pontus Grate, Chief Curator of the National Swedish Art Museums in Stockholm, who devoted considerable energy and effort to the project and insured a productive interaction both within Scandinavia and with us. We are also most grateful to Carl Tomas Edam, Secretary General of *Scandinavia Today* for the Secretariat for Nordic Cultural Cooperation. He was indefatigable in his efforts to see to it that all of the commitments were kept and all of the problems resolved.

We express our appreciation to all the authors of this book and to our volunteer translators in the U.S., Gite Thuna-Andersen and Elfi Von Kartzow Alvin, who were extremely important in the face of five languages. We are also grateful to Peter Berry, Librarian of the New York Public Library, for his kindness. We want to acknowledge all of Professor Varnedoe's students who assisted in research, most especially Patricia Berman, whose extensive work as Chief Research Assistant was crucial. The editorial assistance of Elyn Zimmerman and Sam Varnedoe likewise greatly aided the work.

We also thank our colleagues Peter Marzio, Director of the Corcoran Gallery of Art in Washington, and Sam Sachs, Director of the Minneapolis Institute of Art, and their staffs for their cooperation in setting up the national tour. We are grateful to Sarah Faunce for her work in helping to select the paintings for the exhibition and in managing the project for the Museum. And lastly we would like to thank Kirk Varnedoe for the outstanding quality of his work and the energy, imagination, and sense of purpose he brought to the project, thereby enhancing all our efforts and insuring the importance of the result.

Northern Europe
1910

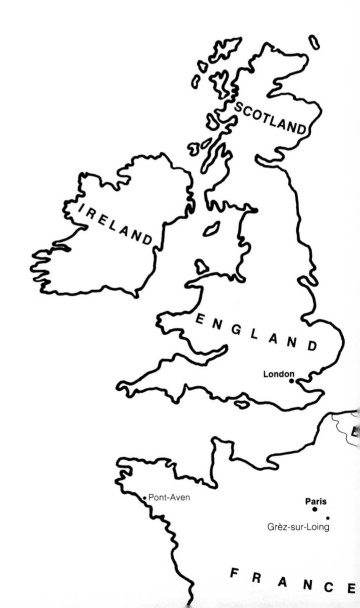

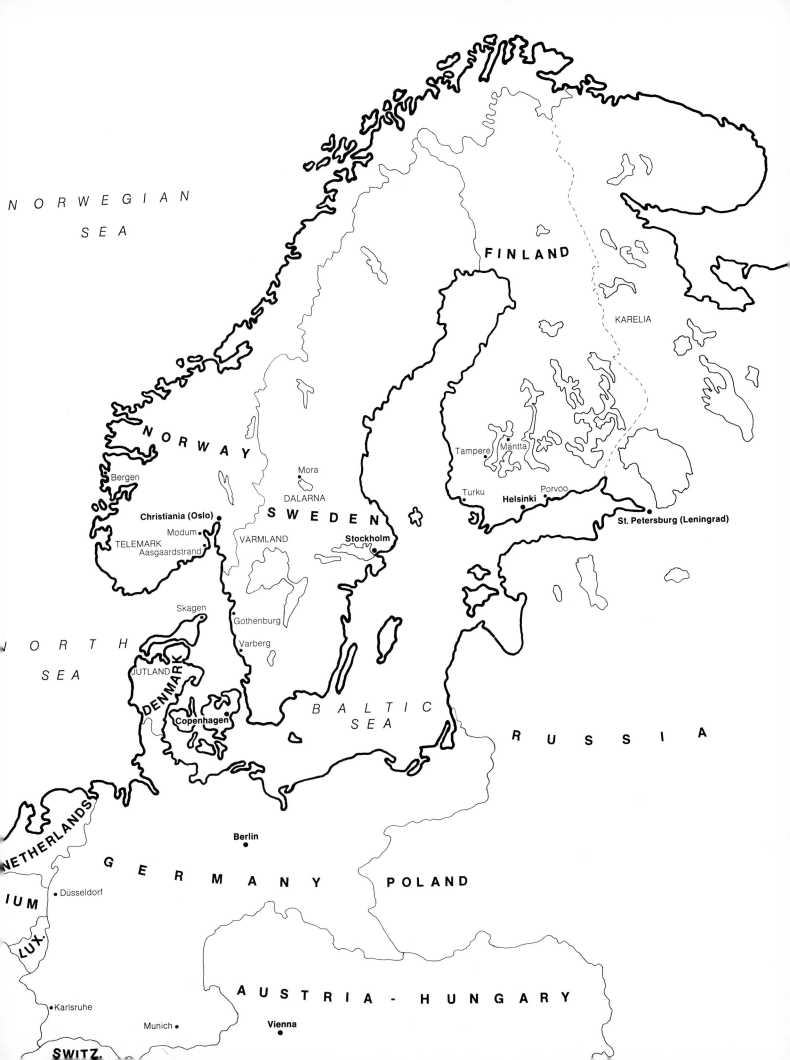

AUTHOR'S NOTE

The paintings in Northern Light *were selected to encourage comparison and contrast between the Realism and Symbolism that shaped a generation of Scandinavian artists in the 1880s and '90s and linked them in important ways to the formation of early modern art. They were not intended to form an inclusive or evenhanded survey of all the developments in Scandinavian painting in the late nineteenth century. Given the problem of representing five nations over more than two decades, the works were chosen with the intent of strengthening the thematic and visual coherence of the exhibition as a whole, as well as with the idea of effectively demonstrating a limited number of key aspects of the art of the five nations. The selection was determined by the quality and interest of individual paintings, rather than by a predetermined list of artists required to be represented.*

Inevitably, these limitations decided the exhibition's focus on some artists at the expense of others. Certain painters of strong individual interest and of importance to their countries' art—Magnus Enckell and Hugo Simberg of Finland, and Ernst Josephson and August Strindberg of Sweden, to name a few—were excluded because their work seemed too idiosyncratic to hang together happily in a coherent exhibition. Perhaps most prominent among the missing is the Danish painter Jens Ferdinand Willumsen (for two examples of his work see pp. 16–17). His absence owes to his experimental painting methods, which have left his key works in a state of fragility that precluded their being lent for the exhibition. Also excluded is the whole realm of ''saga painting'' in a Synthetist, quasi-illustrational style, most notably works by the Norwegian Gerhard Munthe (see cat. no. 55) and the Finn Akseli Gallen-Kallela after 1895. This branch of Northern Symbolism seemed to constitute a stylistic domain apart, more appropriate to a separate exhibition concentrating on literary-narrative painting and/or crafts-and-decoration movements.

Viewers of the exhibition will readily recognize its chronological sequence and its thematic and stylistic groupings; readers of this book can only reconstruct these sequences and comparisons from a chronological list of the paintings (see pp. 33–34) and from commentaries on the paintings and the painters. Both groups, however, will encounter some common problems: unfamiliarity of the works and artists, lack of knowledge about the Scandinavian cultural context in which these paintings were made, and difficulties that arise when we try to place late nineteenth-century Scandinavian painting in the context of better known European art of the same period. The following introductory remarks are intended to help alleviate these problems by outlining relevant historical background, and by suggesting fresh approaches to understanding the internal development of Scandinavian painting and its synchronization with broader patterns of artistic progress in the late nineteenth century.

KIRK VARNEDOE

Nationalism, Internationalism, and the Progress of Scandinavian Art

Kirk Varnedoe
*Associate Professor,
Institute of Fine Arts,
New York University*

DEVELOPMENTS in Scandinavian painting from 1880 to 1910 do not conform to the sequence of stylistic progress we know so well from the often-described evolution of French Impressionism and Post-Impressionism. Scandinavian painters of the time took a different path to modernity. If we are to understand that path, and these painters' places within early modern art, we must set aside our traditional ideas of the evolution of modern European painting and pay closer attention to what was local and particular to the Scandinavian situation.

Specific factors of geography, history, and politics distinguished—and in some cases linked—the art of the five separate Nordic nations at the close of the last century. Iceland, the smallest and most isolated of the five nations, remained outside the major artistic currents of the 1880s and '90s. Although the island's saga literature, linguistic purity, and democratic traditions commanded international as well as Nordic admiration during this period, its first true painters were only just beginning to form a school based on the exceptional local landscape (see Selma Jónsdóttir's essay, pp. 57–59).[1] The other, more interconnected nations of Scandinavia formed two rough pairs: Denmark and Sweden on one hand, Norway and Finland on the other. Denmark, distinct from all its Nordic neighbors by the relatively placid nature of its countryside, was similar to Sweden in significant respects. Though no longer bound under one rule as they had been from the eleventh to the sixteenth century, both had histories of active attachment to continental Europe and well-developed heritages of arts and letters grounded in European Enlightenment experience. Sweden had strong ties to France, and Swedish art had made an international mark via the early Romantic sculptor Johan Tobias Sergel (1740–1814). Denmark, in turn, was bound culturally as well as geographically to Germany; its grand era of Neoclassicism, prolonged by the sculpture of Bertel Thorvaldsen (1770–1844), had been supplemented by a Golden Age of Danish Biedermeier Naturalist painting in the 1830s and '40s.[2] Just as Denmark was similar to Sweden in traditions shared with the larger, established nations of Europe, so Norway resembled Finland in relative detachment from those same European traditions. As the Romantic landscapes of Johan Christian Dahl (1788–1857) demonstrate, Norwegian painting had been linked to Germany. In the early 1800s, however, Norway began to assert an independent pride in its separate national identity—its uniquely spectacular topography, its peasant life, and its Viking history. This nationalist temper, strengthened by a continuing push for independence from Sweden, gave important impetus to Norwegian culture of the late nineteenth century. Finland, though geographically remote from Norway and without any historical or political links to that country, shared its anti-Swedish spirit. Even though Sweden had not ruled Finland since ceding it to Russia in 1809, the "Finnish Renaissance" of the 1890s was as much a reaction against the prolonged domination of Swedish language and culture as it was a manifestation of protest over the expansionist pressures of the Russian Tsar. As in Norway, this anti-Swedish feeling led to celebrations of the country's wilderness and its own heroic mythology and folk style.

Despite the varying local conditions of the Scandinavian nations, there is at least one common pattern in the development of their painting during the last decades of the nineteenth century. This pattern, which is a major defining concern of *Northern Light*, hinges on two periods of change. First, around 1880, the relative isolation of Scandinavian art was broken by an incursion of modern European Realism and Naturalism, which had already been anticipated in literature and theatre. A new gamut of images appeared in Scandinavian painting—images of the working class, scenes of modern life, and *plein-air* landscape. At the same time, young Scandinavian artists directed their attention beyond their traditional training centers in Northern Europe, chiefly towards France (see Bo Lindwall's and Salme Sarajas-Korte's essays, pp. 35–42 and 60–66). Then, around 1890, a second major change occurred, as Scandinavia's international

Akseli Gallen-Kallela
Waterfall at Mäntykoski
1892-94
Mäntykoski
Oil on canvas
270.0 × 156.0 cm.
(106¼ × 61½ in.)
Private collection
Helsinki
Cat. no. 25

This huge vision of the
remote forest was painted
as an homage to Finland's
nationhood, and originally
included a wood nymph
playing music to an
entranced wilderness
dweller. By eliminating the
figures and replacing them
with five golden harp
strings on the picture's
surface, Gallen-Kallela
produced a work that is
simultaneously
representational, abstract,
and symbolic—a giant
tapestry-like canvas poised
between nineteenth-
century Naturalism and
modern art.

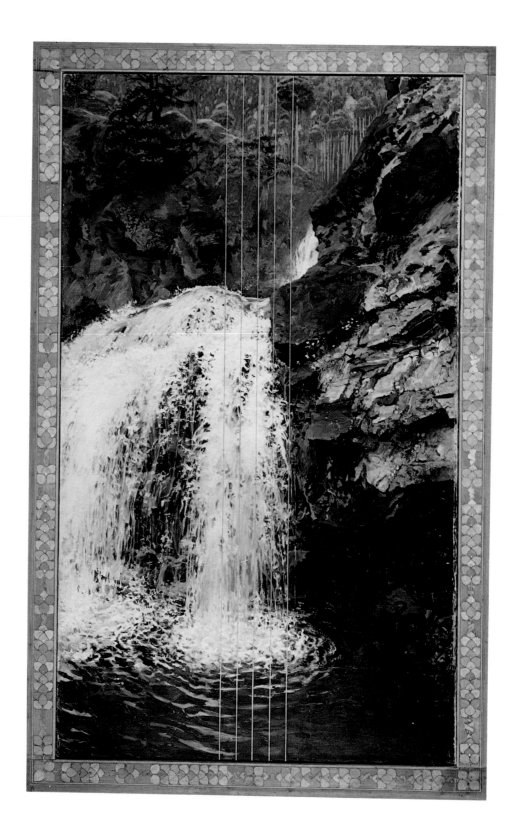

orientation of the 1880s was replaced by a strong resurgence of nationalist, isolationist sentiment that brought Scandinavian painters back to their homelands. Turning to specifically native-Nordic themes, these painters generally abandoned the French Realism that had marked their earlier work and adopted a variety of styles distinguished by the deepened subjectivity, unnatural color, and more obtrusive formal patterning associated with Symbolism. While the exact dates of these changes vary from artist to artist and from country to country—Sweden's artists pioneering in the discovery of French Realism; Norway's artists returning home years before those of other nations—the basic phenomenon is clear, consistent, and common: roughly a decade of internationalism and Realism followed by a decade of nationalism and Symbolism (see paintings by Jens Ferdinand Willumsen on pp. 16–17).[3]

Although this pattern appeared as a sharply demarcated crisis in numerous artists' careers, on several levels the two sides of the demarcation—the seemingly opposite domains of internationalist Realism and nationalist Symbolism—were in fact interdependent. The nationalist and Symbolist currents that would dominate Scandinavian art of the 1890s were already latent in, and in important respects nurtured by, the Scandinavian artists' experiences in France in the 1880s.

It was no accident, but a desired effect of the French government's arts policies, that Paris became a Mecca for foreign artists like the young Scandinavians. The liberal, business-minded opportunists who controlled the late-1870s and 1880s Republican government saw French culture—particularly the Realism they felt embodied their ideals of secular materialism and positivist science—as a kind of propaganda for the dispersion of their progress-oriented values. The diversity of exhibitions and the activity of the private art market made Paris an open laboratory that enticed artists from all over the world to come and study in an atmosphere of modern permissive liberalism unheard of in their native lands.

For the Scandinavians, this cosmopolitan experience had the paradoxical effect of fueling a new appreciation of the virtues of the North and preparing the way for a return to insular nationalism. The pluralism of Paris—especially the blend of independent artistic movements and exhibitions—gave the young Scandinavian artists a model for the reform of their native academies, while the formation of an expatriate community resulted in an increased sense of separate Nordic identity that had been discouraged by the frontiers and internecine politics within Scandinavia itself. This community, in turn, did a great deal to foster the return-to-the-folk attitudes associated with the growing Nordic National Romantic movement. Already, in the oscillation between Paris and the North that characterized the travels of some Scandinavian artists of the 1880s, we can see the interaction of seeming opposites: metropolis and wilderness, progressive internationalism and resolute parochialism—each alternating with and depending upon the other.

Even the Scandinavian artists most involved in the Parisian art world kept their home ties, in part because the French critics and market they sought to please valued not only a foreign artist's technical competence but also the sincere demonstration of the artist's national origins (see Emily Braun's essay, pp. 67–75). More fundamentally, however, the very premise of Realism—the call for an art that dealt not in studio-fabricated universalities but in the precise particulars of individual experience—demanded truth to local character as a mark of authenticity. In the conceptual/stylistic framework of their embrace of progressive Realism, young Scandinavian painters were encouraged both to study the techniques of the Parisians *and* to isolate and depict the special conditions of people, light, and topography that characterized their Northern homelands. In such ways urban internationalism and Realism gave rise to a new concentration on the distinct and separate qualities of Scandinavia and strengthened the growth of a Nordic

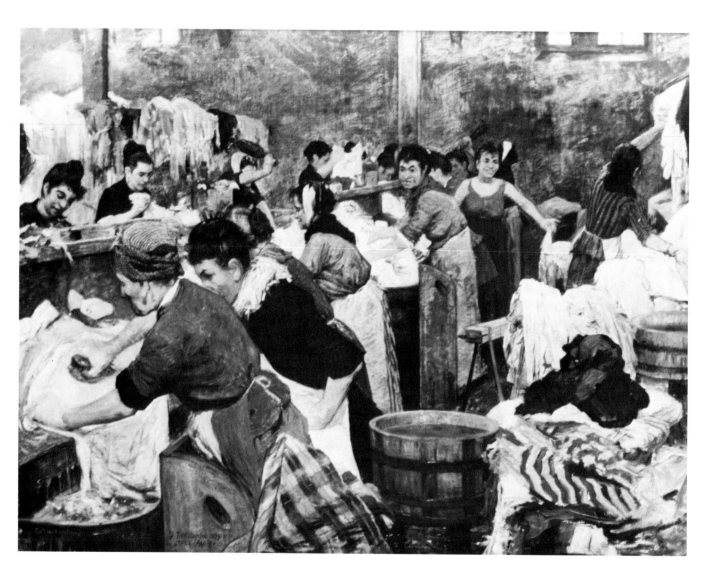

Jens Ferdinand Willumsen
In a French Laundry 1889
I en Fransk Tvättinrättning
Oil on canvas
102.0 x 130.0 cm.(40⅛ x 51⅛ in.)
Collection: Göteborgs Konstmuseum

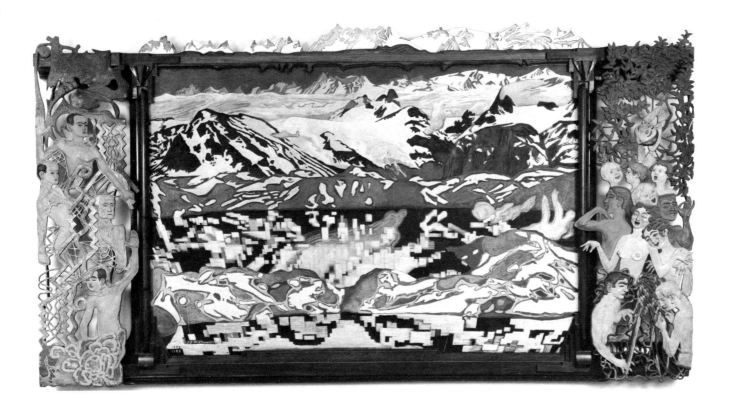

Jens Ferdinand Willumsen
Jotunheim 1892-93
Oil, painted zinc, and enameled copper
150.0 x 277.0 cm. (59 x 109 in.)
Collection: J. F. Willumsens Museum
Frederikssund, Denmark

These two paintings by a major Danish painter
embody the split between the Scandinavian artists'
Paris-oriented Realism of the 1880s and their Nordic
Symbolism of the 1890s. The laundry scene is in the
manner of Jean Louis Forain, a follower of Degas; the
glacier landscape is a highly original combination of
patterned abstraction and caricatural figure reliefs.
Jotunheim is charged with a complex symbolic program
related to a metaphysical revelation experienced by
Willumsen at this majestic Norwegian site.

nationalism already developing within Scandinavia itself in artists' enclaves like the one at Skagen.

The fishing village of Skagen, on the very northern tip of Jutland in Denmark, would seem to be the antithesis of Paris, while the artists' community that formed there around 1880 might appear to be a provincial anachronism. But several artists participated jointly in the Paris and Skagen communities, and just as the Paris experience fostered elements of its opposite, so the anachronistic and provincial Skagen experience was directly connected to significant international artistic developments. The concentration on isolated folk life that characterized the depiction of fishing families at Skagen (see cat. no. 51) anticipated the later direction of Nordic art and announced an impulse that would become broadly characteristic of the 1880s: the search to ground modern art in direct contact with more authentic forms of life beyond the touch of urban society.

Such nostalgia for less modernized ways of life, appearing as an ethnographic-documentary aspect of Realism in the early 1880s, also held a reactionary spirit potentially hostile to Realism's positivist premises. In the latter part of the decade, as dissatisfaction with Realism's materialist concentration on appearances accompanied a new reverence for spiritual mysteries, ethnography was transformed into full-blown folk primitivism—a belief in the superior moral and psychic force of a life lived in pre-rational contact with nature and tradition. Although this transformation was a powerful aspect of Symbolist art and thought (it led Van Gogh to Arles, and Gauguin to Brittany and then Tahiti), it was especially important for Scandinavian art, since— in contrast to France, where primitivism ran against the grain of the nation's civilized history and established commitment to modernization—the newly potent veneration of folk spirit and culture dovetailed precisely with the tenor of increasingly assertive Nordic nationalism. In Scandinavia, Symbolism's general concentration on nature mysticism and the inner life of pre-civilized man received a special impetus by linkage to a collective mythologizing of Nordic national identities.

By lagging behind for much of the nineteenth century, Scandinavia thus found itself at the forefront of the European *fin-de-siècle* rejection of material progress. In the early 1880s, still in the first flush of modernization and still subscribing to an expansionist energy, the less industrially developed Nordic countries had inevitably seen themselves as somewhat backward. But as major economic collapses and the increasing polarization of social politics throughout Europe contributed to deepening pessimism over modernization and its attendant troubles, Northern lands and thought came to hold a special prestige, and less "spoiled" Scandinavia gained a more positive sense of its separateness. What we see in much of European art of the late 1880s and '90s is this inversion of values: modernity becomes passé, the timeless becomes the progressive, a deeply local art comes to be seen as the privileged way to universality, and the marginal members of contemporary civilization—holdouts against the consuming spread of progress—become one of that civilization's central concerns.[4]

In this intellectual/political climate, all the Scandinavian nations intensified their nationalist spirit and gave new attention to indigenous traditions. Danish painters, for example, fused Symbolist tendencies with a revival of their Golden Age Naturalism (see cat. nos. 16, 29, and 35). At the same time Norwegian and Finnish artists benefited from a special energy and commanded particular admiration; less "cultured" in the cosmopolitan sense, they insisted on roots in a primitive past divorced from the civilized traditions of Europe and embodied in such myths and sagas as Finland's epic tale of origins, the *Kalevala*.[5]

The most pervasive and powerful themes in Scandinavian painting of this period were those that fused two strains of anti-rationalism: the general Symbolist current of inward-turning subjectivity, and the local motifs of nation-affirming Nordic identity. Rural folk, for example,

were perceived and depicted not only as psychically privileged in their direct contact with nature, but also as surviving exemplars of a primordial national soul (see cat. nos. 24 and 84). Similarly, "Nordic-ness" became a characteristic goal of Scandinavian landscape painting, moving beyond Naturalistic topographical description to evoke the eerie blue mood of forest and water nocturnes (see cat. nos. 13, 81, and 85), or emblematically monumentalizing rugged sites to speak of history rooted in the land (see cat. nos. 9, 72, and 87). Foremost among these themes of Scandinavian Symbolism was the Nordic summer night, with its traditional overtones of the erotic, the atavistic, and the cosmic. By evoking the fatal power of nature to crumble the artifices of civilization, the midsummer night proved equally attractive to those who were trying to link inner psychological forces with nature's scheme and to those who sought to ground nationalism in the cycle of the seasons and its accompanying folk rituals. This magic and achingly ephemeral night of sensuality, when the pulse of the seasons seemed to magnetize the body, thus became a familiar motif, fusing changing ideas of the self and state and reflecting the singularly charged complexity of this moment in Scandinavian art (see cat. nos. 66, 69, and 94).[6]

Ironically, it is in such specifically local themes and their intensified Nordic separateness that Scandinavian Symbolism joins most forcefully to that of the rest of Europe; just as it is in this reactionary moment that Scandinavian painting belongs most creatively to major international currents in the formation of modern art. The fusion of inward-turning psychology and collectivizing political spirituality in 1890s Northern Symbolism is not a peripheral aberration but a juncture of tendencies that were in constant tension within the general reaction against modernization that swept Europe at the end of the nineteenth century. Scandinavian Symbolism should thus be seen in its relation to broader international movements impelled by the same now-conflicting, now-cooperating values and aims. One need only think of the contradictions inherent in the Arts and Crafts and Art Nouveau movements in England, France, and Belgium during this period—particularly in the coexistence of ideals of collective social integration and concerns for private inner life—to locate one European context for Nordic developments of the 1890s.[7]

Standard overviews of late nineteenth-century art, determined by a retrospective idea of a "great chain of progress" centering on the stylistic innovations of the French avant-garde, have not dealt seriously with such international patterns. By describing the worlds of Realism and Symbolism as completely opposed—scientific vs. irrational, descriptive vs. imaginative, materialist vs. spiritual—these linear, sequential models of art history have also obscured the degree to which progress of any kind is not unilinear and does not always work in graduated sequences. Many of the paintings in *Northern Light* are simultaneously outmoded for their dates in some respects and well ahead of their time in others. Such hybrid works refuse to conform to either/or classification; they seem to be "both/and"—both Realist and Symbolist, both descriptive and abstract, both objective and expressive, both retrograde and avant-garde (see cat. nos. 13, 25, and 30). The painters appear to leapfrog back and forth over the familiar chain of progress to arrive at "forward" positions independently. Thus we find numerous, apparently coincidental, parallels between their works and better known works from elsewhere in Europe (see cat. nos. 18, 34, 39, and 80). The only way to explain these phenomena is to recognize that in painting, as in other activities, innovations, rather than taking their point of departure only from the immediately "advanced" position or from sheer *ex nihilo* invention, may instead draw important substance from minor, dormant, or peripheral areas. This basic fact about the nature of change is worth remembering while considering the relationship of Scandinavian Realism and Symbolism to each other and to the larger pattern of European art history, for it is precisely in its untoward fusions, inversions, and overlaps—indeed, in its "backward" failure to conform—that

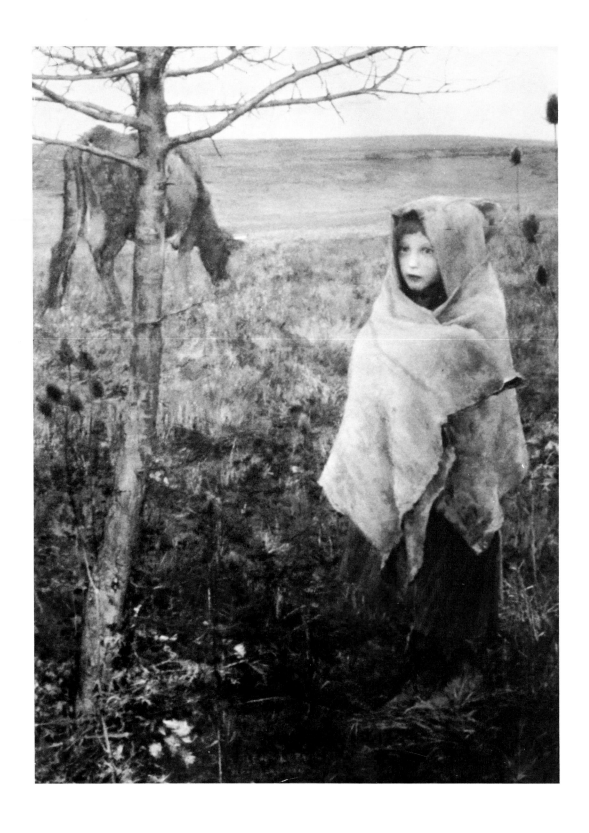

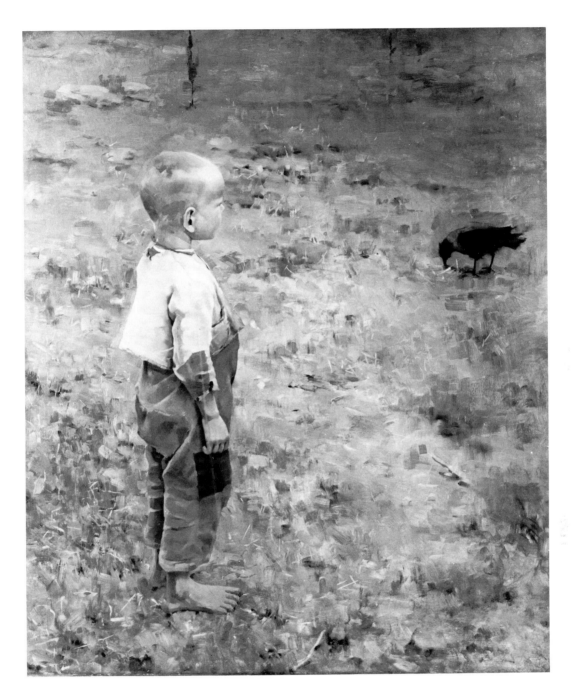

Facing page:
Jules Bastien-Lepage
Pauvre Fauvette 1881
Oil on canvas, 162.5 x 125.7 cm. (64 x 49½ in.)
Collection: Glasgow Art Gallery and Museum

Above:
Akseli Gallen-Kallela
Boy with a Crow 1884
Poika ja Varis
Oil on canvas, 86.5 x 72.5 cm. (34 x 28½ in.)
Collection: Ateneumin Taidemuseo, Helsinki
Cat. no. 20

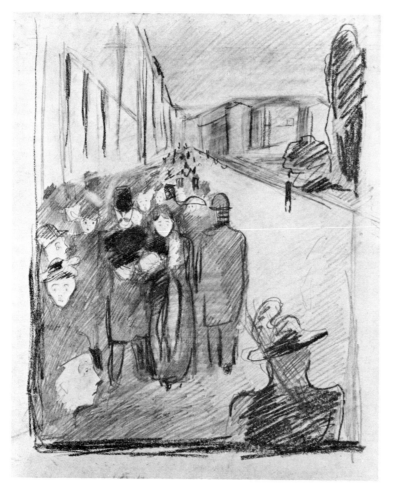

Left:
Edvard Munch
Evening on Karl Johan Street *circa* 1892
Aften på Karl Johan
Pencil and charcoal on paper
33.0 x 25.1 cm. (13 x 9⅞ in.)
Collection: Munch-Museet, Oslo

Facing page:
Edvard Munch
Evening on Karl Johan Street 1893
Aften på Karl Johan
Oil on canvas, 114.9 x 121.0 cm. (33¼ x 47⅝ in.)
Collection: Rasmus Meyers Samlinger, Bergen

Munch's preparatory drawing for
the Symbolist masterpiece shows
that the original compositional
idea was remarkably similar
to—and may have derived
from—Christian Krohg's Realist
street scene, *Struggle for Existence*
(p. 26).

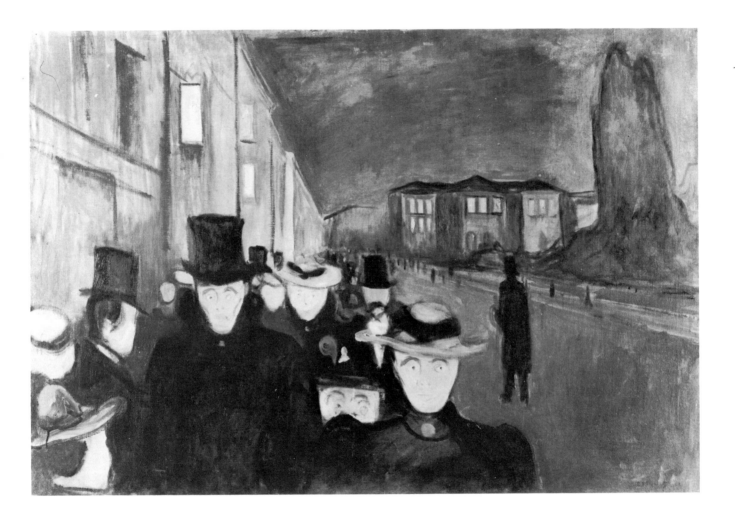

Scandinavian painting of the late nineteenth century has the most to offer to a new, more flexible model of the nature of progress in early modern art.

In dealing with French art and literature, we are accustomed to thinking of Realism as a force that was innovative primarily in the 1850s and '60s in the work of Gustave Courbet, Gustave Flaubert, and the early Émile Zola. Less attention has been paid to the later Realism of the 1870s and '80s, especially in painting, where Impressionist and Post-Impressionist developments are usually held to have subsumed and surpassed all that was innovative in Realism. But for foreigners with different backgrounds and expectations—especially for outsiders like the Scandinavians whose countries came late to the disruptive effects of modernization—later European Realism had an intense catalytic effect and strongly marked their response to Symbolist currents.[8] From the art of French Realist painters like Jules Bastien-Lepage, the Scandinavians isolated and appropriated different and more extreme lessons than are usually believed to have been contained in the original works. By their "creative misinterpretations," they extrapolated from later Realism provocative artistic strategies—such as tilted or funneled perspective structures, ambiguous narrative techniques, or obsessive accumulation of detail—which they felt announced new possibilities. Paradoxically, these strategies often turned out to be anti-Naturalist in their subjectivity and formal artificiality.

The Finn Akseli Galen-Kallela and the Swede Bruno Liljefors, for example, looked at the combination of sharply focused figures and blurred, raking backgrounds characteristic of French Salon Realism in the early 1880s (see Bastien-Lepage's *Pauvre Fauvette*, p. 20) and immediately derived a more insistently spaceless, nearly abstract effect that contrasted with the truth-to-nature "photographic" accuracy intended by the French painters while foreshadowing the decorative flatness associated with their own anti-Naturalist work of the 1890s (see Gallen-Kallela's *Boy with a Crow*, p. 21; and Liljefors' *Dovehawk and Black Grouse*, p. 26). At the same time, the young Scandinavian painters seem to have ignored the more brilliant palette of full-fledged Impressionism to find, in the comparatively timid grayness of that same Salon Realism, something closer to the tonalism and monochromatic harmonies of Symbolist taste.

In yet another such paradox, the personal, lens-truthful variant of German Realism developed by the Norwegian Christian Krohg in the early 1880s had a drastic literalness even more "progressive" in the boldness of its spatial arrangements than his adaptation of Impressionist compositional devices during the same period. The airless deadpan style of *The Sick Girl* (cat. no. 52), for instance, has some of the formal and psychological condensation normally associated with the charged iconic human confrontations found in Edvard Munch's work of the next decade. Likewise, Munch, a pupil of Krohg, is himself a prime example of how Scandinavian Symbolism had its roots in "misinterpretations" of later Realism. In his masterpieces of the 1890s (for example, *Evening on Karl Johan Street*, pp. 22–23), we see, transformed and intensified by the color and line of Gauguin, structures of perspective and narrative organization that are ultimately derived from Realist pictorial strategies visible in Gustave Caillebotte's city views of the late 1870s and Krohg's social polemic paintings of the mid-1880s (such as *Struggle for Existence*, p. 26).[9]

Similar phenomena occurred in Scandinavian drama and literature of the period—in Ibsen's particularly tense and moralizing Naturalism, which came to appear timely and congenial to Parisian Symbolists in the 1890s; and in the special reading given Zola's Naturalistic novels by the Danish critic Georg Brandes, who emphasized the expressive and symbolic aspects of their relentlessly detailed descriptive passages (see Sven Møller Kristensen's essay, pp. 52–56).[10] On another level, the call for scientific detachment posed by Zola's *Roman expérimental* had unexpectedly extreme consequences in the fevered and ultimately destructive *vie expérimentale* of promiscuity and self-willed moral neutrality that the bohemian writers and artists of the

Norwegian capital of Christiania lived out in Zola's name in the 1880s.[11] In all these instances, the impact of Realism was not merely delayed in time compared to France, but more immediately associated with Symbolism and modern subjectivity.

This distinctive phenomenon of interrelation and overlap between the ostensibly opposite tendencies of Realism and Symbolism appeared in matters of content as well as aspects of tone and style in an extraordinarily diverse range of Scandinavian art. The Swedish animal painter Liljefors might seem, for instance, to be only a marginal and eccentric presence in the art of the late nineteenth century; yet his development embodies so clearly the dominant issues of style and meaning we have mentioned that, studied closely, his work provides a paradigmatic example. From the 1880s to the 1890s, remaining all the while within the consistent framework of his stated desire to show the natural order of the world beyond human contral, Liljefors' imagery of birds moved from sharply focused Realist narrative (see *Dovehawk and Black Grouse,* p. 26) to brooding Symbolist nocturne (see *Horned Owl Deep in the Forest,* p. 27). In this shift from a focus on the predatory cycle to an emphasis on the moody harmony of creature and nature, it is, furthermore, easy to see analogies to changing notions of society and individuality.[12] Just as Liljefors' dramatization of the Darwinian battle for survival in the wild echoes Krohg's critique of Social Darwinism (see *Struggle for Existence,* p. 26), so does his later nocturne recall the "psychic Naturalism" of Munch (see *Moonlight,* p. 27).[13] Liljefors' paintings of the late 1890s and early 1900s then go on to integrate the animal into nature even more forcefully. Following his theory that the animal is a kind of self-portrait made by nature, the landscape settings are no longer based solely on scrupulous observation, but on a synthetic extrapolation of the colors and designs of the animals themselves. While these later images (such as *Young Seagull,* p. 28) are still tied to initial Naturalist goals, they have become strongly abstracted, decoratively colored constructs of an ideal of universal harmony. They are unexpectedly—though in fact not at all coincidentally—quite close to the work of the German painter Franz Marc (see *The White Hound,* p. 29), whose Expressionism of 1910–14 embodied a desire to paint the world in terms of the unity experienced by an animal consciousness free from the corruptions of human thought.[14]

The change from Liljefors to Marc, from the world of Darwin to that of spiritualism, is expressed in an artistic progression from detailed descriptive Realism through Symbolism to the edge of abstraction—a progression remarkably seamless in its underlying continuity. Strands of the "backward" and the "avant-garde," of rational scientific observation and psychological imagination, seem thus inextricably woven together in a fashion that makes of Liljefors' career a suggestive distillation of the artistic currents of his time. The development of modernism out of Symbolism, and Symbolism out of Realism, seems in this case to be linked to an evolving idea of natural science, and parallel developments in the human imagery of other Scandinavian painters seem to reflect similar connections to changing sociological and psychological theory in the same period. These examples encourage the idea that late nineteenth-century developments in the natural and human sciences might provide not only the intellectual substructure for much of Northern Realism and Symbolism but also a model pattern of interchange between these two types of painting.

Although the pattern begins with the urge to analysis and the keenly attentive description of variable specificities in the concrete world (weather, motion, facial expression, social types, and so on), this urge leads finally to a supplanting of the analytic by the synthetic, to the positing of new notions of unity and collectivity beyond the perceivable world of fragmented data, and thus to the conviction that "truth to nature" is achieved not through observation and description, but through the intellectual fabrication of ideal forms and abstract schemata. As in the sciences at the century's end, where inductive thought and empirical experiment were supplanted by deductive

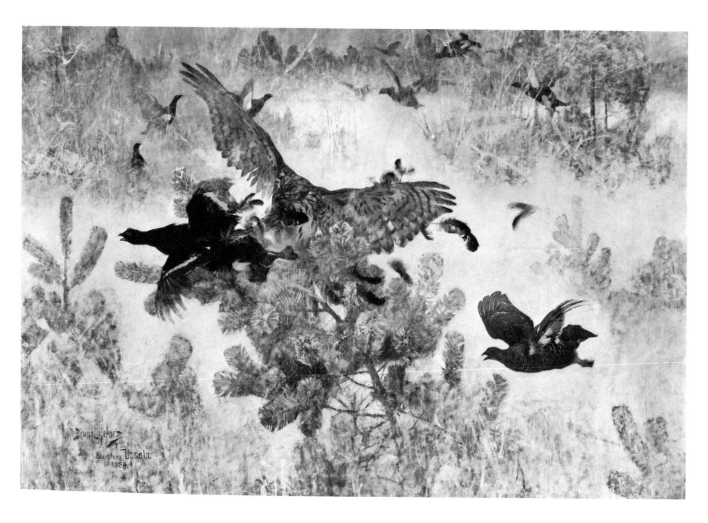

Above:
Bruno Liljefors
Dovehawk and Black Grouse 1884
Duvhök och orrar
Oil on canvas, 143.0 x 203.0 cm. (56¼ x 79⅞ in.)
Collection: Nationalmuseum, Stockholm
Cat. no. 60

Right:
Christian Krohg
Struggle for Existence 1889
Kampen for Tilvaerelsen
Oil on canvas, 300.0 x 225.0 cm. (118⅛ x 88⅝ in.)
Collection: Nasjonalgalleriet, Oslo

Krohg shows the poor of Christiana (Oslo)
fighting for stale bread handed out as charity
each winter morning by a bakery.

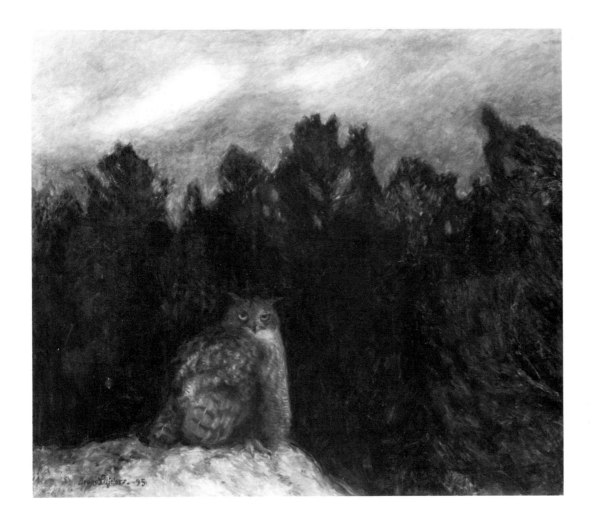

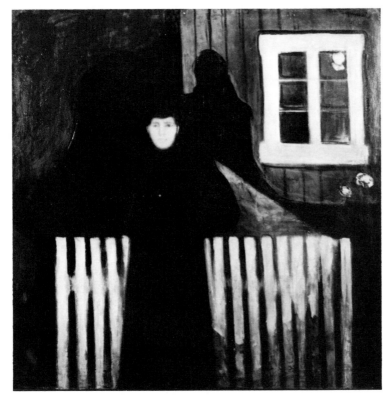

Above:
Bruno Liljefors
Horned Owl Deep in the Forest 1895
Uven djupt inne i skogen
Oil on canvas, 166.0 x 191.0 cm. (65⅜ x 75¼ in.)
Collection: Göteborgs Konstmuseum
Cat. no. 61

Left:
Edvard Munch
Moonlight 1893
Måneskinn
Oil on canvas, 140.5 x 135.0 cm. (55¼ x 53⅛ in.)
Collection: Nasjonalgalleriet, Oslo
Cat. no. 65

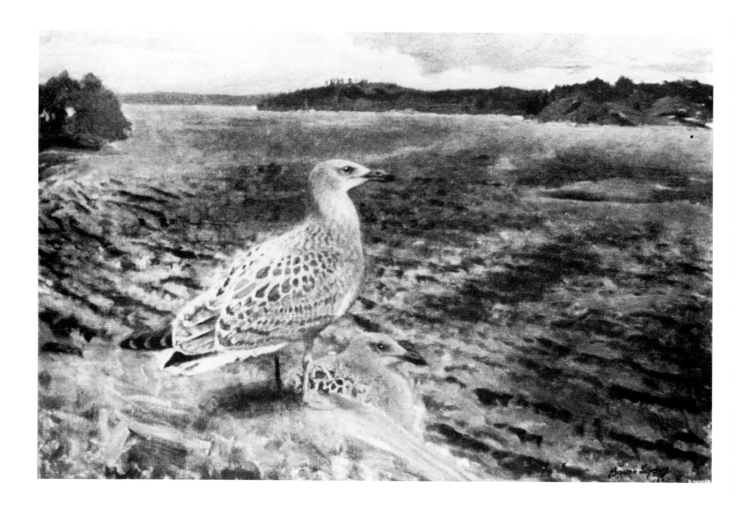

Above:
Bruno Liljefors
Young Seagull 1901
Unga havstrutar
Oil on canvas, 87.0 x 130.0 cm. (34¼ x 51⅛ in.)
Collection: Thielska Galleriet, Stockholm

Facing page:
Franz Marc
The White Hound (Hound Overlooking the World) 1912
Oil on canvas, 111.0 x 83.0 cm. (43¾ x 32¾ in.)
Private Collection, Zürich

theory, so in Scandinavian painting the rural became the *volkisch*, national politics were subsumed in historical saga, and the topography of Scandinavia was generalized as Nordic Nature.

The historian of science recognizes that the inductive and the deductive incorporate elements of one another, and that the change, decisive and important though it is, involves a series of major shifts rather than a revolution in kind.[15] In terms of late nineteenth-century painting, we must correspondingly pay more attention to the particular theoretical program that shaped the self-styled objectivity of 1880s Realism, and similarly emphasize the ongoing Naturalist foundations of Symbolist artifice. Unlike either/or oppositions of rationality vs. irrationality or objective vs. subjective, such a model of interaction allows us to understand the continuities we recurrently observe in later Realism's prefigurations of Symbolism, and in Symbolism's transformation of the content and style of later Realism. Because the Scandinavian painters represented in *Northern Light* encountered Realism late in Realism's development and often jumped into Symbolism with no intermediate phase, their work points up especially clearly the interdependence of the two styles, while also showing the possibility of progress toward modern art by independent and directly spliced linkage between supposedly disparate—retarded and advanced—modes of painting.

Why, then, if Scandinavian painting adds such key elements to our understanding of broader European patterns, has it been ignored while we have spent our attention generously on less original and less challenging offshoots of the French tradition? Simple Francophilia, language barriers, and the special pattern of collecting that has kept so much of this art in the Nordic countries (see Tone Skedsmo's essay, pp. 43–51) provide partial answers. But this neglect may also have something to do with the very idea of a connection between modernization and artistic progress. In many of the paintings in *Northern Light*, the energy that fueled innovation and beauty was that of reaction away from modern civilization toward a greater inwardness, a purer moment in history, or the authority of blood, the soil, and the seasons. Our long-standing ignorance of Nordic painting of this period may have more than a little to do with our failure—perhaps our reluctance—to inquire more searchingly about the role such impulses have played in the development of modern art and thought. Beyond its intrinsic visual appeal, *Northern Light* should join with other recent critical reappraisals in bringing these consequential issues to the forefront of our continuing reassessment of the roots of modern art.[16]

1 One of the most fervent admirers of Iceland's society and literature was the English poet and artist William Morris. Deeply affected by Icelandic sagas, he travelled in Iceland and brought back reports of the virtues of the nation. See *Journals of Travel in Iceland 1871–1873*, vol. 8 of William Morris, *The Collected Works of William Morris* (London: Longmans Green & Co., 1911).

2 On artistic relations between Germany and Denmark in the later nineteenth century (relations that were complicated by Prussian military annexation of Danish territory in 1864), see the exhibition catalogue *Vor hundert Jahren: Denmark und Deutschland 1864–1900, Gegner und Nachbarn* (Copenhagen: Statens Museum, 1981).

Danish Golden Age painting—the work of Christoffer Vilhelm Eckersberg and his students Christen Købke, Johan Thomas Lundbye, et al—is certainly one of the most underappreciated episodes in nineteenth-century painting. See T. H. Golding, V. Poulsen, H. Bramsen, and L. B. Jorgensen, *Dansk Guldalderkunst Maleri og Skulptur 1780–1850* (Copenhagen: Politikens Forlag, 1979).

3 This bipartite division is a generalization adopted to focus attention on key issues and is not intended either to obscure the great variety of styles that fall under the broad labels of Realism and Symbolism in Scandinavia, or to deny the significance of the complex transitional moments that occurred in the work of many of these painters in the late 1880s and early 1890s when they experimented with such anti-Naturalist styles as those of Pierre Puvis de Chavannes or Georges Seurat. For examples of paintings produced in these transitional moments, see cat. nos. 50 and 64. Jens Ferdinand Willumsen's work with Gauguin at Pont-Aven, prior to returning to Denmark and the more fully personal Symbolism seen in *Jotunheim* (p. 17), is another prominent instance of such a transitional period.

4 One of the most consequential manifestations of this anti-modern tenor is the rise of the *volkisch* ideology in Germany. For an excellent account of this phenomenon, see George F. Mosse, *The Crisis of German Ideology* (New York: Shocken, 1981).

5 The *Kalevala* epic was first assembled in definitive written form by a Finnish scholar named Lönnrott in his thesis of 1827. For an English translation see Francus Peabody Magoun, Jr., *The Old Kalevala and Certain Antecedents* (Cambridge: Harvard University Press, 1969).

6 On the importance of summer night celebrations as rallying points for a new idea of the collective state, and for a clear delineation of the sinister manipulation of this kind of festival, see George F. Mosse, *The Nationalization of the Masses* (New York: New American Library, 1977); and George F. Mosse, *Nazi Culture* (New York: Schocken, 1981).

7 A direct connection between Scandinavian art and Arts and Crafts currents in Belgium and England exists by virtue of Akseli Gallen-Kallela's contacts with England and A. W. Finch's participation in Louis Sparre's Iris Workshop (see pp. 108 and 220). Scandinavian painting also had a direct and significant impact on German and Russian art of the late nineteenth and early twentieth centuries. Although Edvard Munch's importance for the German Expressionists has generally been recognized, we are only beginning to acknowledge the interchange that took place between such Scandinavian artists as Gallen-Kallela and early modern figures like Sergei Diaghilev and Wassily Kandinsky. See Peg Weiss, *Kandinsky in Munich: The Formative Years* (Princeton: Princeton University Press, 1979), pp. 65–67; and Peg Weiss, *Kandinsky in Munich 1896–1914* (New York: Solomon R. Guggenheim Museum, 1982), pp. 47–48.

8 For a broader analysis of this phenomenon of "outsider" response to modern currents, see Marshall Berman's remarks on "The Modernism of Underdevelopment," in his *All That is Solid Melts into Air* (New York: Simon and Schuster, 1982).

9 Kirk Varnedoe, "Caillebotte's Space" in *Gustave Caillebotte: A Retrospective Exhibition* (Houston: Houston Museum of Fine Arts, 1976), pp. 69–71 and 149–150; and "Christian Krohg and Edvard Munch," *Arts Magazine*, April 1979.

10 See "Émile Zola" in Georg Brandes, *Menschen und Werke, Essays von Georg Brandes* (Frankfurt: Literarische Anstalt, Rutten und Loening, 1900). The essay was originally written in 1887. See especially the analysis of Zola's *La faute de l'abbé Mouret*, pp. 244 ff.

11 For a rich description of the *vie expérimentale*, see Reinhold Heller, "Love as a Series of Paintings" in *Edvard Munch: Symbols and Images* (Washington: National Gallery of Art, 1978), pp. 87–111 and especially pp. 92–95.

12 My thanks to Björn Fredlund, Director of the Gothenburg Art Gallery, and to Ulf Linde, Director of the Thiel Gallery in Stockholm, for pointing out to me the singular interest of Liljefors' work, and for explaining to me the theoretical bases of these paintings. Liljefors' interest in building an art entirely of nature imagery is not merely a personal quirk, but a special manifestation of anti-urban currents of his time. In 1886, in his autobiographical memoir *Son of a Servant*, August Strindberg wrote: "When a man has discovered society to be an institution based on error and injustice, when he perceives that, in exchange for petty advantages society suppresses too forcibly every natural impulse and desire, when he has seen through the illusion that he is a demigod and a child of God, and regards himself more as a kind of animal—then he flees from society, which is built on the assumption of the divine origin of man, and takes refuge with nature. Here he feels in his proper environment as an animal, sees himself as a detail in the picture, and beholds his origin—the earth and the meadow.... And in our time, when all things are seen from the scientific point of view, a lonely hour with nature, where we can see the whole evolution—history in living pictures, can be the only substitute for divine worship." *(Son of a Servant*, Claud Field trans., New York: G. P. Putnam & Sons, 1913, pp. 197–198) Liljefors' relation to the broader picture of animal imagery in nineteenth-century art and literature is taken up by Bo Lindwall and Lindorm Liljefors in *Bruno Liljefors* (Stockholm, 1960) and by Allen Elenius in his *Bruno Liljefors* (Stockholm: Bokforlaget Carming, 1981).

13 On Munch and psychic Naturalism, see Heller, "Love as a Series of Paintings," *loc. cit.*; and Carla Lathe, "Edvard Munch and the Concept of Psychic Naturalism," *Gazette des Beaux-Arts* (March 1979); also Wladyslawa Jaworska, "Edvard Munch and Stanislaw Przybyszewski," *Apollo* (October 1974); and ultimately Stanislaw Przybyszewski,

"Psychicher Naturalismus," *Die Neue Deutsches Rundschau,* vol. 5, no. 1 (1894).

14 The intervening link between Liljefors and Marc is the Swiss animal painter Jean Bloe Niestlé, whose work, much admired by Marc, is remarkably close to Liljefors'. See Frederick S. Levine, *The Apocalyptic Vision* (New York: Harper and Row, 1975), pp. 34–39; and *Der Blaue Reiter* (Munich: Stadtische Galerie in Lenbachhaus München, 1970), pp. 134–137. Niestlé's work of *circa* 1905, however, is less advanced stylistically than Liljefors' more broadly handled and boldly colored works of the same period. Marc could have seen such later works by Liljefors in sources like the article "Bruno Liljefors" in *Zeitschrift für Bildende Kunst,* no. 16 (1905), pp. 116–121. Two 1905 paintings were there reproduced full-page in color (facing p. 116 and facing p. 132). On the relation of Marc's paintings of animals to human imagery, see Johannes Langner, "Iphigenie als Hund" in *Franz Marc 1880–1916* (Munich: Prestel Verlag, 1980); and the response by Donald Gordon, "Marc and Friedrich Again: Expressionism as Departure from Romanticism," *Source,* no. 1 (Fall 1981).

The speculation on the subjective life of animals and its relation to human thought was not simply Romantic fantasy, but also a central issue of psychological study in the period preceding World War I. Imaginative projection into the subjective impressions of test animals was a key approach to the study of the mind—an approach then under attack from Pavlov's insistence on the sole and independent validity of observable response. See Jeffrey A. Gray, *Ivan Pavlov* (New York: Penguin, 1981), pp. 28–30.

15 I obviously here steal a simplified generalization from a vastly complicated field. For an introduction to relevant ideas of the history and philosophy of scientific change, see Thomas Kuhn, *The Structure of Scientific Revolutions,* 2nd ed. (Chicago: The University of Chicago Press, 1970); and Frederick Suppe (ed.), *The Structure of Scientific Theories,* 2nd ed. (Chicago: University of Illinois Press, 1979).

16 The key text relevant to the reevaluation of Northern art of the nineteenth century is Robert Rosenblum's *Modern Painting and the Northern Romantic Tradition* (New York: Harper and Row, 1975). In many senses Scandinavian painting of the late nineteenth century can be seen as providing a "missing link" between the early nineteenth-century German Romantics and the early twentieth-century German Expressionists. The issues which I feel now need more recognition and investigation are those of the links between artistic imagery and political thought within this Northern tradition. Although the coincidence of psychological and social implications in Scandinavian Symbolism is only another episode in the dialogue between Romantic ideas of the individual and the nation-state, the particular forms and motivations of National Romanticism that underlie Nordic art of the late nineteenth and early twentieth centuries seem particularly fraught with implications for modern politics.

CHRONOLOGICAL LIST OF PAINTINGS

1879

Christian KROHG	*The Net Mender* (Cat. 51)
Peder Severin KRØYER	*Sardine Cannery at Concarneau* (Cat. 56)

1880

Anna ANCHER	*Lars Gaihede Carving a Stick* (Cat. 2)

1881

Christian KROHG	*The Sick Girl* (Cat. 52)

1882

Christian KROHG	*Portrait of Karl Nordström* (Cat. 53)
Peder Severin KRØYER	*In the Store During a Pause from Fishing* (Cat. 57)
Nils Gustav WENTZEL	*Breakfast I* (Cat. 90)

1883

Harriet BACKER	*Blue Interior* (Cat. 3)
Christian KROHG	*Sleeping Mother* (Cat. 54)
Akseli GALLEN-KALLELA	*Cloud Study* (Cat. 19)
Peder Severin KRØYER	*The Artists' Luncheon* (Cat. 58)

1884

Akseli GALLEN-KALLELA	*Boy with a Crow* (Cat. 20)
Akseli GALLEN-KALLELA	*A Loft at Hoskari, Keuruu* (Cat. 21)
Bruno LILJEFORS	*Dovehawk and Black Grouse* (Cat. 60)
Karl NORDSTRÖM	*Garden in Grèz* (Cat. 71)
Eilif PETERSSEN	*Meudon Landscape* (Cat. 73)
Laurits Andersen RING	*The Lineman* (Cat. 75)

1885

Christian KROHG	*Portrait of Gerhard Munthe* (Cat. 55)

1886

Albert EDELFELT	*Sketch for Luxembourg Gardens* (Cat. 7)
Kitty KIELLAND	*After Sunset* (Cat. 50)
Eilif PETERSSEN	*Summer Night* (Cat. 74)

1887

Akseli GALLEN-KALLELA	*A Winter Landscape* (Cat. 22)
Karl Gustav JENSEN-HJELL	*At the Window* (Cat. 47)
Laurits Andersen RING	*Evening. The Old Woman and Death* (Cat. 76)

1888

Richard BERGH	*Death and the Maiden* (Cat. 4)
Akseli GALLEN-KALLELA	*Démasquée* (Cat. 23)
Eero JÄRNEFELT	*Lefranc, Wine Merchant, Boulevard de Clichy, Paris* (Cat. 43)
Harald SLOTT-MØLLER	*The Poor: The Waiting Room of Death* (Cat. 79)

1889

Albert EDELFELT	*Kaukola Ridge at Sunset* (Cat. 8)
Akseli GALLEN-KALLELA	*The First Lesson* (Cat. 24)
Edvard MUNCH	*Inger on the Beach (Summer Night)* (Cat. 62)

1890

Eero JÄRNEFELT	*Portrait of Professor Johan Philip Palmén* (Cat. 44)
Edvard MUNCH	*Night (Night at St. Cloud)* (Cat. 63)
Edvard MUNCH	*A Spring Day on Karl Johan Street* (Cat. 64)
Harald SLOTT-MØLLER	*Georg Brandes at the University of Copenhagen* (Cat. 80)

1891

August EIEBAKKE	*Laying the Table* (Cat. 12)
Louis SPARRE	*First Snow* (Cat. 84)
Anders ZORN	*Midnight* (Cat. 92)

1892

Prins EUGEN	*The Forest* (Cat. 13)

1893

Peder Severin KRØYER	*Summer Evening on the South Beach at Skagen* (Cat. 59)
Edvard MUNCH	*Moonlight* (Cat. 65)
Edvard MUNCH	*Summer Night's Dream (The Voice)* (Cat. 66)
Karl NORDSTRÖM	*Varberg Fort* (Cat. 72)

1894

Albert EDELFELT	*Särkkä* (Cat. 9)
Akseli GALLEN-KALLELA	*Waterfall at Mäntykoski* (Cat. 25)
Akseli GALLEN-KALLELA	*Symposion (The Problem)* (Cat. 26)
Laurits Andersen RING	*Three Skulls from the Convent of the Capuchins at Palermo* (Cat. 77)
Ellen THESLEFF	*Spring Night* (Cat. 85)

1895

Halfdan EGEDIUS *The Dreamer* (Cat. 10)
Eero JÄRNEFELT *Flowers in Water* (Cat. 45)
Bruno LILJEFORS *Horned Owl Deep in the Forest* (Cat. 61)
Edvard MUNCH *Self-Portrait with Cigarette* (Cat. 67)

1896

Halfdan EGEDIUS *Play and Dance* (Cat. 11)
Prins EUGEN *The Cloud* (Cat. 14)
Ellen THESLEFF *Violin Player* (Cat. 86)
Anders ZORN *Self-Portrait* (Cat. 93)

1897

Niels BJERRE *The Prayer Meeting, Harboøre (The Children of God)* (Cat. 6)
Ludvig FIND *Portrait of a Young Man. The Painter Thorvald Erichsen* (Cat. 16)
Anders ZORN *Midsummer Dance* (Cat. 94)

1898

Ejnar NIELSEN *The Blind Girl* (Cat. 70)

1899

Pekka HALONEN *Wilderness* (Cat. 27)
Eugène JANSSON *Dawn over Riddarfjärden* (Cat. 38)
Eugène JANSSON *The Ouskirts of the City* (Cat. 39)
Edvard MUNCH *Melancholy (Laura)* (Cat. 68)
Harald SOHLBERG *Summer Night* (Cat. 81)
Thórarinn B. THORLÁKSSON *Woman at a Window* (Cat. 88)

1900

Richard BERGH *Nordic Summer Evening* (Cat. 5)
Vilhelm HAMMERSHØI *A Farm at Refsnaes* (Cat. 28)
Edvard MUNCH *The Dance of Life* (Cat. 69)
Thórarinn B. THORLÁKSSON *Thingvellir* (Cat. 87)

1901

Prins EUGEN *Still Water* (Cat. 15)
Vilhelm HAMMERSHØI *Interior with Piano and Woman in Black* (Cat. 29)
Vilhelm HAMMERSHØI *Five Portraits* (Cat. 30)
Eugène JANSSON *Self-Portrait* (Cat. 40)

1902

Eugène JANSSON *Hornsgatan at Night* (Cat. 41)
Carl WILHELMSON *The Daughter on the Farm* (Cat. 91)

1903

Björn AHLGRENSSON *Glowing Embers at Dusk* (Cat. 1)
Helene SCHJERFBECK *The Seamstress* (Cat. 78)
Thórarinn B. THORLÁKSSON *Eyjafjalla Glacier* (Cat. 89)

1904

Eugène JANSSON *Österlånggatan* (Cat. 42)
Ásgrímur JÓNSSON *Tindafjöll* (Cat. 48)
Harald SOHLBERG *Night* (Cat. 82)

1905

Vilhelm HAMMERSHØI *Open Doors (White Doors)* (Cat. 31)
Vilhelm HAMMERSHØI *Landscape from Lejre* (Cat. 32)
Eero JÄRNEFELT *Lake Shore with Reeds* (Cat. 46)
Harald SOHLBERG *Flower Meadow in the North* (Cat. 83)

1906

Gustaf FJAESTAD *Running Water* (Cat. 17)
Vilhelm HAMMERSHØI *Study of a Sunlit Interior* (Cat. 33)
Vilhelm HAMMERSHØI *St. Peter's Church, Copenhagen* (Cat. 34)

1907

Gustaf FJAESTAD *Winter Evening by a River* (Cat. 18)

1908

Vilhelm HAMMERSHØI *Interior with a Seated Woman* (Cat. 35)

1909

Ásgrímur JÓNSSON *Hekla* (Cat. 49)

1910

Vilhelm HAMMERSHØI *Female Nude* (Cat. 36)

1911

Vilhelm HAMMERSHØI *Self-Portrait* (Cat. 37)

Artistic Revolution in Nordic Countries

Bo Lindwall

Doctor of Philosophy, former Director of Prins Eugens Waldemarsudde, Stockholm

T HE 1870s ushered in the most philistine, parvenu era Sweden had ever known—the golden age of the nouveau riche, industrialization's puberty. As August Strindberg wrote, it "was a good time, when industry and trade did so much business that money was as abundant as grass and everyone wanted to eat well. Between 1872 and '78, all one heard was of articles of association and warrants of arrest, forged bills of exchange and jubilations. All of Sweden was shady."

As the wealth and corruption of the society grew, so did tensions between the increasingly rich employers and their poorly paid workers. In 1879, the year a bitter strike broke out in the northern town of Sundsvall, Strindberg wrote in his first major novel, *The Red Room*, "A day will come when it will be worse, but then, then we will come down from Vita Bergen, from Skinnarviksbergen, from Tyskbagarbergen, and we will come with a great commotion, like a waterfall, and we will ask for our beds again. Ask for? No, take. And you will have to lie on carpenters' benches as I have had to, and you will have to eat potatoes so that your bellies stand out like drumheads, just as if you had gone through trial by water as we have."[1]

Throughout Scandinavia the basic tone of the era became one of uproar and revolt—against all idea of authority, against all that was reactionary and conventional. Movements for social democracy sprang up in Denmark at the beginning of the 1870s and in Sweden a decade later. In Norway, an agricultural country controlled by Sweden, and in Finland, a former Swedish possession ruled by Russia, nationalism grew steadily more virulent as the century drew to a close.

These struggles for human rights and for social and political equality awakened sympathy in young artists. They felt that they, too, stood in opposition to the conservative ruling classes, whose aesthetic ideals were safely academic. Although a few were confirmed reactionaries, and some felt that for sentimental reasons or to further their careers they had to swear allegiance to reactionary forces, most young Scandinavian artists were radicals, and many were confirmed socialists. Carl Hill, a young Swedish landscapist who waged a private revolt in the 1870s against an authoritarian father and the Royal Academy of Fine Arts, wrote to his mother from Paris that he was a "republican, a socialist, a cosmopolitan.... If you heard my ideas, you would be dumbfounded."[2] That same decade the Danish critic Georg Brandes described the Norwegian painter Christian Krohg and his comrades at Karl Gussow's Berlin art school as "enthusiastic nihilists, socialists, atheists, naturalists, materialists, and egoists. They put the most horrible ideas into one another's mouths as far as social order and one's neighbor's peace go. They praised the politics of the Paris Commune."[3] And the twenty-nine-year-old Swedish artist Carl Larsson wrote in a letter of 1882, "Don't think that I am an indolent slave even though I wear a gaudy suit in gay colors and a laughing mask. If you knew what my life and my gallant battle for existence were like, you would know that I am not going to stay where I am now. But it isn't my goal, as you suggest, to paint expensive pictures in a big country. No, I have two characteristics: I am Swedish and—shudder!—a socialist. I want to *serve* and *gladden*, but *all* and not just *one*."[4]

The atmosphere of revolt that prevailed among these young Scandinavian artists stemmed in large part from dissatisfaction with art museums, academies, and societies, which in the opinion of the artists never purchased anything but rubbish and always awarded medals and grants that were unjust, partisan, and contemptible. As the artists' revolution unfolded in all of Scandinavia, such institutions became the primary targets.

In Denmark, where the Scandinavian artists' revolution first broke out, the attack on the establishment took a peculiar turn. In 1879 a group of artists who had just completed their studies at Copenhagen's Royal Academy of Fine Arts (now the Royal Danish Academy of Art) applied to the state for funds to continue their training by painting live models. The academy itself approved

Eugène Jansson
Demonstration Day 1896 – 1901
Demonstrationståg
Oil on canvas, 157.0 × 221.5 cm. (61⅞ × 87¼ in.)
Collection: Folkets hus, Stockholm

Jansson was sympathetic with the socialist movement in Sweden and worked for several years to complete this celebration of a mass workers' demonstration. Such social unrest was closely related to the Scandinavian artists' revolution.

the idea, and the government granted funds for 1880 – 81. As a result, the upstart Artists' Model School began as a sanctioned extension of the academy.

But there was another group of young artists studying at the academy's regular school who were dissatisfied with the instruction they were receiving. They broke out of the academy and turned to the twenty-eight-year-old Laurits Tuxen, who taught at the Model School, and asked him to be their teacher, too. More and more academy pupils went over to Tuxen's school, where they worked not only in the evenings but also during the day, when they should have been at the academy's school.

Soon plans were made to expand the Model School with state help, to turn it into a modern academy where instruction would be given along radical lines, with the pupils painting live models *outdoors* in the summer. In their application to the Danish government for more funds, the students noted that young artists would be guided by teachers they themselves chose and that these teachers would not take any fees. Strangely enough, the state, without consulting the Royal Academy, granted the funds immediately. The conservative Danish government thus opposed the state's own art school.

For several decades, Danish art life was to be stimulated by this duel between the academies—the royal versus the "free," which was soon named the Artists' Study School. It was undeniably the latter school which guided developments, for although the teachers (including Laurits Tuxen, Peder Severin Krøyer, and Kristian Zahrtmann) taught the same basic methods they themselves had been taught at the Royal Academy, they kept away from the outmoded demands of the old tradition. And yet, because opposition to the establishment also came from the least expected quarter—from the government itself—the fight never became rancorous, and the atmosphere in the Danish art world was never poisoned as much as it was in Sweden and especially in Norway.

There was no academy of fine arts in Norway at the time. Instead, the art world there centered around the art societies, above all the Christiania Art Association (Oslo was called Christiania until 1924). Founded in 1836 "to work, with combined private forces, to awaken a feeling for art," the association was controlled by wealthy dilettantes whose taste was often conspicuously reactionary. In the beginning it bought mostly German works to be raffled out among its members. Gradually, it went so far as to patronize Norwegian artists, but they had to have been trained in Germany. As long as young artists were faithful to German ideals, their discontent with their homeland's art establishment remained within tolerable bounds. Although they grumbled about the amateurish choice of raffle prizes, they did not call any basic principles into question.

Things changed when Norwegian artists began to look more toward Paris. In 1878 and '80, the art association refused good canvases by young painters trained in France, while it bought very bad, amateur works in German style. One particular 1880 rejection, the refusal of a work painted by Nils Gustav Wentzel (a young artist believed by his peers to show considerable promise), caused an uproar, and demands were made that the association's affairs be put under public control. "Purchases could well have their faults," the association's chairman conceded, "but they often involved things which an outsider could not know. It was incidentally a mistake when artists demanded that their paintings be judged by artists, since the association was private, and only members could decide things here. Artists could really not come here and make demands."[5]

Erik Werenskiold, one of the leading young painters, called on all Norwegian artists to revolt. Writing in one of Christiania's morning newspapers, he spoke of the bitter feelings among his comrades. "This is the same bitterness which makes those who live at home only long to get out,"

he said, "while those who are abroad pray to God to deliver them from ever having to live here at home."[6] A short time later, Werenskiold suggested openly that a jury consisting of three painters and three sculptors be formed to decide on the purchases of works for the art association's raffle. Many artists promised to sever their connections with the association unless it accepted his proposal, and when the association refused to capitulate, a strike broke out. The conflict took on a decided political character, with conservative papers extolling the old artists trained in Düsseldorf in the 1840s and '50s, and the liberal press supporting the "opponents" schooled in Munich and Paris.

When the art association finally yielded in 1882, its capitulation spelled the beginning of the end of its private existence. That same year, the young artists organized their first Autumn Exhibition, which told the amazed residents of Christiania what modern art had to say. Paul Gauguin's brother-in-law, the noted painter Fritz Thaulow, described it this way: "We plundered the rooms of rich friends for lovely woven carpets, cases, and other objets d'art, and changed our first exhibition into an elegant salon. We got an engine which produced electric light and a big deficit in our finances. But it was a glorious beginning which awakened a great deal of anger and which held great significance for the future."[7] Two years later, the Artists' Autumn Exhibition was rechristened the Annual State Art Exhibition and received its own facilities and state funds. As the Norwegian art historian Jens Thiis subsequently noted, "The official recognition of the Autumn Exhibitions was a step in the organization of [the] art world with completely democratic self-government, implemented at the same time as parliamentary popular government was carried through in . . . politics."[8]

Whereas the young Danes had rebelled against overly oppressive national bonds and directed their interests to the goals of modern French painting, events in Norway had moved in exactly the opposite direction. Driven off by the dilettante-led art association, most Norwegian artists had lived abroad since the beginning of the nineteenth century. But while they expressed disgust over conditions in Norway, they cherished a love for their homeland. As the most progressive element of their preindustrial society, Norway's intellectuals also felt a certain responsibility. Radical authors and artists, above all, believed that the country's union with Sweden was unsupportable, and this kept their patriotism strong and alive, eventually driving them home. Knowing that they could not live by their art under prevailing conditions, they carried out their revolution with fanaticism, changing conditions profoundly and making an end to the exile of Norwegian art. In 1882, practically the entire Norwegian artists' colony returned home. The artists had won.

Meanwhile, the artists' revolution was breaking out in Finland. A Pan-Russian art exhibition was to be held in Moscow in 1882, and the board of the Finnish Fine Arts Association (dominated, as in Christiania, by dilettantes) had been invited to choose the works for the Finnish section. Artists in Finland had their own organization, the Artists' Association, and they resented being put under the dilettantes' authority in a matter they felt better qualified to handle themselves. The Artists' Association forbade its members to participate in any exhibition organized by the Fine Arts Association, and held its own exhibition that October, the month the Fine Arts Association held its usual autumn exhibition. Locked in a struggle to determine who would control the country's arts policy, the two organizations fought for another twenty-one years.

Although outwardly the Artists' Association presented a united front, harmony was nowhere to be seen within it. A battle was being waged between reactionary and modern artists, and it was complicated by tension between cosmopolitan academicism and Finnophilic nationalism. Finnish national feeling had intensified gradually during the language debates

(between those who spoke Finnish and those who spoke Swedish) that had begun in the early 1860s. Although Swedo-Finn, Western-oriented cultural policies continued to dominate into the 1870s, Finnophiles claimed that Finnish culture could compete with any other and attempted to show that Finnish artists compared favorably with renowned French and German artists. They followed the career of the young, unusually promising Albert Edelfelt with intense national enthusiasm, even though he treated his purely Finnish motifs with the light elegance of French *plein-air* painting.

Beginning in the 1880s, a few younger artists, most notably Axel Gallén (later known as Akseli Gallen-Kallela), tried to keep continental ideals from showing in Finnish motifs by adapting French Naturalism to the poorest Finnish subjects in what was at times a nearly repugnant manner. For the Finns, as for the Norwegians, Naturalism became a means of discovering their own land. They found that the ugliest Finnish motif was more inspiring than Parisian themes, which were cherished so much by the detested Swedes.

In the external battle between the Artists' Association and the Fine Arts Association, Albert Edelfelt played the arbitrator's role with diplomatic virtuosity. But in the struggles within the Artists' Association, he remained uncompromisingly, though without animosity, on the side of the radical Finnophiles. When Edelfelt was appointed chairman of the Fine Arts Association in 1903, the Artists' Association's and the Finnophiles' victories were sealed.

Young artists in Sweden had watched the developments in Finland, Norway, and Denmark with interest, but they tarried a bit in making their own revolution. They lacked the overpowering conviction of the Norwegian artists, who had had to fight for the very existence of Norwegian art in Norway. Instead of defining the era, their revolution was a sign of the times: inspired by the prevailing disdain for authority, they rebelled against the older generation.

The young Swedes' professed disgust for reactionism's stronghold—the Royal Academy of Fine Arts in Stockholm—may, in fact, have been partly feigned. Many of the young artists who later became revolutionaries began their careers on good terms with the academy and remained in contact with its leading teachers long after moving to Paris. If we compare their work from their time at the academy with their work from their first years in the French capital, it seems that their instruction in Sweden had been good, or in any case better than they admitted a few years later in their anti-academic propaganda. That they adapted so easily to the prevailing ideal shows that they had mastered the elementary skills of painting.

But even if they kept to the *juste-milieu* ideal, with Jules Bastien-Lepage as their guide and without daring to go to the extremes of the radical Frenchmen, young Swedes in Paris considered themselves the radical reformers of Swedish painting. Unlike the Finnish and Norwegian radicals (and like the Danes), the young Swedes were originally anti-national. Rome had been their Mecca until 1848, and between 1850 and 1865 nearly all of them had gone to Düsseldorf or Munich. When Bismarck's armies attacked Denmark in 1864, the Swedish King Karl XV, who himself painted in Düsseldorf style, called on his fellow artists to break off all contacts with Germany and study in Paris, where Napoleon III, his mother's second cousin, was emperor. Under Karl's successor, his brother Oscar II, conditions in the Swedish art world degenerated drastically, and the slow but steady invasion of France by Swedish artists gained momentum in the mid-1870s. As one of them wrote, the young revolutionaries wanted to get "away from the land of barbarians. Away from ice and snow. Away from all coarse excesses. Away from [them] selves." And so they went off to Paris, firmly convinced that Sweden was a "country without motifs"—a land of hard, unharmonious colors.

Yet as the winds of nationalism swept over Europe in the mid-1880s, even Swedish artists were gripped by an irresistible longing for home. Carl Larsson, who had been living for several

years among the Swedish and American artists in the little village of Grèz-sur-Loing at the edge of the Fontainebleau Forest, expressed the innermost feelings of many Swedes in France when he wrote, ''Why in the name of turquoise not paint Swedish landscapes direct in Sweden?''[9] In 1885 Larsson became one of the first to return home for good, and two years later one of his friends, Richard Bergh, gave in a letter something for the Swedes still in Paris to think about: ''We must take our French gloves off,'' he wrote, ''and get into our 'peau-de-Suède.' ''[10]

Of course the returning Paris-trained Swedes were not exactly welcomed with open arms. The Royal Academy of Fine Arts, which had just gotten a thoroughly reactionary new director, was quite capable of blacklisting them. Since the artists on the acquisitions committee at Stockholm's National Museum had been appointed by the academy, the museum bought almost none of the radicals' work. And when the academy itself discontinued its regular exhibitions, the sale of works brought home to Sweden became even more restricted. Theoretically, there was still the Stockholm Art Association to sell to, but its chairman was also the president of the academy.

In 1884 the Paris-trained artists began a series of press attacks against the academy. The articles that attracted the most attention were written by Ernst Josephson, leader of the Swedish painters in Paris. Condemning the whole academic system of education, Josephson wrote, ''the academy, as it now stands, is actually just a large and costly show which works against the spirit of the times and true artistic developments.''[11] Among the reforms he proposed were allowing pupils to choose their own teachers (along Danish and French lines), appointing teachers for only three years, and awarding grants on the recommendations of a special jury made up of academy members and their opponents.

Josephson later put his demands in a letter to the academy and collected the signatures of eighty-four Swedish artists living in Paris, Rome, London, and Düsseldorf. Although the letter contained the threat of a strike, the academy refused to enter into any discussion and referred the opponents to the Swedish government if they wished to continue the struggle.

While they were awaiting a reply from the government, the Paris-trained Swedes took their case to the public, opening an exhibition entitled *From the Banks of the Seine* in Stockholm on April 1, 1885. Although the exhibition was an enormous success with both the public and press, the academy-controlled Stockholm Art Association demonstrated the power of tradition by mounting its own equally successful exhibition that August in celebration of its 150th anniversary. Unable to rest, the opponents opened their second exhibition six weeks later. This exhibition, containing contributions by all the artists who had signed Josephson's letter of protest, was also a hit.

The following summer, at a large meeting of Scandinavian artists in Gothenburg, word came that the government had rejected the young Swedes' demands. Expecting such news, the Swedish artists hastened to proclaim the founding of a socialist-style union they had been planning since the first of the year. Named the Artists' Union, the new organization was ''to work against all outmodedness that can be considered harmful, and to seek to carry out all reforms that can be considered to serve Swedish . . . and industrial art.''[12] Since exhibitions were believed to be the most effective means of achieving results, the union decided to hold its first showing that very autumn in Stockholm.

As the conflict between the radicals and the reactionaries evolved into stalemate, the Artists' Union found itself unable to fulfill its original goal of uniting all Swedish artists outside the academy's camp. Animosity and intrigue, as well as a longing for peace in which to work, led artists from both camps to create a third organization called the Swedish Artists' Association. Although its ''nonpartisanship'' made it too weak to look after its members' interests in the battle between the two parties, the new association served to isolate the Artists' Union. The

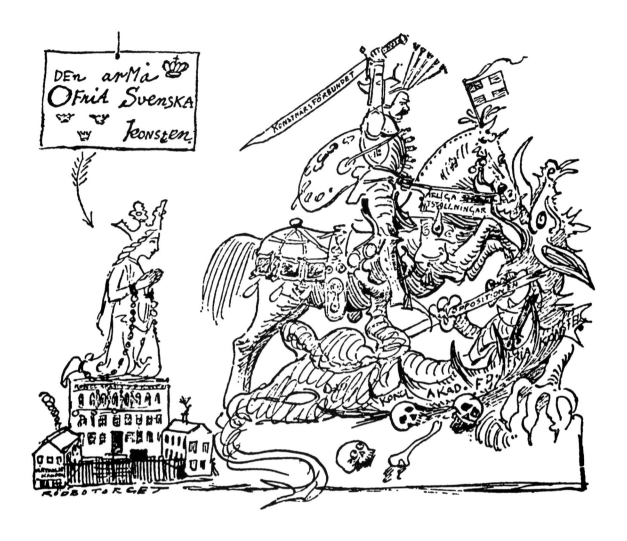

Carl Larsson's cartoon of "St. George and the Dragon" appeared in the catalogue to the Swedish Artists' Union's 1886 exhibition. Parodying a famous Stockholm sculpture carved by the fifteenth-century German artist Berndt Notke, it shows the buildings of the Royal Academy of Fine Arts on the left surmounted by a woman representing "Swedish art still deprived of liberty." Brandishing the sword of the union and carrying a palette on his back, "St. George" attacks the dragon of the academy, who has already been speared by a lance labeled "opposition." (From "Complexité et Importance des Contacts des Peintres Nordiques avec L'impressionisme," by Henri Usselmann)

association's refusal to be co-opted led the union to forbid its members to take part in it, and this in turn led many opponents who were tired of the union's authoritarian language to leave it one after another. Instead of being, or trying to be, a broad-based professional interest group, the union became a very left-wing band intent on seizing power.

Ironically, there were no longer any artistic grounds for enmity. Most Swedish artists now favored painting wide, unpopulated landscapes bathed in quiet, solemn twilight—images that were intended to stand for each artist's own personal Sweden. Standing before these lofty depictions of untamed but self-possessed Swedish landscapes, the unknowing viewer of a later age couldn't possibly suspect that they were painted in a period of constant, bitter dissent in Swedish art.

But even though the Artists' Union's National Romantic ideal had triumphed, it would be many years before the union would be able to effect any tangible policy reforms. It took until the turn of the century for the Royal Academy of Fine Arts to appoint professors who adopted the radical new principles of education and belonged to the union, and even then there was no true conciliation. Peace was not made until 1913, when a joint exhibition was held in the academy's rooms. That same year, Richard Bergh, one of the union's leading members, was appointed advisor to the head of the National Museum, and was thus singled out as his successor when the old man retired two years later.

The Artists' Union had fought hard for more than a quarter of a century to reach these goals, but in the end its victory was more a matter of compromise than of confrontation. The union and the academy had gained a common enemy in the very young and aggressive generation that had studied at the union's school only to leave it in order to avoid being suffocated by its authoritarianism. These young artists had moved to Paris, where they wanted to get into Matisse's school and learn to express the *joie de vivre* that was banned by the National Romantic, serious-minded members of the Artists' Union. The time was thus ripe for a cease-fire between the now mature "opponents" and their academy rivals. Like Caiaphas and Pontius Pilate, they had become friends for the moment.

1 August Strindberg, *The Red Room* (Stockholm, 1879).
2 Carl Hill to his mother, autumn 1876.
3 Georg Brandes, *Berlin* (Copenhagen, 1885).
4 Carl Larsson to an unknown correspondent, 1882.
5 Minutes of the general assembly of the Christiania Art Association, 1881.
6 Erik Werenskold, article in the Christiania newspaper *Morgenbladet*, 1880.
7 Fritz Thaulow to Jens Thiis. Quoted in Jens Thiis, *Norske Malere og Billedhuggere, 2* (Bergen, 1907).
8 Jens Thiis, *op cit.*
9 Carl Larsson to an unknown correspondent, May 23, 1884.
10 Richard Bergh to the Swedish painter Georg Pauli, summer 1887.
11 Ernst Josephson, article in the Stockholm newspaper *Dagen Nyheter,* November 29, 1884.
12 Programme of the Artists' Union, 1886.

Patronage and Patrimony

Tone Skedsmo
Curator
of Paintings
Nasjonalgalleriet
Oslo

ONE of the major reasons that late nineteenth-century Scandinavian painting is so little-known outside Scandinavia is that so few of the major paintings of this period have ever left their homeland. The great masterworks of turn-of-the-century Scandinavian art—even those of artists like Edvard Munch who were internationally admired in their day—are to be found without exception in Scandinavia itself, and primarily in public collections there. This centralization, which in the long run has served to restrict a wider appreciation of Nordic painting, owes its existence to a particularly devoted and patriotic group of collectors who dominated the Scandinavian art scene at the turn of the century. Many of the most important paintings in this book come from the collections these men formed, and their lives and patterns of acquisition are central subjects of interest for anyone concerned with the conditions that shaped this exceptionally rich period in Nordic cultural life.

In Scandinavia, as elsewhere in Europe, the traditional patriarchal relationship between sovereign and artist had come to an end by the late nineteenth century. Since the established art institutions, centers of "official" art life, resisted the ideas of the new generation, the artists of this generation were desperately in need of patrons. Beginning in the 1880s, at approximately the same time as Scandinavian Naturalist painting broke away from the mid-century German-dominated style—and from the average taste of the public—there arose to meet this need a new type of art collector, one who became more influential than earlier collectors had been.

For this new generation of collectors, interest in the work of art was not limited to connoisseurship, nor was the collection seen as an end in itself. Typically, these new collectors felt, for varying reasons, a deep interest in the plight of the innovative artists of their time. As well as buying the new works and helping to support the artists, they strove with the artists for a better public understanding of the art and of the artists' conditions. Each of the patrons discussed here, at some point in his collecting career, decided that his collection should be made public property. Thus their collections, formed under circumstances in which the artists were pleased to sell them their best works, became part of the national heritage, or patrimony, of the individual countries—in most cases during the collector's lifetime.

Although this was not unrelated to European, and particularly German, patterns of collecting, the Scandinavian collectors played a greater part in the art life of their time than did many of their counterparts on the continent. During a period of change, unrest, and controversy, they took a positive stand with the artists in their struggle against the established institutions—be they academies, museums, or critics. Although the issues and problems varied somewhat from country to country, dissatisfaction with existing institutions was common to them all, and in each country the new patrons not only supported the progressive artists but also created new public institutions based on their work. While the patron-collectors discussed here are far from being the only ones in their respective countries, they are good examples of the kind of courageous collecting and patronage that characterized this period in Scandinavian art history.

In Denmark, two collectors, Heinrich Hirschsprung and Wilhelm Hansen, stand out as the major patrons of the young artists who rebelled against the country's conservative Royal Academy of Fine Arts (the issues involved in the artists' revolution in Denmark and the other Nordic countries are discussed by Bo Lindwall beginning on page 35). At a time when public museums would not even consider acquiring works by these young Danish artists, the purchases of Hirschsprung and Hansen were of invaluable importance.

Born in Copenhagen in 1836, Heinrich Hirschsprung got into collecting at an early age, using profits from the family tobacco business that he and his brother took over from their father in 1858. After his marriage to Pauline Elisabeth Jacobson in 1864, Hirschsprung's home became a

Peder Severin Krøyer
Portrait of the Hirschsprung Family 1891
Oil on canvas, 108.0 × 128.0 cm. (42½ × 50⅜ in.)
Collection: Den Hirschsprungske Samling, Copenhagen

meeting place for artists, authors, actors, and musicians. Advised by the painters Wilhelm Marstrand and Constantin Hansen and by the art historian Julius Lange, Hirschsprung began to buy works by artists his own age: Carl Bloch, Christen Dalsgaard, Julius Exner, Wilhelm Kyhn, and Gottfed Rump. To these he soon added paintings by artists of Denmark's so-called Golden Age (the first half of the nineteenth century). Included were works by Marstrand, Hansen, Christoffer Vilhelm Eckersberg, Christen Købke, Johan Thomas Lundbye, Jørgen Roed, and Peter Christian Skovgaard.

It was through his friendship with the young painter Peder Severin Krøyer, whom he met in 1874 and whose travels in France and Spain from 1877 to 1881 he financed, that Hirschsprung first became interested in the new generation of embattled Danish artists. With the aim of showing their development by buying paintings from the different stages of their careers, he

collected the works of such young artists as Anna and Michael Ancher, Vilhelm Hammershøi, Julius Paulsen, Theodor Philipsen, Laurits Andersen Ring, Joakim Skovgaard, Kristian Zahrtmann, and—on the advice of the art historian Emil Hannover—Johannes Larsen, Fritz Syberg, and Jens Ferdinand Willumsen.

Although Hirschsprung's original intention had been to furnish his home with art to please himself, his family, and his friends, the idea of establishing a museum gradually emerged. In 1902 Hirschsprung and his wife donated their collection to the Danish government with the condition that it remain undivided and that a public museum be built to house it. Under construction when Hirschsprung died in 1908, the museum opened in Copenhagen in 1911. With six hundred paintings, two thousand watercolors, pastels, and drawings, and two hundred statuettes, it provides a compact and highly representative selection of Danish art from 1800 to 1910. Three of the paintings in the museum are documented in this book: works by Ludvig Find (cat. no. 16), Peder Severin Krøyer (cat. no. 57), and Ejnar Nielsen (cat. no. 70).

Seven years after the opening of the Hirschsprung Collection, Wilhelm Hansen inaugurated Ordrupgaard, a huge Copenhagen estate that housed his impressive collections of Danish and French art. This private showplace, which was built for Hansen by the architect Gotfred Tvede, was open to the public once a week.

A fifty-year-old insurance magnate, Hansen had begun collecting Danish art in the 1890s with the purchase of a few paintings by the young artists Viggo Johansen, Vilhelm Hammershøi, and Joakim Skovgaard—choices that indicated the future character of his collection. By the time he moved to Ordrupgaard in 1918, he had 140 works by twenty-four Danish artists. While the older Danish school was amply represented by such painters as Eckersberg and his students Købke, Roed, and Marstrand, the collection's greatest strength lay in the works of such younger artists as Skovgaard, Peter Hansen, and Theodor Philipsen. One of Hansen's Danish acquisitions—a painting by Hammershøi—is included in the catalogue section (no. 29).

Assisted by the Frenchman Theodore Duret, Hansen had been collecting French art since 1916. In 1918, six months before the opening of Ordrupgaard, he formed a consortium for the purchase and sale of French works with Herman Heilbruth and the Winkel and Magnussen auction firm. When Hansen died in 1936, his widow turned over to the state not only a splendid collection of Danish art but also an extraordinarily valuable collection of modern French art that included outstanding pieces by Manet, Degas, Renoir, Cézanne, and Monet. In 1938, the public gained full-time, permanent access to these treasures.

Not all of the new Scandinavian collectors were as acquisitive as Hansen and Hirschsprung. When the Finnish patron Herman Frithiof Antell died in Paris in 1893 at the age of forty-six, he had only forty paintings, twenty-eight sculptures, and ten prints and drawings.

Through his will, however, Antell made a major contribution to modern Finnish art. His estate helped fund Finland's National Museum, donated important works to the Finnish Art Society and the Society for Applied Art, and established scholarships as well as endowments for art, historical, and ethnographic collections at Helsinki University.

Antell had inherited his wealth from his father, who had promised to leave it to him if he went to college. He obtained a degree in medicine, but after his father's death in 1874 he gave up a practice as an eye specialist and moved to France. He began travelling, too, and during a visit to Stockholm met the Polish art dealer Henryk Bukowsky, who became his adviser in matters of collecting. In the beginning Antell concentrated on early and late seventeenth-century art, but later he came to favor such young Finnish painters as Gunnar Berndtson, Albert Edelfelt, Walter Runeberg, Johannes Takanen, Ville Vallgren, and Akseli Gallen-Kallela (see cat. no. 23), as well as such radical Swedish artists as Alfred Wahlberg, Allan Österlind, and Anders Zorn.

Antell was never as close to the Finnish radicals as were two other important Finnish collectors, Gustav Adolf Serlachius and his nephew Gösta Serlachius. The owner of a pulp mill in Mänttä, Gustav Serlachius was something of a father figure to Akseli Gallen-Kallela, Albert Edelfelt, and Emil Wikström. He was particularly fond of Gallen-Kallela, and understood well the national significance of his art. From 1888 until his death in 1901, Serlachius carried on a correspondence with the artist, frequently apologizing for a lack of knowledge about art but expressing himself briskly about the art business and criticizing sharply the current critics and taste. Although he bought only three works by Gallen-Kallela—portraits of himself (1887), his daughter Sissi (1889), and his wife Alice (1896)—he gave the painter constant financial support.

Serlachius's nephew became his son-in-law when Gösta married Sissi in 1899, and when Gustav died two years later Gösta took over the Mänttä mill and continued his uncle's patronizing of the arts. In addition to Gallen-Kallela and Emil Wikström, who remained close to the family, Gösta counted Hannes Autere, Alvar Cawén, Marcus Collin, and Lennart Segerstråle among his artist friends. Unlike his uncle, who was more of a patron than a collector, he bought many works from the artists he supported. And like Antell, he also acquired foreign art, both old and new.

Advised by such art experts as Bertel Hintze of Finland and Louis Richter and Tancred Borenius of England, Serlachius put together an impressive enough collection to open a Fine Arts Foundation in Mänttä in 1933. Housed in Joenniémi Manor, an estate designed for Serlachius by Jarl Eklund, the Foundation has more than five hundred works of Finnish and foreign art, including seventeenth-century Flemish paintings and works by Italian and Spanish masters of the Rennaisance and Baroque periods. The collection's greatest strength is in nineteenth- and twentieth-century Finnish art; of special interest are eighty works by Gallen-Kallela (including cat. nos. 21 and 22) that show that artist's development from 1883 to 1925.

The highly personal approach to collecting taken by the Serlachius family was also common to the new collectors in Sweden. But the Swedish patrons not only aided the individual efforts of the young Swedish artists, they supported their organization, the Artists' Union, as well.

It was to Pontus Fürstenberg, a wholesale dealer's son who married into wealth, that the Swedish radicals first turned when they began coming home from France. Fürstenberg had become acquainted with the Paris-trained Swedes at a meeting of Scandinavian artists in Gothenburg in 1881. He lived in Gothenburg, and during the several subsequent artists' meetings that took place there during the 1880s, his home became the radicals' refuge. He also travelled to France every year, visiting Paris, where Hugo Birger became his protégé, and Grèz-sur-Loing, where many Scandinavian and American artists worked. When the painters from the Swedish colony in Paris held their pioneering exhibition in Stockholm in 1885, he bought up many of their works and installed them in the first two halls of his gallery, which he opened to the public that year.

After the founding of the Artists' Union in Gothenburg in 1886, Fürstenberg helped turn the city into a testing ground for the union's ideas. He supported the construction of a building for the Gothenburg Museum's Painting and Drawing School and managed to get Carl Larsson appointed as a teacher there so that Larsson could practice the radical educational principles the union was fighting for. Likewise, the commissions that he gave Larsson, George Pauli, and Carl Wilhemsen for murals in Gothenburg's public institutions led to a flourishing of decorative art throughout Sweden.

Fürstenberg left his entire collection and the gallery in which it was housed to the Gothenburg Museum (see cat. nos. 5, 13, and 61 for three of the works he left). Unfortunately, in 1922 the museum moved all 260 of Fürstenberg's Swedish and foreign works to the museum's own building, and the gallery Fürstenberg had built was abandoned.

Askseli Gallen-Kallela
Portrait of Gustav Adolf Serlachius 1887
Oil on canvas, 77.5 × 57.5 cm. (30½ × 22⅝ in.)
Gösta Serlachiusksen Taidesäätiön Kokölmat,
Mänttä

Carl Larsson
Interior of the Fürstenberg Gallery 1885
Interior fran Fürstensbergska galleriet
Oil on canvas, 78.0 × 56.5 cm. (30¾ × 22¼ in.)
Collection: Göteborgs Konstmuseum
Pontus Fürstenberg is seated in the foreground.

While the Gothenburg Museum provides a good survey of modern Swedish art up to 1900, the Thiel Gallery in Stockholm takes up where Fürstenberg's collection leaves off. Formed by the financier Ernest Thiel in the early years of this century, the gallery's holdings show a later stage in many of the same artists' development.

Born in Norrköping in 1859, Thiel moved with his family to Stockholm in 1867 and at fifteen was sent to Germany to be trained as a banker and businessman. Returning to Sweden, he became firmly established in the world of Swedish finance before he was thirty. He married Anna Josephson, sister of the well-known publisher Karl Otto Bonnier, in 1884, and at his brother-in-law's home he met the famous Swedish artists and writers of the 1890s.

Then, suddenly, in 1897, Thiel's life totally changed. He fell in love with his wife's lady-in-waiting, Signe Hansen, was divorced, and remarried. The scandal cost him his acquaintances, but he kept his fortune.

Signe had a good knowledge of art and may have encouraged Thiel to begin collecting. When they married, he had only three of the paintings now in the collection: Anders Zorn's portraits of

Edvard Munch
Portrait of Ernest Thiel 1907
Oil on canvas, 191.0 × 107.0 cm.
(75¼ × 42⅛ in.)
Collection: Thielska Galleriet, Stockholm

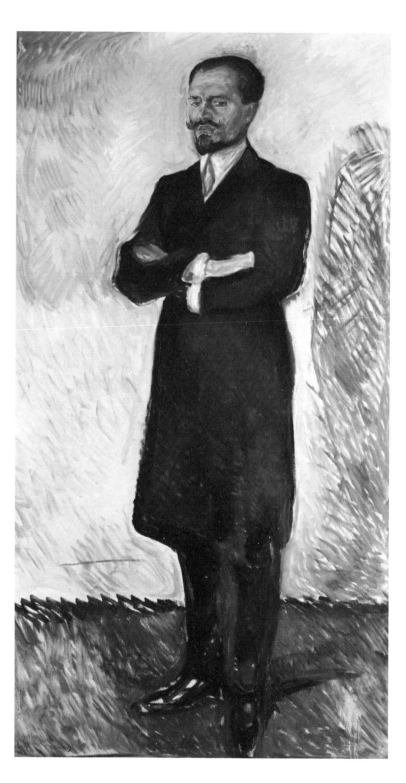

his parents, painted in 1890, and a landscape called *Dawn* completed by Bruno Liljefors in 1896. After the couple moved to Strandvägen, however, he bought a few paintings to decorate their home, and in 1901 he began to collect in earnest by spending 19,000 Swedish kroner at the Artists' Union exhibition. The following year, when he purchased nineteen more works by Liljefors, he became known as *the* patron.

Taking Fürstenberg as his model, Thiel felt it his duty to collect all the Artists' Union art he could lay his hands on. The walls in his house soon grew crowded, and in 1904 he bought a lot in Stockholm and commissioned the architect Ferdinand Boberg to design a residence that would be a "home decorated with paintings on all the walls; it should be homely, I want to *live* there." Ready the next year, the house quickly became the center of a flourishing social life for the Thiels and their artist friends. Its walls, too, were soon crowded, and in 1907 a new wing was added.

As suddenly as before, Thiel's life then took another turn. In 1908 his business began to fail; he and Signe were separated in 1910, and she died in 1915. Although he continued to live in his gallery, which he opened to the public on certain days beginning in 1909, he lost most of his fortune during World War I and went bankrupt in 1922.

The state took over Thiel's gallery in 1924 for 1.5 million kroner, and in 1926 the collection was opened permanently to the public (an event that Thiel survived by twenty-one years). In addition to works by Thiel's Swedish friends J. A. G. Acke, Ivar Rosenius, Richard Bergh, Albert Engström, Gustav Fjaestad, Carl Larsson, Bruno Liljefors, Karl Nordström, Herman Norrman, Nils Kreuger, Anders Zorn, and Eugène Jansson (see cat. nos. 40 and 42), the collection contains paintings by such other Scandinavian artists as Edvard Munch, Thorvald Erichsen, Viggo Johansen, and Vilhelm Hammershøi (see cat. no. 30). In the park that surrounds the gallery there are works by Auguste Rodin and the Norwegian sculptor Gustav Vigeland.

Losing his collection was not something that the third major patron of the radical Swedish artists, Prins Eugen, had to worry about. As the son of King Oscar II and Queen Sophia, Eugen was in quite a different position than any other new collector in Scandinavia.

Yet in supporting the Artists' Union, the "red prince," as he was called, was risking the wrath of his father, who had driven most of the young Swedish artists to France with his conservative cultural policies. Although he was a painter like his uncle King Karl XV, it would have been too radical a gesture for him to have actually joined the union. It was already a striking commitment that he advocated the union's program and bought its members' work.

Eugen made his first acquisition, a winter landscape by Karl Nordström, in 1889. But it wasn't until 1905, when he moved into Waldemarsudde, a home built for him by Ferdinand Boberg, that he really started collecting. Although he bought mostly from his union friends Bergh, Jansson, Kreuger, Larsson, Liljefors, Norrman, Zorn, Carl Hill, Ernst Josephson, and Hanna and George Pauli, the prince collected works by the Academicists and by the next generation of Swedish artists as well. To accommodate his growing collection, which also included Norwegian and French art, he designed a new wing for Waldemarsudde in 1913 and added more space in 1945.

Prins Eugen died in 1947, leaving Waldemarsudde and all its art to the government. In 1948, the estate was opened to the public, and today one can study in its halls and galleries not only Swedish art from the turn of the century but also the eight hundred paintings that constitute the prince's lifework. Three Waldemarsudde acquisitions—works by Bergh, Jansson, and Nordström—are documented in this book (see cat. nos. 4, 38, and 72).

Unlike their counterparts in Sweden, the new collectors in Norway were not involved in the initial stages of their country's artists' revolution. By the time Olaf Schou and Rasmus Meyer, the two major collectors of modern Norwegian art, arrived on the scene, the Norwegian radicals had

already triumphed against the dilettante-led Christiania Art Association and had obtained state recognition and funds for their annual Autumn Exhibitions.

Still, the young Norwegians were indebted to Schou and Meyer for finding their work a permanent public home. Aware that the country's museums were not fulfilling their obligations, these collectors won for the new art the recognition it had proven it deserved.

Schou, who is responsible for the oustanding collection of modern Norwegian art in Oslo's National Gallery, was the son of one of nineteenth-century Norway's captains of industry and grew up in a highly cultured and liberal home. Although he took over the family brewery and textile factories with his brothers in 1883 at the age of twenty-two, he never participated in running the business. Instead, he wanted to become a painter, and in the winter of 1883-84 he started his artistic education in Berlin under the famous Norwegian artist Hans Gude. But illness cut short his studies, and in constant poor health he lived at home with his mother until 1913, when he left Norway for Switzerland. He died in Neuilly outside Paris in 1925.

Realizing that he would never become an artist himself, Schou chose to devote his time, strength, and money to helping those who were. In addition to collecting, he gave yearly stipends, or "private grants" as he called them, to such young Norwegian artists as Harriet Backer, Theodor Kittelsen, Nikolai Astrup, Emanuel Vigeland, Harald Sohlberg, and Edvard Munch. Although he was close friends with many Norwegian painters, including Backer, Kitty Kielland, Gerhard Munthe, and Eilif Peterssen, his support was never based merely on friendship. "A 'private grant,' " he wrote, "must never be regarded as 'personal support.' Of course this does not stop me from following the person whose art I support. The person and the artist cannot be separated—if the person is no good, then in a while this will in some way influence his art."[1]

With no apparent interest in building his own collection, Schou began giving paintings to the National Gallery in 1888. Around 1900 he decided that he would eventually give all his paintings to the gallery, and when word leaked out that he intended to make sure the museum obtained a representative collection of modern Norwegian art, Munch, Backer, and others gladly began selling him their best efforts.

The collection that Schou finally gave to the National Gallery in 1909 included 117 examples of both old and new Norwegian art as well as a few foreign paintings. In addition to giving a good understanding of Munch's early work (for an example, see cat. no. 69), it provides an excellent survey of the painting of such Naturalists and new Romanticists as Backer, Kittelsen, Munthe, Peterssen, Hans Heyerdahl, Thorlof Holmboe, Sven Jørgensen, Amaldus Nielsen, Christian Skredsvig, Fritz Thaulow, Gustav Wentzel, Erik Werenskiold, and Oda and Christian Krohg (see cat. no. 52). Although Schou felt that many of the youngest Norwegian artists lacked the necessary training, there are also works by Thorvald Erichsen, Alfred Hauge, Arne Kavli, Henrik Lund, Anders Svarstad, Oluf Wold-Torne, Otto Hennig, Harald Sohlberg, and Halfdan Strøm.

Schou's collection gave the National Gallery's new director, Jens Thiis, a solid base on which to build. Thanks to an endowment that Schou set up before his death in 1925, the museum has made many more important acquisitions of modern Norwegian painting throughout the years.

The other outstanding public collection of Norwegian art from the turn of the century is in Bergen. Put together between 1903 and 1915 by Rasmus Meyer, heir to the largest lumber mill in Scandinavia, it includes more than 550 paintings and watercolors as well as four hundred prints and drawings.

Meyer took his initial inspiration in collecting from the Danish patron Heinrich Hirschsprung. When Hirschsprung and his wife donated their collection to the public in 1902, Meyer saw the collection—and H. B. Storck's plan for a building to house it—at an exhibition in the Charlottenborg palace in Copenhagen. Impressed by its historical breadth, he decided to

follow Hirschsprung's advice and acquire a good cross-section of Norwegian painting. "My intention," he wrote, "is to build an art gallery like the Hirschsprung in Copenhagen—on a smaller scale—that will show the development of Norwegian art in the nineteenth and twentieth century."[2] With this in mind, he acquired works by Munthe, Nielsen, Gude, and Johan Christian Dahl in 1903, and made a large purchase of older Norwegian art at the 1905 estate auction of the Bergen collector Annanias Dekke.

Realizing that he lacked a thorough knowledge of art, Meyer turned for expert advice to Erik Werenskiold, the painter who more than any other had led the successful strike against the Christiania Art Association in the early 1880s. At Werenskiold's urging, he bought paintings by such members of Werenskiold's generation as Peterssen, Skredsvig, Kielland, and Backer, and such members of the younger generation as Erichsen, Wold-Torne, Severin Grande, Jean Heiberg, Axel Revold, Einar Sandberg, Lars Jorde, Henrick Sorensen, and Dagfin Werenskiold.

Meyer didn't always follow Erik Werenskiold's advice, however. He was particularly fond of Munch (see cat. no. 62), whom Werenskiold found a bit too radical, and he also bought from such young Impressionists as Arne Kavli, Ludvig Karsten, Soren Onsager, and Anders Svarstad, as well as from their moral supporters Hans Heyerdahl and Christian Krohg (see cat. no. 54).

The year 1909 was an exciting, and in many ways decisive, one for Meyer. In keen competition with Olaf Schou and the National Gallery he made his biggest Munch acquisitions, and in order to accommodate his growing collection he decided to build a gallery. The idea of combining a gallery and home especially appealed to Meyer: he was only fifty-one, and such an arrangement would allow him to enjoy his paintings as long as he lived while at the same time making them available to the public. Interested in how the Swedish patron Ernest Thiel had accomplished this, he visited the Thiel Gallery in Stockholm and jotted down twenty pages of detailed information.

From then on, Thiel became Meyer's ideal. In Thiel's collection he saw a pattern which inspired him to continue buying the newest Norwegian art, and in 1910 and '11 he gave up the idea of making a survey of the whole of Norwegian art history, regretting that he had ever followed Hirschsprung's example. All he wanted now was a *galerie des perles*.

Meyer was never able to realize his plans for a building to house his collection: he died in 1916 at the age of fifty-eight. Although he had failed to deal with his collection in his will, his heirs gave it to the city of Bergen with the condition that it be kept separate from others, be open to the public, and carry the name of Rasmus Meyer. In 1924, the Bergen Picture Gallery, which had taken on the task of administering the collection, opened the building that Meyer had dreamed of.

1 Olaf Schou to his close friend, the pianist Halfdan Cleve, November 12, 1900, University Library, Oslo, letter collection no. 366.
2 Rasmus Meyer to his helper Rolf Thommessen, University Library, Oslo, letter collection no. 462.

Christian Krohg
Literary Historian and Critic Georg Brandes 1879
Literaturhistoriken og kritikeren Georg Brandes
Oil on canvas; 71.0 × 55.0 cm. (28 × 21⅝ in.)
Collection: Skagens Museum

Georg Brandes, Cultural Emissary

Sven Møller
Kristensen
*Doctor of Philosophy,
Professor
University of Copenhagen*

Among Scandinavian writers and artists of the decades around the turn of the century there existed a feeling of working together for common goals that had never been experienced before and has not been experienced since. This solidarity of purpose was due in no small part to the work of one man, the Danish critic Georg Brandes. By interpreting Southern European aesthetics for the Northern intelligentsia, Brandes became the main link between French Naturalism and Scandinavian Realism. Although he was primarily a literary critic, his insistence on the political nature of art and his emphasis of the symbolic content of Realism are reflected in the combination of Realist style, politics, and Symbolism that characterize Scandinavian painting of the period. A fervent character who believed in the power of thought to further the age's progressive ideas, he served as the constant conscience of Scandinavian literature and art. "It is criticism which moves mountains," he wrote, "all the mountains of belief in authority, prejudices, vapid power, and dead tradition."

Born Georg Cohen in Copenhagen in 1842, Brandes developed an early belief in activism by studying the objective idealism of Hegel and the existentialism of Hegel's opponent, Søren Kierkegaard. Although the positivists and the French philosophers Hippolyte Taine and Joseph Renan exerted an important influence on him, he found them too passive in their response to social and political developments. In contrast, the English philosopher and economist John Stuart Mill was a man after his own heart—both a thinker and a doer. After having gained personal insight on the subject through a liaison with an unhappily married woman, he translated Mill's *The Subjection of Women* into Danish in 1869.

At the University of Copenhagen in 1871 Brandes began a fight to awaken Denmark's stagnant cultural life by delivering a series of provocative lectures on the main currents in European literature from 1800 to 1848. Because he peppered his literary analysis with attacks on religion, marriage, and the double standard, as well as with praise of free thinking and free love, these lectures produced considerable outcry and indignation.

Although he was considered a social revolutionary, Brandes was not a socialist. Politically, he was actually a late adherent of early liberalism, a fighter for the ideas of the French revolutions of 1789 and 1848. Literature, he felt, should be concerned with something. It should describe current reality both realistically and truthfully, and serve as a vehicle for modern radical ideas. As yet unacquainted with the new French Naturalism, he held up as models Lord Byron and the militant French Romanticists Victor Hugo, George Sand, Honoré de Balzac, and Stendahl.

Through his lectures and writings, Brandes had a highly stimulating influence on the circle of young authors and scholars that gathered around him. He inspired the young August Strindberg and formed a close and lifelong friendship with Henrik Ibsen, who together with Bjørnstjerne Bjørnson took up realistic modern drama.

But the Danish public was furious, and the press was hostile, eventually closing its doors to him. Prevented from speaking out, and unable to live by his pen, he was forced to leave Denmark in 1877.

Settling in Berlin, Brandes worked unremittingly, writing articles for German and Scandinavian periodicals and newspapers, and publishing books about Ferdinand Lassalle, Benjamin Disraeli, and French Romanticism. Gradually, his name became widely known, not only in Germany but also in England and France.

Ever since his youth, Brandes had been an enthusiastic admirer of art, especially that of Greek antiquity and the Italian Renaissance. In Berlin he now saw modern paintings by the French Impressionists Claude Monet and Alfred Sisley, and became acquainted with such young artists as Max Klinger of Germany and Christian Krohg of Norway, who lived under the most poverty-stricken conditions in a place they called "Hunger Tower." He was particularly fond of

Klinger and wrote two major essays on his art in 1880 and 1897—practically his only writings about a non-literary artist.

Brandes became so popular in Germany that he could have remained permanently if he had wanted to. But at the exhortation of a group of prominent Danes, he returned to Copenhagen in 1883, resuming his lectures despite the conservative government's refusal to grant him a professorship.

After his return to Denmark, Brandes made regular visits to the artists' colony in Skagen, where he obviously felt at home. He wrote that in 1883 he was surrounded by four artists who wanted to paint him at the same time. Two of them—Peder Severin Krøyer and Michael Ancher—completed their portraits, while Elif Peterssen and Oscar Björck discarded their drafts. The country's young artists considered him an unprejudiced and kindred spirit, and he, in turn, had a high opinion of their art. "Where," he wrote in 1899, "does Germany have painters of the same age who surpass Krøyer, [Kristian] Zahrtmann, Viggo Johansen, [Michael] Ancher, [Vilhelm] Hammershøi, Joakim Skovgaard, or women painters like Anna Ancher and Agnes Slott-Møller?"

During the 1880s Brandes reached his prime as a critical authority, writing superb essays on the French Naturalist authors Gustave Flaubert, Guy de Maupassant, and the brothers Edmond and Jules Goncourt. His ideal was always a simple style like that of Maupassant or Prosper Mérimée, and although he had great respect for Émile Zola, he considered him a little heavy. Urging Scandinavian writers to avoid rare adjectives, he suggested that they search for significant details, "the characteristic features which make a figure or situation come alive." Above all, he felt that writers should be thinkers, abreast of the day's knowledge and philosophy and thus able to look critically at reality. "In our time in the North," he maintained, "all of the poetry which has healthy vitality in it will necessarily be socially critical. We are living at the moment in a period with an almost glaring contradiction between the theologico-pedagogico-political basic principles on which official society rests, and the world view which progressive minds have seized upon."

Brandes was still a target of public hostility, and during the debate on sexual morals that raged in Scandinavia in 1885 and '86, he came under fire for an article in which he called for open information on sex and described the sexual asceticism of unmarried women as "a miserable thing, an unnatural thing, a sacrifice that is often made to a worthless prejudice." Although this hardly sounds strong today, at the time it aroused considerable anger.

In order to occasionally escape such controversy, Brandes made periodic lecture tours to other countries, including the United States. He often visited Paris, which he considered the artistic center of the age, and formed special friendships there with the writer Anatole France and the statesman Georges Clemenceau. His *Impressions of Poland* and *Impressions of Russia* are based on observations made during several trips to those countries, where he lectured on Scandinavian and French literature in Warsaw, St. Petersburg, and Moscow. The Poles in particular welcomed him as something of a savior, and he in turn always cherished a special love for the Polish people, expressing it in the phrase "One loves Poland as one loves freedom."

In keeping with his liberalism, Brandes continued to encourage the efforts of great men, so long as they used their genius for the common good. Yet he grew increasingly despondent at seeing how the liberal citizenry betrayed its ideals and at how democratic social developments led not to an uplifting of culture but to domination by "mediocrities."

In such a state of mind Brandes came to read the writings of Friedrich Nietzsche, recognizing at once a like thinker. In his first letter to the German existentialist, he wrote that he was especially

Anna Ancher
The Girl in the Kitchen 1883-86
Pigen i køkkonet
Oil on canvas; 80.0 × 67.0 cm. (31½ × 26⅜ in.)
Collection: Den Hirschsprungske Samling, Copenhagen

in accord with Nietzsche's "profound disgust with democratic mediocrity, with your aristocratic radicalism." His 1889 lectures and essay on Nietzsche made the philosopher well-known throughout Scandinavia.

But Brandes was not an uncritical admirer. He protested against Nietzsche's indifference to the sufferings of the masses, his contempt for women's struggle, and his derision of socialists and anarchists. He didn't care for Nietzsche's ideal of the superman, either, and in a disputation entitled "The Great Man, the Source of Culture," he expressed his own belief that in modern society it is more important than ever to produce great, distinctive personalities—the only ones who can act against increasing vulgarization and conformity.

In one of his letters, Nietzsche called Brandes "the good European" and "a missionary of culture." Although Brandes disliked the word "missionary," he was, in fact, a masterful mediator, a writer who carried messages from country to country. He brought the French spirit and literature to Germany and Scandinavia, Scandinavian literature to the rest of Europe, and Polish and Russian literature to the West. An active participant in the events of the new century, he was enormously productive right up until his death in 1927 at the age of eighty-five.

SELECTED BIBLIOGRAPHY OF BOOKS
BY AND ABOUT GEORG BRANDES

Doris R. Asmundsson, *Georg Brandes: Aristocratic Radical* (New York: New York University Press, 1981).

Georg Brandes, *Friedrich Nietzsche* (London, 1914).

——————, *Henrick Ibsen,* translated by Jessie Muir (New York, 1964).

——————, *Main Currents in Nineteenth-Century Literature* (New York: Macmillan, 1901–05) [originally, *Hovedstrømninger i det 19de Aarhundredes Litteratur* (Copenhagen, 1872–90)]:

Vol. I, *The Immigrant Literature*
Vol. II, *The Romantic School in Germany*
Vol. III, *The Reaction in France*
Vol. IV, *Naturalism in England*
Vol. V, *The Romantic School in France*
Vol. VI, *Young Germany*

——————, *Menschen und Werk. Essays von Georg Brandes* (Frankfurt, 1900).

Henning Fenger, *Georg Brandes et la France* (Paris, 1963).

Bertil Nolin, *Georg Brandes* (Boston: Twane, *circa* 1976).

Art in Iceland at the Turn of the Century

Selma Jónsdóttir

Director,
The National Gallery
of Iceland, Reykjavík

In the late nineteenth century, Iceland was one of the last places on earth one would have expected to find a museum of fine arts. The Icelandic people numbered only slightly more than seventy thousand, and the population of the capital, Reykjavík, was only about three thousand. The country was under Danish rule, and it was to Copenhagen that Icelanders looked for education, since there was no university at home. One could not really speak of a contemporary Icelandic art, for although a few Icelanders had studied at Copenhagen's Royal Academy of Fine Arts, they had devoted little time to art beyond the end of their studies.

Yet despite all this, an Icelander named Björn Bjarnarson had a vision. In October 1884, he founded the National Gallery of Iceland, or, as it is known in Icelandic, Listasafn Íslands. Although he started with little money, a handful of paintings, and no building, Bjarnarson's dream not only became a reality, it also inspired the first flowering of Icelandic art.

Though his background was in law (he had obtained a legal degree at the University of Copenhagen and was working as an assistant to Copenhagen's royal bailiff), Bjarnarson took a special interest in Icelandic cultural affairs. In order to air his opinions, he edited and published in Copenhagen a monthly Icelandic-language magazine entitled *Heimdallur.* It was in the July 1884 edition of this magazine that he first floated the idea of establishing an Icelandic museum of art.

"It occurred to me this winter," he wrote, "to set up a museum of oil paintings back home in Reykjavík, a museum which was to be the property of the nation. The pictures I thought of as being gifts from painters in Scandinavia, while the framing would be done by asking people here and at home to donate money for the purpose. Since then I have approached various painters here with the request that they give pictures, and have been promised sixteen. Of those who have promised pictures I would mention the painters [Peder Severin] Krøyer, [Carl] Locher and [Christian] Blache (who have both visited Iceland), professors [Julius] Exner and [C. F.] Aagaard, [and] Thorvald Niss and [Janus] La Cour, who are considered the best painters in Denmark. Moreover, two sculptors, Prof. [Theobald] Stein and the Norwegian [Oscar Ambrosius] Castberg, have promised me some kind of work. I now have hopes of being able to assemble at least thirty paintings, which is, it is true, not a large collection, but it is to be hoped it will grow bit by bit."

The experience of Iceland's three existing cultural institutions—the National Library, the National Museum (which contained ethnographical and archaeological collections), and the Natural History Museum (which was just being formed)—did not bode well for Bjarnarson. Public support for these institutions had apparently been less than total, for many Icelanders had been selling to foreigners important objects of archaeological and scientific interest. Attacking this practice, Bjarnarson wrote, "The consciousness of having made one's contribution towards building up one's country's museums ought always to be of more value than the few cents that one might receive for the items involved."

Having visited the museums of Copenhagen, Bjarnarson knew how important such institutions could be to a country's cultural life. "The museums are not only for pleasure," he explained, "but necessary and quite indispensable, if science and the fine arts are to flourish; and besides being essential for artists and scientists, large and good museums have an educational role as regards the general public, for even those who visit them for pleasure learn much from them without effort, and the desire to learn more may awaken in many of them."

As if this were not enough to encourage Icelanders to support his plan to create a museum of art, Bjarnarson appealed both to his countrymen's sense of national pride and to their pocketbooks. "It ought to be the concern of every Icelander to increase the number and size of our museums," he maintained, "for it is both to our country's credit to own many fine museums, and moreover profitable."

Bjarnarson's initiative received a significant endorsement when the Danish King Christian IX and his daughter-in-law Louise donated two paintings each. By the time he proclaimed the founding of the National Gallery that October, he had assembled a collection more impressive and varied than he had hoped for. There were thirty-eight oil paintings, of which thirty were by Danish artists, four by Norwegians, two by Swedes, one by a Nowegian and a Swede, and one by an Austrian. In addition, he had collected eleven graphic works—all by Danish artists—and one sculpture by the Norwegian Olaf Olafsen Glesimodt.

Bjarnarson's enthusiasm and enterprise were extraordinary. Using money collected from Icelandic well-wishers, he had the paintings framed over the winter, then persuaded a Danish shipping company to carry the items free of charge to Iceland, where they were entrusted to the care of the Governor-General Magnús Stephensen. Even the problem of housing the collection did not seem to faze him. "There is not much accomodation available for an art museum in Reykjavík," he wrote in *Heimdallur,* "but with good will and management it will be possible to make do for some while, and when the collection has become so large that there is nowhere to house it, it is not unlikely that the Parliament will have a house built for it. I had thought to begin with it might be possible to house it . . . in the Parliament building."

The collection was indeed set up in the newly built Parliament, and Bjarnarson continued to send works home until 1887, when he returned to Iceland himself. There he maintained a large farm, was appointed judge and revenue officer of his country district, and served as a member of Parliament. Although there is no record of his having concerned himself with the affairs of the National Gallery after his return, it is probable that all the gifts made to the collection up until the turn of the century were a result of his efforts.

As Bjarnarson had hoped it would, the collection grew little by little. In 1888, the Rev. Helgi Sigurdsson, one of the small number of Icelanders who had studied at Copenhagen's Royal Academy of Fine Arts during the middle of the century, left the museum three oil paintings and forty drawings by himself. The following year, Copenhagen's Thorvaldsen Museum—named after Bertel Thorvaldsen, a Danish artist of Icelandic descent—presented to the National Gallery five folders containing sixty-six graphic works that had been made during Thorvaldsen's sojourn in Rome in the early 1800s. Eight of these works were by Thorvaldsen himself, while the others were from sculptures by Thorvaldsen and were done by various artists who had worked in Rome at the same time. In 1892, the collection acquired two more oil paintings, both gifts from the artists themselves, and in 1895 it received twenty-nine paintings and watercolors from the estate of Dr. Edvald J. Johnsen, an Icelandic physician who had collected the works while practicing in Copenhagen in the 1870s and '80s. Two additional paintings given to the collection in 1896 were the last gifts accepted by the National Gallery before the turn of the century.

By exposing young Icelandic artists to what was happening in the rest of Scandinavia—primarily Denmark—the growing National Gallery helped shape Iceland's emerging national art. Although there was still nothing that could be called a school of painting in Iceland at the beginning of the twentieth century, the two pioneers of Icelandic painting, Thórarinn B. Thorláksson and Ásgrímur Jónsson, both embraced the Naturalism that had swept the other Nordic countries. Though each interpreted it in his own way, both Thorláksson and Jónsson were under the spell of the colorful and majestic Icelandic countryside; indeed, both had been born and brought up in the midst of it. As two respected citizens with strong personalities, they had a deep effect on the course of Icelandic art in the following decades.

Thorláksson's exhibition in the autumn of 1900 marked a turning point in the history of Icelandic art, for it was the country's first one-man exhibition by an Icelandic artist. For the first

time, the people of Iceland were given an opportunity to see their country interpreted in line and color by one of their fellow citizens. In the paintings from this exhibition one can see the peculiar brightness and atmosphere and fine tonality of color that were to become permanent features of Thorláksson's work. Like Icelandic poets of the period, Thorláksson reflected the public's attitudes towards the country and its landscape, and the idyllic tone of his paintings is most closely related to the works of Steingrímur Thorsteinsson, one of the most influential poets of the time. Thorláksson and Thorsteinsson perceived and represented the country in an extraordinarily similar way, with the same colors and touch of nostalgia. In his landscapes, Thorláksson seems always to be alone; like Thorsteinsson, he is out in the country in the "shrine of solitude."

It is sometimes difficult to tell the location represented in a Thorláksson painting, since he adds mountains, cliffs, lakes, or rivers for the sake of a picture. Although he takes inspiration from the countryside and delights in its clarity and stillness, his prime concern is with the painting and its demands; he builds up the picture so as to create a work of art, not just a copy of a landscape.

Unlike Thorláksson, Ásgrímur Jónsson radically altered his technique during the course of his career. At his first exhibition in Iceland in 1903, his use of dark, heavy colors showed the influence of Rembrandt; later he came to know the works of the French Impressionists and began to paint the Icelandic countryside in colors that were pure and bright. Initially he used these new colors with great restraint and experimented with them by painting many watercolors. But as his attitude toward color became more intense and simple, color took over completely from form and his canvases positively vibrated. In these later works the passionate side of his character found expression not only in color but in subject matter and composition as well.

Jónsson painted out in the open every summer and often in the winter, too. Although his greatest delight was to paint the country in all its glory on a clear day, he also painted Iceland's great natural disasters, the volcanic eruptions. Likewise, the landscape is a prominent feature in his representations of Icelandic history and myth. Deeply interested in his nation's sagas and folktales, he did countless drawings of dreadfull trolls, elves, and other supernatural beings. All of these drawings are charged with rich imagination and bubbling humor, and many have been used in children's books, never to be forgotten by those who grew up with them.

Since the time of Jónsson and Thorláksson, Icelandic art has grown and flourished, and the institution which provided the first impulse has reaped the rewards of this artistic awakening. Moved to a specially designed part of the National Museum's new building in 1951, the National Gallery of Iceland now has about 4,400 works of art, both native and foreign. Thanks to the generosity of two public-spirited families, it is now at work on a building of its own.

The Scandinavian Artists' Colony in France

**Salme
Sarajas-Korte**
*Director of Exhibitions,
The Fine Arts Academy
of Finland, Helsinki*

On Christmas evening in Paris in 1877, the Swedish painter Carl Larsson rented a room at his favorite restaurant and threw a party for his Swedish and Finnish friends. By the time the Finnish artists Ville Vallgren and Ernst Nordström arrived, the party was already going strong.

"When we came in . . ." Vallgren later wrote, "all of the Swedish artists were sitting around a table with a little lit Christmas tree in the middle, a little Christmas pig on each side of the tree, and a lot of wine bottles beside the pigs. . . . Larsson immediately called out, 'Hi there, Finn boys! Welcome!' We took our first, second, and third drinks of Norwegian akvavit, then [had] fish, roast, porridge . . . and a very lot more.

"When we sang our drinking song in one big chorus, the window panes shook. . . . Hundreds of people stopped below on the boulevard and listened. . . . Then . . . Larsson gave a humorous and brilliant speech over our Christmas ham . . . and ended with a toast for old Sweden.

"We [later] went [to Larsson's] studio [which had] rafters under a mansard roof [and] looked like a Viking hall. . . . A large Christmas tree stood in the middle of the floor. The lights were lit, and we all danced together around the tree and sang 'And Now It's Christmas and the Lights are Burning'. . . .

"When we started with the Christmas punch, Larsson placed a large copper pot on a table in the middle of the floor. A lot of bottles of cognac were poured in, two pokers were placed over the pot, and a large lump of sugar was ignited. All the lights were extinguished and we danced hand in hand around the infernal blue flames and sang the incantation chorus from *Robert le Diable*. It had a tremendous mystical effect. The oldest [Scandinavian] artists in Paris came in at the same moment: Hugo Salmson, Nils Forsberg, [Vilhelm] von Gegerfeld, and Alfred Wahlberg. Wahlberg sat down at the piano and played very fine, touching melodies, especially old Swedish folk songs. That Christmas party ended at seven in the morning. We all went up to Moulin de la Galette and ate onion soup and oysters, and drank champagne."[1]

To be a young Scandinavian artist in Paris in the period from the late 1870s to the mid-1890s was not only to revel in such freedom and comradeship but also to feel that one was part of a revolutionary movement redefining the parameters of art. Having left Scandinavia to escape the conservative academicism of their native lands, the young Nordic expatriates found in the French capital an atmosphere of artistic upheaval. During their years in Paris, they formed lasting friendships, sharing a rich social life and intense intellectual stimulation. Although they would eventually leave France disillusioned, their experience—the discovery of new worlds of art, the formation of artistic alliances transcending Nordic borders, and the general strengthening of Scandinavian involvement in European cultural life—would have a profound and lasting impact.

Anyone who studies the Scandinavian artists' colony in Paris becomes immediately ensnared in a mesh of influences and cross-influences, for the creative talents of the different Scandinavian nations were here in closer contact than they had ever been before, or ever would be again. The Scandinavians were not always so unified as Vallgren's description would suggest, but instead were often divided by ideologies and styles of life. Some of them, notably the Finn Albert Edelfelt, were assimilated into Parisian society and moved in well-to-do circles with such French painters as Jules Bastien-Lepage and Pascal Dagnan-Bouveret. The Dane Peder Severin Krøyer, the Swede Anders Zorn, and of course the Swedish painter from the royal family, Prins Eugen, also lived lives of sophistication. But there was a wide gap between this circle and the more bohemian group that formed around the Swedish writer August Strindberg, the Norwegian poet Hans Jaeger, and the Finnish painter Axel Gallén (who was later to rename himself Akseli Gallen-Kallela). Gallén put it succinctly when he said, "All my friends look like bums."[2] Edelfelt regarded this scruffy group with sympathy and perhaps even a little envy; of Gallén, he said, "He

Hugo Birger
Scandinavian Artists' Lunch at Café Ledoyen, Paris 1886
Skandinaviska konstnärers frukost i Cafe Ledoyen i Paris
Oil on canvas, 183.5 × 261.5 cm. (72¼ × 103 in.)
Collection: Göteborgs Konstmuseum

lives with a Norwegian wild like himself [the painter Gro Dörnberger]. They are radical, valiant, and brave; it is just a shame that they philosophize more than they actually paint."³

The social radicalism of the bohemian group was more than just a matter of fashionable life-style, for the condition of the poor and the possibility of a new socialism were hot topics among all those Scandinavian painters who had committed themselves to Realism. The roots of Scandinavian *plein-air* Realism had been established in the 1870s by such painters as Sweden's Alfred Wahlberg, Hugo Salmson, and Carl Hill. These painters' quiet style (influenced by such Frenchmen as Bastien-Lepage) had continued into the early 1880s, most notably in the work of those artists who gathered in the small community of Grèz-sur-Loing outside Paris. But increasingly in the 1880s a commitment to Realism brought with it the question of engagement in social questions and a conscious search for tendentious subject matter. Just as they had in French Realism, depictions of work became more common in Scandinavian painting. Artists travelled the impoverished countryside and went to find the lower classes in the provincial towns. Even the society painter Edelfelt was eventually affected; in 1887 he resolved to discover the "obligatory character" in the unfortunate classes. "When I have seen," he wrote, "all of my old Finns in

Peräseinäjoki [a backwoods Finnish village] and gotten them all down on canvas, that will be something... and I guess there are a few Finnish beggars at the poor house in Porvoo."[4]

This trend toward social Realism was encouraged as much by the social polemic writings of Scandinavian and German authors as by the Naturalism of such Frenchmen as Gustave Courbet and Émile Zola. The Norwegian writers Henrik Ibsen, Bjørnstjerne Bjørnson, and Alexander Kielland, for instance, were just as influential as such French Naturalist thinkers as Zola and Hippolyte Taine. Ibsen's play *A Doll House* had raised the issue of women's rights, both in Norway and abroad, in the early 1880s, and Bjørnson turned in the same period towards a preoccupation with the social implications of Darwin's and Spencer's ideas. Kielland (brought into the Parisian community by the Norwegian painter Fritz Thaulow) wrote in radical fashion about social injustice and class differences; according to Vallgren, all the Scandinavian artists in Paris read his 1882 novel *Skipper Worse* with great admiration.[5] The Danish critic Georg Brandes stressed the reformist implications of such writing, and his call for an active, critical Realist art was echoed in the social pathos subjects so characteristic of the young Scandinavian painters' work of the mid-1880s.

Of all the Scandinavian artists in Paris, none possessed a deeper social commitment than the Swedish painter Ernst Josephson. In the late 1870s, along with Vallgren and Edelfelt, Josephson had founded the Jesus Syrach Society, a group that met on Wednesdays at the Jesus Syrach tavern in the Latin quarter. It was at these meetings, which were eventually attended by as many as sixty people, that he laid the groundwork for the Swedish artists' revolt against Stockholm's Royal Academy of Fine Arts—an uprising that culminated in the exhibition *From the Banks of the Seine* in Stockholm in 1885. According to Vallgren, Josephson's lectures at Jesus Syrach were often stormy and passionate: " 'Down with the cities!' he proclaimed.... 'Do you think it is sane and good for people to pack themselves together and live on top of one another in seven or eight stories so that they can dirty one another? No, my friend. Out to the country. Take knowledge out to the farmers. Live as they do!' Josephson made a magnificent impression.... He beat his breast and fell weeping like a child.... One has rarely seen greater passion in one man's heart for the... educative powers of art. People were anxious for Josephson [he went mad some years later] but simultaneously admired his beautiful ideas. He was the modern Christ."[6]

Although Josephson was able to realize his idealistic program for art in a substantial Realist style (such as that of his 1881 painting *Spanish Blacksmiths*, for example), many of the young Scandinavian painters were forced to compromise their ideals. In order to earn their livelihood (and/or keep their academy grants) they constantly painted with attention to the tolerance of the buyers and official academicians, adding to their work the gloss the art historian Bo Lindwall has called "salon perfume."

Perhaps because he seemed to ignore recklessly all such demands of propriety, Strindberg was an exceptionally powerful presence in the Scandinavian-Parisian community—a presence ever more dominant in the later 1880s. The Finnish aesthete Carl Gustaf Estlander called the whole age Strindbergian,[7] for the Swedish author raged through the ideologies of the time one by one, taking each to its extreme. He aggressively attacked feminist ideas like those of Ibsen, and the publication of the two parts of his novel *Married* in 1884 and '86 confirmed his reputation as an immoral man who tore apart all common values. In 1888 he became strongly infatuated with the existentialism of Friedrich Nietzsche and made contact with the German philosopher through Brandes just as Nietzsche's mental illness was worsening. The two carried on a correspondence that, while near madness, was filled with expressions of mutual admiration.[8]

Strindberg's Nietzschean phase coincided with the flight of the writer Hans Jaeger from Norway to escape legal prosecution for his book *From Christiania's Bohemia*, a scandalous and

censored novel of the radically oriented artists' group that had formed around him in the Norwegian capital. When these two men came together in Paris, the stage was set for a shift in ideology among the expatriates. Now, instead of focusing on the masses and their plight, discussion turned to the cult of the superman, to the rights of genius and of homeless exiles like

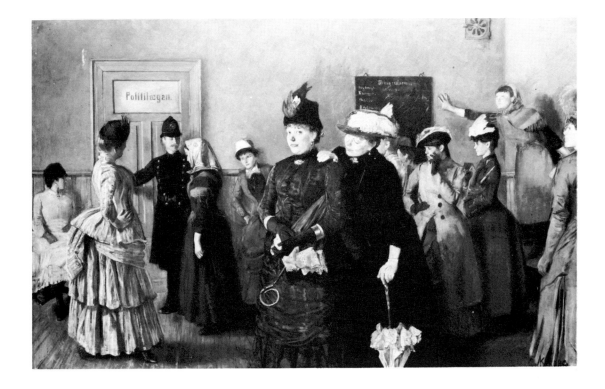

Christian Krohg
Albertine in the Police Doctor's Waiting Room 1887
Oil on canvas, 211.2 × 326.0 cm. (83⅛ × 128¼ in.)
Collection: Nasjonalgalleriet, Oslo

Christian Krohg belonged to the group of radical artists that formed around the poet Hans Jaeger in the Norwegian capital of Christiania in the early 1880s. He brought socialist ideas to the Paris community when he visited in 1882, and subsequently evoked an uproar in Norway when he wrote the novel *Albertine*. An exposé of the corrupt involvement of the police in the tragedies of prostitution, the book was immediately seized and banned upon its appearance in 1886. The following year, Krohg painted this scene from one of the novel's most dramatic moments. In it, a young, innocent girl surrounded by experienced prostitutes is about to be admitted to the police doctor's examination room, where she will undergo a degrading physical inspection that, in its trauma, will hasten her fall into prostitution. Although Krohg's friend Jaeger criticized the picture's artificiality, its display was one of the most sensational events in Norwegian artistic life at the end of the century.

Jaeger. The young Scandinavian artists began to see themselves as children of the future who, born too early, were able to live only in freer, richer societies, and thus had to fight the three giants: Christianity, morals, and the old concept of justice.[9]

Within this current of thinking in the late 1880s, Strindberg and Jaeger had a marked influence on Axel Gallén—a good example of how literature and art interacted among the Scandinavian-Parisians. Discarding his earlier "realistic ugliness," which had included anti-clerical drawings as well as peasant depictions, Gallén would eventually turn to Symbolism. In this he shared with Strindberg a kind of clever opportunism; just as Strindberg translated and retitled those earlier works he felt best suited to the increasing spiritualism of Paris in the 1890s,[10] so Gallén reworked a simple Realist portrait with a new complement of symbolic signs in order to bring it up-to-date.[11] Even though others had preceded him in embracing the "new mysticism" and its accompanying decorative style, Gallén thus succeeded in being seen as the first Scandinavian representative of French Symbolism. Nietzschean though he was in the late 1880s, he did not actually read Nietzsche's work until 1894.[12]

If Gallén can be accused of superficiality, he is hardly alone. Nothing better demonstrates the superficial manner in which the Scandinavian-Parisians often adapted to the new ideologies than their attitude towards feminism. Although there were quite a few women artists in the Scandinavian colony in Paris in the 1880s, they were largely obliged to remain in their own circles. The École des Beaux-Arts would not accept them, and the new, free academies relegated them to separate studios. Even the most gifted women artists were often treated by their male peers as little more than useful assistants. When Edelfelt was asked to paint a reproduction of his portrait of Pasteur, for example, he had his fellow Finnish artist Helene Schjerfbeck do the primary work.[13] Similarly, a few Danish women artists he had met made him think of "the victims

Akseli Gallen-Kallela
In the Studio 1888
Ateljeessa
Oil on canvas
88.9 × 68.6 cm.
(35 × 27 in.)
Collection:
Kokoelma Wulff,
Helsinki

which the Ibsenian search for truth and character has . . . produced. . . . They supposedly have a lot of talent. But there was something brutal and insolent about them which displeased me immensely. It wasn't that they had been insulting in any way, but their whole being exuded a contempt, a feeling of spitefulness, against all convention . . . and for them, as for Strindberg, everything is convention."[14]

The one ideology that seems to have had a genuine effect on all the Scandinavian artists in Paris was nationalism, and as the 1890s approached, they faced the difficult problem of reconciling it with the new tendency toward a universal mysticism. Ironically, they were helped out of this dilemma by the French, who held that the whole Symbolist movement had a disruptively non-French, and specifically Nordic, element. While the German composer Richard Wagner and the Belgian poet Maurice Maeterlink were identified as the spearheads of this trend, the 1890s also saw—along with a renewed attention to German philosophy and to the eighteenth-century Swedish mystic Emanuel Swedenborg—a surge of appreciation for Ibsen's plays, which were treated as Symbolist. People spoke of a new generation enchanted by the North, the land of northern lights, sagas, and dreams. Furthermore, all of this shift to an interest in things Nordic was held to be inevitable, as the theosophic idea of the fluctuation of periods in world history led to a belief that Scandinavia's moment to lead the world's spiritual development had now arrived.[15]

This change in thinking about the North coincided almost exactly with a new wave of artistic influences on the young Scandinavian painters. The whole new generation of Nordic artists that arrived in Paris at the beginning of the 1890s swore by the decorative style of Pierre Puvis de Chavannes. As the Swedish painter Georg Pauli noted in 1892, "It is strange about this Puvis: all styles have use for his art, from the academicists to the Impressionists, Symbolists, and Synthetists." The Scandinavians were generally slower to pick up on the Synthetist art of Paul Gauguin, Émile Bernard, and Paul Sérusier, and the Finnish artist Louis Sparre related how his Swedish and Finnish colleagues shied away from the modernistic doctrines taught by Sérusier at the Academie Julian ("He gave his models purple hair!" Sparre recalled in horror).[16] But Synthetism's influence was eventually felt, particularly among younger painters and especially after Gauguin's major exhibition in Copenhagen in 1892. Seeing that exhibition meant a complete reorientation for the Swedish "Varberg Group"—Karl Nordström, Nils Kreuger, and Richard Bergh. Carl Larsson wrote of them that they "lay in Varberg and painted landscapes which resembled one another and which they had actually stolen from Gauguin."[17] Likewise, the Swede Olof Sager-Nelson was enthusiastic about the Gauguin exhibition he saw in Paris in late 1893, and Finland's Pekka Halonen and Väinö Blomstedt, together with the Swedish landscapist Helmer Osslund, were pupils of Gauguin at the beginning of 1894, before his second trip to Tahiti.[18] The motivation of these artists was best summed up by the Swedish painter Ivan Aguéli, who arrived in Paris in 1890 to study under Bernard. "Our souls' most noble faculties," Aguéli wrote, "are in the process of withering away (through positivism). We must react. We must once again cultivate the higher characteristics of the soul. We must once again become mystics."[19]

By the middle of the 1890s, however, the principles of Synthetism had fallen out of favor with the Scandinavians (owing partially to Gauguin's absence). The influence which then made itself felt was that of Sâr Péladan, the eccentric theorist of mystic and Symbolist art who founded the Rose + Croix order of artists and the nearly annual Rose + Croix Salon. Finland's Vallgren showed in these Salons and left a colorful description of Péladan in his memoirs.[20] But others felt that Péladan's ascendancy was only a mark of trivialization and of the bankruptcy of Parisian art. Although his own Symbolist style was indebted to Péladan's exhibitions and theories, Gallén criticized the Rose + Croix Salon of 1892 as indicating that France's ancient culture was in its

death thralls, and that only wailing among the ruins was left.[21] The Swedish critic Ludvig Looström subsequently echoed this damnation, with its rejection of Paris, in his 1896 review of the Rose + Croix: "The audience . . . for the most part is rather indifferent to this nonsense. Today it laughs at what some people two or three years ago thought was going to be the art of the future. But we must no longer remain in this stifling atmosphere. We must move toward Munich, where fresher breezes meet us not only in the Glass Palace but also in the excellent exhibition of the Secessionists."[22]

Such anti-French comments were widespread among the Scandinavians by the mid-1890s, and Scandinavians began avoiding Paris in favor of trips to Italy and Berlin. They began to feel that the self-styled spiritual ideas of Parisian mysticism were only superficial covers for an ever more evident confusion and instability of values. Amidst this reaction against the Parisian intellectual climate, many expatriate Scandinavians wound up in severe religious crises,[23] while others (like the Swede Olof Sager-Nelson and the Finn Magnus Enckell) simply longed for a clearer atmosphere. Gallén had had enough of Paris by 1892, and three years later he warned his young pupil Hugo Simberg about the moral degeneracy of the French capital, directing him instead to England, where he himself had just visited. *The Studio*—an English magazine with an Arts and Crafts and Art Nouveau orientation—now began to have an increasingly marked influence in Scandinavia,[24] and Berlin became more and more the expatriate Scandinavian art center in the mid-1890s. Norway's best known painter, Edvard Munch, and its most famous sculptor, Gustav Vigeland, both went to Berlin, and Munch and Gallén had a brief and tempestuous friendship there. During the same period, the Danish Symbolist Jens Ferdinand Willumsen exercised influence on the Germans themselves, as well as on his fellow Scandinavian-Berliners.[25]

Thus the heyday of the Scandinavian artists' colony in Paris ended. The pilgrimage of Scandinavian artists to France might be repeated, as it was around 1906, when the art of Picasso and Matisse rejuvenated the French avant-garde. But the "golden moment" of that special group of pioneers who first "colonized" Paris—the Scandinavian colony of Vallgren, Strindberg, Josephson, Jaeger, Gallén, et al—would never again be equalled.

1 Ville Vallgren, *Ville Vallgrens ABC-bok med bilder* (Ville Vallgren's ABC book with pictures), Helsinki, 1916, pp. 16–17.
2 Kirsti Gallen-Kallela, *Isäni Akseli Gallen-Kallela* (My father Akseli Gallen-Kallela), Porvoo, 1964, p. 71.
3 Albert Edelfelt, *Liv och arbete* (Life and works), Helsinki, 1926, pp. 56–57.
4 Edelfelt, p. 186.
5 Vallgren, p. 94.
6 Vallgren, p. 99.
7 C. G. Estlander to Carl Snoilsky, July 31, 1884, in *Carl Snoilsky och hans vänner. Ur skaldens brevväxling*, 1-2, Stockholm, 1917–18. See also Salme Sarajas-Korte, *Vid Symbolismens källor. Den tidiga symbolismen i Finland 1890–1895* (At Symbolism's sources. Early Symbolism in Finland, 1890–1895), Jakobstad, 1981, pp. 17–18.
8 Olof Lagercrantz, *August Strindberg*, Helsinki, 1979, p. 163.
9 Hans Jaeger, *Fra Kristianiabohemen*, Oslo, 1950, pp. ix–xi.
10 Lagercrantz, p. 325.
11 Sarajas-Korte, pp. 267–271. In 1888, Gallén painted an American friend whom we know only as Wilbur, a

Nietzschean hero. Gallén titled the later Symbolist version *Envisaging Death*.
12 Sarajas-Korte, p. 247.
13 Edelfelt, pp. 154–155.
14 Edelfelt, p. 99. Not until the 1890s, evidently thanks to the Finnish artist Magnus Enckell, were women artists accepted on a more equal footing in the Scandinavian artists' colony in Paris.
15 Sarajas-Korte, pp. 52–53.
16 Sarajas-Korte, p. 71.
17 Nils-Gösta Sandblad, *Nordiskt sekelskifte. Tidens konsthistoria III* (Nordic turn-of-the-century. The age's art history III), Stockholm, 1944, p. 472.
18 Axel Gauffin, *Olof Sager-Nelson*, Stockholm, 1945, p. 197. Sarajas-Korte, pp. 95, 100–105.
19 *Svensk konströnika under 100 år* (Swedish art chronicle for 100 years), 1894.
20 Vallgren, pp. 165–169.
21 Sarajas-Korte, pp. 233–235.
22 *Svensk konströnika under 100 år*, 1896.
23 Sarajas-Korte, pp. 88–89.
24 Sarajas-Korte, p. 235.
25 Sarajas-Korte, p. 285.

Scandinavian Painting and the French Critics

Emily Braun

Institute of Fine Arts
New York University

O_F French cultural chauvinism the Norwegian playwright Bjørnstjerne Bjørnson once remarked, "In our cold continent there are two races: on the one hand Europe, the united states of Europe, Cosmopolis, if you want, and on the other, isolated from the rest by a wall of China: *la France.*"[1] True to form, during the 1878 Paris World Exposition, the French critics wrote of Scandinavian painting: "Art vegetates in Denmark, lives slightly in Sweden, and doesn't exist at all in Norway."[2] The reviews were generally unfavorable, with little to commend and much to correct. It was an art which the French considered to be uninformed, technically awkward, and, worst of all, void of national identity.

Only eleven years later, however, at the next World Exposition, the French were pleasantly impressed by the rapid progression of Scandinavian art. The formation of national schools and a more than able technique made the Northerners worthy of close examination and critical acclaim.

Why in the space of a decade had there been such a dramatic change from a patronizing air to a genuine interest? As the French themselves readily admitted, admiration of the Scandinavians was a form of self-glorification. In the words of Charles Ponsonailhe, "If I place Scandinavia first, it is because I follow an order that is flattering to France, and recognizant of the foreign schools which are the daughters of French art."[3] The Scandinavians, perceived as the most successful products of the French *éducation beinfaisante*, were of special interest to the critics. At the same time, they managed to express characteristics of their land and race, and so fulfilled a stringent critical double standard: the demand for technical dexterity, clearly a French attribute, and the expression of national identity.

It also becomes apparent in reading the criticism of three World Expositions and some twenty-five years of Salon reviews, that the French created an image of the Scandinavians as aesthetic innocents. The critics viewed their own nation's art as being past the apex, at the brink of decline, and cultivated a myth of French art as decadent and over-civilized. The Scandinavians, in contrast, were seen to maintain a purity of vision, an unspoiled eye, and a virgin temperament, with their art free of a weighty pictorial tradition and scholarly prejudices. In the words of the critic Georges Lafenestre, the Scandinavians represented "a reserve of noble simplicity and wholesomeness for our central Europe, tired by her excess of egotistical and sensual imagination."[4]

Finally, one can argue that the Scandinavians held a special attraction for the French as Northerners of an anti-classical heritage, as a Teutonic but non-Germanic people. The critics could praise their qualities of Protestantism, puritanism, perserverance, and single-mindedness—racial qualities that were implicitly Germanic and clearly admired by the French, but which for reasons of patriotism and politics, they could not admire in Bismarck's nation. The Scandinavians thus provided an outlet for racial admiration and interest within the bounds of French national pride.

The World Exposition of 1878 was the first since the Franco-Prussian War, and the first opportunity for the French to reassure themselves of their artistic supremacy. Accompanying their self-evaluation as a modern-day Athens was a strong ethnological and political interest in the art and schools of other nations. The bulk and intensity of their evaluation was focused, naturally, on their German rivals. German art was viewed with condescension and apprehension: the French criticized the Germans' dry style and were wary of their assertive drive to create a national art. As Mario Proth wrote of German painting, "It smiles very rarely, and laughs even rarer still. The Germans philosophize to an excess. Their art attests to the work, the austere energy and patience of a conquering nation, which wants to have an art as it wants to have an empire."[5] Yet despite their puerile procedure and insipid naiveté (even in battle paintings

August Hagborg
Fisherman's Daughter
Date and location unknown

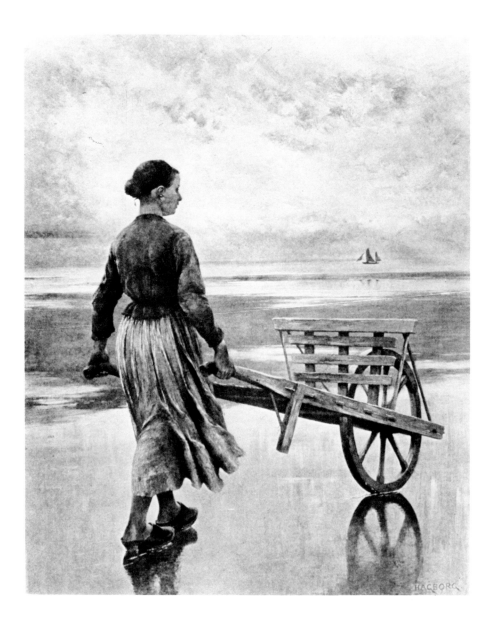

which they had the courtesy not to send), the Germans clearly held a position of fascination for the French.

Not so with the Scandinavians. In contrast to the political clout and cultural presence of the Germans, the Scandinavians had little importance in European affairs and no past or present art to rival the French. Lacking an expressive, indigenous school, they failed to attract even ethnological curiosity. An overwhelming majority were trained by the isolated and retrograde native academies, and the few reputable names—such as Hans Gude and Johan Christian Dahl—were foreign trained. Curiously, in 1878 the landscape of Scandinavia was viewed as

being anti-pictorial and not conducive to the arts in general. It was described as a land of unnatural colors, geological upheavals, and meteorological disturbances that trouble the eye and spirit.[6] This contrasts sharply with later writings in which the landscape is taken as a given, is admired for its individuality, and plays a crucial role in the French characterization of the Scandinavian *volk*. But in 1878, "the genius of art gets too chilly" in the north. Overall, the Scandinavians fell short in both technique and national expression. The message of the critics was clear: the Scandinavians could no longer isolate themselves from the current artistic developments in Europe (meaning Paris) if they wished to eventually create recognizable and respected schools.

The migration to the French capital did in fact take place, not in small part due to the humiliation of 1878. The Scandinavians sought instruction in the studios of Léon Bonnat, Ernest Laurent, Jules Lefebvre, Jean Léon Gérôme and other leading academicians. Nordic names began to populate the Salon *livrets* in the late 1870s, with an average yearly attendance of close to forty in the 1880s, before diminishing to under ten in the first decade of the twentieth century in the Salons of the Société Nationale.[7] In the 1880s the Swedes represented half the entries, followed by the Norwegians, Danes, and Finns. The French were aware of the foreign invasion of their national exhibitions, and the reactions ranged from the rare xenophobic remark to a general cordial welcome. After all, imitation is the finest form of flattery, and most agreed with Albert Wolff in *Figaro:* "that which demonstrates in an incontestable fashion the supremacy of French art and the importance of the French Salon, is the eagerness of foreigners to send their work there."[8]

In the Salons, foreigners competed on French ground and were therefore evaluated by the standards applied to the best of French art. Guest exhibitors were judged with an overriding attention to modernity, which in the official and often conservative reviews was generally termed as *plein-air* painting. For the most part, Scandinavian entries such as August Hagborg's *Fisherman's Daughter* (Salon 1885) received a minimal line or two of casual, mostly descriptive comment, despite earning frequent reproduction in the Salon reviews. The stress on technique is exemplified by Albert Wolff's critique of Hagborg's canvas: "the well drawn subject" is a pretext to paint simply "a study in *plein air*, and to make evident that he follows with attention the modern movement of French painting."[9]

The French considered themselves the ultimate grammarians of art and judged sophistication of style and ease of brush according to their high standards. In the 1880s there emerged at the Salons a new generation of Scandinavians who the French believed rivalled them at their own game. The Danish artist Peder Severin Krøyer, trained by Léon Bonnat to become a leader of Northern painting, was a particular favorite, "the most complete and first among them."[10] He made his debut in 1879 with *Daphnis and Cloe* and exhibited regularly until 1901, winning a third-class medal in 1881, a second-class medal in 1884, and the *Chevalier de l'ordre de la Legion d'honneur* in 1887.

Albert Edelfelt's position in the eyes of the French critics was equally impressive. The Finnish artist exhibited in all but four Salons in the last two decades of the century, and in 1882 he won a second-class medal for his *Divine Service at the Edge of the Sea*, which was praised for its "spectacle of northern piety."[11] His real success, however, and what the French considered his *chef d'oeuvre*, was his portrait of *Louis Pasteur* (Salon 1886). The portrait was a true coup for Edelfelt, for it was preferred over Bonnat's image of Pasteur exhibited at the same Salon, and was purchased by the French government the same year.

A third favorite of the French was the Swedish painter Anders Zorn, who began a successful Salon career in 1888. The critics cited Zorn frequently for his unrivalled execution and virtuoso

brushwork, which made him seem the most French of the Scandinavians. His propensity for sunny days and colorful nudes differed from the usual repertoire of Northern painters, and he was the only Scandinavian to be featured in Armand Silvestre's annual review *Le Nu au Salon*, in which his *Summer Sweden* was reproduced in 1890.[12]

Clearly the French were attracted to those painters who reflected their Parisian training, the light and truth of Naturalism, and the lively French finesse. On the whole, Salon criticism paid little attention to individual schools or national characteristics. The Scandinavians themselves, wanting to be accepted into French exhibitions, naturally submitted palatable works not far from the norm. Although the critics could cite the expression of native simplicity in works such as *At Grandmother's House* (Salon 1885), by the Swedish artist Hugo Salmson, and *Bridal Dress* (Salon 1893), by his countryman August Hagborg, there was not much evidence of an indigenous Scandinavian style.

The French developed their critical apparatus for analyzing Scandinavian culture and the Danish, Swedish, Norwegian, and Finnish schools not at the Salons but at the World Expositions. The Danes were associated with their Neoclassical past (theirs was the only Scandinavian nation to have such a heritage), and it followed logically for the critics that they were the most precise in form and least accepting of the *plein-air* style. The Danes were, above all, characterized as painters of interiors, such as those by Vilhelm Hammershøi and Anna Ancher. They were seen as favoring domestic scenes, and as having a bourgeois interest in affairs of the heart, be they intimate conversations, meals, or quiet meditations. Danish art was believed to reflect the Danes' puritan reserve, honesty, moral temperance, Protestant customs, and above, all, good-natured sensibility or *Gemütlichkeit*. These characteristics are non-French, non-Mediterranean, and non-Catholic, and the French consistently associated them with Dutch Naturalism as opposed to German Realism. Krøyer was clearly an anomaly in this context and was perceived as such. He had a "faculty of design, elegance of allure, something nervous and jaunty which is not of his country."[13] Hammershøi, too, was seen as something of a curiosity, but was nonetheless grouped with the other painters of interiors and considered characteristically Danish. Only after the turn of the century did the French appreciate him as a Symbolist—"a mimosa among potatoes" in the words of one critic quoting a German.[14]

The Swedish school was consistently admired for revealing the greatest affinity with the French. Most of the Swedish artists were Parisian trained and exhibited what the French viewed as a more elegant, sensuous, and extensive style of painting. The expressive gaiety of their canvases seemed to fit their nature: robust, energetic, beautiful, and balanced. The Swedes, however, also received frequent reprimands for displaying too much of a boulevardier indifference and virtuosity, for being too French and losing contact with their origins. Zorn was commonly the object of such dual praise and caution. He, Alfred Wahlberg, and the Naturalists shared the bulk of the French attention, while Richard Bergh was frequently cited as an excellent portraitist, and Karl Nordström received passing mention. Again, it was only after the turn of the century that painters of a more decorative style and originality—Gustaf Fjaestad, Carl Larsson, and Bruno Liljefors—were appreciated for their individuality.

The Norwegians were seen as fundamentally rural, the least cosmopolitan, and the most exotic. Their rugged environment and brave battle against the elements seemed to have insured their insularity and protected their indigenous qualities. As a people they were characterized by perseverance and wholesomeness, with "The stature of a race carved by the blow of an axe, tender under a rough bark."[15] Their art was similarly noted for an outward technical roughness with an expression of honest sentiment. Erik Werenskiold was the Norwegian painter *par excellence* and his *A Country Funeral*, exhibited at the 1889 World Exposition, was the perfect

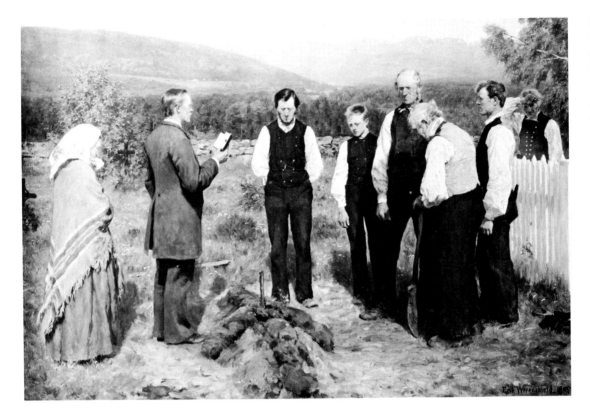

Erik Werenskiold
A Country Funeral
1883 – 85
En bondebegravelse
Oil on canvas
102.5 × 150.5 cm.
(40⅜ × 59¼ in.)
Collection:
Nasjonalgalleriet, Oslo

vehicle for the French interpretation. Fritz Thaulow and Otto Sinding were frequently excluded from their national school for being, like Krøyer, too adroit, too knowing. Because of such artists as Elif Peterssen, Christian Skredsvig, and Kitty Kielland, the Norwegians were categorized as landscape painters with a love of silence and the still environment. They were also considered to have an able school of genre painters, including Nils Gustav Wentzel and Harriet Backer.

Finnish art was the least defined, and in both 1889 and 1900 the Finnish school was briefly summed up as an annex of the Swedish or Norwegian.[16] As a people the Finns were seen as possessing the same good nature as the Norwegians. Attention to Edelfelt, perceived as their leading figure, overshadowed the rest, although Akseli Gallen-Kallela's paintings of Finnish legends were the objects of some passing fancy, and Eero Järnefelt and Helene Schjerfbeck received an occasional citation. Lack of definition for the Finns was most pronounced in 1900, when few critics tended to view them apart from the Russians, with whom they were grouped in the catalogue. There were no pleas for autonomy on their behalf by the French, despite the larger European concern for their independence.

The expression of an indigenous spirit was the virtue most valued by the French in the art of any nation, and they frequently criticized those who stepped outside the bounds of originality and sincerity. Yet if Thaulow was accused of whisking snow like eggs, and Zorn of coming dangerously close to contagious decadance, Krøyer and Edelfelt could, at the same time, be extolled for their portraits of great French men. The criteria were clearly biased and flexible, and

the Scandinavians often painted a fine line between a French and a national style. Nonetheless, there was a pervading sense of anxiety that those who lose their verism also lose their significance. Above all, sincerity was the marked characteristic of the Northern schools. The Scandinavians were set on a pedestal to serve as a foil for the French self-image as a people and school of sensuality, egotism, and over-sophistication.

Nowhere was this opposition of culture versus civilization, Scandinavia versus France, more evident than in the *Gazette des Beaux-Arts* Salon review of 1891 by Édouard Rod.[17] Here Jean Béraud's *Mary Magdalene in the House of the Pharisee*, the epitome of the bizarre and bad taste in the opinion of the author, was contrasted with two Scandinavian paintings of similar subject in the same Salon: Edelfelt's *Christ and the Magdalene* and Skredsvig's *Son of Man*. Rod bemoaned the decadence of Béraud, whose brush he saw as devoid of piety. In contrast, in the scene transformed to the Northern hinterland, he saw not a brilliant courtesan, but a poor country fisherman's wife without any ornament save a plain necklace bought at some market. Her humble plea for grace

Jean Béraud
Mary Magdalene in the House of the Pharisee
1891
Oil on canvas
126.5 × 157.0 cm. (49¾ × 61¾ in.)
Collection Musée d'Orsay, Paris

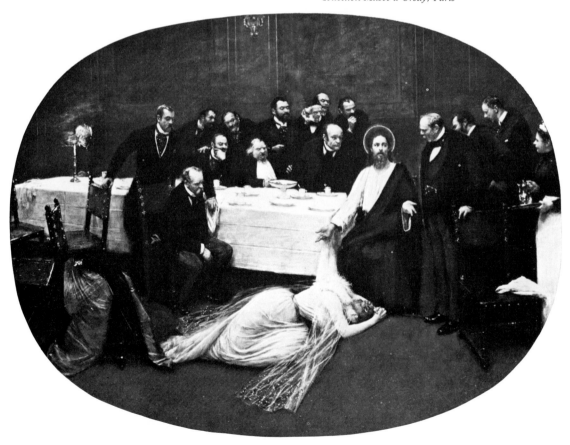

offered a strong counterpoint to the melodramatic display of the French Magdalene. Similarly, Rod commended the universality of Skredsvig's *Son of Man*, contrasting it with the boulevard specificity of the Béraud. The critics could deplore examples of frivolity and superficiality in bad French paintings, whereas with the Scandinavians, in the words of Gustave Geffroy, "no fatigue of decadence is visible, wholly on the contrary, it is a free and healthy force which manifests itself."[18]

Implicit in the French admiration of the Scandinavians was an appreciation of the qualities which the French themselves did not possess. There was conscious polarization of Catholic versus

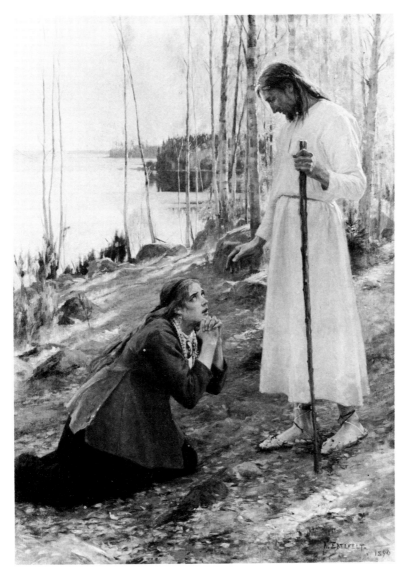

Albert Edelfelt
Christ and the Magdalene 1890
Kristus ja Mataleena
Oil on canvas
221.0 × 154.0 cm. (87 × 60⅝ in.)
Collection: Ateneumin Taidemuseo, Helsinki

Protestant, Nordic versus Mediterranean, classical versus Teutonic. Yet the French were rarely so admiring of the same racial characteristics in the Germans. When the Scandinavians showed "awkwardness and boldness," it was proof of their noble temperament; when the Germans displayed similar traits, they were seen as suffering from dull tonalities and dry rendering. Likewise, the serious and constrained note of the virtuous Norwegians became the sullen predilection of the Prussians.[19] That the French admitted their respect for the Teutonic race through the Scandinavians and not the Germans is evident in Charles Ponsonailhe's description of Albert Edelfelt, who, in the "sveltness of his high figure, masculine and smiling physiognomy, blond moustache and freshness of blue eyes, represents the accomplished type of the man of the North, in all his attractiveness."[20]

It is interesting to note the consistent lack of a more realistic critical interpretation, or one which would have acknowledged the growing anti-Naturalistic trends in Scandinavian art.[21] This may be due, in part, to a time lag—also attributable to French chauvinism. As Georg Brandes once commented, "the French public generally accepts that which comes from the outside only twenty years after other people."[22] Such was the case with Scandinavian theatre: Ibsen, for example, was not known in France until 1889, long after his plays had been acclaimed in other countries. Yet the analysis of Northern culture by the theatre critics was much more perceptive than that revealed by the art reviews. In his influential critique of *Ghosts* in the 1889 *Journal des débats*, Jules Lemaître described Ibsen's plays as dramas of conscience and his characters as individuals in revolt against society, recognizing that troubled silence had replaced the beautiful quiet of the fjords.[23]

The differing perspectives of the French drama and art critics is not only a matter of context but also of intent, for in the World Expositions of 1889 and 1900 the new tendencies were already on view. Scandinavian art was attractive to the more conservative critics who wanted to maintain the Naturalist idiom, and they emphasized those painters whose art acknowledged the hegemony of French painting.[24] The Scandinavians whose art matured in the 1890s had been nurtured by the French academies a decade before, and the critics did not abandon this association easily, despite the apparent changes in style and approach. In the end, the French critics revealed more of their own national self-image than that of the countries of Scandinavia they chose to interpret. Their critique of Northern painting allowed a postulation of their own cultural position: one of artistic supremacy, but of imminent decline; of a glorious, classical, old-world tradition in the face of modern, developing, Teutonic cultures.

1 Bernard Douay, "Une opinion de M. Björnson sur la France" *Revue hebdomadaire*, March 2, 1901, p. 99. Quoted by Dikka Reque, *Trois auteurs dramatiques Scandinaves Ibsen Björnson Strindberg devant la critique francaise 1889 – 1901* (Paris: Honoré Champion, 1930), p. 1.

2 The words of Armand Dayot, "Anders Zorn" *L'art et les artistes*, 3, 1906, p. 43, a paraphrase and summary of the review by Charles Blanc, *Les Beaux-arts à l'exposition universelle de 1878* (Paris: Librairie Renouard, 1878), pp. 341 – 346.

3 Charles Ponsonailhe, *Les artistes Scandinaves à Paris* (Paris: Librairie Nilson, 1889), p. 13. Ponsonailhe's

pamphlet is the most striking example of the use of the Scandinavians for French national self-aggrandizement.

4 Georges Lafenestre, "L'exposition universelle: les écoles Étrangères," *La revue de l'art*, VIII, (1900), p. 287.

5 Mario Proth, *Voyage au pays des peintres. Salon universelle de 1878* (Paris: Baschet, 1879), pp. 138 – 139. See also Proth's chapter on the Scandinavians, "Du fria, du friska, du fjellhoega nord!", pp. 211 – 288.

6 M. Duranty, "Exposition universelle: les écoles étrangères de peintre," *Gazette des beaux-arts*, 1878, XVIII, p. 156.

7 These figures are approximations taken from the Salon catalogues.

8 Albert Wolff, *Figaro Salon 1885* (Paris: Baschet, 1885), p. 99.

9 *Ibid.* p. 39.

10 Henry Havard, "L'exposition des beaux-arts: les écoles étrangères," *Revue de l'exposition universelle de 1889,* ed. F.G. Dumas (Paris: Baschet, 1889), p. 293.

11 Daniel Bernard, in Paris, *Salon de 1882. L'exposition des beaux-arts* (Paris: Baschet, 1889), p. 88.

12 Armand Silvestre, *Le nu au Salon* (Paris: E. Bernard and Co., 1890).

13 Maurice Hamel, "les écoles étrangères," *Gazette des beaux-arts,* 1889, LXV, p. 378.

14 William Ritter, "Exposition internationale des beaux-arts de Munich," *Gazette des beaux-arts,* 1909, II, p. 348.

15 Hamel, 1889, p. 397.

16 See for example Hamel, 1889, p. 379; Georges Lafenestre, *Artistes et Amateurs* (Paris: Societe d'editions artistique, 1900), pp. 215 – 219; Léonce Bénédite L'exposition decennale: La peintre étrangère, *Gazette des beaux-arts,* 1900, XXIV, p. 494.

17 Édouard Rod, "Les salons de 1891 au Champ-de-Mars et aux Champs-Elysées," *Gazette des beaux-arts,* 1891, VI, pp. 18 – 21.

18 Gustave Geffroy, *La vie artistique* (Paris: H. Floury, 1901), p. 156.

19 The French critics tended to view German art, marked by a heavy touch, a serious or mystic mood, as an antithesis to their own. See for example: Proth, *op. cit.,* or Léon Greder *Loisirs d'art* (Paris: Nogent-le-Rotrou, 1901), pp. 29 – 30. Ponsonailhe, 1889, p. 4, commented on the politics of the situation: "L'orgueil teuton hésite a admettre une esthétique née en France."

20 Ponsonailhe, 1889, p. 45.

21 As Reinhold Heller notes, Symbolism in Europe as a whole was not defined as a new movement by the international critics until after 1890. Heller writes: "French and German critics in 1890, if aware of any international artistic tendencies, rightly saw a dominant Impressionist Naturalism, frequently singling out the Norwegians such as Werenskiold at the 1889 *Paris Exposition* for their naivete and coloristic audacity." See "Edvard Munch's *Night,* the Aesthetics of Decadence and the Content of Biography," *Arts Magazine* 53, (Sept. 1978), p. 103, n.39. Even in the 1890s a general and Naturalist view of Scandinavian painting prevailed in the minds of the French. This biased interpretation was reinforced by a lack of attention towards the more overt Scandinavian Symbolist painters; those Symbolists who did exhibit on rare occasion in France received little or no attention from the independent reviews or from the more progressive critics such as Felix Fenéon or Albert Aurier. Similarly, such painters as Edvard Munch, Richard Bergh, Gerhard Munthe, and Carl Larsson lacked significant critical attention when they exhibited with *Les XX* in Belgium.

22 Georg Brandes in "Henrik Ibsen en France", *Cosmopolis,* Jan. 1897, p. 114, quoted by Reque, 1930, p. 2.

23 *Ibid.* pp. 61 – 63.

24 Edvard Munch exhibited in Paris on only five occasions during the years 1880 – 1900, as compared to his participation in sixteen exhibitions in Germany during the same period. His art did little to alter the general and conservative impression of Scandinavian painting formed by the French. The Danish painter Jens Ferdinand Willumsen, who was associated with Gauguin and the Pont-Aven group, received some attention from the more progressive critics when he exhibited at the Salon des Indépendants of 1891, 1892, and 1893. The French reviews, however, focused on his Synthetist and "caricatural style" as opposed to any peculiarities of his national origin. (See Roald Nasgaard, "Willumsen and Symbolist Art," unpublished doctoral dissertation, Institute of Fine Arts, New York University, New York, 1973, pp. 159 – 169.)

Catalogue

The catalogue is arranged alphabetically by artist; the works by each artist are in chronological order. Dimensions are in centimeters (inches in parentheses); height precedes width. Unless otherwise indicated, the medium is oil on canvas. The collection is given in italics.

The addition of an * following an artist's name indicates that biographical information on the artist is included in this catalogue.

The following is a list of the artists by nationality (for a chronological list of the paintings, see pages 33-34):

DENMARK
Anna ANCHER
Niels BJERRE
Ludvig FIND
Vilhelm HAMMERSHØI
Peder Severin KRØYER
Laurits Andersen RING
Harald SLOTT-MØLLER

FINLAND
Albert EDELFELT
Akseli GALLEN-KALLELA
Pekka HALONEN
Eero JÄRNEFELT
Helene SCHJERFBECK
Louis SPARRE
Ellen THESLEFF

ICELAND
Ásgrímur JÓNSSON
Thórarinn B. THORLÁKSSON

NORWAY
Harriet BACKER
Halfdan EGEDIUS
August EIEBAKKE
Karl Gustav JENSEN-HJELL
Kitty KIELLAND
Christian KROHG
Edvard MUNCH
Ejnar NIELSEN
Eilif PETERSSEN
Harald SOHLBERG
Nils Gustav WENTZEL

SWEDEN
Björn AHLGRENSSON
Richard BERGH
Prins EUGEN
Gustaf FJAESTAD
Eugène JANSSON
Bruno LILJEFORS
Karl NORDSTRÖM
Carl WILHELMSON
Anders ZORN

Catalogue Contributors
Scandinavia
[GCB] Görel Cavalli-Björkman
[BF] Björn Fredlund
[PG] Pontus Grate
[SSK] Salme Sarajas-Korte
[MM] Magne Malmanger
[KM] Kasper Monrad
[BN] Bera Nordal
[TS] Tone Skedsmo
[OT] Oscar Thue

U.S.A.
[EB] Emily Braun
[PGB] Patricia Gray Berman
[AC] Alan Chong
[ADG] Alison De Lima Greene
[SRG] Shellie R. Goldberg
[RH] Rosemary Hoffmann
[WPM] Wendy Persson-Monk
[SMN] Sasha M. Newman

BJÖRN AHLGRENSSON Sweden
1872–1918

Björn Ahlgrensson was born in Stockholm in 1872, the only son of a theater scene painter and an actress-singer. The Ahlgrensson family moved to Copenhagen in 1874 and to Paris three years later. Björn began to take music lessons and to play the violin, and when his mother and sister returned to Stockholm in 1886 to join his father (who had returned three years earlier to seek a fortune as a newspaper publisher), the fourteen-year-old boy remained in Paris with family friends to pursue his musical studies.

In 1890 Ahlgrensson was called back to Stockholm. His father had died of tuberculosis, and the family, never well off, was facing a financial crisis. Ahlgrensson put his musical aspirations aside and apprenticed himself to Carl Grabow, the chief scene painter of the Stockholm Opera. Encouraged by Fritz Lindstrom, a young painter whom he had met through his work at the theater, he began taking painting classes at the Artists' Union.

On the recommendation of the union's president, Richard Bergh*, Ahlgrensson won a travel grant to France in 1893. Although none of the work from his nine-month stay in Paris has been recovered, it is clear from the memoirs of his friend Axel Erdman, who was a member of the Swedish artists' community there, that Ahlgrensson was open to advanced French painting, particularly Synthetism and certain aspects of Neo-Impressionism.

In 1899 Ahlgrensson married Fritz Lindstrom's sister Elsa and moved to the Lindstrom villa in Värmland (western Sweden). There he became part of the artists' community centered around Gustaf Fjaestad* at Lake Racken. The landscapes and mood interiors from his home in Rackstaad, among them *Glowing Embers at Dusk*, show his technique in his primary medium of tempera at its most refined stage.

Ahlgrensson's horizons were rather limited by his self-imposed isolation in Värmland, and he was not in contact with the new generation of painters who came into prominence in Sweden around 1910. Suddenly in 1911, after finishing an altarpiece for the Arvika church, he left the confines of home and family and visited artists' communities in Copenhagen, Visby, Jämtland, Stockholm, and Paris. His style and choice of motifs unchanged, he returned to Rackstaad in August 1915 and died there three years later of the Spanish influenza. [SMN/PG]

1 *Reproduced in color on back cover*
Glowing Embers at Dusk 1903
Skymningsglöden
Tempera on canvas
83.0 × 120.0 (32⅝ × 47¼)
Signed lower left: "B. Ahlgrensson/1903"
Göteborgs Konstmuseum

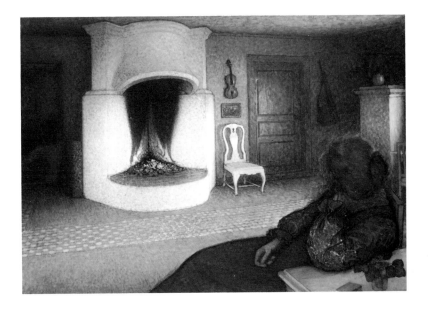

Evening or twilight interior views of his home in
Värmland, most often including his wife, were
important subjects for Björn Ahlgrensson from 1899
until 1910. *Glowing Embers at Dusk* and Ahlgrensson's
other important work from 1903, *Late Summer Evening
(Hedenskog)*, are about feminine realms of solitude in
which silent interiors are charged with the mystery of
the everyday. *Glowing Embers at Dusk* depicts a moment
of winter twilight in which the progression of time is
only vaguely suggested by the fading light from the
window in the next room and the dying embers of the
fire. Ahlgrensson mixes the woman's reverie and our
contemplation in a manner reminiscent of Jan Vermeer
and other seventeenth-century Dutch masters of the
interior. This style links him to the widespread Vermeer
revival of the late nineteenth century and relates his
quiet interiors to the work of Vilhelm Hammershøi*.
The tightly wrought decorative surface of the painting,
in which the divisionist brushstrokes derived from
Neo-Impressionism are controlled by the clearly defined
contours of figure and objects, is also related to the
linear rhythms of the Swedish Art Nouveau style so
important to the group led by Gustaf Fjaestad*.

Glowing Embers at Dusk resonates with the life of the
imagination; even the placement of the woman's fingers
against her head suggests inner absorption. Yet the
viewer's focus is not the seated figure but the fireplace,
the object of her contemplation, which is curiously
provocative in its Art Nouveau elegance. The swelling
shapes of the fireplace and indeed each object in this
spare room—the vacant chair, the unplayed lute and
violin upon the wall—are feminine and resonate with
the spiritual and physical presence of the dreaming
woman. All exist in a suspended state, and, keyed by
the withdrawn figure and the banked fire, the room
becomes implicitly charged with the force of male
absence.

Ahlgrensson's interiors have often been compared to
those by his contemporary Carl Larsson. Yet Larsson's
sunlit illustrations of happy, active family life have little
to do with Ahlgrensson's penetration into psychology
and silence. *Glowing Embers at Dusk* is more related to
the sets that Maurice Denis, Paul Sérusier, Paul Ranson,
and Édouard Vuillard designed for Lugné Poe's Théâtre
de l'Oeuvre (which Ahlgrensson would certainly have
attended since it opened in 1893, his year in Paris), and
particularly to Vuillard's interiors of the early nineties.
The Théâtre de l'Oeuvre presented modern Symbolist
theatre which was primarily foreign and Northern:
except for French works by Maurice Maeterlinck, only
work in translation was performed, with a
concentration on plays by Ibsen, Bjørnstjerne Bjørnson,
Strindberg, and the German Gerhart Hauptmann. Its
sets, true to Maeterlinck's feeling for the static theatre of
quotidian life, were fragmentary statements suggesting
more than portraying the tensions lurking beneath the
surface of simple domesticity (R. Goldwater, *Symbolism*,
1979, pp. 109 – 110). Yet like Vuillard, Ahlgrensson
also cherished the material comforts and serenity of
everyday life, which he blended so evocatively with the
blue Nordic twilight. [SMN/PG]

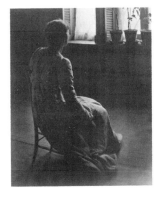

Clarence Hudson White
Evening—Interior 1899
Platinum print
19.0 × 15.2 (7½ × 6)
The Museum of Modern Art, New York
The moody introspection of women in
much of the imagery associated with the
Photo-Seccession of the 1890s belongs
to a female typology widespread in
Symbolism and is echoed in Ahgrensson's
portrait of his wife in *Glowing Embers
at Dusk.*

ANNA ANCHER Denmark **1859-1935**

Anna Ancher was born in the fishing village of Skagen on the northern tip of Jutland. She was the daughter of Erik Brøndum, owner of the tavern and hotel that became the focal point of the summer colony of artists who came to paint Skagen with increasing frequency after the mid-1870s.

Between 1875 and 1878 she studied during the winter months in Copenhagen at the drawing academy for women directed by Vilhelm Kyhn, a landscape painter. While her training under Kyhn must have been highly conventional, she must also have been fully aware of the new move toward Realism among the Skagen painters, in particular Michael Ancher, who began visiting Skagen in 1874, and Christian Krohg*, who first arrived in 1879.

In 1880 she married Michael Ancher. The two settled in Skagen, and it was at this time that Anna emerged as a serious artist. In 1882 she travelled to Vienna with her husband. She did not visit Paris until 1888; there she was immediately attracted to the circle of Pierre Puvis de Chavannes and studied drawing at his school for six months. In 1904 she was elected a member of the Copenhagen Academy. [ADG]

2

Lars Gaihede Carving a Stick 1880
Lars Gaihede snitter en pind
39.0 × 29.0 (15⅜ × 11½)
Signed lower right: "A.B. 1880"
Skagens Museum

Anna Ancher, née Brøndum, was an exception among the Skagen community of artists in that she was not only an accomplished woman painter, but a native Skagener as well. This painting must have been executed shortly before her marriage to Michael Ancher, since she did not use her maiden initials "A.B." after her wedding in August 1880. It is one of her first mature works and shows no trace of the somewhat clumsy and naive style of such earlier works as her 1878 *Return from the Church after a Burial* (Skagens Museum).

The subject of the painting is Lars Gaihede, one of Michael Ancher's favorite models. Gaihede was a member of a large Skagen family, and many of his relatives posed for other Skagen painters as well (see Christian Krohg's *The Net Mender*, cat. no. 51). Anna Ancher's orientation, like that of many Scandinavian artists then working in Skagen, is essentially Naturalistic, avoiding the sentimental and anecdotal qualities of mid-century depictions of peasant life. Using a palette similar to her husband's, Anna studies the model in an intimate, up-close view. Her main interest lies in depicting the play of light and the simple, concentrated action of Gaihede. The interior is described with little specificity, and the artist avoids the picturesqueness characteristic of her husband's work.

It was several years before Anna Ancher achieved a fully personal style. She received only sporadic training and surprisingly little encouragement. The Copenhagen critic Karl Madsen, for example, expressed a low opinion of her work. More daunting still was the advice she received from her professor of drawing, Vilhelm Kyhn. As a wedding present, he sent her a set of china accompanied by a note suggesting that she go down to the beach with her painting box and all her painting equipment and set them "to sail the seas, because now, as a married woman she would no longer want to be an artist, but a housewife." (biblio. ref. no. 12, p. 60) [ADG]

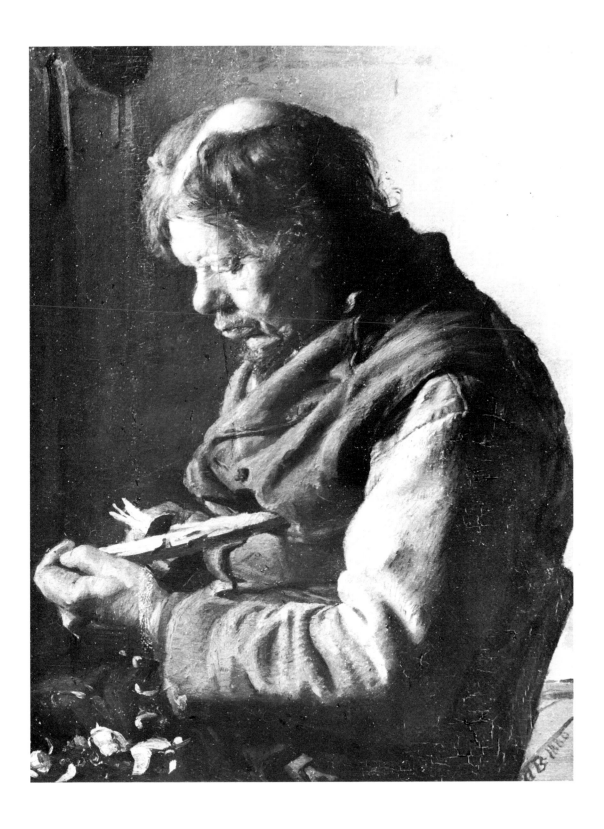

HARRIET BACKER Norway **1845-1932**

Born in 1845 in Holmestrand, a large shipping center on the Christianiafjord, Harriet Backer was the second of four daughters. Her parents encouraged her artistic aspirations, and Harriet began drawing lessons at the age of six with Joachim Carlmeyer, a former pupil of Norway's distinguished Romantic landscapist Johan Christian Dahl. In 1857, the family relocated to Christiania, where she attended Johan Fredrik Eckersberg's school from 1861 to 1865, Christian Brun's school from 1867 to 1868, and Knut Bergslien's painting academy from 1872 to 1874. She travelled with her family throughout this period, spending several winters in Berlin and Weimar and the winter of 1870 in Italy, where she devoted herself to copying the old masters.

Backer went to Munich in 1874 and studied briefly with Lambert Linder and, beginning in 1875, with Eilif Petersen*. In 1878, as younger Norwegian painters were becoming increasingly attracted to French Naturalism, she moved to Paris (along with Hans Heyerdahl and Kitty Kielland*), where she remained for ten years, sharing lodgings with Kielland. She received four large scholarship stipends that enabled her to paint in Brittany as well as in Paris. During her first two winters in Paris she took instruction from Jean Léon Gérôme and Léon Bonnat and briefly with Jules Bastien-Lepage, rapidly combining her experience of the darker tonalities of Munich colorism with the new tendencies. Backer's 1880 peasant interiors from Brittany are among her earliest works in this new style. She made her debut in the Paris Salon the same year.

In 1889 Backer returned permanently to Norway, spending the summer months painting in the valleys north of Christiania and the rest of the time teaching at her own painting school, which she managed until 1912. This school had a great influence on the younger Norwegian painters—Halfdan Egedius* and Harald Sohlberg*, among others, were Backer's pupils.

Backer's own lifetime production was rather small. She worked slowly and continued to paint her richly luminous Norwegian interiors until 1908-09, when she completed her final major series of church interiors from Opdal and Stange. During the last twenty years of her life, Backer concentrated primarily upon still lifes, which she had not undertaken seriously since her years in Munich. [SMN/TS]

3
Blue Interior 1883
Blått interiør
84.0 × 66.0 (33 × 26)
Signed lower left: "Harriet. Backer./Paris. 1883."
Nasjonalgalleriet, Oslo

Blue Interior, painted in Paris during the winter of 1883, is a key work in late nineteenth-century Norwegian painting, standing midway between the Naturalism of the 1880s and the mood paintings of the 1890s. In the 1890 Christiania Exhibition, Norwegian *Blaamalerei* triumphed. Blue had become the dominant tone, suppressing dissonances of local color in the search for emotional expression rather than illusionism. Some years earlier, in 1883, Backer's *Blue Interior* had been shown at the Autumn Exhibition in Christiania, where it was a great success in the local art community (R. Heller, "Edvard Munch's 'Night'," *Arts*, October 1978, p. 80). Both Erik Werenskiold and Andreas Aubert praised its courageous harmony of blue color and blue light. Backer later composed several variations of this quietly knitting woman suffused in light.

The emancipation of Backer's color had begun in 1881 with her interior *Andante* (Stavanger Faste Galleri), initiating a lifelong involvement with the study of daylight penetrating into and defining interior spaces. In *Blue Interior* the play of light animates all matter—the leaves of the plant, the brilliant red chest, and the seated figure in blue—although Backer never relinquishes her strong sense of compositional structure and design. In her reverent and perceptive transformation of a small corner of reality, Backer may have been stimulated by Alfred Stevens' celebrated interiors. One of Stevens' greatest triumphs had been at the 1878 Paris World Exposition; he exhibited fifteen paintings that must have come to Backer's attention during her first year in Paris.

In Backer's composition, the window, cut off from our view, no longer reveals the outside world; instead the light that it sheds unites the world inside in a coloristically determined mood of peace, contemplation, and silence. [SMN/TS]

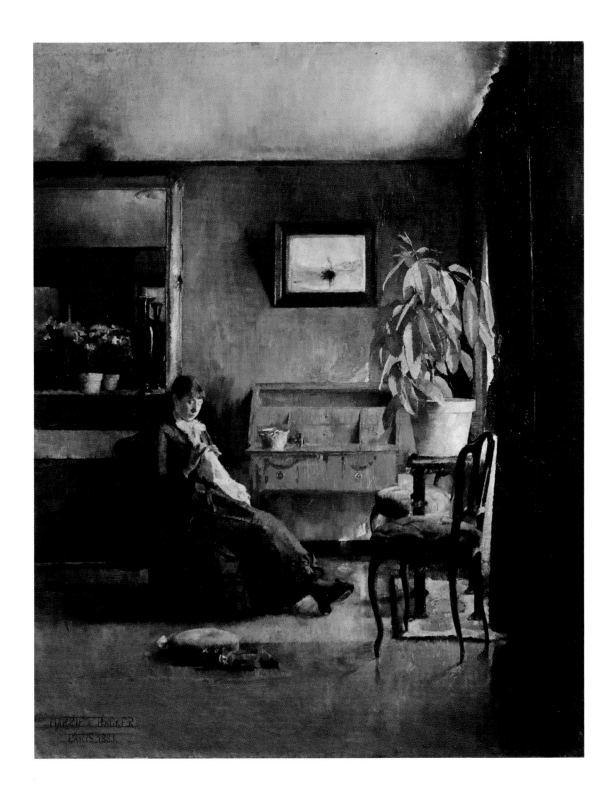

RICHARD BERGH Sweden **1858-1919**

The son of the prominent landscapist Edvard Bergh, Richard Bergh studied at Sweden's Royal Academy of Fine Arts, where his father was a professor, from 1877 to 1881. His early work depicted scenes from Scandinavian history or local legend in a German academic style. From 1881 to 1884 Bergh lived in Paris, where his art was transformed by the influence of Jules Bastien-Lepage and the Impressionists. He showed at the Paris Salon in 1883, '84, and '86, and established an international reputation as a portraitist. In Paris his style moved toward the emotional and lyrical. He was also interested in themes of the supernatural and in the kind of pseudo-scientific spirituality reflected in his large canvas *The Hypnotical Seance* (1887; Nationalmuseum, Stockholm).

Bergh played an important role as a critic, author, and organizer in the Swedish art world, first in the expatriate community in France and then, in 1885 and '86, as a rebel against the Swedish Royal Academy and as a founding member of the Artists' Union. Bergh was the society's president from 1890 to 1897 and its secretary from 1896 until his death. His efforts for a cooperative association of artists engaged in instruction, politics, and fund raising were modelled on the social art theories of William Morris and John Ruskin.

Bergh wrote extensively on art and was instrumental in defining the so-called National Romantic style in Sweden. Although he admitted to French influence on Scandinavian painting, he believed that Nordic art was independent because it sprang from an affinity with the native landscape. To exploit this "Nordic nature," he moved with Karl Nordström* and Nils Kreuger to the isolated and ancient town of Varberg in western Sweden and formed a new style of landscape painting. After 1900 Bergh's ideas had become widely accepted by the Swedish art establishment. In 1915 he was appointed head of the Nationalmuseum in Stockholm, where he undertook a thorough reorganization of the museum's galleries and administration. [EB/AC/PG]

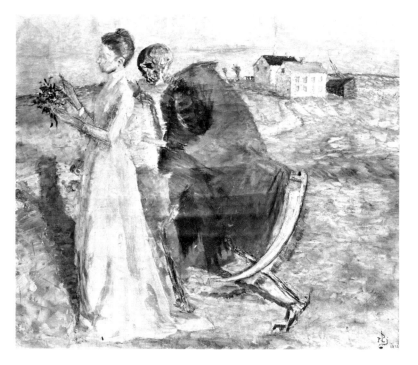

4

Death and the Maiden 1888
Flickan och Döden
71.5 × 83.5 (28⅛ × 32⅞)
Signed lower right (in monogram): "RB /1888"
Prins Eugens Waldemarsudde, Stockholm

Begun in Paris in 1888 and apparently left unfinished, *Death and the Maiden* represents a transitional period in Bergh's oeuvre. The free brushwork and sunlit space recall his earlier *plein-air* studies. The limited palette and the return to a Northern landscape, however, indicate a new departure, as does the macabre theme. In the late 1880s Bergh increasingly challenged the "lower-class" limitations of Naturalism with its "potato fields and breakfast tables" and called instead for a new beauty in art to "lift the senses" (see Richard Bergh, *Efterlåmnade skrifter*, Stockholm: A. Bonnier, 1921).

The motif of Death chosen by Bergh was fairly common in Scandinavian painting and literature around 1890, as artists turned to allegorical schemes in their initial reaction against Naturalism (compare, for example, Edvard Munch's *Death at the Helm*, 1893, Munch-museet, Oslo, or Laurits Andersen Ring's *Evening*, cat. no. 76). The medieval allegory of The Dance of Death had been revived in Germany, and Bergh may have had in mind contemporary German Decadent poetry of a similar theme, or Max Klinger's morbid print cycle *Ein Leben* (1881 – 84). On the original frame of Bergh's picture, in addition to a painted skull and cross, appears a quotation from *Der Tod und das Mädchen*, an uncharacteristically morose

work by the German poet Matthias Claudius (1740 –
1815):

Ein Mädchen windet Bluth und Klee
Es tritt heran
ihr wird so weh
Wer mag den Strauss vollenden

A maid twines blossoms and clover
He approaches her so that
he may finish the bouquet
[and end the suffering]

The maiden in the painting is Bergh's first wife
Helena Klemming. He had painted her in several earlier,
more cheerful portraits (Thielska Galleriet, Stockholm;
Nationalmuseum, Stockholm; Göteborgs
Konstmuseum). As her health declined during a long
illness, she was also the subject of such somber portraits
as *The Convalescent* (1887; Prins Eugens Waldemarsudde,
Stockholm). She died a year after *Death and the Maiden*
was completed.

In his work of the 1890s Bergh continued to search
for a resolution between a Naturalist landscape style and
visionary and allegorical subjects. *The Knight and the
Maiden* (1897; Thielska Galleriet, Stockholm) represents
such a combination, and a variation on the theme of the
present image. [EB/AC/PG]

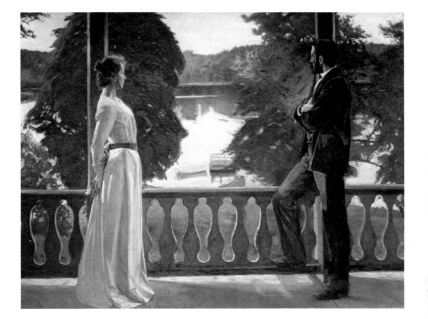

5 *Reproduced in color on page 6*
Nordic Summer Evening 1899 – 1900
Nordisk Sommarkväll
170.0 × 223.5 (67 × 86)
Signed lower left (in monogram):
"RB./1899 – 1900."
Göteborgs Konstmuseum

Nordic Summer Evening was begun in Assisi, Italy, in
1899 when the artist made an oil sketch of the singer
Karin Pyk. Later that same year he sketched his close
friend Prins Eugen* on the second-floor veranda of a
house on the island of Lidingö in Sweden. Bergh
incorporated both studies into this canvas of 1900. Prins
Eugen recalled the day that he posed as a model while
he, the painter Oscar Bjork, and Bergh discussed the
Dreyfus affair in France. "Modelling took some time,"
wrote Eugen, "but I did some good since Bergh's
painting was brilliant." He realized that the picture's
contemporary setting represented a breakthrough for his
friend. He also sensed that Bergh's trip to Italy allowed
the artist to "perceive with greater clarity and
naturalism than before" (Prins Eugen, *Breven berätta*,
pp. 261, 252).

In contrast to the overt symbolism of *Death and the
Maiden* (cat. no. 4), *Nordic Summer Evening* relies solely
on the mystical power of natural phenomena—light and
landscape—to heighten reality. During his stay with
Prins Eugen in Italy in 1897 and '98, Bergh apparently
developed a new appreciation of the unique Swedish
landscape. He believed that Scandinavia's midsummer
nights and midwinter scenes triggered primitive
emotional responses in its people, much as music may
arouse spiritual feelings. Sweden, to his mind, was a
new Eden, capable of inspiring poetry and art in those
who were willing to seek it. The emotional experience
of the Nordic summer evening also included a sexual
awakening, suggested here by the self-conscious stance
of the woman and the ambiguous psychological tension
that pervades the scene.

The lack of interaction between man and woman and
the relationship between figures and landscape are
highly reminiscent of Henrik Ibsen's plays. Ibsen often
directed characters to observe silently some action or
object in an area of the stage away from the audience.
He also frequently included a Nordic landscape
background seen through a window, as, for example, in
the play *Ghosts*. [EB/AC/PG]

NIELS BJERRE Denmark **1864-1942**

Niels Bjerre was born into a family of scholars, musicians, and politicians on his parents' farm near the rural West Jutland town of Nørrelund. Niels retained lifelong the native dress and indigenous tongue of West Jutland, and made his central occupation the recording of the landscape and peasant culture of the region.

Bjerre travelled to Copenhagen to study drawing in 1879 and two years later enrolled in Copenhagen's Royal Academy of Fine Arts, where he remained for seven years. His teacher Frederik Vermehren, a painter in the painstaking Naturalist tradition of Christoffer Vilhelm Eckersberg, strongly influenced his development. Having twice failed his final examination, he left the academy without graduating in 1888. The following winter he attended the *plein air*-oriented Artists' Study School established by Peder Severin Krøyer* and Laurits Tuxen (1853-1927).

Beginning in 1892 Bjerre exhibited annually at the radical artists' Free Exhibition. Inspired by seventeenth-century Dutch interior painting, his work consisted of portraits, domestic scenes, and images of religious revival meetings. The greatest of these, *The Prayer Meeting, Harboøre (The Children of God)* earned him a bronze medal in the 1900 Paris World Exposition.

Joining the Scandinavian pilgrimage to Italy, Bjerre travelled to Florence and Naples with Laurits Andersen Ring* from 1899 to 1901. He travelled to Paris and Auvergne in 1914, the Faroe Islands in 1925-26, and Holland, Belgium, and France in 1931. After 1906 he painted only desolate landscapes and dramatic vistas of his native Jutland. In 1930-31, commissioned by the Ny Carlsberg Foundation, he produced twelve large landscapes for the Lemvig Central Library.

Bjerre pursued literary interests as well as painting. In 1890 he translated Nietzsche's *Thus Spake Zarathustra* into his native tongue. His short stories and essays include *The Fisherman*, published under a pseudonym in 1891, and *The Sacred Congregation*, written in 1892 and published in 1932. [PGB]

6
**The Prayer Meeting, Harboøre
(The Children of God)** 1897
Bønnemøde. Harboøre (Guds Børn)
82.0 × 106.5 (32¼ × 41⅞)
Signed bottom center: "Harboøre.1897.Niels Bjerre"
Aarhus Kunstmuseum

Niels Bjerre lived among the peasants he painted, suffering their difficulties and representing them without Romantic idealization. From the time he wrote his essay *The Sacred Congregation* in 1892, he repeatedly painted images of the Home Mission evangelical movement in West Jutland. The Home Mission, documented in *The Prayer Meeting* (originally entitled *The Children of God*), incorporated the nationalistic revivalism of clergyman Nicolai Frederick Grundtvig (1783 – 1872) and the theological existentialism of Søren Kierkegaard (1813 – 1855). Renouncing the institution of the Church in favor of small evangelical enclaves, the converted, or "Children of God," practiced stern Biblicism, observed the Sabbath, and gave up such frivolity as dance and theater, thus separating themselves from the unconverted, or "Children of the Earth."

The weather-ravaged fishing town of Harboøre, the location of Bjerre's *Prayer Meeting*, was deeply affected by the Home Mission. Before the wave of evangelism, it had been a homogeneous community held together by fishing and dairy cooperatives, native customs, and religious worship in the local parish. The Home Mission's prohibition of Sunday fishing and dairy farming dissolved joint ownership of fishing vessels and dairy cooperatives between the "Children of God" and the "Children of the Earth," and created a hardship during an economically depressed period. Its social code further fragmented the community, reordering marriage and festival patterns. The local peasants retaliated by excluding the "Children of God" from community meetings and harassing them both verbally and physically.

Earlier in the century, religious evangelism had been the focus of the Düsseldorf-trained painters Christian Dalsgaard and Frederick Vermehren (Bjerre's teacher), who viewed prayer meetings as picturesque manifestations of peasant culture suitable for genre painting. Bjerre, however, had sympathies for the Home Mission, and, acutely aware of the emotional contradictions implicit in religious conversion, recorded *The Prayer Meeting* with keen psychological insight. His six figures are suspended in individual, self-absorbed reveries that undercut their religious collectivism.

The painting is vitalized by the compositional strategies of Christian Krohg*, whose work Bjerre had admired since the 1888 Northern Agriculture and Art Exhibition in Copenhagen. Vast jumps in scale from the looming foreground figure to the riveting woman in the back activate a nearly isocephalic ordering of figures. The low-angle view of the ceiling and the sidelong depiction of the windows underscore the claustrophobic

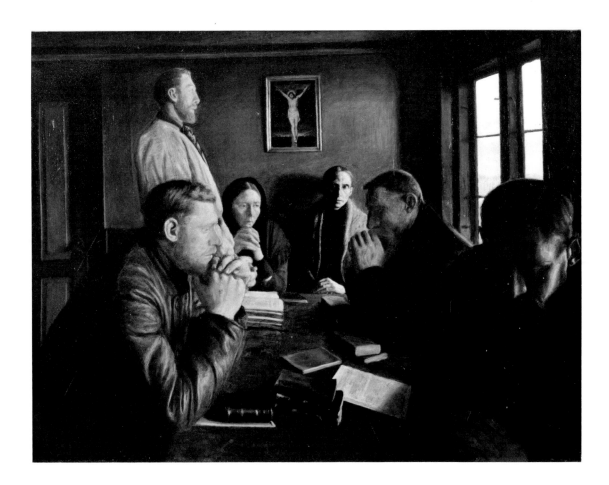

nature of the room, whose focus is the painted crucifix
on the far wall. The subtlety of color and psychological
intensity of the scene have often been likened to
Vilhelm Hammershøi's *Five Portraits* (cat. no. 30),
painted three years later.

The painting's current title, *The Prayer Meeting,
Harboøre*, defuses Bjerre's message by keeping the
religious orientation anonymous and implying group
participation. The original title, *The Children of God*,
stresses the pietists' painful alienation from their
once-familiar village community. [PGB]

ALBERT EDELFELT Finland 1854-1905

Albert Edelfelt, an aristocratic Finn of Swedish extraction, began his formal training at the Fine Arts Association in Helsinki at the age of sixteen. After a year he transferred to Helsinki University, where he remained until 1873. He moved to Paris in 1874 and studied intermittently at the École des Beaux Arts, under Jean Léon Gérôme, until 1878.

A fighter for Realism in Finnish art, Edelfelt influenced the younger generation of Scandinavian artists who studied in Paris—particularly his Finnish compatriot Akseli Gallen-Kallela*. He exhibited in the Paris Salon, the Salon des Champs-Elysées, and the Salon du Champ de Mars throughout the 1880s and '90s, and won a Grand Prix d'Honneur at the 1889 Paris World Exposition.

Enamored of "Norwegianism," Edelfelt believed that the Norwegian writers, painters, and composers whom he met in Paris possessed a cohesive creative spirit. Despite his strong cosmopolitan and Francophilic leanings, he had great hopes for a Finnish national art, and a strain of nationalism appeared in his own work in the late 1880s (for example, *Old Women from Ruokalahti on the Church Hill*, 1887).

National Romanticism grew throughout the 1890s, and Edelfelt incorporated Finnish themes more and more frequently into his work. Russian intervention in Finnish affairs culminated in Czar Nicholas II's February Manifesto of 1899 in which Finland became subject to Russian imperial legislation. In response, 523,000 Finns and a thousand European intellectuals signed a Pro-Finlandia petition defending Finland's right to self-government. Jan Sibelius composed his tone poem *Finlandia* that same year, and in 1900 Edelfelt, with his international reputation and French connections, persuaded officials of the Paris World Exposition to permit Finland its own pavilion—separate from the Russians with whom the Finns were often exhibited.

Also in 1900 Edelfelt created a series of drawings illustrating the *Tales of Ensign Stål*, patriotic poems by the Finnish poet laureate Johan Ludvig Runeberg. In 1904, the year before his death, the artist executed mural decorations in the old assembly hall at the University of Helsinki. These frescoes, depicting the inauguration of Finland's university in Turku in 1640, were destroyed in World War II. [SRG/SSK]

7
Sketch for Luxembourg Gardens 1886
Pariisin Luxembourgin Puistosta, Luonnos
Oil on wood
26.0 × 35.0 (10¼ × 13¾)
Not signed
Ateneumin Taidemuseo, Helsinki

Edelfelt had already achieved considerable success in official art circles by the mid-1880s. He won gold medals at the Salons of 1880 and 1882, and the French government bought his *Portrait of Louis Pasteur* (1885; Sorbonne, Paris). This work is the last sketch for the final version of the *Luxembourg Gardens* (1886 – 87; Ateneumin Taidemuseo, Helsinki). Both the sketch and the final painting represent the synthesis of lessons Edelfelt learned from French *plein-air* Naturalism.

In the sketch a maid adjusts the hair of a little girl, while an older woman gazes at them, and young children play in the open space that stretches back toward the faintly sketched barrier surrounding the Luxembourg Palace. The foreground figures in shadow contrast with the ladies and children who promenade in the bright, blond light illuminating the background. Chalky blues, grays, and sand dominate this scene of Parisian pleasures. The drawing is loose and the brushwork free.

Edelfelt altered his technique in the final version, replacing the loose, Manet-like application of paint with tighter draftsmanship and a more precise facture. Like his Finnish compatriots in Paris, Edelfelt was ambivalent about French Impressionism. The artist, friendly with French academic painters including his former teacher Jean Léon Gérôme, perceived Impressionism as a passing trend. He wrote in a letter home: "Tomorrow I will begin on my Luxembourg painting...I was at Gérôme's early this morning...He spoke a great deal about the Impressionists and the latest fashion in art, and not without bitterness...'to go in for this madness...it's pernicious. Take care. Don't let yourself be carried away. What is beautiful will always remain so, and they who only seek to follow the fashion will more readily become outmoded than those who work simply and honestly.' "

In the final work, roughly five-and-a-half times the size of the sketch, Edelfelt expanded his composition. The point of view is closer to the palace, reducing the broad, expansive middle-ground of the sketch to a shorter and more restrained space. The final version of *Luxembourg Gardens* was completed too late for exhibition in the 1887 Salon but was shown instead in an international exhibition at George Petit's Gallery. Arranged by Claude Monet, Auguste Rodin, and Edelfelt, among others, the exhibition also included the Scandinavians Peder Severin Krøyer* and Carl Larsson. [SRG/SSK]

Albert Edelfelt
Luxembourg Garden 1887
144.0 × 188.0 (56⅝ × 74)
Ateneumin Taidemuseo, Helsinki

8
Kaukola Ridge at Sunset 1889
Kaukolan Harju Auringonlaskun Aikaan
116.0 × 83.0 (45⅝ × 32⅝)
Signed lower right: "A. Edelfelt"
Ateneumin Taidemuseo, Helsinki

Kaukola Ridge at Sunset falls at that crucial juncture in Edelfelt's art when he sought to synthesize Parisian sophistication with Finnish nationalism. In the late 1880s and early 1890s Edelfelt painted several works that reflected his change in values. The artist experienced a tremendous pull toward native subjects as early as 1886. He wrote then in a letter to his mother: "I have thought a great deal about making a trip to northern Finland, possibly with Gallén if he will join me. I must see wilder terrain…see summer light and real Finnish Finns. Tar boats, wilderness [and] rapids…are beginning to take hold of me" (Jukka Ervamaa, "Albert Edelfelt's The View from Kaukola Ridge," *Ateneum Taidemuseo Museojulkaisu*, vol. 20, 1975 – 76, p. 44).

In 1887 Edelfelt travelled to southeastern Finland to illustrate an article for *Harper's New Monthly Magazine.* This trip sharpened his sensitivity to the Finnish landscape, and in early summer 1889 he and his wife Ellan de la Chapelle journeyed to Saari in northern Finland, where he painted *Kaukola Ridge at Sunset.*

The still body of water that reflects its surrounding landscape is the western part of the sound leading from Lake Kuivajärvi to Lake Pyhäjärvi. The high horizon line and insistent verticality of the picture blend the smooth sound and sky into one unit. Islands and evergreens punctuate the expansive, predominantly gray backdrop. Edelfelt's familiarity with French Naturalism is evident in the subtle, overall luminosity of the work, but the atmosphere is crisper and cooler than in works from his Parisian period (see *Sketch for Luxembourg Gardens*, cat. no. 7).

Kaukola Ridge was shown in Paris in 1890 at an exhibition arranged by the Société National des Beaux-Arts and was reproduced in the catalogue. The painting was never exhibited in Finland during Edelfelt's own lifetime but beginning in 1893 was known there in reproduction. Finnish art historian Bertel Hintze postulated that the picture might have spawned a new school of National Romantic lake paintings (*Albert Edelfelt*, Porvoo, 1953). Lake scenes painted from particularly high viewpoints were popular in the 1890s and into the early years of the twentieth century in both Finland and Sweden. [SRG/SSK]

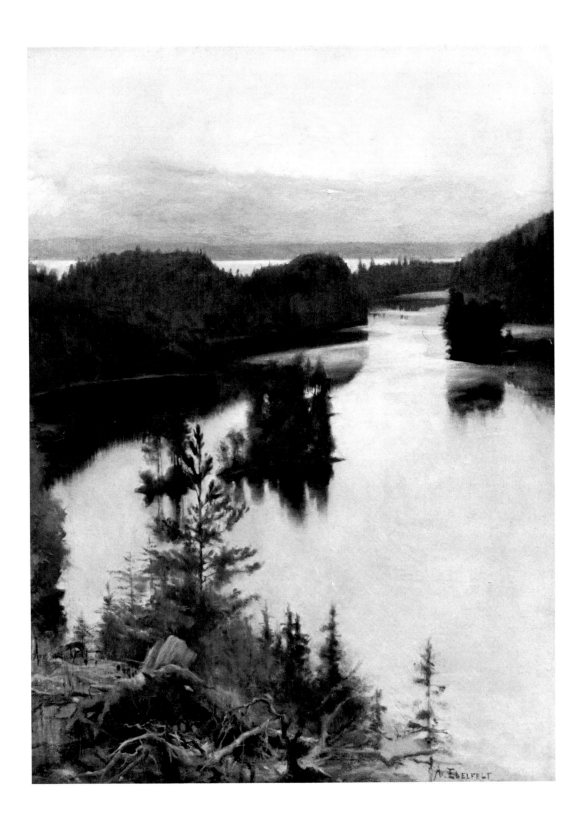

9
Särkkä 1894
63.0 × 91.0 (24¾ × 35⅞)
Signed lower right: "A. Edelfelt/1894"
Ateneumin Taidemuseo, Helsinki

As Karl Nordström does in his *Varberg Fort* (cat. no. 72), Edelfelt here chooses an innately Romantic subject—a weathered fortress on the sea—and emphasizes its evocative power with a dramatic use of light and space. Isolated against the sweep of the water and silhouetted at the edge of gathering night, the blunt outcropping is heavy with connotations of lonely, heroic survival. The structure represented is the Viapori Fortress in Helsinki Harbor, scene of an historic surrender to Russian forces in the war of 1808–09. Given the continuing Russian threats to Finnish autonomy in the 1890s, Edelfelt could hardly have chosen this view without an awareness of its bitter associations. The National Romantic context helps to explain the rhetorical sweep of the conception. [SRG/SSK]

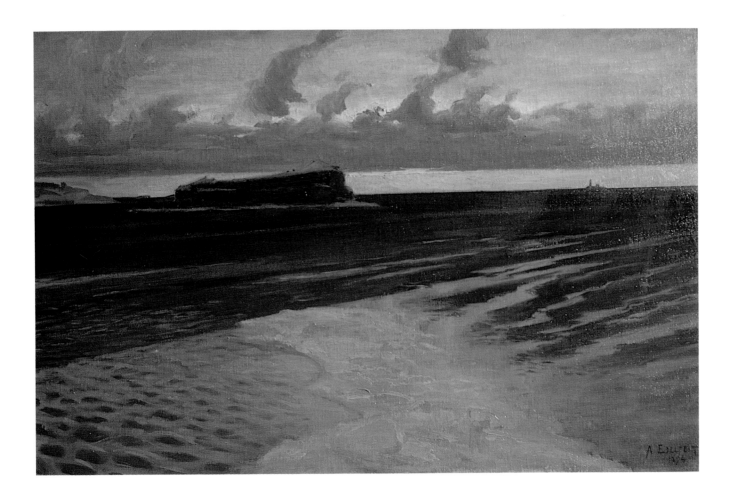

HALFDAN EGEDIUS Norway 1877-1899

Halfdan Egedius, the son of a railroad accountant named Carl Johnsen, was born in the town of Drammen, thirty miles south of Christiania. Exhibiting a prodigious talent for drawing, he was sent at the age of nine to study under Knut Bergslien (1827-1908).

From 1886 to 1889 Halfdan, who later changed his name from Johnsen to Egedius, attended Bergslien's school of painting in the studio building "Pultosten." There he came to know Christian Krohg's* circle of painters, particularly Thorvald Erichsen, (1868-1938; cat. no. 16), who showed an immediate interest in his work.

In the summer of 1890 Egedius accompanied Erichsen to a farm in the Krøderen district where they practiced *plein-air* painting. The next year he enrolled in Christiania's Royal Academy of Drawing and then studied under Erik Werenskiold (1855-1938), whose interest in native Norwegian topography and customs significantly shaped his artistic outlook. At Werenskiold's prompting, he made a pivotal trip to the remote southern region of Telemark in the summer of 1892. There he met Werenskiold's former student, the painter Thorleiv Stadskleiv (1867-1946), who rapidly became his intimate friend. For the rest of his life, he and Stadskleiv summered in Telemark.

In the summer of 1893, Egedius painted his first masterpiece, *Saturday Evening* (Nasjonalgalleriet, Oslo), a moody, atmospheric landscape that marked the beginning of his tendency toward nature mysticism. The following year, he debuted in the Christiania Autumn Exhibition and with Harald Sohlberg* catapulted to fame as the leader of the Neo-Romantic movement.

After briefly attending Harriet Backer's* school in 1894, Egedius made his sole trip outside of Norway to study in the Copenhagen studio of Kristian Zahrtmann. Upon his return to Telemark in 1895, he painted *Midsummer Dance* (Nasjonalgalleriet, Oslo), the first of his interpretations of indigenous peasant customs. Inspired by Edvard Munch's* psychic Naturalism, he had assumed by 1896 a fully Symbolist aesthetic best exemplified by *Play and Dance* (cat. no. 11).

Egedius executed drawings for Fridjof Nansen's two-volume history *Farthest North* in 1896, and as a result Gustav Storm engaged the artist to illustrate the *Snorre Sturluson Sagas* the following year. Other artists on the project included Christian Krohg, Eric Werenskiold, Eilif Peterssen*, and Gerhard Munthe. Like Munthe, Egedius interpreted the mythic sagas in an archaizing, supernatural style that vitalized his landscape painting. The Snorre saga illustrations occupied Egedius until his death in 1899 of an acute, degenerative disease. [PGB/TS]

10
The Dreamer 1895
Drømmeren
100.0 × 81.5 (39⅜ × 32⅛)
Signed lower right: "H. Egedius 1895."
Nasjonalgalleriet, Oslo

Egedius painted this brooding portrait of Thorleiv Stadskleiv in the summer of 1895. The setting is Stadskleiv's cabin "Bøstua," which Egedius perceived as his own spiritual center. Earlier, in November 1894, he had written from Christiania: "It is strange how, suddenly in a room where everything is alive, I can sit and think about our sitting-room and our life last summer and fall. It is as if I don't know where I belong" (Halfdan Egedius to Thorleiv Stadskleiv, Nov. 15, 1894, in Østvedt, "Egedius og Stadskleiv," p. 194). In a separate letter, he expressed a strong desire to paint Stadskleiv's portrait.

Stadskleiv, a native of Bø, thought himself blessed with peasant "second sight." He frequently had visionary experiences, including a premonition of Egedius's early death. Egedius and Stadskleiv shared a Romantic preoccupation with mysticism and would sit through the night before their white stone fireplace, while Stadskleiv told supernatural tales drawn from local folklore. Their nocturnal sessions often provided ideas for their work. *The Dreamer* seems to represent the fatigued Stadskleiv at the conclusion of such a session.

The Dreamer echoes the Saturnine figure of Albrecht Dürer's engraving *Melancholia I* (1514), much celebrated during the nineteenth century for its associations with insanity and death as well as with artistic creativity, clairvoyance, and intuition. In the Romantic tradition of Delacroix's *Michelangelo in his Studio* (1851; Musée Fabre Montpellier), Egedius draws upon Dürer to represent Stadskleiv as the melancholic artist isolated in his studio. While Delacroix surrounds Michelangelo with the material attributes of his vision, Egedius isolates Stadskleiv, underscoring his inner vision. The enframing fireplace separates the artist from a room that is only obliquely defined through fragmentary furniture and architectural elements. The room is further abstracted through its self-enclosure: the window is only implied by light cast on the floor, removing the scene from any direct contact with nature.

Artists in the 1890s gave the imagination free reign as the Symbolists came to view the inner life of the mind as preeminent over the material world. Egedius wholeheartedly subscribed to this credo and, in portraying the peasant-artist as self-absorbed visionary, gave prominence to Stadskleiv's mythic, fecund mental life. [PGB/TS]

Eilif Peterssen
Portrait of Arne Garborg 1894
133.0 × 106.0 (52⅜ × 41¾)
Nasjonalgalleriet, Oslo

As Magne Malmanger (Curator, Nasjonalgalleriet, Oslo) has noted, this introspective portrait of novelist, poet, and journalist Arne Garborg (1851 – 1924) is strikingly similar in posture and mood to Egedius's *The Dreamer*. Peterssen and Egedius were in close contact during the mid-1890s and it is likely that Egedius was inspired by this portrait, which was painted in 1894 and purchased by the Nasjonalgalleriet the following year.

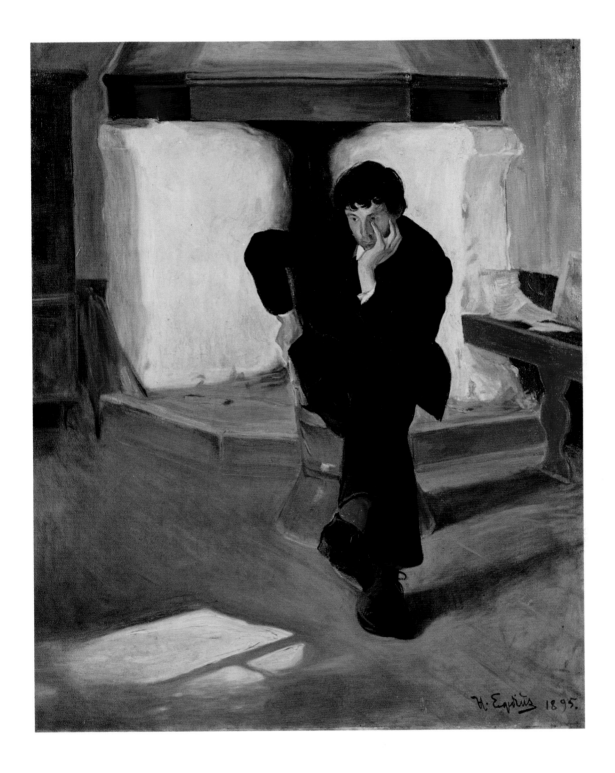

11
Play and Dance 1896
Spill og dans
83.0 × 95.5 (32⅝ × 37⅝)
Signed lower right: "H. Egedius/96."
Nasjonalgalleriet, Oslo

Musical theory played a significant role in Romantic and Symbolist aesthetics and was used at the end of the nineteenth century as a justification for dispensing with Naturalistic representation. Music and dance were ideal vehicles for one of Egedius's chief preoccupations, the physical expression of internal mental states. *Play and Dance,* begun in Telemark during the summer of 1896, exemplifies this interest.

Falling into a long tradition of musician-enchanters in art, the fiddler in *Play and Dance* has clearly taken possession of the ecstatic dancers in the background. The furious brushwork and theatrical lighting bring to mind Delacroix's portrait of violinist *Nicolo Paganini* (1830; Philips Collection, Washington, D.C.), the quintessential Faustian musician whom the critics called unearthly and possessed, and who bewitched audiences with his virtuosity. Telemarkian folklore included the *fossegrim,* a fiddler inhabiting mills and waterfalls who would exert an uncontrollable power over all who heard him play, and the great violinist Olle Bull (1810-1880), Norway's "flaxen-haired Paganini," was said to have learned to play from such a creature. Egedius knew Ernst Josephsen's controversial *Water Sprite* (see below), in which the *fossegrim* is transformed into the folkloric incarnation of wantonness. The hypnotic gaze and slackened mouth of Egedius's fiddler mirror the water sprite's self-induced ecstasy. His satyr-like features (the painter Thorleiv Stadskleiv was the model) glow from the darkened canvas, demonically distorted in the spectral second head that thrusts out from the fiddler's neck. The multiple depictions of the fiddler's head and violin infuse the scene with a sense of high irrationality.

Per Hesselberg's well-known sculpture *Magnetism* (1883-84; Göteborgs Konstmuseum) provided a model image of hypnosis as a tool of seduction, a popular notion in the eighties and nineties. Egedius drew upon this imagery in *Play and Dance,* fusing it with regional concerns. His fiddler plays the highly ornamented *hardanger* fiddle native to the region, and the spinning dancers wear Telemarkian festival garb. Telemarkian fiddle music and folk dance greatly interested the Norwegian ethnographers associated with the National Romantic movement of the latter half of the century, and Egedius's mixture of native custom and modernism, resulting in the psychological interpretation of peasant culture, was central to the concurrent Neo-Romantic movement in painting.

Egedius viewed *Play and Dance* as his most challenging work. Its resolution evaded him, and he lamented on his deathbed in 1899 that the fiddler would remain unfinished. [PGB/TS]

Ernst Josephson
Water Sprite 1884
Strömkarien
216.0 × 131.5 (73 × 51¾)
Prins Eugen Waldemarsudde, Stockholm

AUGUST EIEBAKKE Norway **1867-1938**

August Eiebakke was born on his parents' farm in Askim in the spring of 1867. An aspiring sculptor, he enrolled in Christiania's Royal Academy of Drawing in 1883. Remaining there on and off until 1889, he developed his technical skills under sculptor Julius Middelthun. The Romantic Naturalism of Erik Werenskiold shaped his early sensibility, and from 1886 to 1888 Eiebakke studied *plein-air* painting under the leading French-trained proponents of Naturalism, Christian Krohg*, Eilif Peterssen*, and Hans Heyerdahl.

Eiebakke debuted at the Christiania Autumn Exhibition in 1887, exhibiting regularly until 1933 and winning critical acclaim in 1891 with *Laying the Table* (cat. no 12). In January 1892, he entered the Copenhagen studio of Kristian Zahrtmann, wishing to branch out stylistically into a more Synthetic realm. He travelled to France, Holland, and Belgium in the following year and then in 1894 trailed the migration of Danish artists to Italy. In the winter of 1895-96 he returned to Italy, where, swayed by the Grundtvigian fundamentalist religious movement, he painted altarpieces and Danish religious motifs akin to the work of Joakim Skovgaard (1856-1933).

In 1897 Eiebakke joined Halfdan Egedius* and Erik Werenskiold in illustrating Fridtjof Nansen's Arctic Circle chronicles *Farthest North*, which were published concurrently in Norway, Germany, and England. He briefly studied with Zahrtmann the following year, returning to his early Naturalist style.

Eiebakke married Christine Fasting in December 1904, honeymooning in Italy, Denmark, and Germany. In 1910 he began teaching at the Royal Academy of Drawing, where he served as director from 1912 until 1937, when infirmity forced him to retire. He died in Oslo in 1938. [PGB/TS]

12
Laying the Table 1891
Anretning
93.5 × 120.0 (36¾ × 47¼)
Signed lower left: "August Eibakke/1891."
Nasjonalgalleriet, Oslo

Laying the Table, touted by Christian Krohg*, Erik Werenskiold, and Eilif Peterssen* as the apogee of Naturalism, was a turning point in Eiebakke's career. It was purchased from the 1891 Christiania Autumn Exhibition by the Nasjonalgalleriet and was awarded a gold medal at the 1900 World Exposition in Paris. Eiebakke developed the idea for this four-figure composition, his most ambitious to date, while staying on his parents' farm in the spring of 1891. On May 17 he wrote of his intent to critic Andreas Aubert, stating his dissatisfaction with banal Realism: "Neither I will [sic] depict poverty with wasted faces and herring and potatoes, or snobbish people in vulgar interiors, but a scene where well-being and satisfaction are shown as I have known it . . ."

Eiebakke's family, posed in Sunday best, modelled for the four figures. The artist reported that his progress was often interrupted throughout the summer because members of his family had to leave their austere oak-lined parlor to work the fields. The painting, which at one time also bore the title *Guests at Home,* records the strict social conventions of a Sunday or holiday visit on a southern Norwegian farm. The "well-being" of the familiar table-setting ritual is tinged with an air of anticipation. The guests awkwardly wait for the table to be set with the cheese, butter, heavy sour cream, and holiday bread that by convention they must refuse several times before being served. Preoccupied with the significance of physiognomy, Eibakke repeatedly sketched his subjects to master the subtlety of their expressions. In so doing, he captured the tension of the hostess and her guests in their introspective poses, endowing the scene with psychological undercurrents reminiscent of Henrik Ibsen's dramas.

To our eyes *Laying the Table* may be pure Ibsen, but critics of both the Norwegian and French exhibitions viewed the painting as a masterfully rendered tranquil interior. They particularly noted the serene backlighting and rich coloration and marveled at the luminosity of the linen tablecloth. The room at once resonates with tension and placid simplicity, reflecting Eiebakke's adaptation of the ambiguous narrative, if not the stylized form, of Symbolist impulses arriving in Norway from Paris and Berlin. [PGB/TS]

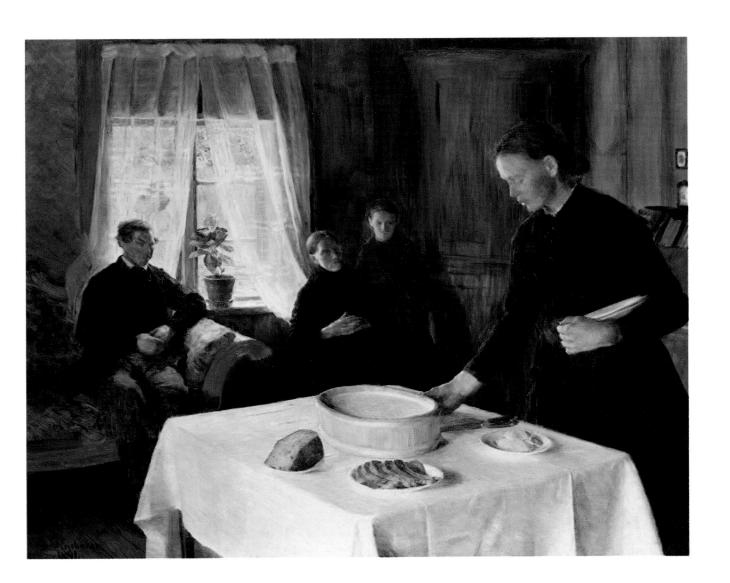

PRINS EUGEN Sweden 1865-1947

Eugen Napoleon Nicholas, Duke of Närke, was the youngest son of King Oscar II of Sweden and Norway, and the brother of the future king, Gustav II. He decided at twenty to become an artist—a sensational decision for a member of the Swedish royal family. He studied in Uppsala from 1885 to 1886 with the *plein-air* landscapist William von Gegerfeld. In 1887 he left for Paris and was taught at various times by Léon Bonnat, Henri Gervex, and Pierre Puvis de Chavannes. Eugen exhibited with the rebellious Artists' Union (whose members included Ernst Josephson and Richard Bergh*) and shared their progressive views, but could never officially join the organization because of his social position.

Influenced by the work of Max Klinger, Arnold Böcklin, and early nineteenth-century Northern Romantic painting, Prins Eugen specialized in monumentalized landscapes of a decidedly anti-Naturalistic mood. He was encouraged to experiment in fresco painting after a trip to Italy in 1892, and painted large frescoes for the foyer of the Royal Opera House (1898), the hall of the Stockholm North Latin School (1901), the Drama Theater (1908), and (in a Cubist-derived style) the City Hall (1922-23).

In 1899 Prins Eugen acquired property at Waldemarsudde on Djurgårdin island near Stockholm and in the following years built a house there designed by Ferdinand Boberg. As he worked increasingly at Waldemarsudde, he began to concentrate on the nearby urban and harbor vistas. Waldemarsudde became a center of artistic activity as Eugen constructed a large studio, designed decorative objects, and expanded his collection of contemporary Swedish and international art. He exhibited at the Paris World Exposition of 1889 and the Chicago World's Fair of 1893, and visited America in 1912-13 when his work was included in an exhibition of Scandinavian art. [EB/AC/PG]

13
The Forest 1892
Skogen
150.0 × 100.5 (59 × 39½)
Signed lower right: "Eugen/1892"
Göteborgs Konstmuseum

The year 1892 marked the beginning of Prins Eugen's individual style. Although he continued to sketch out-of-doors, in his finished paintings he sought a more lyrical and studied mood based on rigorously structured compositions and evocative simplification of form. He favored dramatically lit landscapes and depended on the special colors of dawn, sunset, and the Nordic summer night.

Eugen spent the summer and part of the autumn of 1892 at Fjällskäfte in eastern Sweden near Valla Station. He painted the deep forests of the area from several different approaches; *Forest Clearing* (1892; Prins Eugens Waldemarsudde, Stockholm), for example, presents a more open, less intimidating image of the woods. *The Forest* was the most abstract of the series and was considered the most important by the artist. For Eugen, the power of primeval nature was a vital source of Nordic identity. Such association of the self and the *volk* with the native landscape was a particularly Northern phenomenon of the nineteenth century, enjoying a revival in Sweden in the 1890s with the style known as National Romanticism.

Although it never truly departs from reality, the picture is a highly abstract, symmetrical arrangement of texture and vertical line. Upon seeing *The Forest* in 1892, Richard Bergh* marvelled: "A pine forest at dusk; a glint of the evening sun between the tall blue trunks which resemble thousands upon thousands of majestic pillars in a boundless church—in nature's own great temple. Over there, the glow of the evening sun—many miles away—resembles a faintly shining choir window with gilt glass, towards which all the pillars, tall and majestic, lead..."

The combination of moody nocturne and insistent Art Nouveau verticality link this painting to a broad spectrum of forest images in international Symbolism of the 1890s and early 1900s and to artists as diverse as Belgium's Fernand Khnopff, the American photographer Edward Steichen, and the young Piet Mondrian. [EB/AC/BF]

Far left:
Piet Mondrian
Woods 1898 – 1900
Boslandschap
Watercolor and gouache on paper
45.5 × 57.0 (17⅞ × 22½)
Gemeentemuseum, The Hague

Left:
Fernand Khnopff
In the Fosse. Under the Fir Trees 1894
A Fosset. Sous les sapins
65.5 × 44.0 (25¾ × 17⅜)
Galerie Isy Brachot, Bruxelles and Paris

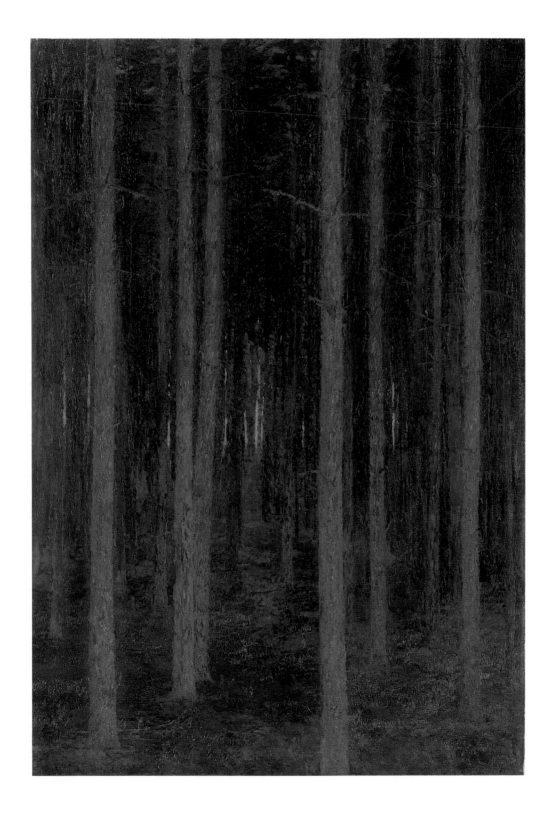

14
The Cloud 1896
Molnet
112.0 × 103.0 (44⅛ × 40½)
Signed lower right: "Eugen/1896"
Prins Eugens Waldemarsudde, Stockholm

Heinrich Kuehn
A Summer Day 1898
Ein Sommertag
Blue pigment gum-bichromate print
78.7 × 52.6 (31 × 20⅞)
The Metropolitan Museum of Art, New York
The Alfred Stieglitz Collection, 1933
The striking resemblance between Kuehn's photograph and
Prins Eugen's *The Cloud* may owe to the two artists' common
admiration for the nature lyricism of the German painters
(such as Otto Modersohn) who painted at Worpswede in
the 1890s.

Prins Eugen spent his summers in the remote regions of
the Scandinavian countryside—first in Norway, then on
the island of Tyresö near Stockholm, which provided
most of his subjects in the 1880s and '90s. Although he
sought direct contact with nature to inspire the
contemplative mood of his landscapes, he often began
with a graphic design in mind before moving
out-of-doors to find a corresponding natural motif. His
working method accounts for the abstract quality and
the artful symmetry and silhouettes of his landscapes.
Such is the case with *The Cloud*, a second version of a
subject first painted in 1895. The earlier work
(Göteborgs Konstmuseum), although highly abstracted,
seems like an oil sketch from nature in comparison. The
later composition is dominated by a strong sense of
two-dimensional design: the elliptical curve of cloud in
the upper sky, the serpentine path, the undulations of
the hill and tree line. The woods emerge as eerie and
suggestive forms of indiscernible mass and volume, in
contrast to the specific weight and texture of the large
cloud that looms ambiguously beyond. A strange
quality of light also cleaves the canvas into a brilliant
blue sky set off against a dusk-enshrouded foreground.

In a scene devoid of human life or literary, historical
connotations, Prins Eugen creates a subtly disturbing
image by abstract devices alone. His is a pure Symbolist
landscape. Unlike Arnold Böcklin or Pierre Puvis de
Chavannes, Eugen generates emotions and sensations
entirely within the setting, without using supernatural
or allegorical elements. The formal reduction of nature
and concentrated absence of life recall scenery by
Vilhelm Hammershøi (see cat. nos. 28 and 32),
although Eugen relies on more dramatic means to
arouse a feeling of the sublime in Nordic nature.

Prins Eugen's account of *The Cloud*'s conception sheds
a revealing light on his subjective working method
during these years: "Once I suddenly saw with my
inner eye a play of lines and a mass effect that I found
pleasing and suggestive. I draw [sic] the lines on a large
canvas. The light effect that I needed in the center I first
thought to achieve thanks to a sun, but this form proved
to be too small. It had to be a large circle and it became
a cloud. I was studying cumulus clouds during this
period. After I had got a clear idea of the general
composition I went out into nature and immediately
found a hillside and a group of trees. With a little good
will I could divine a path. The whole corresponded to
my intentions, or so I thought. Then I worked out my
motif quite thoroughly on the spot in front of nature,
but when I came back there the following year I could
not recognize the motif any longer, nor could anybody
else" (cited in *Tidskrift for konstvetenskap* 23, 1940/41, p.
102). [EB/AC/PG]

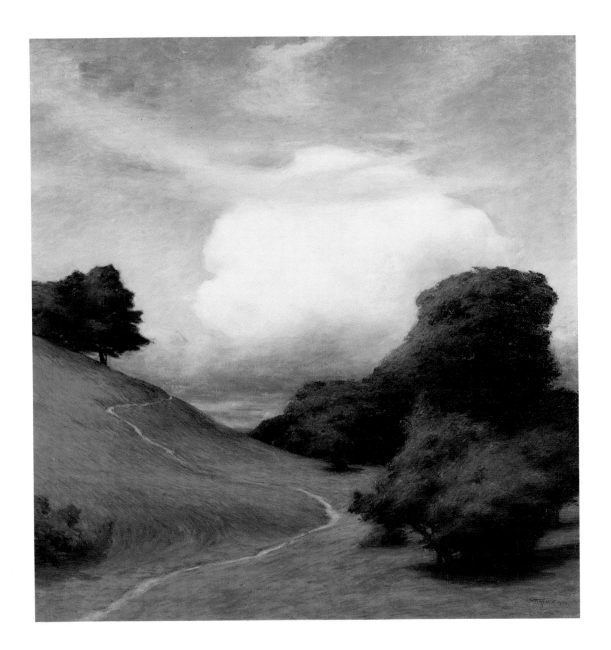

15

Still Water 1901
Det lugna vattnet
142.0 × 178.0 (55⅞ × 70⅛)
Not signed
Nationalmuseum, Stockholm

Still Water is one of the last and most intensely lyrical of Prins Eugen's Romantic landscapes. At the end of the century he visited Tyresö less frequently as he involved himself with the building of his home Waldemarsudde and his monumental fresco projects. In August 1901, however, he abandoned his work in the city for a brief retreat in the solitude of Tyresö: "Here it is beautiful and still...I work and wander around the hills. However, I am in a big hurry to start work on a large picture: a little round lake, that is, like a pool in the bottom of a kettle, calm and black, untouched by winds that drive the clouds high up in the air" (Prins Eugen, *Breven berätta*, pp. 275 – 276; letter dated August 15, 1901).

Once again the artist transformed a motif observed in nature into an arbitrary and forceful composition. Two-thirds of the canvas are devoted to the play of the turbulent sweep of sky, in contrast to the still silhouette of forest and the implacable pond below. The symmetry of the composition reinforces the contrary moods. Striated violet clouds flow into a thin line of yellow sunset that creates a luminous glow on the distant horizon. The overview onto the oval pond, flat and black in the foreground, is juxtaposed against the sudden pull of space through the woods in the direction of the rushing clouds and creates an odd sensation. As usual, there is no human presence in the landscape. "I want to people my landscapes myself and I want to reign supreme there," Eugen once wrote. "Oddly enough my landscapes have nearly always peculiar, actually wrong proportions in which a figure would never fit" (*Til Prins Eugen*, p. 32).

Eugen's dramatic use of a seemingly infinite horizon, his precise delineation of the landscape, and his thin brushwork and unnatural colors have more in common with the German school of Romantic landscape than with the Parisian milieu in which he was trained. During the summer of 1901 Eugen also painted *The Night Cloud* (Thielska Galleriet, Stockholm), which, like *Still Water*, is a symmetrical composition with a dark, opaque body of water set beneath a stormy sky. [EB/AC/PG]

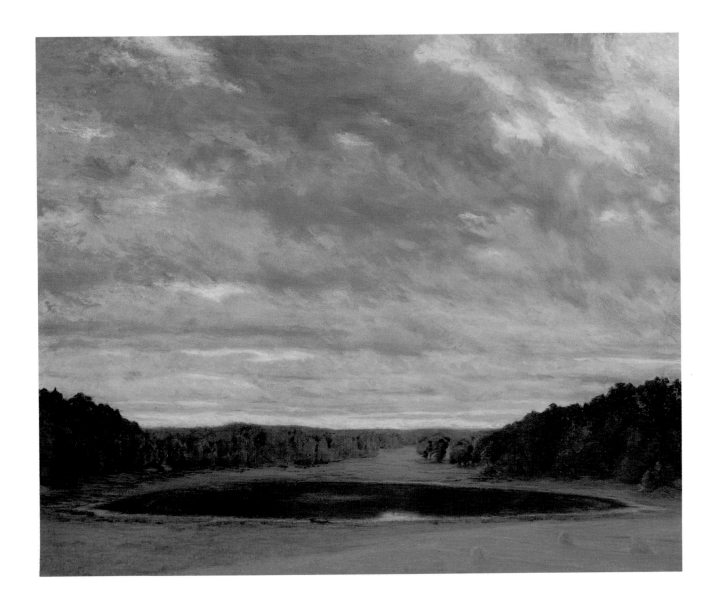

LUDVIG FIND Denmark **1869-1945**

Ludvig Find was the son of the theologian and minister Carl Vilhelm Find. He trained first at the Jensen-Egebergs technical school and then at Copenhagen's Royal Academy of Fine Arts, which he entered in 1886. Dissatisfied with the academic curriculum, he left in 1888, and studied with Peder Severin Krøyer* at the Artists' Study School.

Find was introduced to more advanced French painting, including the decorative style of Paul Gauguin, at the French Exhibitions in Copenhagen in 1888 and '89, and soon joined the reaction against Naturalism that occupied the Copenhagen art scene in the 1890s. Although he made his debut at Charlottenborg Palace in 1889, his first impact on the critics came in 1893 with an exhibition at the Kleis gallery in Copenhagen. A review in the newspaper *Taarnet* cited him as an exemplar of the new Symbolism.

Find exhibited at Charlottenborg until 1896 and was part of the Free Exhibition in Copenhagen in 1897. Following the more insular period of Romantic nationalism of the 1890s, he was one of the first Danish painters to renew contact with current French painting after 1900. He made his reputation as a portrait painter with a particular talent for depicting children. The majority of his work dates from the early twentieth century, and his mature style consists of a loose and bold use of color inspired by Pierre Bonnard and Édouard Vuillard. [EB]

16

Portrait of a Young Man. The Painter Thorvald Erichsen 1897

Portraet av en ung mand. Maleren Thorvald Erichsen

113.0 × 97.5 (44½ × 38¼)

Signed lower left: "Find '97"

Den Hirschsprungske Samling, Copenhagen

Find made his debut in the radical Danish artists' Free Exhibition (*Den frie Udstilling*) in 1897 with *Portrait of a Young Man. The Painter Thorvald Erichsen*. The painting was also shown at the Paris World Exposition of 1900 where it won a bronze medallion. It represents a period in Find's career when his affinity with Symbolism was strongest and he had not yet developed the cheerful and painterly style of his maturity. Its subject, Thorvald Erichsen (1868 – 1938), earned his fame after the turn of the century as a landscapist of a bold and loose colorism inspired by Pierre Bonnard.

Find depicts the young Erichsen sitting on a birch wood sofa of Neo-Classical design with patterns of inlaid ebony. Behind him are several photographs of paintings framed together: Taddeo Gaddi's *Presentation of the Virgin*, Masaccio's *Expulsion of Adam and Eve*, and Duccio's *Washing of the Feet*, works that Find saw in Florence and Siena in 1893–94. The style of the Italian primitives was emulated by certain Danish painters of the nineties who wished to achieve a simple, pure form of spiritual expression in their own art. Find's use of these images makes the painting a manifesto of sorts, proclaiming the artist's allegiance to the Symbolist movement.

Erichsen sits stiffly, betraying the self-conscious intensity of a young bohemian artist. The anti-Naturalism of the painting is apparent in comparison to the most famous friendship picture in Danish art, Christen Købke's *Frederik Søndring, the Painter* (1832; Den Hirschsprungske Samling, Copenhagen), which is candid, intimate, casual, and warm. By contrast, Find's portrait is proper and distant, a mood best exemplified by Erichsen's hands, the right clenched and held by the left in tense restraint.

The formality, the sombre palette, and the tight brushwork recall the portrait style of Christoffer Vilhelm Eckersberg, the father of Danish Golden Age painting. Find also uses a Neo-Classical sofa almost identical to that depicted by Eckersberg in his portrait of *Madam Schmidt* (1818; Den Hirschsprungske Samling, Copenhagen; see biblio. ref. no. 23, p. 41). Find was encouraged to revive earlier Danish painting by Johan Rohde (1856 – 1935), a leading figure in the Free Exhibition, and *Portrait of a Young Man* is a key painting in Danish art of the nineties. It reveals the desire for universal expression embodied in the Italian primitives, yet betrays a dominant nationalism that rejects French and revives indigenous Danish styles. [EB]

GUSTAF FJAESTAD Sweden **1868-1948**

Gustaf Fjaestad, the son of a shoemaker, began his artistic studies in 1891-92 at the Academy of Fine Arts in Stockholm. Afterwards he trained under Carl Larsson and with Bruno Liljefors*, whom he assisted on the backgrounds of the large dioramas at the Biological Museum in Djugården. In 1897 he left the city and settled at Lake Racken, near Arvika, in the province of Värmland (western Sweden). Gradually others moved there as well, and a small artists' community formed around Fjaestad and his wife Kerstin Maria Hellén.

Fjaestad had his first public success in 1898 when he exhibited winter landscapes at the Artists' Union in Stockholm. From that time on his works were highly acclaimed in both Sweden and Europe. His first one-man show was held in 1908 in Stockholm, and his paintings were especially well received in Berlin in 1914 and in London in 1927.

The majority of Fjaestad's paintings depict the winter landscape: views of pristine snow-covered fields or frosted branches. These works were extremely popular and widely disseminated in reproduction. In addition to painting, Fjaestad was involved in almost every aspect of the decorative arts. He designed large tapestries (often executed by his wife), copper and wrought-iron candlesticks, lamps and household utensils, and furniture that has been described as resembling richly sculptured gnarled tree stumps covered with pine needle tufts. [WPM/PG]

17

Running Water 1906
Rinnande vatten
Woolen fabric
203.0 × 312.0 (79⅞ × 122⅞)
Signed lower right: "F. 06"
Göteborgs Konstmuseum

Fjaestad often composed landscapes with an eye to eventually realizing them in tapestry decorations. The spatially flattened patterns of such canvases were pushed further toward abstraction in tapestry designs. This particular tapestry is close in composition to both *Winter Evening by a River* (cat. no. 18) and another winter river canvas of 1906 also called *Running Water* (Thielska Galleriet, Stockholm).

Unlike the cheerier, more sunlit decorative schemes that Fjaestad had woven on commission for Ernest Thiel's home (see below), the present tapestry has a subtle harmony of muted hues. Fjaestad recalled of this work: "The material is common Swedish wool on fish-net warp. After I had completed the cartoon, I realized the impossibility of making the dyer appreciate the small necessary differences in the values and colors of the water. I therefore asked him to dye wool which had not yet been spun with the lightest blue and the darkest brown, and then we mixed the different intermediate shades from these two just the way you mix colors on a palette." *Running Water* was woven at the Malmöhus Läns Slöjdmagasin under the supervision of Märta Måås-Fjetterström.

Fjaestad's tapestry landscape suggests a number of references both within Scandinavia and in the international currents of the turn of the century; the decorative projects of Édouard Vuillard and Pierre Bonnard come to mind, as do the Japanese-influenced graphic design and pale, low-key tonality of such Photo-Secessionist photographers as Alvin Langdon Coburn. But Fjaestad's wall-hangings of watery abstraction—especially his room-closing tapestries done to fit Thiel's salon doors—evoke more than anything

else Claude Monet's project for giant wall decorations of water and water lilies, which was conceived by the early 1900s but not realized in the Paris Orangerie until 1927. [WPM/PG]

Gustaf Fjaestad
Freshwater 1905
Sötvatten
Tapestry
205.0 × 310.0 (80¾ × 122)
Thielska Galleriet, Stockholm

18
Winter Evening by a River 1907
Vinterafton vid en älv
150.0 × 185.0 (59 × 72⅞)
Signed lower right:
"G Fjaestad 1907 Wermland"
Nationalmuseum, Stockholm

The basic character of Fjaestad's work was formed in the 1890s and varied little during his career. *Winter Evening by a River* is in most respects a representative work. Fjaestad's preference for landscape, and perhaps also some of the Japanese influence evident in this composition, stemmed from his training with Bruno Liljefors (see cat. nos. 60, 61). But the surface handling of the canvas—subtle, short, dark strokes overlaid as a rhythmic unifying pattern independent of description—seems closer to the 1890s work of Nils Kreuger, who was an admirer of Van Gogh's technique and along with Karl Nordström* and Richard Bergh* a member of the so-called Varberg School.

As in the Finn Eero Järnefelt's water scenes (cat. nos. 45, 46) there is a fusion here of naturalist and decorative interests. All aspects are naturalistically detailed, but there is an obtrusive sense of pattern in the reflections and in the cropping of the composition. A strong element of Art Nouveau design perhaps reflects Fjaestad's contact with his countryman Carl Larsson's decorative treatment of natural forms. Like his horizonless downward view, Fjaestad's fascination with water's rippling movement is an Art Nouveau tendency embodied in such geographically remote contemporary work as that of Claude Monet and Gustav Klimt (see below). In this particular treatment, a Symbolist tone of meditative contemplation, uncommon in Fjaestad's work, pervades the dark, icy water with a subtle glow of pale-lemon light. [WPM/PG]

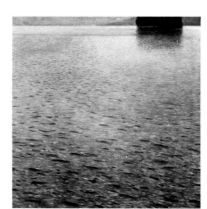

Gustav Klimt
Island in the Attersee
circa 1901
100.0 × 100.0
(39⅜ × 39⅜)
*Estate of
Dr. Otto Kallir,
Courtesy
Galerie St. Etienne,
New York*

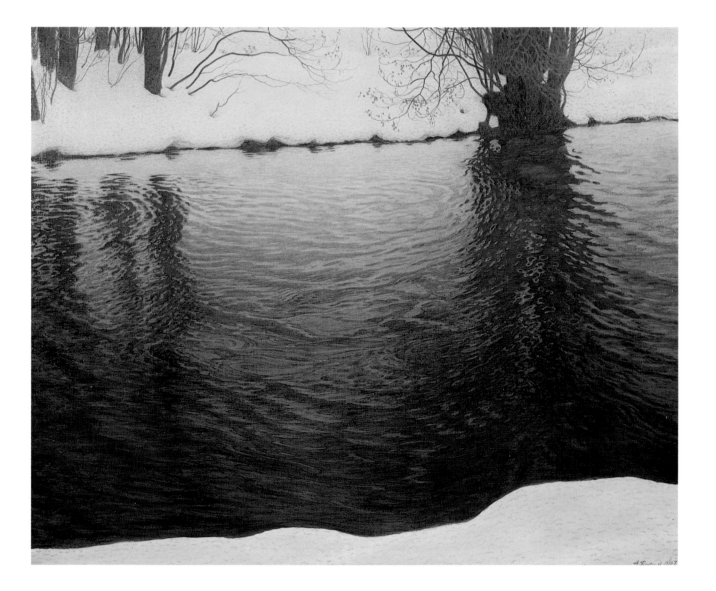

AKSELI GALLEN-KALLELA Finland 1865–1931

Born with the Swedish name Axel Gallén, the artist later changed his name to the Finnish-language equivalent Akseli Gallen-Kallela as a gesture of support for the indigenous culture of his nation. His father was a Bank of Finland cashier who later became a lawyer. Axel attended Swedish grammar school in Helsinki and in 1880, at the age of fifteen, decided to become an artist. The following year he began his studies both at the Finnish Fine Arts Association and at Adolph von Becker's private academy in Helsinki. He supported himself in the early 1880s by illustrating pamphlets for the temperance movement.

Taking his painting *Boy with a Crow* (cat. no. 20) along as an example of his work, Gallen-Kallela first went to Paris in 1884 and studied there off and on until 1890. The young Finn worked first with Adolphe Bouguereau and Robert-Fleury at the Academie Julian but soon switched to Cormon's studio. He began to associate with the colony of Scandinavian artists that included such painters as Albert Edelfelt* and Anders Zorn*.

Plein-air Realism, influenced by the work of Jules Bastien-Lepage, characterized Gallen-Kallela's work during the mid-1880s. The sincerity of *Old Woman and Cat* (1885; Turun Taidemuseo, Turku), in which the artist sought to combine the depiction of an aged hag with a faithful representation of a landscape, earned him the title "Apostle of Ugliness."

In 1889, Gallen-Kallela became the first Finnish member of the Societé Nationale des Beaux Arts. The next year he married Mary Helena Slöör, and the couple honeymooned in the province of Karelia, whose folkloric traditions played an important part in Finnish National Romanticism. Gallen-Kallela was at the center of the National Romantic movement, which reached its climax in the 1890s in the Russian Pan-Slavists' increasingly aggressive attempts to Russify Finland. During this period, he actively pursued themes from the *Kalevala*, the Finnish national epic, eventually creating a linear style accented by self-contained units of local color. Inspiration from *Kalevala* themes sustained him artistically for the rest of his life.

In 1895, Gallen-Kallela travelled with his family to London where he became interested in the arts and crafts achievements of William Morris. That year also marked his joint exhibition with Munch in Berlin, and the creation of the magazine *Pan* on whose staff he served along with Munch, the poet and art historian Julius Meier-Graefe, and the painters Anders Zorn, Max Klinger, and James McNeill Whistler. In 1898 he journeyed to Italy to study fresco technique, and the following year he used his knowledge of Trecento and Quattrocento murals to create four large frescoes depicting *Kalevala* themes for the Finnish Pavilion at the Paris World Exposition.

In 1902, Wassily Kandinsky invited Gallen-Kallela to exhibit thirty-six works in the Phalanx IV exhibition in Munich. The next year he exhibited with the Secessionists in Vienna, achieving wide acclaim. After exhibiting in the 1908 Salon d'Automne in Paris, he travelled with his family throughout Africa from 1909 to 1911. He exhibited with Die Brücke group in

Dresden in 1910, and in 1914 the Panama Pacific World Fair in San Francisco requested seventy of his paintings—works which also travelled to New York and Chicago. Always committed to Finnish freedom, he volunteered to fight in the War of Independence of 1918.

In the last decade of his life, Gallen-Kallela's art was exhibited throughout the United States. He and his family visited Mexico in 1923 and the following year they lived in the artists' community in Taos, New Mexico. In 1931, upon returning from a lecture to the Danish-Finnish Society in Copenhagen, Gallen-Kallela contracted pneumonia and died in Stockholm. He was honored with a national hero's funeral. [SRG/SSK]

19

Cloud Study 1883
Pilviä
20.5 × 34.0 (8 × 13⅜)
Signed lower left: "Axel Gallén Aug 1883"
Mrs. Kaari Raivio, Helsinki
(Courtesy of Gallen-Kallela Museo, Espoo)

This sketch and two following (cat. nos. 21 and 22) were painted in Finland within four years of one another, but represent three distinct phases in the artist's development. *Cloud Study* dates from student days at the school of the Finnish Fine Arts Association in Helsinki and was executed a year before Gallen-Kallela's first trip to Paris. The motif of a cloud-filled sky dominating almost the entire canvas belongs to a tradition of sky and/or cloud paintings beginning in the late eighteenth century and particularly characteristic of Northern painters. The British painter John Constable's cloud sketches of the 1820s are the best known, but the numerous small sky views by the younger German-trained Norwegian Johan Christian Dahl (1788–1857) are perhaps more apt precedents here.

While the nineteenth century saw the formation of modern meteorology, and writers such as Goethe and Ruskin made scientific inquiries into clouds, painters like Constable, Dahl, and J.M.W. Turner emphasized the changeable cloud-filled sky as a motif of pictorial power and expressiveness—"the chief organ of sentiment" in Constable's words (quoted in Basil Taylor, *Constable, Paintings, Drawings, Watercolors,* Phaidon, London, 1973, p. 224). With its broad, luminously mottled cumulus sky set against darker bands of woods and water, *Cloud Study* seems simultaneously to look back to that Romantic tradition and forward to the moodier skies of the American photographer Alfred Stieglitz's *Equivalent* series of the 1920s. [SRG/SSK]

20

Boy with a Crow 1884
Poika ja Varis
86.5 × 72.5 (34 × 28½)
Not signed
Ateneumin Taidemuseo, Helsinki (Antell Collection)

Bound for Paris in the autumn of 1884, the nineteen-year-old Gallen-Kallela self-consciously rendered *Boy with a Crow* as a virtuoso "admission ticket" to the Parisian art world. "When I came to Paris with this canvas in 1884," he later wrote in his *Kalela Book,* "the teachers were amazed at how modern it was, even though I had not seen any of the modern art of the time..." Painted that summer, the composition was inspired by a small peasant boy at Sipi farm, where Gallen-Kallela was staying. The boy was told that he could capture a crow by sprinkling salt on its tail, and the artist sketched him as he stalked the birds.

This quasi-narrative genre scene was directly inspired by the work of Jules Bastien-Lepage (1848–1884), an artist who deeply influenced Finnish painters during the 1880s. Albert Edelfelt, Finland's "cultural ambassador" to France, had become a strong proponent of Bastien-Lepage while working in Paris in the mid-seventies, and had inspired the younger generation of Finns, including Helene Schjerfbeck* and Ellen Thesleff*, to study under him. The Helsinki studio of the French-trained artist Adolph von Becker, where Gallen-Kallela studied, was also a breeding ground for Bastien-Lepage's *plein-air* style. Reproductions of Bastien-Lepage's work, such as *Pauvre Fauvette* (1881; Glasgow Art Gallery and Museum), circulated at von Becker's studio and throughout Helsinki.

In *Boy with a Crow* Gallen-Kallela assimilated Bastien-Lepage's characteristic strategy of placing a highly focused figure against a blurred background. He also followed Bastien-Lepage's suggestion of painting a landscape as one sees it from a standing position, thereby avoiding the hackneyed image of a figure monumentally juxtaposed against the sky. The paint handling of the background gradually shifts from dense detail at the bottom of the canvas to longer, thinner strokes above, establishing a slight sense of recession akin to Bastien-Lepage's limited range of focus. Further, Gallen-Kallela shared Bastien-Lepage's technique of visually rooting the peasant to the soil, rendering the boy in the same pigments used for the background, and subtly shifting values of the surrounding grass to reflect the gradation of color from the boy's dark pants to his pale skull. Bruno Liljefors (see cat. nos. 60 and 61) also adapted this technique in creating his mutually reflexive portraits of animals and nature.

While absorbing Bastien-Lepage's means into his own work, Gallen-Kallela radically extended them. The overall blond tonality of *Boy with a Crow,* although reflective of Bastien-Lepage's palette, is suppressed into a narrow range. By dispensing altogether with a horizon line, Gallen-Kallela transforms the background into a near-abstract decorative surround resembling the insistent flatness of a tapestry. The ambiguous narrative and peculiar spatial organization of *Boy with a Crow* set it apart from Gallen-Kallela's other Naturalist paintings of the early eighties, creating an idiosyncratic foreshadowing of his later Synthetic style. [PGB/SSK]

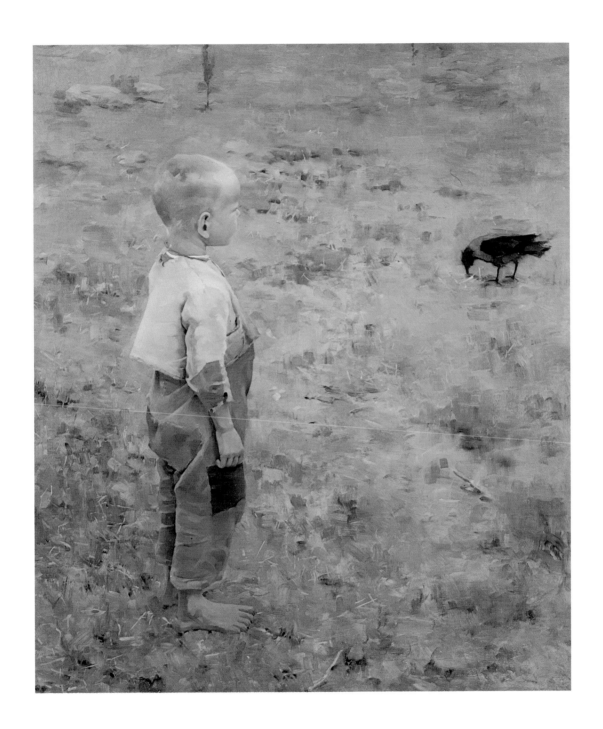

21

A Loft at Hoskari, Keuruu 1884
Luhtikuja, Hoskarin Talo Keuruula
Oil on canvas glued to cardboard
33.5 × 18.0 (13 × 7¼)
Signed lower right (in monogram):
''AG/Aug 84''
*Gösta Serlachiusksen Taidesäätiön Kokölmat,
Mänttä*

Scandinavian artists and intellectuals of the 1880s were
keenly interested in humble native architecture. In
Sweden the open-air museum Skansen, containing
churches, cottages, and farmhouses transported from
different parts of the country, was inaugurated in 1891.
In Finland numerous artists and architects of the period
designed studios in wilderness locations in the style of
indigenous peasant structures (see *Studios in the Wilds,
Artists' Country Studios at the Turn of the Century,*
exhibition catalogue, Helsinki: Museum of Finnish
Architecture, 1978). Gallen-Kallela's own studio home
''Kalela'' in Ruovesi was a prominent example. Finnish
native architecture also played a significant role in the
Neo-Romantic architectural style evolved by
Gallen-Kallela's contemporaries Lars Sonck and Eliel
Saarinen.

During his Paris years Gallen-Kallela returned home
every summer to explore Finnish culture, travelling into
the wilds in search of the purity and simplicity of the
uncorrupted peasant. He painted *A Loft at Hoskari,
Keuruu* in the summer immediately following his first
year of study in France.

In this modest view of native Finnish architecture,
delapidated farm tools lie on the ground, cast in shadow
between two rough wood-and-stone structures. Beyond
the alley, a loft stands bathed in sunlight beneath a blue
sky. The blondish tones of a new ladder and roof
contrast with the older brown and gray wood of the loft
and its neighboring structures, and the new ladder is a
strong and erect foil to its decaying predecessor lying in
the dimly lit debris below.

This seemingly casual little study shows traditional
architecture in a strikingly untraditional fashion.
Severely cropped, the building elements are composed
as a flat pattern of light and shadow, with the central
vertical rectangle of the alley rigorously restating the
canvas's proportions. The resultant strong linear design
and compression of space announce some of
Gallen-Kallela's later decorative interests, and tempt
one to see here evidence of the artist's contacts with
advanced French painting. [SRG/SSK]

22
A Winter Landscape 1887
Talvimaisema
25.5 × 17.0 (10 × 6¾)
Signed lower right: "Axel Gallén./1887"
Gösta Serlachiuksen Taidesäätiön Kokölmat,
Mänttä

Gallen-Kallela spent the winter of 1887 in Finland
instead of returning to Paris as he did for other winters
of the 1880s. Travelling alone to the Keuruu forests of
central Finland, he found an old farmhouse in which he
lived and painted. *A Winter Landscape,* comprised of the
most delicate grays, blacks, and whites, reflects his
response to the challenge of the Northern landscape,
especially the subtle gradations inherent in the
monotony of snow. The sketchy technique and
compressed space are reminiscent of the work of Jules
Bastien-Lepage.

The artist painted other winterscapes and executed
many drawings during this trip (see Okonnen, 1947).
Likewise, snow scenes appear again later in his work.
By 1902 he was painting in the more linear style
evident in *Landscape under Snow* (Ateneumin
Taidemuseo, Helsinki), one of a series of symbolic
representations of the seasons executed for the Juselius
Mausoleum in Pori. That painting exhibits "a formal
abstractness wavering ambiguously between the real
and the symbolic" (Peg Weiss, *Kandinsky in Munich:*
1896–1914, exhibition catalogue, The Solomon R.
Guggenheim Museum, New York, 1982, p. 48). The
interchange between this small Naturalist sketch of
1887 and the later Symbolist decorative canvas
exemplifies an ongoing dialogue also evident in
Gallen-Kallela's *Waterfall at Mäntykoski* (cat. no
25). [SRG]

23

Démasquée 1888
Alaston Naismalli ("Démasquée")
65.0 × 55.0 (25⅝ × 21⅝)
Signed upper right: "Axel Gallén/1888"
Ateneumin Taidemuseo, Helsinki (Antell Collection)

In 1888 Gallen-Kallela wrote home that he was painting a "dirty picture" commissioned by the Finnish collector Herman Frithiof Antell. The work he was referring to was *Démasquée,* and the year he painted it was a turning point for him. From the depiction of Finnish folk life, seen in *Boy with a Crow* (cat. no. 20), he turned to a fascination with French bohemianism, which soon gave way to an abiding interest in Romantic themes from the Finnish *Kalevala* epic.

Démasquée contains elements of several of Gallen-Kallela's preoccupations. The careful rendering of the eighteenth-century ryijy-rug reflects his interest in all aspects of the decorative arts, especially Finnish folk weavings and furniture. And the skull, lillies, Buddha, and Japanese fans point toward the more openly Symbolist content of some of his later paintings and stained-glass pieces, while also contributing a chic, cosmopolitan quality to the atmosphere of the work. Essentially, however, *Démasquée* is aggressively Realist. The "Apostle of Ugliness," as Gallen-Kallela was known, has represented the model as a model: unglamorous, unidealized, and in an ungainly pose. A sense of artificiality is reinforced by the guitar, which obviously functions as a prop.

An impression of a rather odd lack of resolution is created by this conjunction of Symbolism and Realism. Gallen-Kallela seems to be self-consciously attempting to create a Symbolist work, yet it is so emphatically Realist that one senses something satirical or cynical. Perhaps the title was chosen for the possibilities of meaning inherent in the word. *Démasquer* means not only "to unmask" but also "to show one's hand," "to lay the cards on the table." It could be that before he devoted himself to the *Kalevala,* Gallen-Kallela wanted to unmask this type of subject and demonstrate the artificiality of posed models and props, thus exposing his changing attitude or showing his hand. [WPM/SSK]

24

The First Lesson 1887–89
Ensi Opetus
115.5 × 98.0 (45½ × 38⅝)
Signed lower right: "Axel Gallén/1889"
Ateneumin Taidemuseo, Helsinki

Gallen-Kallela began *The First Lesson* in the rural community of Ekola in south-central Finland during his winter hiatus from Paris in 1887. By the time he completed it in 1889 the National Romantic elements in his work had become charged with the psychological overtones of an inquiry into the mental life, as well as the material culture, of the isolated Finnish peasantry.

At first glance the painting appears to be a simple narrative. A peasant child reads aloud while her grandfather pauses from his task of mending nets to hear her words. Enveloping them is the quiet interior of their rustic cabin, bathed in all but the farthest corner by wintry light from the outdoors mingled with the glow of a wood fire. Closer scrutiny of these figures, however, reveals a disturbing relationship which stems from the tense, almost malevolent, gaze of the old man.

The grandfather's expression may be explained, in part, by the earlier stages of the painting. *The First Lesson* was generated from a series of physiognomic studies Gallen-Kallela did of "Sauna-Jonas," the keeper of the Ekola saunas. In his *Kalela Book* the artist reports that the ambiance of Jonas's cabin reminded him of the *Tales of Ensign Stål*, the masterpiece of Finland's national poet Johan Ludvig Runeberg (1804–1877). The elegiac painting that took shape illustrated a highly dramatic episode from the *Tales* in which the young Runeberg confronts the aging war veteran Stål in his firelit cabin and reads from a book of Finnish military history. At the moment when the two men form their bond of friendship Runeberg writes of Stål (for whom Jonas modelled), "And of a sudden his old eyes flashed with a warrior's ardor..."

The figure of Runeberg, silhouetted against the window, had been problematic for Gallen-Kallela from the beginning. When it was suggested that Runeberg spoiled the integrity of an otherwise fine composition, Gallen-Kallela painted him out. He exhibited the painting at the Artists' Association's third spring exhibition in 1887 under the title *Study: Firelight*, and it was received well by the critics, who felt that, though unfinished, it was a brilliant experiment in light effects and ethnographic detail. But the artist continued to grapple with the painting until 1889 when he transformed it into *The First Lesson*. Then in Paris, he inserted what he described as a "banal little girl" into the composition, using the daughter of his concierge's friend as his model.

Gallen-Kallela intentionally preserved the unsettling intensity of Jonas's face from the Stål composition in order to cast a veil of mystery over the seemingly straightforward *First Lesson*. Similarly, his friend Louis Sparre retained elements from the initial version of his 1891 painting *First Snow* (cat. no. 84) in order to cultivate a sense of unease and claustrophobia in the final version. Shifting from literal narrative to more ambiguous meaning, Gallen-Kallela had begun to assimilate Symbolist ideals into his work of the late eighties, revising the natural world to fit the matrix of internal feelings he perceived in the Finnish peasantry. [PGB/SSK]

25 *Reproduced in color on page 14*
Waterfall at Mäntykoski 1892–94
Mäntykoski
270.0 × 156.0 (106¼ × 61½)
Not signed
Private collection, Helsinki

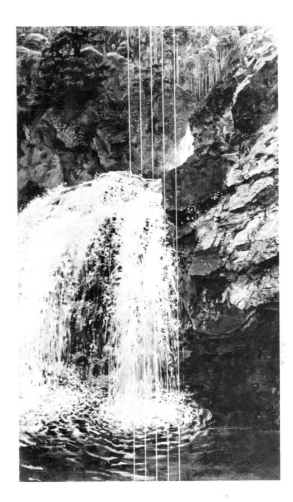

Although National Romanticism flourished in Finland
throughout the 1890s, among cosmopolitan artists like
Albert Edelfelt* and Gallen-Kallela the concern for
indigenous elements was often influenced by broader
European developments in painting. A self-conscious
reference to folk art and the reduction of forms to flat,
often abstract shapes resulted in a highly decorative
style which was simultaneously encouraged by Émile
Bernard's and Paul Gauguin's Synthetist canvases of the
late 1880s and the Norwegian Gerhard Munthe's
tapestries of the 1890s. Gallen-Kallela and his circle,
which included Louis Sparre*, experimented with
decoration throughout the 1890s and into the 1900s,
creating rugs, furniture, and appliquéd and embroidered
cushions.

The specific, the symbolic, and the decorative were
not always mutually exclusive terms. In the Northern
Romantic art of Philipp Otto Runge (1777–1810) "the
extremes of the most close-eyed perceptions of nature
and [the] most visionary abstract forms and systems
[had been] juxtaposed and, at times, combined" (see
biblio. ref. no. 13, p. 46). Gallen-Kallela's *Waterfall*
continued this tradition.

A critic who viewed this painting in the artist's studio
in early 1893 commented on the presence of two
allegorical figures beside the fall—a water nymph
playing "nature's harp," and a human listener.
Although a resident spirit of the woods and waters is
common to Nordic folklore, Gallen-Kallela may have
drawn specific inspiration for this conception from the
Swedish painter Ernst Josephson's highly controversial
Water Sprite of 1884 (illustration on p. 94). Apparently
dissatisfied with this form of outmoded allegory,
however, he subsequently removed the figures (though
the spellbound listener, overpainted, is still discernible
at the lower right). To convey the idea of music, he
painted instead five golden harp strings extending the
entire length of the picture and lying tautly on the
surface of the canvas in delicate tension between the
specific and the evocative. This device both accentuates
the familiar Symbolist analogy between art and music
and reinforces the already prominent decorative
qualities of the tall, flattened scene. The painted,
patterned frame Gallen-Kallela designed for the work
further encouraged the tapestry effect. *Waterfall*,
virtually contemporary with *Symposion* (cat. no. 26),
represents a transitional moment in the artist's
development and is a fascinating mixture of Naturalism,
Symbolism, and abstraction. [SRG/SSK]

26
Symposion (The Problem) 1894
Symposion (Probleema)
74.0 × 99.0 (29⅛ × 39)
Signed lower left (in monogram): "AGK"
Private collection, Helsinki

In 1892 a group of Helsinki intellectuals and artists formed Young Finland, a circle devoted to progressive art. The group included many painters with whom Gallen-Kallela had been friendly in Paris and was expanded to include the poets Juhani Aho and Kasimir Eino and the musicians Jean Sibelius and Robert Kajanus. Sibelius, whose work incorporated themes from Finnish folk songs and the *Kalevala* epic, had patriotic interests particularly parallel to those of Gallen-Kallela.

Symposion (sometimes called *Symposium*) derives its title from the Greek *symposión*, a drinking together. The ultimate precedent for intellectual bacchanals like the one shown here is Plato's *Symposium*, in which fourth-century-B.C. Athenians gathered nightly to combine drinking and rumination. Gallen-Kallela's updated version of the tradition shows (from left to right) the artist himself, the composer Oskar Merikanto (face down), Kajanus, and Sibelius.

These bohemians stare across a table laden with empty bottles and half-filled glasses at an apparition, a creature we can only imagine from the two great wings that intrude from the left edge of the canvas. According to family tradition, Gallen-Kallela included in the original sketch a full image of a flayed sphinx, perhaps representing, as sphinxes did elsewhere in European Symbolism, the mysteries of artistic creation. Apparently because the beast was too repulsive, the artist cut down the sketch, and only the suggestive wings were transferred to the final version.

An intermediary oil study for *Symposion* (see below) shows that the picture strongly suggested caricature in its original conception. Though the sketch contained more obvious symbolic elements—including a naked background figure rising to the heavens, much like Gallen-Kallela's contemporary nude *Ad Astra* (Private collection, Helsinki)—the final version retains a strong Symbolist flavor in the wings and in the hallucinatory intrusion of the lake landscape background, where the poet Eino saw "a fantastic tree in whose top the free winds of the world play their eternal songs of power" (biblio. ref. no. 34, p. 20). It also retains some of the satirical humor of the sketch, as the elaborate contrivance of the scene and the raffish bleariness of the figures combine to spoof the tone of self-conscious solemnity. The picture was taken seriously when displayed at the 1894 Exhibition of Finnish Artists, causing a memorable scandal and bringing stinging attacks on Gallen-Kallela by his fellow painter Albert Edelfelt* and other critics.

Within Scandinavian art *Symposion* falls chronologically almost exactly between Peder Severin Krøyer's *The Artists' Luncheon* of 1883 (cat. no. 58) and Vilhelm Hammershøi's *Five Portraits* of 1901 (cat. no. 30). Both the disjunctions of the picture's style—naturalistically detailed in the foreground, synthetically patterned in the nocturnal landscape background—and its decadent bohemian urbanity make it a midpoint between the hearty, sunlit conviviality of Krøyer's *plein-air* painters and the private, isolated silence of the artists and intellectuals in Hammershøi's picture. [SRG/SSK]

Akseli Gallen-Kallela
Sketch for Symposium, A. Gallen-Kallela,
Robert Kajanus, Jean Sibelius 1894
58.5 × 56.5 (23 × 22¼)
Gösta Serlakinsksen Taidesäätiön Kokölmat, Mänttä

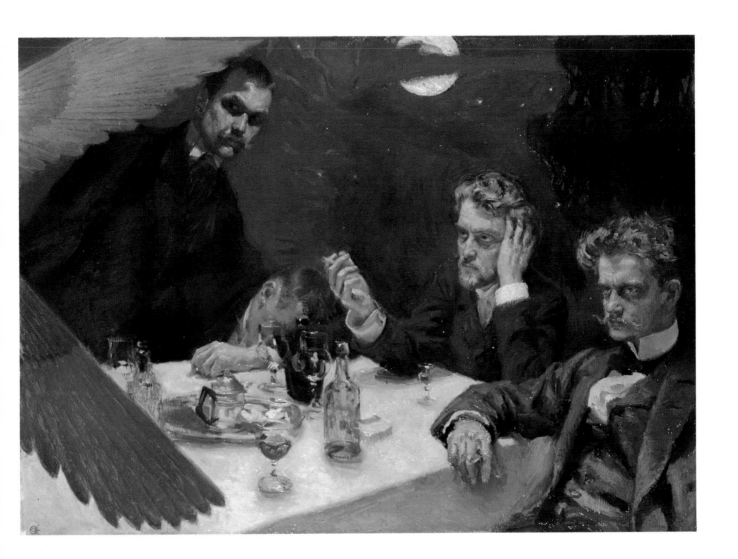

PEKKA HALONEN Finland **1865–1933**

Halonen's father, a farmer, was an enthusiastic amateur painter, and Pekka often experimented with the older man's paints. At his parents' request he initially attended normal school to become a teacher, but eventually began formal training in art at the age of twenty-one. He attended the Fine Arts Association in Helsinki from 1886 to 1890 and in 1891 went with the Finnish painters Magnus Enckell and Ellen Thesleff* to Paris, where he studied at the Academie Julian for a year. Drawn to the art of Jean François Millet, Camille Corot, and Pierre Puvis de Chavannes, he maintained a Naturalist style, intentionally shying away from Modernism.

The artist returned to Helsinki in the summer of 1892 and travelled east to the province of Karelia. "Karelianism" was the name given to the Finnish National Romantic movement of the 1890s, and pilgrimages to this province were an integral part of the National Romantic painters' mission to find their Finnish roots, for there the old ways of peasant life were preserved. In Karelia Halonen associated with the patriotic painters Albert Edelfelt* and Akseli Gallen-Kallela*.

In the 1890s Halonen painted a series of folk subjects exemplified by *The Blind Kantele Player* (1892; Collection of Inger Korkeakivi, Oulu), in which a peasant woman plays the *kantele*, a Finnish folk instrument that his own mother had mastered. In 1892–93, the artist experienced a severe religious crisis after reading Leo Tolstoy's writings on practical Christian theology. He returned to Paris in the fall of 1893 and became fascinated by theosophy. In 1894, influenced by the art of Paul Gauguin, he adopted the Synthetist style visible in *Wilderness*. He became interested in mural art, especially that of Giotto, and travelled to Italy to study in 1896–97, around the same time as Gallen-Kallela.

Though deeply patriotic, Halonen never painted themes from the Finnish national epic, the *Kalevala*. His reputation rests on his calm and harmonious vision of Finnish nature, permeated throughout by soft, blondish light. His many winterscapes are especially highly regarded. He exhibited in Stockholm in 1897, with the exhibition of Finnish and Russian artists in 1898, and in the Finnish Pavilion at the 1900 Paris World Exposition. In later life his style became looser and more Impressionistic, akin to that of the late Monet, and he incorporated religious themes into his work. [SRG/SSK]

27
Wilderness 1899
Erämaa
110.0 × 55.5 (43¼ × 21⅞)
Signed lower right: "P. Halonen./1899"
Turun Taidemuseo, Turku

In 1899 Czar Nicholas II issued the February Manifesto, bringing Finland under the dominion of Russian imperial legislation. In a letter to fellow artist Emil Wikstrom, Pekka Halonen wrote of this challenge: "The Finnish people are tough as Juniper; we can't be beaten by so little...the land and the nation will live!" Halonen's comparison of his countrymen with wood was a theme that found frequent expression in the forested landscapes and images of lone trees in Northern Romantic painting. In the *Wilderness* canvas, Finland's forest stands as a symbol of nationalist sentiment in a year of crisis.

Wilderness may also be viewed as an image of Finland's most important natural resource. The Finnish forest industry developed rapidly in the late nineteenth century as lumber was needed for, among other things, the expanding railway network of Scandinavia. As virgin land was tapped, peasant farmers acquired unprecedented wealth, changed their way of living, and became increasingly dependent on the external market (see John H. Wuorinen, *A History of Finland*, New York, 1965). Eero Järnefelt's* 1893 painting *Burning the Forest Clearing* (Ateneumin Taidemuseo, Helsinki), with its subtitle *Slaves to Money*, apparently refers to this shift. By the late 1890s the undeveloped Finnish forests had thus become a Janus-faced symbol of Finland as not only enduring but also increasingly surrounded and threatened.

The picture's insistent verticality and radical cropping at the top help to accentuate the height of the trees, transfiguring them into potent and lasting natural forms that continue to grow well beyond our field of vision. The sparsely needled parallel conifers are compressed into a shallow space that further accentuates the image's power and aggressiveness.

At the turn of the century Halonen painted other works in this highly linear and somberly colored style derived from Parisian Synthetism. *Winter Day* (1899; reproduced in Ooti Hämäläinen, 1947) is also vertically conceived and cropped at the top like *Wilderness*, and features a tree dominating the shallow space. The format and style of *Wilderness* likewise strongly recall Akseli Gallen-Kallela's* *The Woodpecker* of 1893 (Collection of Jörn Donner, Helsinki), and the muted palette is reminiscent of paintings by Pierre Puvis de Chavannes. [SRG/SSK]

VILHELM HAMMERSHØI Denmark 1864–1916

Hammershøi was born, the eldest of three children, to Frederikke Rentzmann and the Copenhagen merchant Christian Hammershøi. His biography is void of dramatic event, since he left no written commentary on his art, and he was, by nature, a highly sensitive, private, and stubbornly silent man. (Olson, "Vilhelm Hammershøi" in Ordrupgaard, 1981, p. 31). In September 1893 he married Ida Ilsted, the sister of the Danish painter Peter Ilsted (1861–1933). The couple remained childless, a condition that undoubtedly contributed to the pervasive stillness, the lack of youth and vigor, so characteristic of Hammershøi's painted interiors. It also left them free to travel. Hammershøi made fourteen trips abroad, including extensive tours of Germany, the Netherlands, Belgium, and Italy and periods of residence in Paris (October 1891–March 1892), London (October 1897–May 1898), and Rome (October 1902–February 1903).

Although well aware of current European trends, Hammershøi maintained a self-conscious dialogue with the artistic traditions of his homeland. Ironically, he was viewed as the most representative and interesting of Danish painters by foreign critics but suffered from neglect in his native country, save for the invaluable patronage of the Copenhagen dentist Alfred Bramsen. He exhibited at the Paris World Expositions of 1889 and 1900, and in Munich (1891, 1892), St. Petersburg (1897), Berlin (1900, 1904, 1905), London (1907), and Rome (1911). The sophistication and Symbolist tenor of his art appealed to an international audience, and his admirers included Theodore Duret, Sergei Diaghilev, and Rainer Maria Rilke.

Hammershøi began his artistic training in 1878 under the landscape painters Frederik Rohde (1816–1886) and Vilhelm Kyhn (1819–1903). From 1879 to 1884 he studied at Copenhagen's Royal Academy of Fine Arts with C. F. Andersen and H. Grønvold. In 1883 he enrolled concurrently at the Artists' Study School, where, under the tutelage of Peder Severin Krøyer*, he learned to draw from the live model and paint *plein air*—exercises not offered in the academic curriculum. It was apparent in his student work that his style conformed neither to the exactitude of academic taste, nor to the restless bravura of Krøyer. Instead, the formative influence on his early development was the art of James McNeill Whistler, a debt made explicit in his *Portrait of the Artist's Mother* (1886; private collection), a paraphrase of Whistler's *Arrangement in Black and Gray: The Artist's Mother* (1887; Louvre, Paris). In 1885 he made his debut in Copenhagen's annual Charlottenborg exhibition, the equivalent of the French Salon, with the well-received *Portrait of a Young Woman* (Den Hirschsprungske Samling, Copenhagen). In 1888 and 1890, however, his entries were rejected by the Charlottenborg committee. As a result of these refusals and general dissatisfaction with the academy, Hammershøi and five other artists formed *Den frie Udstilling* (the Free Exhibition) in 1890.

In the nineties Hammershøi experimented briefly with more overt modes of Symbolism. His first programmatic painting, *Artemis* (1894; Statens Museum for Kunst, Copenhagen), was an unsuccessful attempt to incorporate the style of the Italian *primitifs*, who were then enjoying a vogue among the younger Danish painters (see Ludvig Find, cat. no. 16). In *Three Young Women* (1895; Ribe Art Museum) he was inspired by the decorative style of Paul Gauguin. Ultimately these manners were incompatible with his innate preference for suggestion and understatement. By the late nineties he consolidated his technique: the enveloping atmosphere, first gleaned from Whistler, developed into a methodical application of short, layered strokes, and was limited to a silvery-gray tonality. At this time, Jan Vermeer's influence appeared, specifically in the *Double Portrait of the Artist and his Wife* (1898; Aarhus Kunstmuseum).

The first decade of the twentieth century marked Hammershøi's maturity and high point. From 1899 to 1909 he lived in an historic Christianshavn house built by the Lord Mayor Mikkel Vibe in 1636. There he painted the interiors that made his reputation. In 1911 he was one of five artists to win a *Grand prix* at the International Exhibition in Rome. His last trip abroad was to London in 1913. Weakened by the death of his mother and by his own serious illness, he painted little after 1914. He died at the age of fifty-one on February 13, 1916. [EB]

28
A Farm at Refsnaes 1900
Bondegård. Refsnaes
53.0 × 62.0 (20⅞ × 24⅜)
Signed lower right: "V.H."
Davids Samling, Copenhagen

Refsnaes is a peninsula on the west coast of Sjaelland. Its flat landscape is dotted with traditional thatched-roof farmhouses like these depicted by Hammershøi. Such distinctly Danish buildings were a popular subject among turn-of-the-century painters who wished to assert their national heritage—Julius Paulsen (1860–1923) and Laurits Andersen Ring*, for example. The motif appears among Hammershøi's earliest works, including *Farmhouse* (1883; private collection) and *Landscape with Farmhouse* (1886; Marie Louise Koch, Copenhagen), both of which are rendered in a heavy, generalized manner.

In this mature work, Hammershøi concentrates on the precise articulation of the timid light of winter. The cloudless sky and barren ground form a uniform plane of gray, disturbed solely in the foreground by slices of falling shadow. Utter silence and stillness prevails, except for the pale shaft of smoke that rises, barely discernible, into the gray expanse of sky. The smoke and the open door are the only hints of human presence. Hammershøi betrays an obsessive attention to the rendering of the most minute details and subtle gradations of tone. Even the immateriality of reflected light is captured and ordered into pattern on the window panes. The artist establishes a play between the

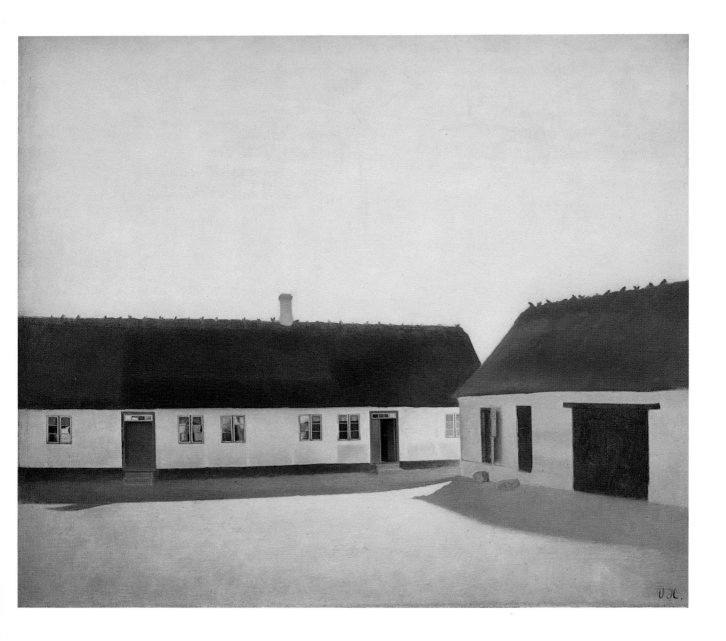

long line of the roof and the staccato rhythm of the windows along the wall. He guides our eye to the space between the house and barn, directing us by the arrow of light on the ground, the placement of the two rocks, and the beckoning illumination from around the corner. The fine-tuned tenor of the picture creates a gradual, unresolved tension and heightens our awareness of a reality beyond the seen.

The critic Andreas Aubert noted Hammershøi's overt anti-Naturalism as early as 1890 and considered the artist an exponent of the new aesthetic of Decadence (Heller, 1978, p. 81). Hammershøi and Munch were the only Scandinavians to be singled out by Aubert and were thereby associated with the international coterie of James McNeill Whistler, Pierre Puvis de Chavannes, Arnold Böcklin, Max Klinger, and Gabriel Max. [EB]

29
Interior with Piano and Woman in Black
1901
Stue med klaver og sortklaedt kvinde
63.0 × 52.5 (24¾ × 20⅝)
Signed lower right: "V.H."
Ordrupgaard Malerisamlingen, Copenhagen

Although the motif of a woman in an interior appears in Hammershøi's work of the mid-eighties, it does not develop into his representative subject until after 1900. *Interior with Piano* is one of the first of more than sixty interiors he painted from 1889 to 1909 at 30 Strandgade in Copenhagen (Hansen, "The Black and White Colorist," in Ordrupgaard, 1981, p. 14). The house dates from 1636, but the rooms that Hammershøi occupied on the *piano nobile* were of late eighteenth-century design. He painted several versions of this corner of his sitting room, rearranging the furniture, varying the pose of his wife, or shifting the angle of view. His devotion to the rooms and objects of his home parallels similar series by the Belgian artists Georges Le Brun (1873–1914) and Xavier Mellery (1845–1921).

The interior provides a symbolic retreat from modernity and the outside world. For Hammershøi it is an inner sanctum of serene classic design, of fine objects filled with memories, and of mahogony furniture imbued with the past. Books, music, and art represent the pleasures of this aesthetic withdrawal. The anonymous woman is the emblem of the introspective self, the spirit that takes refuge in seclusion and solitude. She is ageless and dressed in timeless attire.

The empty chair, the silent instrument, and the unseen window are devices that Jan Vermeer also used in creating the sensation of a moment frozen in time. Although the revival of seventeenth-century Dutch masters was prevalent at the turn of the century, Vermeer was viewed as different from the rest and enjoyed a Symbolist interpretation (for an example, see Gustave Vanzype's *Vermeer de Delft*. Brussels: G. Van Oest and Co., 1908). Hammershøi could have seen works by the Dutch artist during his pre-1900 trips to Dresden, Amsterdam, and London. His *Interior with Piano and Woman in Black* recalls Vermeer's *Lady Reading a Letter* (Staatliche Gemaldegalerie, Dresden), or more specifically, *Couple Standing at a Virginal* (Buckingham Palace, London). Vermeer produces an emotive resonance rooted in the meticulous observation of the material world, a bridge between Naturalism and Symbolism that Hammershøi would have found congenial to his own aims. Both artists thrive on paradox as a means of pictorial strategy: "Images of full presence double as evocations of absence and aloneness. Completeness of being resonates with intimations of death and impending loss; an atmosphere of timelessness evokes thoughts of evanescence, of the momentary, of life passing and passing by" (Description of Vermeer by Edward Snow, *A Study of Vermeer*. Berkeley: University of California Press, 1979, p. 10). [EB]

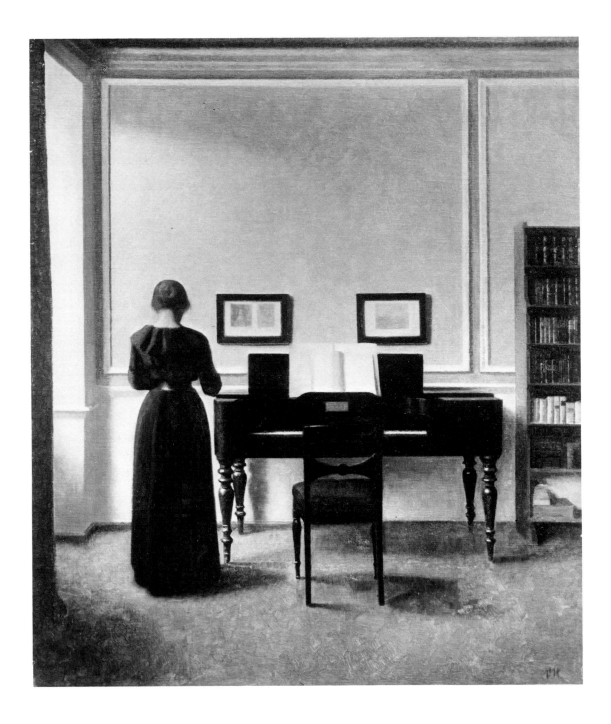

30
Five Portraits 1901
Fem portraetter
190.0 × 300.0 (74¾ × 118⅛)
Not signed
Thielska Galleriet, Stockholm

Five Portraits has been called the most forceful painting in Danish art (Wanscher, 1915, p. 407). It portrays five friends of the artist, all supporters of the progressive Free Exhibitions. From the left they are the architect Thorvald Bindesboll (1846–1908); the artist's brother Svend, (1873–1948), also a painter; the art historian Karl Madsen (1855–1938); and the painters Jens Ferdinand Willumsen (1863–1958) and Carl Holsøe (1863–1935). The five friends are depicted in the evening, in the sitting room of Hammershøi's Copenhagen residence at 30 Strandgade. The veil of brushstrokes and the subdued but infinite values of gray contribute to a sense of mystery, and the silence, the solitude, and the darkness make *Five Portraits* a masterpiece of the Symbolist tradition.

Hammershøi intended the picture to be a *tour de force,* and he did several compositional sketches and individual portrait studies in preparation for the final version (Statens Museum for Kunst, Copenhagen). It is argued that he was influenced by Rembrandt's *Claudius Civilis* (1662; National museum, Stockholm), which he saw in 1897 (Vad, 1957, p. 17). Certainly there is a similarity in the almost supernatural luminosity of the tablecloth, and Rembrandt's subject of an oath of rebellion may have appealed to Hammershøi in his depiction of a group of secessionist artists. *Five Portraits,* however, is devoid of any anecdote or drama. It lacks the bohemian fellowship of Gallen-Kallela's *Symposion* (cat. no. 26) or, as Professor Gert Schiff of the New York University Institute of Fine Arts has noted, the sense of conviviality evoked in such other contemporary group portraits as Lovis Corinth's *The Freemasons* (1889; Stadtische Galerie, Lenbachaus, Munich). It is a friendship picture unlike any other in the long European tradition of painting comrades gathered round a table.

Despite attempts to liken the table to a coffin or the position of Svend to that of Judas in depictions of The Last Supper (Wanscher, 1915, p. 407), *Five Portraits* resists interpretation. The painting's force rests in its ambiguity and impenetrability. Though brought together for a group portrait, the five friends are shown in disparate attitudes, isolated from one another, each lost in private thought. Faced with impervious gazes and preoccupied stares, the viewer feels ill at ease among such inaccessible personalities. There is also something enigmatic in the circumstance of their assembly—a pervasive sobriety that suggests the occasion of a ritual. The stiff, formal attire of the men at back, the central placement of the attenuated candles, and the delicate glasses set amidst these ponderous forms all add to the intensity of mood. Although the tension is somewhat relieved by the near-comic enormity of Holsøe's feet, his very posture reinforces the sedentariness, the inaction of the group.

The painting was shown in the Free Exhibition of 1902, the Venice Biennale of 1903, and the Berlin Secession exhibition of 1904. In 1904, Hammershøi began a sequel to the work entitled *Evening in the Room* (Statens Museum for Kunst, Copenhagen), but abandoned it before completion, bitterly disappointed by the failure of a Danish museum to acquire *Five Portraits.* The following year, *Five Portraits* was purchased by the Swedish collector Ernest Thiel at an exhibition in Gothenburg. [EB]

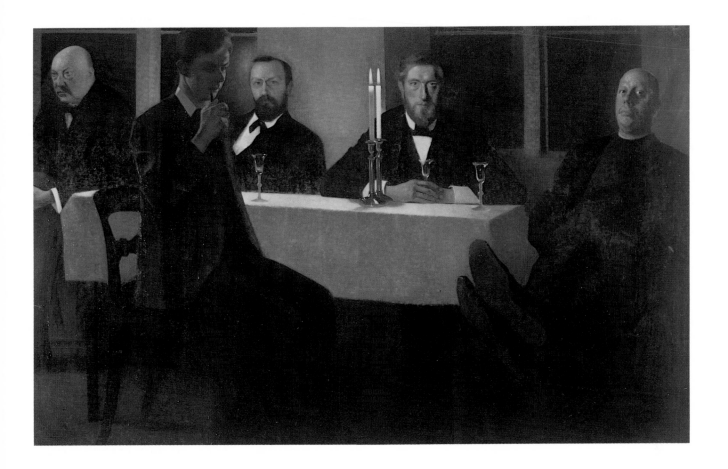

31
Open Doors (White Doors) 1905
Åbne døre (Hvide døre)
52.0 × 60.0 (20½ × 23⅝)
Not signed
Davids Samling, Copenhagen

The Scandinavian art historian Poul Vad considered
Open Doors (White Doors) Hammershøi's most important
work, an opinion supported by Vad's colleague Jens
Thiis, who called it "the essence of his genius." (Vad,
1957, pp. 22–23). It was appropriate that Hammershøi,
the isolated artist and introspective man, should find his
leitmotif in the inner recesses of his home seen through
the veil of his neurasthenic sensibility. The room is filled
with the sense of someone's recent departure and the
expectation of their return, an "indissoluble tension, a
vestige of a complete human drama that still hangs on
the walls and the doors" (Thiis quoted by Olsen,
"Vilhelm Hammershoi" in Ordrupgaard, 1981, p. 29).
The flash of reflection from the brass door handle and
the ethereal line of light that falls along the floor convey
an impression of transience. Yet time also seems
unnaturally suspended. The doors appear to hover
slightly, and their frames swell; there is a moment of
hesitation before the journey through the open doors,
into the hallway, and towards the light. The view into a
back space was made famous by the seventeenth-
century Dutch masters, who used the device to present
an informal but intimate glimpse into everyday life. But
Hammershøi transforms the motif into a modern
metaphor of passage, and the serenity of quiet spaces is
replaced by a haunted emptiness.
 Open Doors was exhibited during the artist's lifetime in
Berlin (1905), London (1907), Rome (1911), and New
York (1913), and contributed to his reputation as "the
painter of deserted rooms" (Poulsen, 1976, p. 143). He
shared this distinction with the Belgian Xavier Mellery
(1845–1921), whose series of drawings, *L'âme des choses
(The Soul of Things)*, was begun in 1889. Yet Mellery's
more theatrical scenes depend on dramatic shadows and
the eerie presence of sculptures and plants.
Hammershøi's means are less explicit and ultimately
more evocative; *Open Doors (White Doors)* is a conception
without parallel in the art of its time. [EB]

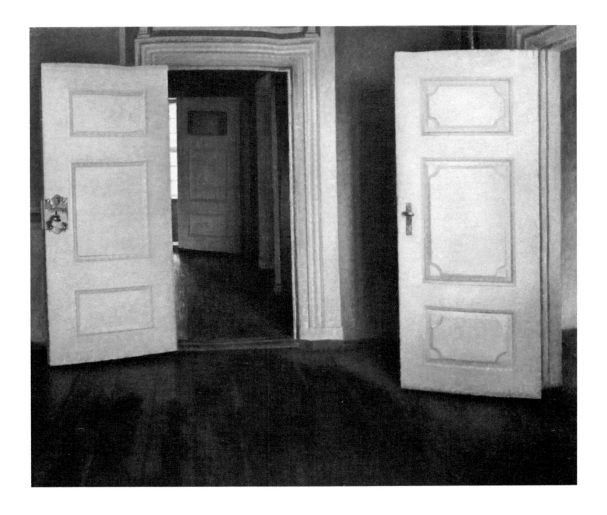

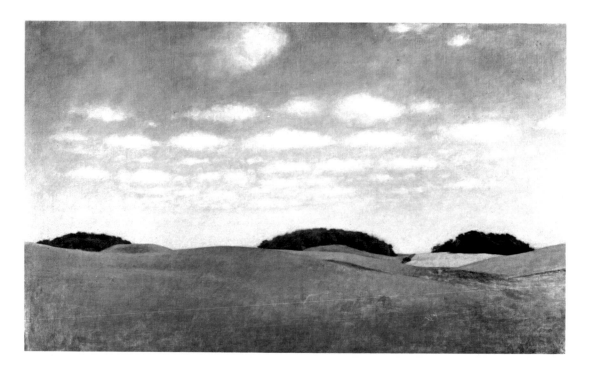

32
Landscape from Lejre 1905
Landscab. Lejre
41.0 × 68.0 (16⅛ × 26¾)
Not signed
Nationalmuseum, Stockholm

Here Hammershøi depicts the characteristic rolling hills of the countryside at Lejre, near the center of Sjaelland. The gently swelling landscape, dotted with trees or an occasional farmhouse, was a favorite subject of earlier Danish painters, notably Johan Thomas Lundbye (1818–1848) and Peter Christian Skovgaard (1817–1875). Hammershøi owned a Lundbye, and his first instructors, Vilhelm Kyhn and Frederik Rohde, were landscape painters in the same tradition. He acknowledges his artistic heritage in the choice of subject and in his affinity for the unassuming character of the local scenery. His rendering of the linear rhythm of the land, the sweep of the hills and forests against the horizon, are particularly reminiscent of Lundbye.

Hammershøi's landscapes also include intimate views within small woods, where tree trunks form evocative silhouettes and the foliage blurs into a mass of feathery strokes. These are Symbolist landscapes, cloaked in a hazy light, suggestive, and of an undefined locale. *Landscape from Lejre,* however, belongs to a group of monumental images that depict the recognizable topography of his native Sjaelland. In *Lejre,* openness and clarity prevail. The small woods appear as dark mounds on the horizon, echoing the undulations of the ground and the oval wisps of clouds in the sky. Hammershøi concentrates on the formal reduction of the scenery in a landscape void of people, incident, or the slightest irregularity of nature. Even the clouds diminish in perspective according to clearly ordered rows, emphasizing the horizontal character of the land and the impression of infinite expanse just beyond the gentle rise of hills. [EB]

33 *Reproduced in color as frontispiece*
Study of a Sunlit Interior 1906
Stue. Solskinsstudie
55.0 × 47.0 (21⅝ × 18½)
Not signed
Davids Samling, Copenhagen

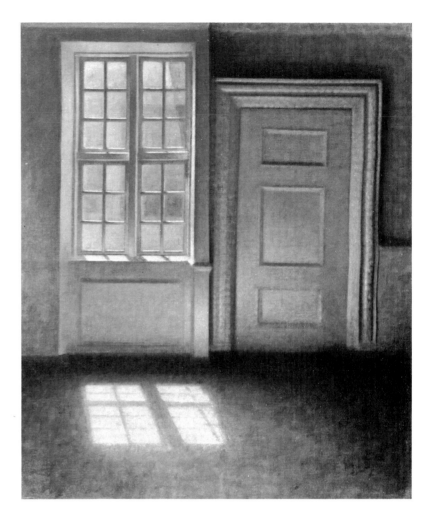

Study of a Sunlit Interior presents a variation of a
celebrated Hammershøi painting entitled *Dust Motes
Dancing in Sunlight* (1900; Steen Kristensen,
Copenhagen). It depicts the same wall of Hammershøi's
Copenhagen home nearly identically. Only the time of
day, the location of the sun-filled image of the window
cast upon the floor, and the quality of light have
changed. All is mute and incorporeal; space is defined
solely by the vibrating rays of the light and the abstract
geometry of the interior design.

Of all the Scandinavian painters of the late nineteenth
century, Edvard Munch* and Vilhelm Hammershøi
were the most noted for their neurasthenic
temperaments and for their ability to render their
emotional sensitivity through expressive line and color.
Both artists favored the light-filled window as a visual
symbol and personal vehicle of introspection (see, for
example, Munch's *Night,* cat. no. 63, or *Young Woman
at the Window,* a print of 1894; Schiefler, 1923, #5).
Hammershøi's use of the motif, however, is more
radical than Munch's, for his interior lacks curtains,
furniture, or most significantly, a human figure in the
act of contemplation. Instead, the viewer becomes lost
in the dream-provoking emptiness of the room. Nothing
is more ethereal yet more thought-absorbing than the
sunlight filtering through the window panes.

The critic Emil Hannover called Hammershøi the
"Nordic counterpart to des Esseintes" (Hannover, 1922,
p. 346), the decadent hero of Joris Karl Huysman's
novel *À Rebours* (1884). Although Hammershøi shared
themes with the French and Belgian poets, his work
also had close ties to an indigenous school of Danish
Symbolist literature and has been compared to that of
his friend, the poet Sophus Claussen (1865–1931),
whom he visited in Rome in 1902 and 1903 (Finsen in
Ordrupgaard, 1981, p. 8). His temperament was also
similar to that of the decadent protagonist in *Niels
Lyhne,* Jens Peter Jacobsen's novel of 1880. Jacobsen
was a strong influence on the German poet Rainer
Maria Rilke (see Lydia Baer, "Rilke and Jens Peter
Jacobsen," *Publication of the Modern Language Association
of America,* 54, no. 3, September 1939, pp. 900–932; no.
4, December 1939, pp. 1133–1180), who admired
Hammershøi and planned to do a monograph on him
(Finsen, in Ordrupgaard, 1981, p. 6). Hammershøi, like
Rilke, belonged to Jacobsen's "Company of the
Melancholy," a group of artists who have been
described as "robust neither in their persons, nor their
poetry; poets of dreams and longing, tending towards
segregation, loneliness and solitude" (Baer, 1939, p.
903). [EB]

34
St. Peter's Church, Copenhagen 1906
S. Petri Kirke, København
133.0 × 118.0 (52⅜ × 46½)
Not signed
Statens Museum for Kunst, Copenhagen

The silence that reigns over Hammershøi's landscapes and interiors continues in his architectural views. In addition to painting the historic castles and palaces of Copenhagen and the surrounding countryside, giving a new and dream-like context to landmarks of both personal and national memories, he repeatedly depicted the less prestigious warehouses of the East Asiatic Company across the street from his home. While abroad, he painted views of the British Museum. As in *St. Peter's Church* these buildings stand completely deserted and shrouded in gentle mist, and are seen from atypical or intimate angles to promote the impression of a mysterious encounter. An unsettling stillness presides over sites formerly alive with human drama, and a sense of nostalgia permeates their walls.

The image of a sleeping or abandoned city had been made famous by the Belgian poet Georges Rodenbach in his 1892 *Bruges-la-Morte*, and international critics commented on the similarity between Rodenbach and Hammershøi. William Ritter, for example, considered the poet and the painter ''sister natures'' preoccupied with the theme of silence (Ritter, 1909–10, p. 264). Rodenbach's *Bruges* had inspired a series of illustrations begun in 1904 by his compatriot Fernand Khnopff, and Hammershøi and Khnopff employed like means: the fragmented view, the melting edges of monumental forms, the concentrated absence of life and movement. Hammershøi's mature versions of the sleeping-city theme date from the early 1900s, and even earlier pictures of farmhouses or the towers of Kronborg castle resonate with the same studied quietude. His depiction of historic Danish architecture—for reasons of national pride and interest in monumental form—has its precedent in Danish Golden Age painting. The twilight setting and contemplative mood of Christen Købke's *Frederiksborg Castle at Dusk* (1835; Den Hirschsprungske Samling, Copenhagen) provided an important example. [EB]

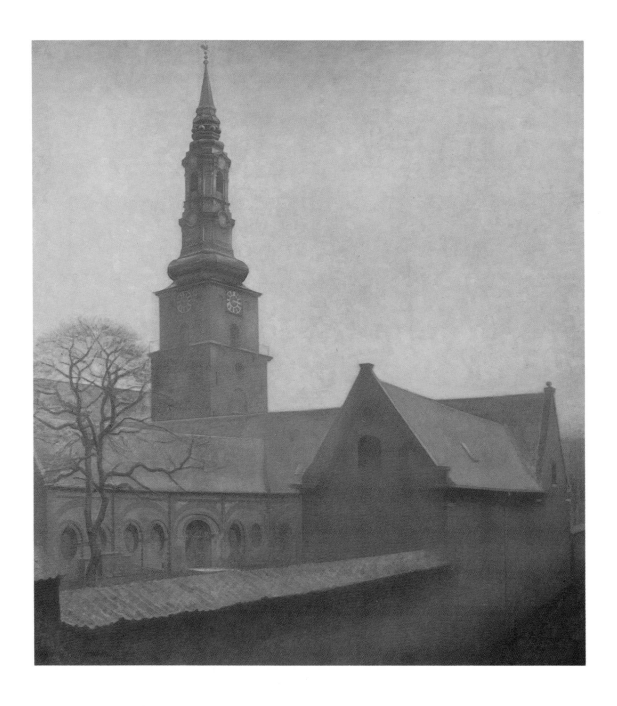

35

Interior with a Seated Woman 1908
Stue med kvinde seddende på hvid stol
71.0 × 57.5 (28 × 22⅝)
Signed lower left: "V.H."
Aarhus Kunstmuseum

Hammershøi executed a series of sitting or standing figures in combination with the doors of the ante-room depicted in *Open Doors* (cat. no. 31). The image here is similar to one painted by the artist in 1900, *Interior with a Woman Seated on a White Chair* (private collection). In other versions the woman stands on the threshold of the open door or has progressed to the middle of the back hallway. Typically, she is presented with her back to us, preoccupied by her reading or some undefined activity. Unlike the traditional Romantic figure who longs for freedom by an open window, the woman in Hammershøi's interiors does not resist her enclosure, but becomes immutably ensconced among the objects and furniture that surround her.

Paintings of domestic interiors have a long history in Danish art, beginning with the Biedermeier scenes of Christoffer Vilhelm Eckersberg (1783–1853) and his pupils. These artists expressed the unpretentious comfort of their bourgeois environments with a clarity of observation and strict architectonic design, vestiges of the classicism that dominated Copenhagen's Royal Academy of Fine Arts at the turn of the nineteenth century. Hammershøi continued this tradition in the composition of his interiors, playing horizontal against vertical, two-dimensional design against spatial illusion. He once commented on his art, "When I choose a motif it is first and foremost the lines that I consider" (Vad, 1957, p. 24). In *Interior with a Seated Woman* there is a delight in the repetitive geometry of the wainscoting and door moldings and in the reverberation of rectangles across the picture plane and into space.

Although a nostalgia for the Danish Golden Age is central to his art, Hammershøi departs from these traditional interiors and from those of his contemporaries Peter Ilsted (1861–1933) and Carl Holsøe (1863–1935). The juxtaposition of an abstract surface geometry with a palpable haze of brushwork gives his work its special tension. The veil of atmosphere creates a continuum informed by spirit, where "not too solid matter shades imperceptibly into a space not truly void" (Robert Goldwater, *Symbolism*, New York: Harper and Row, 1979, p. 159). The familial *Gemütlichkeit* and Protestant simplicity so essential to the Biedermeier character are replaced by melancholy solitude and fragile asceticism. [EB]

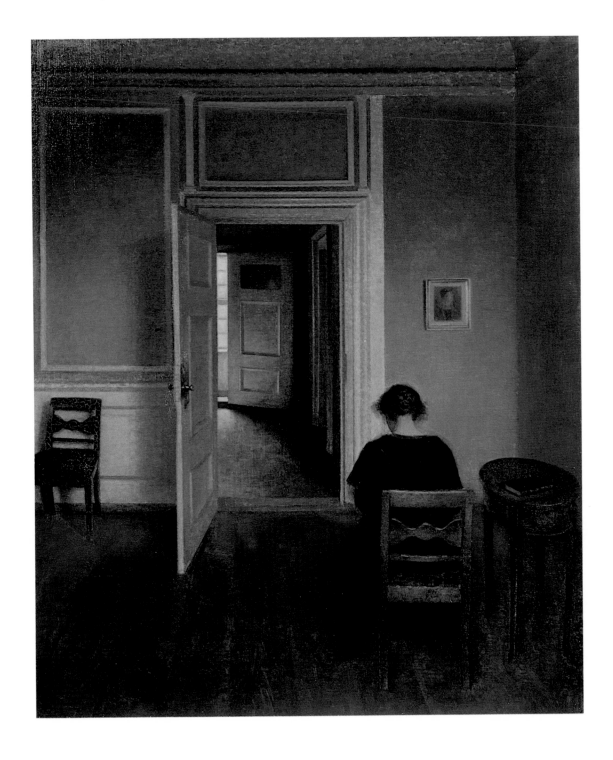

36
Female Nude 1909–10
Kvindelig model
205.0 × 153.0 (80¾ × 60¼)
Not signed
Statens Museum for Kunst, Copenhagen

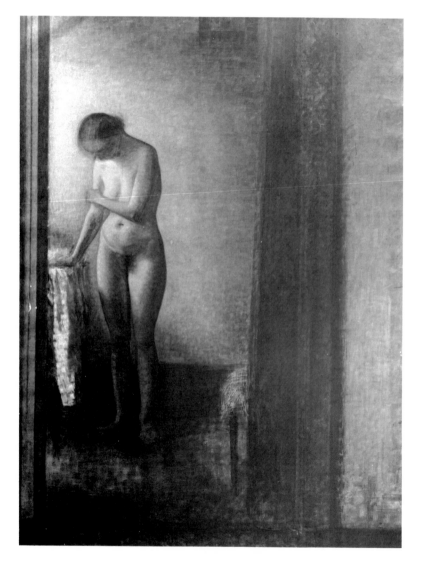

At the end of the first decade of the 1900s, Hammershøi returned to the nude, a motif he had ignored since *Artemis* (1893–94; Statens Museum for Kunst, Copenhagen) and the academic studies of his youth. Despite the time interval, the artist's interest remained the same: the definition of form and volume through the subtle means of tonal gradation. In *Study of a Young Female Nude* (1884; Den Hirschsprungske Samling, Copenhagen) he achieved this through the black-and-white modulation of conté crayon in a manner similar to that of Seurat. An oil sketch of a standing nude he executed while at Peder Severin Krøyer's school (1886; private collection) is similar to the image here in the obscured face and blurred forms of hands and feet and in the overriding attention to the luminous, smooth curves of the female torso.

Hammershøi views his subject through the physical and psychological intermediary space of a door. The device of framing the figure between the door frames was used by Christoffer Vilhelm Eckersberg in his famous *Model Study* (1833; Ny Carlesberg Glyptotek, Copenhagen), a painting Hammershøi undoubtedly knew. But unlike Eckersberg, who painted a pristine and enamel-like surface, Hammershøi left his canvas unfinished, revealing a play of textures from the square impasto stroke of the white tablecloth to the scratched surface of the chair at the lower right. The picture shows the artist's working process, a careful layering of small brushstrokes that approximates a loose web in its initial stages and coalesces into solid matter in its final form, as in the door molding at left. From the scumbled surface of the canvas emerges the definition of a female nude, her contours smooth and precise, her thighs and abdomen possessing a delicate, mother-of-pearl shine.

The same year Hammershøi did a finished and highly realistic standing nude (see below). The model stands before the viewer in a plain space without definition or accessories, her facial features clearly visible. There is an uncompromising fidelity to the details of her age and the posture of her body. In contrast, the model depicted in *Female Nude* bows her head and covers her breasts with her left arm in a gesture of modesty. The whole is rendered with a delicacy and sensitivity to both form and person, in contrast to the merciless verism of the other contemporary nude. [EB]

Vilhelm Hammershøi
Standing Nude 1910
172.0 × 96.5 (67¾ × 38)
*Davids Samling,
Copenhagen*

37
Self-Portrait 1911
Selvportraet
126.0 × 149.5 (49⅝ × 58⅞)
Not signed
Statens Museum for Kunst, Copenhagen

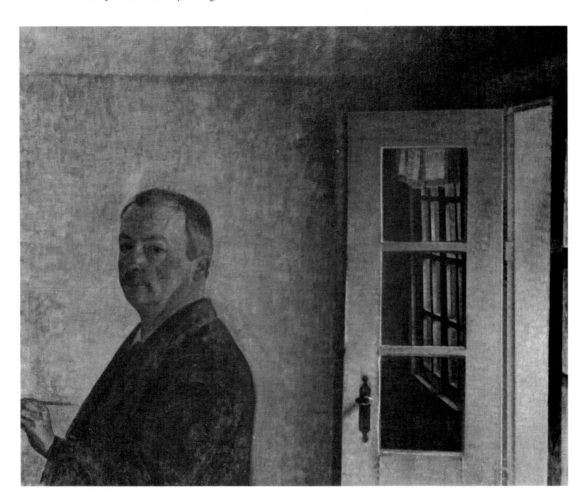

Hammershøi spent the summer of 1911 near
Frederiksdal at Villa Spurveskjul (Shelter for a
Sparrow), the historic country residence of the
Neoclassical painter Nicolai Abildgaard (1743–1809).
There he painted three self-portraits, of which this is the
largest and most important (Vad, 1957, p. 23). In a
recent essay Harald Olsen ("Vilhelm Hammershøi" in
Ordrupgaard, 1981, p. 31) interprets it as a double
portrait of the artist and his leitmotif, the interior, here
distilled in the form of an open door placed
emphatically beside him. The style is characteristic of his
late period after 1910, with looser brushwork and
empty spaces that lack their former tension.

 Hammershøi painted more than ten self-portraits,
including three double portraits with his wife. In the
early images he remains slightly aloof, his face masked
by shadow (1891; Gerda and Peter Olufsen,
Copenhagen) or distanced by a dreamy attitude (1889;
Statens Museum for Kunst, Copenhagen). Likewise, in
the 1898 *Double Portrait of the Artist and his Wife* (Aarhus
Kunstmuseum) he depicts himself with his back to the
viewer. Later, however, he discarded these mannerisms
in favor of a more critical self-scrutiny and
confrontation with the viewer, revealing that the lean
look and aristocratic features of his youth had been lost
in a middle-aged fullness of face. Such uncompromising
Realism and sense of resignation pervade his 1913
self-portrait painted at the request of the Uffizi Gallery
in Florence after his acclaim at the Rome International
Exhibition of 1911. [EB]

EUGÈNE JANSSON Sweden 1862–1915

A life-long resident of Stockholm, Eugène Jansson
began his artistic training at the city's technical school in
1878 under Edward Perseus (1841–1890). He
continued his studies at the Royal Academy of Fine Arts
under Georg von Rosen (1843–1923), a noted painter of
portraits and historical subjects. His early works include
still lifes and portraits of family members.

Becoming acquainted with the radical Swedish
painters who had returned from France, Jansson joined
the Artists' Union in 1886. He served as secretary of the
union and remained an active member the rest of his
life. He was plagued by economic difficulties, ill health,
and a progressive loss of hearing.

At the recommendation of Karl Nordström*, the
collector Ernest Thiel began to take an interest in
Jansson's views of Stockholm in the late 1890s. Thiel
bought several paintings and sponsored Jansson's trips
to Paris in 1900 and to Italy and Germany the following
year.

From 1890 to 1904 Jansson painted city views almost
exclusively. In 1905 he turned to male nudes—a change
of subject matter that links him with the prevailing
interest in vitalism. He was secretive about the change
and did not exhibit the new works until 1907. In this
last period he also painted portraits and military
dances. [RH/PG]

38
Dawn over Riddarfjärden 1899
Gryning över Riddarfjärden
150.0 × 201.0 (59 × 79⅛)
Signed lower left: "Eugène Jansson/1899"
Prins Eugens Waldemarsudde, Stockholm

Many of Jansson's nocturnal cityscapes of the 1890s
represent views from his studio or apartment in the
southern part of Stockholm. According to
contemporaries, he painted from memory to record the
feelings he experienced while watching the quiet city
(biblio. ref. no. 95, p. 282). Here the view is from a high
vantage point over the dark forms of the Södra hills and
the white strand with boathouse and ships, looking
across the Riddarfjärden bay which separates the
southern and northern parts of the city. In the
background the coastline and skyline are rendered
summarily but accurately: the reflections in the water
conform to reality, as do the relative size and location of
the church steeples piercing the sky. At the center is the
spire of Riddarholm Church, the largest church in
Stockholm.

The fascination with shore lights and their reflections,
the high horizon line, and the color harmonies recall
the 1870s *Nocturnes* of James McNeill Whistler, whose
work was an important influence upon Swedish and
Norwegian Blue Painting. Edvard Munch* was also a
major influence on Jansson, and the major exhibition of
Munch's work in Stockholm in 1894 stimulated
Jansson's development of city views. Works of 1894
that depict part of the site pictured here included more
details of the strand, the hills, and the anchored ships.
In the *Southern Strand* of 1896 (Thielska Galleriet,
Stockholm) Jansson eliminated much detail and
absorbed all angularity in the bold, flowing contours
that characterize works from the height of his blue
period. The directional brushstroke that creates the
sense of an energized field is related to works by Van
Gogh and the Varberg painters Nils Kreuger and Karl
Nordström*. Jansson subsumed their influences into a
personal calligraphic touch, employing systems of curly
and long, undulating strokes to differentiate sky from
water and water from hill. In *Dawn over Riddarfjärden* he
has created a topographically accurate view that
conveys a nearly hallucinatory mood of beauty and
mystery. [RH/PG]

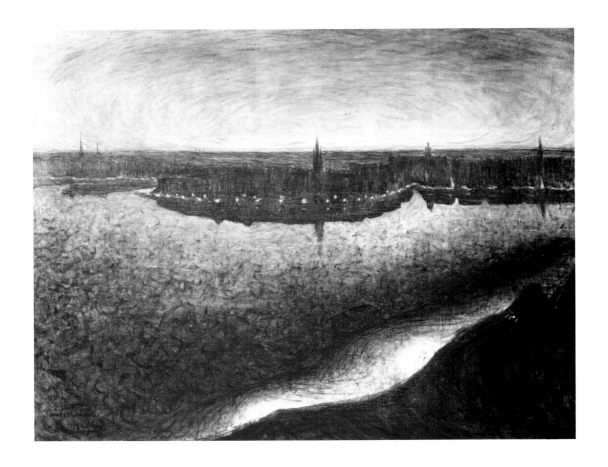

39

The Outskirts of the City 1899
Stadens Utkant
152.0 × 136.0 (59⅞ × 53½)
Signed lower left: "Eugène Jansson/1899"
Nationalmuseum, Stockholm

Since his 1890 pastel of the Stockholm street Karlbergsvägen (Näsby, Carl Robert Lamm), Jansson had been interested in portraying the outskirts of Stockholm, where city and country coexist. Another canvas (1899; Thielska Galleriet, Stockholm) shows the same building depicted in *The Outskirts of the City* from the opposite side and from a high viewpoint.

With increasing industrialization, Stockholm grew rapidly in Jansson's lifetime. By the turn of the century, poverty and a severe shortage of housing plagued the city. As a response to this situation, large buildings were constructed on the outskirts to house workers. Jansson shared the radical social ideals of the Artists' Union and participated in various demonstrations in support of workers. At the time he painted *The Outskirts of the City*, he was working on the conception of his monumental tribute to the workers' movement, *Demonstration Day* (see page 36).

Despite the absence of humans and the stark architectural style, this view of a new apartment building seems to convey a positive feeling. Seen from a distant low viewpoint that exaggerates its height, the pristine white structure reflects the late-afternoon light and shines between the brilliant, energized sky and the lush, cultivated gardens. Although the scene has a bizarre quality, it nevertheless may be a statement of faith in the future of a social order based upon the ideals of the proletariat.

By paying attention to the indeterminate zone where the city ends, Jansson's picture recalls numerous canvases of the late 1880s by such French Neo-Impressionists as Paul Signac and Charles Angrand. But in giving prominence to the blank modern style of new workers' housing, *The Outskirts of the City* has still stronger affinities with the views of Milan's suburbs painted by the Italian Futurist Umberto Boccioni around 1908. Jansson's sense of the romance of the city at night, his socialist leanings, and his active brushwork all suggest an odd, totally coincidental parallel with the early works of the Futurists. [RH/PG]

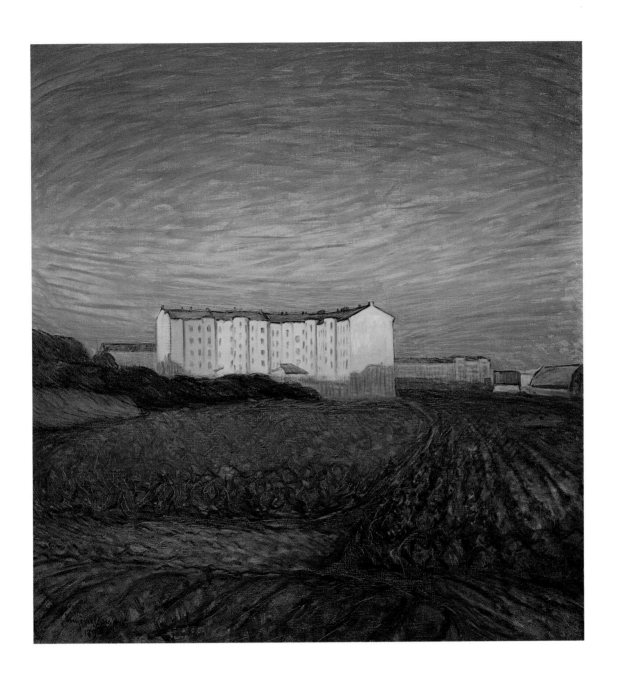

40
Self-Portrait 1901
Jag. Självporträtt
101.0 × 144.0 (39¾ × 56¾)
Signed lower left: "Eugène Jansson/1901"
Thielska Galleriet, Stockholm

Here Jansson portrays himself standing before a window—possibly in his studio or in the apartment he shared with his mother and brother—overlooking Riddarfjärden bay and the lights of Stockholm. The unusual horizontal format for a half-length portrait, the painter's confrontation with the viewer, and the window and city view as background recall Lovis Corinth's *Self-Portrait with Skeleton* (1896; Städtsiche Galerie, Lenbachhaus, Münich). It is not known, however, whether Jansson was aware of Corinth's portrait.

Approaching forty, Jansson stares out with a frown and knit brows as if to express his unhappiness or the seriousness of his work. He has his hands in his pockets and stands before a bare table. A friend of Jansson attributed the alienation of this portrait to the artist's illness and the isolation he then needed in order to do his work (biblio. ref. no. 95, p. 282). Though the face is tightly painted, the surroundings are rendered in the loose manner characteristic of Jansson's other works of the period. Clearly meant to be read as a view through a window, the background suggests four other Jansson canvases. He painted the entire wide panorama as well as narrow vertical sections of the same view.

Jansson's only other self-portrait (1910; Nationalmuseum, Stockholm) offers a telling comparison. Both depict the artist not at work, but framed by the principal subject matter of his art during the period each was painted: here a nocturnal view of Stockholm and in the other male nudes in a bathhouse. In neither is the artist immersed in the world he portrays.

Here architecture, table, and contrasting tonalities separate the figure from the city of Stockholm. In the bathhouse self-portrait the artist's clothes and his lack of contact with the other men mark him as a non-participant. His striding figure clad in a light tropical suit and surrounded by athletic, light-drenched bodies reflects his interest in vitalistic philosophy. In contrast, here the slouched, dark-clad figure with hands in pockets expresses the turn-of-the-century introspection of the Decadents. [RH/PG]

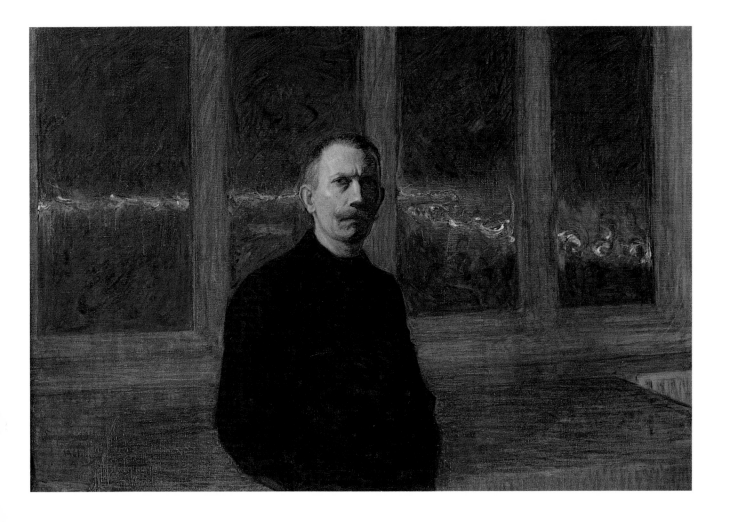

41
Hornsgatan at Night 1902
Hornsgatan nattetid
152.0 × 182.0 (59⅞ × 71⅝)
Signed lower right: "Eugène Jansson/1902"
Nationalmuseum, Stockholm

This is one of two 1902 depictions of Hornsgatan, the main street of the southern part of Stockholm: here a view toward the east, in the other (Thielska Galleriet, Stockholm) a view toward the west.

Adapting the sinuous line of Edvard Munch* and the directional brushstroke of Vincent Van Gogh, Jansson transformed the dark street into a place of haunting beauty. Reversing the systems used in *Dawn over Riddarfjärden* (cat. no. 38), here he rendered the lower half of the canvas with long, straight strokes and created the sky with his characteristic curling squiggles.

The row of buildings high upon the bank at the left looms up to form an unsteady balance for the deep void of the night sky. The double row of streetlights lead the eye along the fall and rise of the street, seen from an oblique angle, into the darkness at the end. Lines that radiate from beneath the lamppost at the left set up conflicting horizontal movements.

Jansson's mastery of the mood and colors of nocturnal Stockholm is paralleled in literature by the novels of Hjalmar Söderberg (1869–1941), whom he may have known through the Swedish collector Ernest Thiel. Söderberg's works evoke the "poetry" of the city streets, waterways, and buildings as they are altered by dim lights and drifting mists and the fluctuations of the seasons (biblio. ref. no. 81, p. 357). [RH/PG]

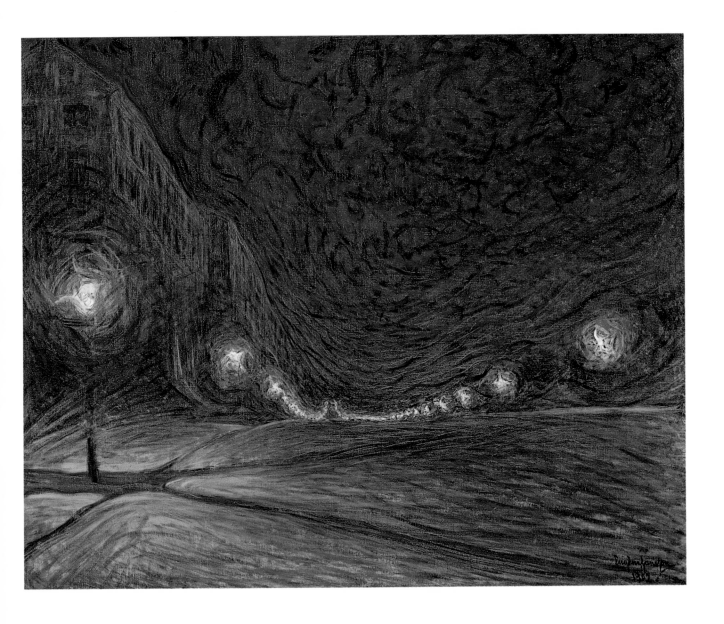

42
Österlånggatan 1904
168.0 × 112.0 (66⅛ × 44⅛)
Signed lower right: "Eugène Jansson/1904"
Thielska Galleriet, Stockholm

The last of Jansson's cityscapes, this canvas depicts a narrow street in the medieval section of Stockholm. The agitated brushwork contrasts strikingly with the peaceful stillness of the deserted street. The absolutely motionless large flag at once constricts the space and forms a translucent screen through which the other flag and the tops of buildings can be sensed. Seeping around the edges of the flag, the beautiful light of the summer night reflects off the windows of the upper stories.

The prominent position of the flags is provocative. The art historian Carl Laurin has mentioned in this connection the Scandinavian sailors' superstition that a flag left out after sunset is flown in honor of the devil (Laurin, 1930, p. 41). Or, considering Jansson's social and political interests, the flag may refer to contemporary events. The union of Norway with Sweden was a contested issue in 1904; the following year the union would finally be dissolved. Jansson's focusing upon the flag, with its symbol of union in the upper corner, may express his involvement with the debate.

The stillness and mournful feeling of this painting make it a Symbolist counterpoint to the festive pictures of flags—often similar in composition—that were painted by the French Fauve artists only two years later. [RH/PG]

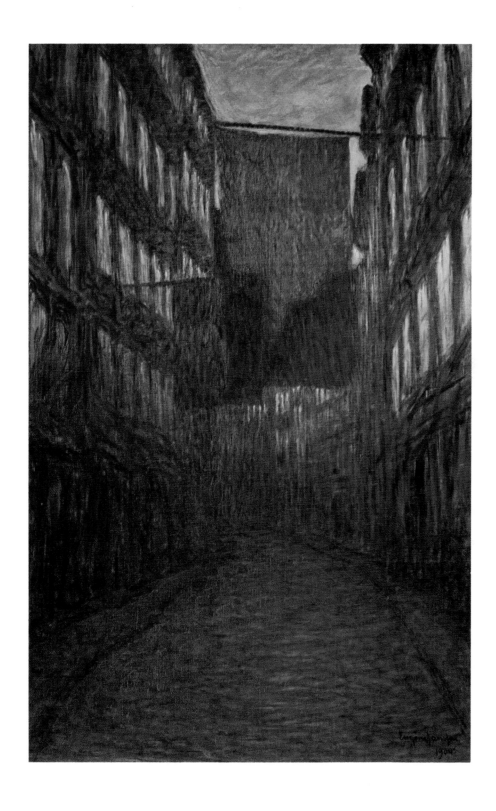

EERO JÄRNEFELT Finland 1863–1937

Eero Järnefelt came from an old, culturally oriented family. His brother Armas became a distinguished conductor and composer, his brother Arvid a leading writer, and his sister Aino the wife of the composer Jean Sibelius. At eleven Järnefelt began his artistic training in Helsinki at the Finnish Fine Arts Association, remaining there for four years. When he went to the Art Academy in St. Petersburg in 1883, he studied under his uncle, Michail Klodt von Jürgensburg, a *plein-air* painter. From 1886 to 1891 he worked in Paris at the Academie Julian under Adolphe Bouguereau and Robert-Fleury. While there he twice received Finnish state stipends. Drawn to *plein-air* painting, he spent the spring of 1888 in Veneux-Nadon (between Barbizon and Fontainebleau) with Scandinavian and French artists. In 1894 the Finnish government subsidized a study trip to Germany and Italy, and again in 1897 he was awarded funds to travel in Italy.

The Russian critic Sergei Diaghilev divided Finnish artists of the end of the nineteenth century into two groups: those with nationalistic approaches and those who followed the aristocrats of the West (biblio. ref. no. 46, p. 29). An exemplar of the latter, Järnefelt nonetheless developed in an atmosphere sympathetic to the Finnish national movement. He lived for several years in the small town of Kuopio amidst a circle of artists and writers who were dedicated to liberal ideas of Realism and at the same time fighting for the Finnish language and education of the masses.

Järnefelt, who married the actress Saimi Pia Swan, became a professor of drawing at the University of Helsinki and an inspector for the Finnish Artists' Association. Among his many awards were gold medals at international art exhibitions in Paris in 1900 and Budapest in 1907. [WPM/SSK]

43
**Lefranc, Wine Merchant,
Boulevard de Clichy, Paris** 1888
Ranskalainen Viinikapakka
61.0 × 74.0 (24 × 29⅛)
Signed lower left: "Eero Järnefelt/1888"
Ateneumin Taidemuseo, Helsinki

Although Järnefelt shows us two men in a wine shop, the true subject of *Lefranc, Wine Merchant* is light. Back lighting, palpable in its intensity at the front of the shop, sharply outlines the standing figure, whose face and hands are illuminated by a match. The red gauze attached to the spiral staircase is also back-lit, intercepting the light from the front and throwing the seated older man's face into shadows. Reflective surfaces such as the polished metal bar are modelled by light, and the light is transmitted through or held by the liquid in the bottle and the glasses on the table.

Järnefelt's studies at the Academie Julian clearly show up in this work. His preoccupation with the treatment of light in all its variations foreshadows his interest in *plein-air* painting, which he was to explore later that year at Veneux-Nadon. *Lefranc* also reveals his close affinities with Salon Realism of the 1880s. It is specifically allied with the Realism characteristic of many works at the 1888 Salon, where concentration on the rendering of light was also apparent. [WPM/SSK]

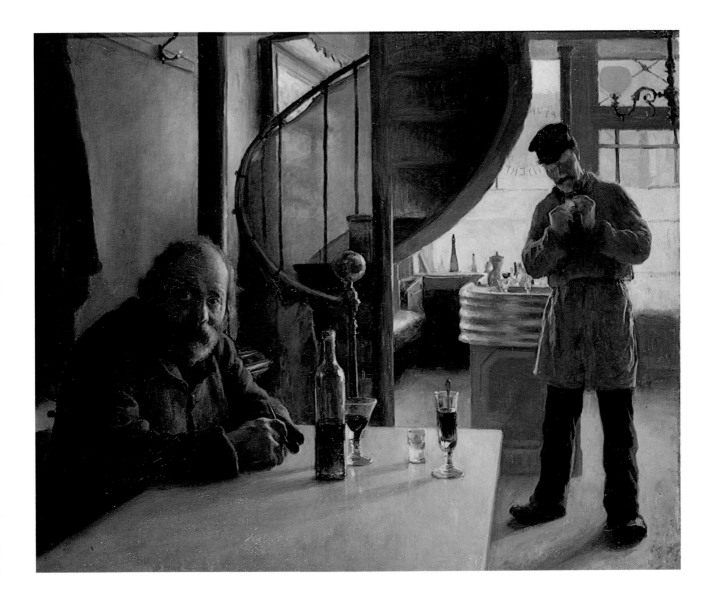

44

Portrait of Professor Johan Philip Palmén 1890

Yliopiston Varakansleri J. Ph. Palménin Muotokuva

116.0 × 84.0 (45⅝ × 33⅛)

Signed lower left: "Eero Järnefelt./1890."

Ateneumin Taidemuseo, Helsinki

Järnefelt was a successful and sought-after portrait artist. He painted the *Portrait of Professor Johan Philip Palmén* during a summer spent in Finland toward the end of his residency in Paris. A Finnish scholar and senator, Palmén belonged to a milieu much like that of Järnefelt's own family.

In this work Järnefelt combines naturalism with a spatial conundrum. Palmén is represented in meticulous detail, sternly confronting the viewer in the attitude of a Napoleonic Quaker. Much attention is also given to details of the interior, from the Biedermeier furniture to the exotic plants. Inasmuch as it is a highly detailed depiction of a person in equally detailed surroundings, the painting appears to reveal Järnefelt's affinities with Parisian Realism.

Yet, for all that, a spatial game is being played. The space is illogical, and the relationship of the parts of the interior is hardly decipherable. The rug with the triangle design is so flat that at first it seems to be a wall. Once it has been identified as a rug, it is not certain if it is one rug, two overlapping rugs, or two rugs separated by a thin strip of floor. The progression of rooms into the background is equally confusing: strips of white and color seem to define rooms and frame doorways; yet again it is not certain how many rooms are represented. In pun-like fashion, these strips also frame the portrait on the back wall. Adding to the confusion of depth and pattern are the spider-like forms of the tropical plants.

In this portrait Järnefelt reveals both Realist and decorative-abstract sensibilities, creating a dialogue between pattern and high Realism. Two years later he painted Palmén's portrait again, abandoning the intricacies of this work for a simpler, more traditional representation with a flat, grayish background (present location unknown; for a reproduction see biblio. ref. no. 40, p. 209). [WPM/SSK]

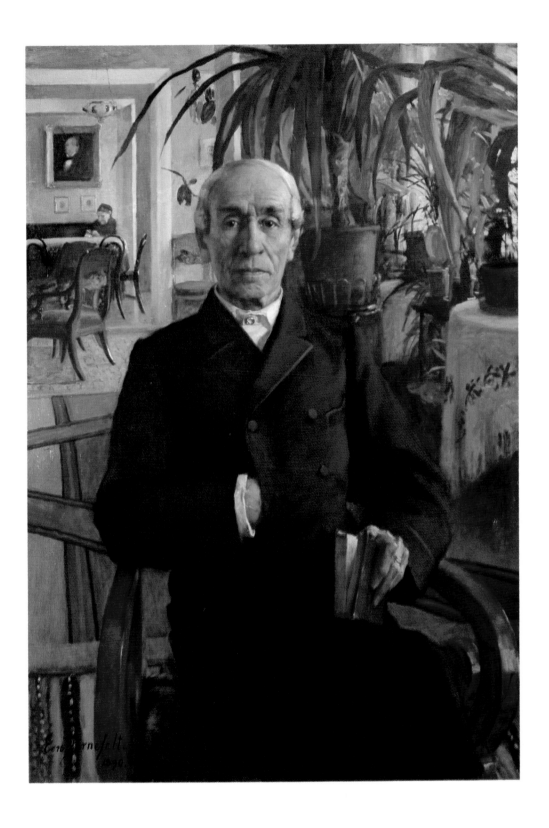

45
Flowers in Water 1895
Ahvenruoho
39.0 × 28.0 (15⅜ × 11)
Signed upper right: "Eero Järnefelt/1895"
Ateneumin Taidemuseo, Helsinki

This small, subtle nature study is closely cropped in order to concentrate on a few elements: clear water with a single vine of flowers on the surface and a suggestion of rocks beneath. While still linked to the *plein-air* Naturalism in which he trained, the picture embodies Järnefelt's 1890s tendency toward a sparer vision of nature reduced in details and colors. The downward view also shows the preoccupation with flattened pattern evident in the *Portrait of Professor Johan Philip Palmén* (cat. no. 44). There is a stress on decorative qualities that is more fully realized in the later *Lake Shore with Reeds* (cat. no. 46), where the water is no longer transparent but opaque and matte. A strain of Art Nouveau runs through all three of these Järnefelt paintings, and in *Flowers in Water* we have a modest precursor of the later contemplative water decorations of Gustaf Fjaestad (see cat. nos. 17 and 18). [WPM/SSK]

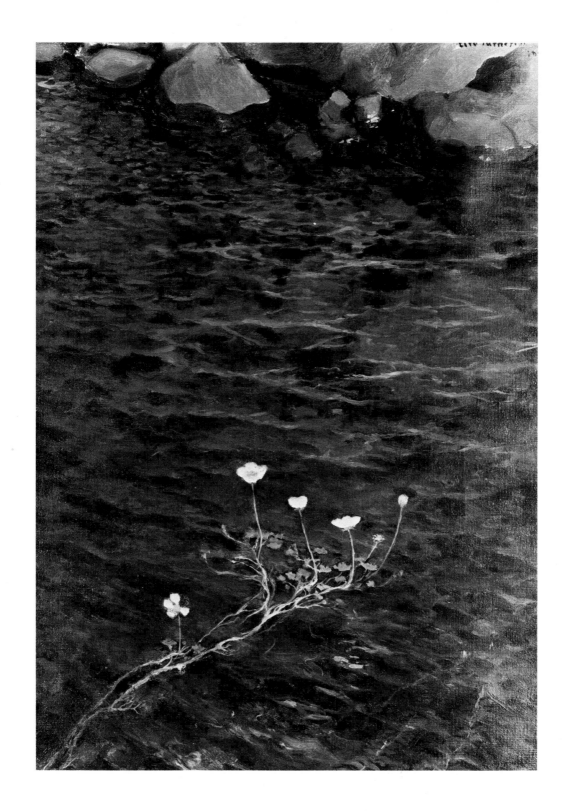

46
Lake Shore with Reeds 1905
Kaislikkoranta
94.5 × 75.0 (37¼ × 29½)
Signed lower right: "E. Järnefelt/05."
Ateneumin Taidemuseo, Helsinki

Järnefelt expressed his love for Finland in his landscapes. In *Lake Shore with Reeds* he conveys what has been described as the intimate and elegiac lyricism of the Finnish countryside.

Like such comparable works by Albert Edelfelt as *Kaukola Ridge at Sunset* (cat. no. 8), this landscape resonates with a mournful northern atmosphere; in it Järnefelt poetically depicts Scandinavian fall. The odor and dampness of nature's decay are brought out and reinforced by the somber autumnal tonalities and the still water and trees. An empty wicker chair set at the lake's edge signals winter's onset and the desertion of the out-of-doors. This chair, emphasizing man's necessary retreat, is evocative rather than symbolic. The closing in of nature is further stressed by the high horizon line and viewpoint. On the whole the work is more wistful and melancholy than it is death-like.

This painting reveals the influence of Synthetism on Järnefelt's fundamentally naturalistic landscape style. He is highly selective in his use of shapes and cropping. The simplified, almost abstract forms of the trees, reeds, and water—represented in restrained and harmonious colors—make this work more a whole than a combination of independent parts. Also contributing to this effect are the overcast twilight sky, which denies the water's reflective quality, and the matte surface of the entire work. Thus Järnefelt incorporates Synthetist qualities without departing from Naturalism in terms of either form or mood. [WPM/SSK]

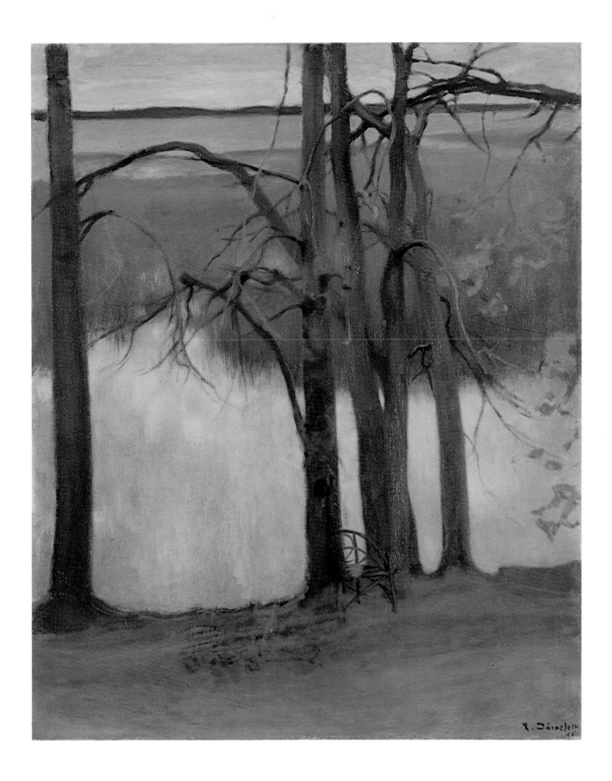

KARL GUSTAV JENSEN-HJELL Norway 1862–1888

Karl Gustav Jensen-Hjell was born Karl Jensen in 1862 and assumed the name Jensen-Hjell in the early 1880s. The son of a restaurant keeper, he was orphaned in his youth.

Jensen-Hjell began his studies at Christiania's Royal Academy of Drawing and then enrolled in Knut Bergslien's school of painting, where he met his lifelong friend Nils Gustav Wentzel*. Around 1882, he joined Christian Krohg's* circle of young artists at the studio building "Pultosten," where he encountered the French-inspired Naturalism that he was to advance. At the urging of Eilif Peterssen*, he went to study in Munich in 1882 and '83. Returning to Norway in 1884, he visited Numedal and there completed *Interior from Numedal* (Nasjonalgalleriet, Oslo), his first submission to the Christiania Autumn Exhibition.

Also in 1884 Jensen-Hjell took his maiden trip to Paris, accompanying Gustav and Kitty Wentzel. A short time later he studied with Fritz Thaulow (1847–1906) at Thaulow's "Open-Air Academy" in Modum. Returning to Christiania, he joined the notorious bohemian community whose key figures included writer and political theorist Hans Jaeger, and artists Edvard Munch*, Christian Krohg, and Kalle Løchen. Munch used the bearded Jensen-Hjell as the model for two paintings emblematic of the Christiania bohemians, the 1884 *Tête-à-Tête* (Munch-museet, Oslo) and the 1885 full-figure *Portrait of Jensen-Hjell* (private collection) that scandalized the Autumn Exhibition of that year.

Jensen-Hjell visited Italy and France in 1886, living first in Capri with painter Frits Kolstø (1860–1945), and then in Paris. In the following year he moved to a valley in the Valdres region of Norway, where he began to explore the sweeping vistas of the central Norwegian landscape. At the Autumn Exhibition of 1887 he received his first recognition from the press. Critic Andreas Aubert cited him as an important young Impressionist follower of Krogh in the *Dagbladet* of February 10, 1887, especially praising *Summer Day at Valdres* (Nasjonalgalleriet, Oslo) for its fresh interpretation of the native landscape.

Jensen-Hjell had been suffering from tuberculosis for several years. In 1888 his condition worsened, and on his doctor's advice he moved to Loftus in the remote Hardanger region of Norway. He died there at the age of twenty-six. [PGB/MM]

47
At the Window 1887
Ved vinduet
73.5 × 99.5 (29 × 39⅛)
Signed lower right: "Xania 87/Karl Hjell."
Nasjonalgalleriet, Oslo

Jensen-Hjell delighted in observing the play of light over intimate interior spaces. *At the Window*, painted in 1887 after his return from Italy and France, reflects this preoccupation, which he shared with Nils Gustav Wentzel* and Harriet Backer*.

The work portrays the painter Kalle Løchen (1865–1893) reading in a corner of his studio. A popular member of the radical Christiania bohemians, Løchen served as a model for Christian Krohg's* *A Corner of My Studio* of 1884 and Eilif Peterssen's* *Portrait of Kalle Løchen* of 1885, both now in the Nasjonalgalleriet, Oslo. His meditative presence in *At the Window* is dominated and ultimately subsumed by the meticulously arranged clutter of his studio. In the tradition of such images of artists as Edgar Degas' *Jacques Joseph Tissot* (1868; Metropolitan Museum of Art, New York), Løchen's surroundings provide the key to his identity, influences, and achievements. His interest in exotica is made clear by the presence of oriental tapestries, porcelain, and a Japanese fan, and his decorative concerns are revealed through the painted studio table and still-life arrangements. A copy of Pierre Puvis de Chavannes's *The Sacred Grove* (1884), the most significant element in the studio, serves as a backdrop for oil sketches representing Løchen's own repertory: seascapes, lamp-lit interiors, portraits, landscapes, and full-figure studies (see A. Th. Dedichen, "Kalle Løchen. Fra attiarnes kunstnerliv," *Kunstog Kultur*, 15, 1928).

Puvis de Chavannes's influence was widely felt in Norwegian painting, particularly after the 1884 Paris Salon in which *The Sacred Grove* was exhibited. The critic Andreas Aubert devoted a laudatory article in the Christiania *Aften Posten* to Puvis's work that year, equating the decorative rhythms and suppressed tonalities of *The Sacred Grove* with musical harmonies. Although French critics admired Puvis primarily for his figure painting, young Norwegians like Edvard Munch* Jensen-Hjell, and Løchen viewed him as the master of the emotionally evocative landscape. As the art historian Marit Lange points out (biblio. ref. no. 67, p. 84), Jensen-Hjell's placement of Løchen halfway between the window to the natural world and *The Sacred Grove* symbolizes the "two poles" governing the aspirations of the Norwegian Naturalist painters:

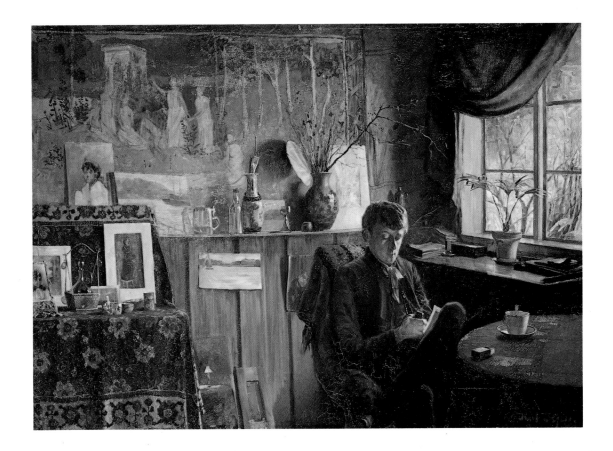

plein-air Realism and the Synthetic world of the imagination.

Løchen's studio also establishes a dialogue between these two poles. Jensen-Hjell leads the viewer on a reductive journey from nature to abstraction, beginning with the uncultivated trees outside the window, moving through the potted plant and ornamental dried weeds behind Løchen, and culminating in the flattened trees of Puvis's *The Sacred Grove*. Through this conceit Jensen-Hjell demonstrates his belief that although art is born of nature, imagination liberates the artist from the slavish imitation of appearances. This attitude mirrors the central concerns of the Norwegian Naturalist movement of the 1880s. [PGB/MM]

ÁSGRÍMUR JÓNSSON Iceland 1876–1958

Ásgrímur Jónsson, along with Thórarinn B. Thorláksson*, introduced the modern art movement to the largely rural and sparsely populated country of Iceland. Jónsson was born on a farm in the district of Árnasýsla in southern Iceland, one of the few fertile and habitable areas on the island. He spent his early years as a transient laborer, taking jobs on farms and ships in order to earn a living. In 1897 he decided to become an artist and journeyed to Copenhagen. There he supported himself as a house painter and attended the preliminary drawing classes at the school of Gustav Vermehren (1863–1931). He entered the Danish Royal Academy of Fine Arts in 1900 and studied with, among others, August Jerndorff (1846–1906) and Frederik Vermehren (1823–1910). The curriculum of the academy had long been outmoded, and Jónsson updated and expanded his artistic education through frequent visits to the Danish National Museum. There he was exposed to the art of Vincent Van Gogh, which made an early and distinct impression on the young artist, although he did not adopt a gestural brushstroke and coloristic style until his later years.

Jónsson earned his fame as a landscape painter, the first to establish a distinct Romantic interpretation of the rugged Icelandic countryside. His paintings of native sagas and folk tales, which were later adapted for book illustrations, also reflected his nationalism. Still under the influence of the Copenhagen academy, his style in the first decade of this century was marked by a dry Naturalism. But after a trip to Germany and Italy from 1907 to 1909 and an exposure to Impressionism, his palette and touch lightened significantly. He was also an accomplished watercolorist, and used the medium to develop a greater clarity of color and formal simplicity.

In 1903 Jónsson held a one-man exhibition in Reykjavík, following the precedent set by Thorláksson in 1900. He exhibited regularly at the Charlottenborg palace in Copenhagen from 1904 to 1912, became an honorary member of the Swedish Royal Academy of Fine Arts in 1952, and was the subject of a major retrospective at Listasafn Íslands in Reykjavík in 1956. [EB/BN]

48

Tindafjöll 1903–04
80.0 × 125.5 (31½ × 49⅜)
Signed lower left: "Ásgrímur Jónsson 1903–4"
Listasafn Íslands, Reykjavík

In the summer of 1902 Jónsson left Copenhagen, where he was studying, and returned to Iceland to sketch the native landscape. A study of the glacier of Tindafjöll was the basis for this work, which he began painting in the studio the following year. The canvas is characteristic of his early style and restricted palette.

There was no traditional landscape school in Iceland for Jónsson to look to; instead he learned from the Neo-Romantic style of his Scandinavian contemporaries. The topography of Iceland, with its jagged fissures, lava fields, glaciers, and craters, provided numerous stark and sublime motifs. As in *Tindjafjöll*, Jónsson often contrasted flat plateaus with soaring mountain peaks. His compositions are frequently symmetrically organized and divided into horizontal bands.

In this painting there is a sense of monumentality and drama in the sweep of space from the nearby foreground to the luminous, clear sky and distant mountains. The whole is seemingly inaccessible and inimical to human life. The sharp contrasts between foreground and background, dark and light, the soft forms of the lava field and the craggy contours of the mountains effectively suggest the volatile and variegated nature of Iceland's climate and geology. [EB/BN]

49
Hekla 1909
150.0 × 290.0 (59 × 114⅛)
Signed lower left: "Ásgrímur J."
Listasafn Íslands, Reykjavík

Here Jónsson depicts Mount Hekla rising in the distance
above the hills and farms of Árnasýsla, the region where
he was born. It is early morning, and both the
snow-capped peak of the majestic Hekla and the tiny
column of gray smoke from a farmhouse below rise into
the cool fresh air of dawn. The view is panoramic, an
unusually large and ambitious canvas for the young
Jónsson. As a result of his 1908 trip to Berlin, where he
saw his first Impressionist paintings, the colors are more
luminous than in the earlier *Tindafjöll* (cat. no. 48).

Hekla is a major national and cultural symbol of
Iceland. It is one of the highest mountains in Europe,
rising 5,110 feet, and is one of the most famous active
volcanoes. It was notorious in medieval Catholic Europe
as the home of the damned or as the gateway to
purgatory, and in local folklore was the traditional
gathering place for witches. At the time of Jónsson's
painting, Hekla's most recent eruption had occurred in
1845–46 and had decimated the surrounding farms and
countryside. Here the houses appear as lonely outposts
amidst vast and ungenerous nature. Despite the seeming
cool and calm of the panoramic scene, there is an
understanding of the mountain's violent history and
potential. [EB/BN]

KITTY KIELLAND Norway **1843–1914**

Kitty Kielland was born into the leading patrician family of Stavanger in southwestern Norway. She was an essayist about art, morals, and the position of women; her brother Alexander Kielland (1849–1906) was a leading novelist. Although her father opposed her ambition to become a professional artist, in 1873 she left for Karlsruhe to study with the important landscapist Hans Gude (1825–1903). In 1875 she moved to Munich, where she studied with Hermann Baisch (1846–1894) and enjoyed the cultural life of the city in the company of a group of Norwegian artists that included Harriet Backer* and Eilif Peterssen*. She visited Paris in 1877 and settled there in 1879. Sharing lodgings with Harriet Backer, Kielland joined a circle of French and Norwegian artists and writers. She first exhibited at the Salon in 1879 and continued to show there frequently, receiving a positive critical response. In 1889 she moved to Christiania, where she lived for the rest of her life.

During the years she lived in Germany and France, Kielland spent much of each summer back in Norway. In 1886 and '87 she summered with Christian Skredsvig and Eilif Petersen on the farm of Fleskum near Christiania. The majority of her works depict the calm of the Jaeren plain, south of her native Stavanger. Other landscape subjects include the mountains that border Jaeren, scenes from northern France in the early 1880s, and quiet areas in southeastern Norway in the mid-eighties. [RH/MM]

50
After Sunset 1886
Efter Solnedgang
80.0 × 115.5 (31½ × 45½)
Signed lower left: "Kitty L. Kielland/Paris 1886"
Stavanger Faste Galleri

This canvas, the second version of a work executed in 1885 and now at the Royal Palace in Oslo, was painted in Paris. The subject is an old building at Bosvik near the small Norwegian coastal town of Risør where Kielland had spent part of the summer of 1885 with Harriet Backer*.

Kielland viewed the first version of this work as her breakthrough, and the art historian Marit Lange has suggested that the critic Andreas Aubert's praise of the work may have marked it as a turning point in the artist's mind (Lange, p. 72). Aubert had lauded the canvas for using a typical Norwegian subject illuminated by the light of a summer evening to convey a feeling of intensity (*Nyt Tidsskrift*, 1885, p. 526; cited in biblio. ref. no. 67, p. 72).

Of approximately the same dimensions, the two versions differ only slightly. In the second the hat of the woman is a different shape and color, and her reflection is not so clear as in the earlier work. In general, there is a slight blurring of detail in the second version, resulting in a decreased emphasis on surface texture. The local color is also less strong, giving way to a stronger overall tonality. This version may represent Kielland's desire to place more importance on the mood than on the particulars of the idyllic scene. She had asked Erik Werenskiold to send her a photograph of her 1885 work as an aid in creating a new version to submit to the Salon, and she invited Léon Pelouse (1838–1891), with whom she had studied, to critique the revision. Pelouse lamented that she had gone astray and had begun to paint in the manner of Pierre Puvis de Chavannes (biblio. ref. no. 67, pp. 78–80). Despite his comments, she exhibited the painting in Gothenburg in 1886, in Copenhagen in 1888, and in Paris at the World Exposition of 1889.

This work has been cited as one of the earliest examples of the development of Norwegian landscape painting from Realism to New Romanticism, particularly the simplified depiction of nature and the emphasis upon such typically national subjects as the light summer night. Lange has linked this change in the work of Kielland and Eilif Peterssen* with their admiration of the work of Puvis (biblio. ref. no. 67, pp. 79ff). With Peterssen, Kielland initiated the style that would dominate Norwegian painting in the 1890s. [RH/MM]

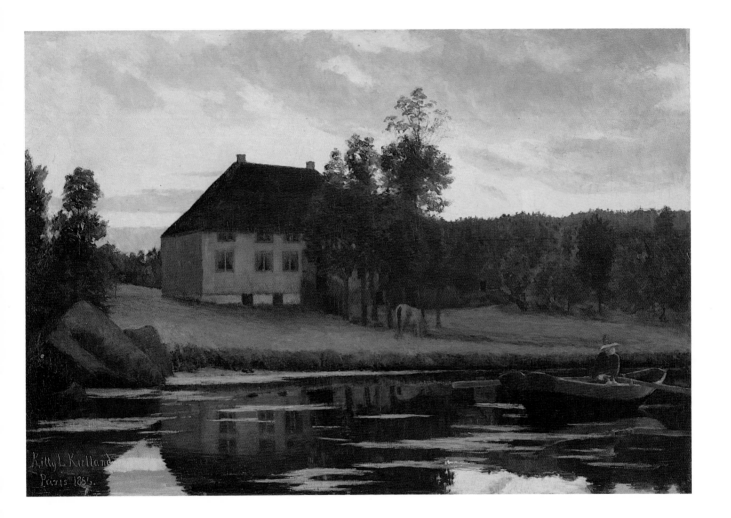

CHRISTIAN KROHG Norway 1852–1925

Krohg was born in Aker, outside Christiania, and in 1870 attended the drawing class of the landscapist Johan Frederik Eckersberg (1822–1870). Following his father's wishes, he studied law and received his degree in 1873. After his father's death in 1874, he studied painting under Hans Gude (1825–1903) and Karl Gussow (1843–1907) in Karlsruhe. In 1875 he followed Gussow to Berlin, where he shared quarters with the German artist Max Klinger (1857–1920) and met the Danish critic Georg Brandes. He visited Skagen in 1879 and again during the summers of 1882, '83, '84, and '88. In Paris in 1881 and '82 he assimilated the influence of Édouard Manet, Jules Bastien-Lepage, and Gustave Caillebotte, and showed in the 1882 Paris Salon. In 1885 he visited Belgium.

Thereafter Krohg spent most of his time in Christiania, where he directed a school of painting together with Hans Heyerdahl (1857–1913) and Erik Werenskiold (1855–1938). With Hans Jaeger, he was the leader of the Christiania bohemians and for a time editor of their review *Impressionisten*. In 1886 he published his notorious novel of prostitution *Albertine*, which was immediately confiscated. Krohg lived in Copenhagen in 1889–90, went to Berlin and Rügen in 1893, and visited France and Spain in 1898. He returned to Paris for a prolonged stay in 1901 and taught at the Academie Colarossi. From 1889 to 1910 he wrote for the Christiania newspaper *Verdens Gang*, and from 1910 to 1916 for *Tidens Tegn*. In 1909 he became director of the newly founded Academy of Fine Arts in Christiania, a position he held until his death. [ADG/OT]

51

The Net Mender 1879
Garnbinderen
93.5 × 66.5 (36¾ × 26¼)
Signed upper right: "C. Krohg/79"
Nasjonalgalleriet, Oslo

Krohg visited the artists' community at Skagen in 1879, the year he completed his studies in Berlin. His fellow Norwegian artist Fritz Thaulow (1847–1906), who had invited him, was then working at Skagen with a camera lucida, experimenting with cropped compositions and abrupt spatial juxtapositions. Krohg followed Thaulow's example, and his paintings of that summer—including *The Net Mender* with its raked space—display similar compositions.

This is the second version of *The Net Mender*. The first (location unknown; reproduced in Madsen, 1929, p. 88) was completed in Skagen during the summer of 1879 and was exhibited at the Christiania Art Association on October 4, only a few days after Krohg's return to the Norwegian capital. It was criticized as overly crowded, and Krohg reworked the scene in Christiania that autumn (an intermediate drawing has been preserved in the Kunsthalle, Hamburg). While the changes are minimal, the Christiania version shows a more coherent organization of space and more solidly drawn figures.

The models are Niels and Ane Gaihede, members of the family that posed for many Skagen painters (see cat. nos. 2 and 54). Their social role is abundantly clear: Niels, too old to continue fishing, is shown mending nets; Ane winds yarn in the background. Their labor, while undramatic, fulfills a specific need in the rural community. Krohg depicts them with an abrupt Realism that owes more to the tradition established in Munich by Wilhelm Leibl (1884–1900) than to Norwegian and Danish precedents. Works like *The Net Mender* signalled a decisive break with the conventions of the Düsseldorf school, which had dominated this genre throughout the 1860s and '70s.

The painting's emphasis on labor stands in contrast to the generally anecdotal scenes of peasant life made popular by the Norwegian painter Adolf Tidemand (1814–1876). While both Tidemand and Krohg shared a sense of nationalism, documenting the roots of Scandinavian life in peasant culture, there was a major difference in approach. Tidemand's avowed purpose was to preserve the character and mores of Norwegian peasant culture before they were swept away by the Industrial Revolution (Wend von Kalnein, "Der Einfluss Düsseldorfs auf die Malerei ausserhalb Deutschlands," *Die Düsseldorfer Malerschule*, Kunstmuseum Düsseldorf, 1979, p. 198). Conversely, Krohg acted as a recorder rather than a preservationist. He was concerned first and foremost with depicting the mundane environment and activities of the fisherman and his wife. Where Tidemand would have searched for an interior filled with folk handicrafts, Krohg chronicled the mass-produced prints on the wall: two charts of what seem to be various breeds of animals and a reproduction of Da Vinci's *Last Supper*. He thus minimized the distance between the nineteenth-century viewer and the subject, bringing the heritage of the peasant culture into the immediate present rather than pushing it into a fabled past. [ADG/OT]

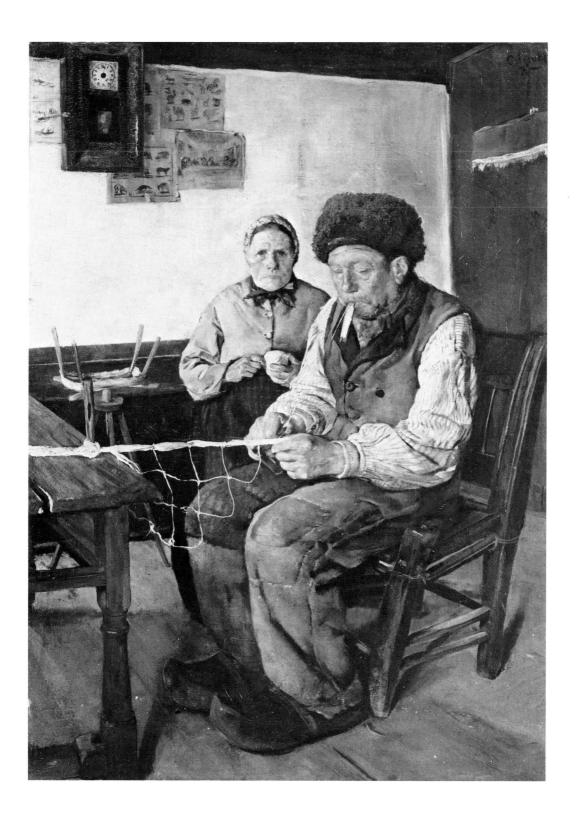

52
The Sick Girl 1880–81
Syk pike
102.0 × 58.0 (40⅛ × 22⅞)
Signed lower right: "C. Krohg"
Nasjonalgalleriet, Oslo

Krohg's Skagen paintings (cat. nos. 51 and 54) represent only one aspect of his career. While he was depicting rural subjects, establishing both his nationalist and Realist sympathies, he also devoted a number of works to urban themes. *The Sick Girl* must be considered within this category, for it is a startlingly direct documentation of tuberculosis, which had reached almost epidemic proportions in mid-century Christiania. It was painted during the winter of 1880–81 while Krohg was living in the city, and at least one half-length study survives (Nasjonalgalleriet, Oslo). The child stares out, her skin pasty and her eyes rimmed. Her stark features are thrown into relief by the white of her pillow and gown; the red border on the pale blanket looks almost like a wound across her body. A wilting rose scattering leaves across her lap underlines her imminent death.

The sick child is a common theme in art. In the nineteenth century the Düsseldorf school frequently used it, and works like Michael Ancher's *A Sick Girl* (1882; Den Hirschsprungske Samling, Copenhagen) are representative of the general Scandinavian interpretation of it. These paintings typically show the subject from a picturesque distance, the model languorous and refined by her illness, the overall mood cloyingly sweet. The Norwegian painter Edvard Munch* dismissed the genre as "the days of pillows, of sick beds, of feather quilts," and criticized his fellow artists for not showing the true horror of the theme (letter to Jens Thiis, circa 1933; Stang, 1979, p. 60). Although Munch included Krohg in this criticism, Krohg avoided the standard attitudes of the time by reworking the familiar composition into a head-on engagement.

This work can be viewed in a personal context as well. While the actual model for this scene is not known, Krohg, like Munch, had seen his sister die of tuberculosis in 1868. He later wrote of her death in the short story "Sister" in the 1906 collection *Dissonantser:* "She was still sitting in the rocking chair looking with fatigue in front of her. . . . There it was again, this doomed, demanding look in her big eyes." (Oslo, *Nasjongalleriet,* 1981, pp. 69–70.)

Krohg has pared the scene down to its absolute minimum. He pushes the girl into our space by extreme cropping and forces an uncompromising confrontation with this picture of decay. It was this aspect of the painting that most disturbed contemporary critics. When it was exhibited at the Christiania Art Association, Andreas Aubert wrote in the newspaper *Morgenbladet,* "We demand something more to be satisfied, we must see something more of the surroundings" (Oslo, Nasjonalgalleriet, 1981, p. 69). By eliminating such surroundings, however, Krohg had invested the painting with an emotional concentration and physical immediacy unprecedented in his work. These qualities make his art a bridge between the Realist conventions of his contemporaries and the expressive intensity of the next generation exemplified by Munch. [ADG/OT]

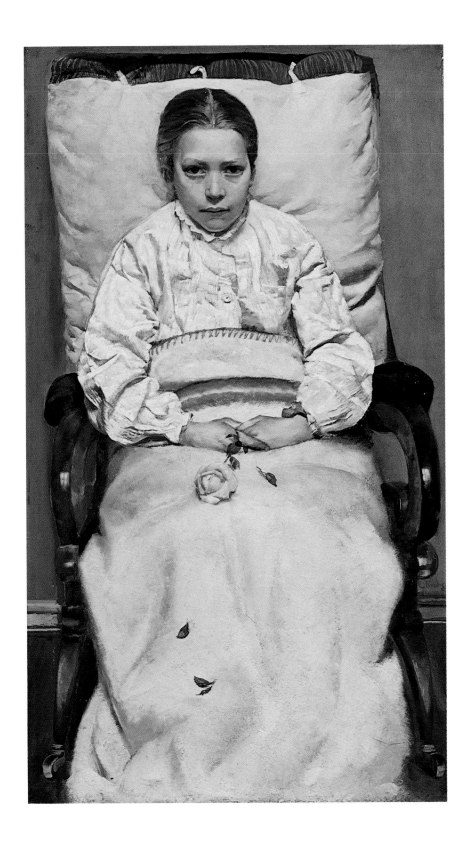

53

Portrait of Karl Nordström 1882
Den svenske maler Karl Nordström
61.5 × 46.5 (24¼ × 18¼)
Not signed
Nasjonalgalleriet, Oslo

Krohg travelled to Paris in October 1881 and enthusiastically visited exhibitions of French art where he studied the techniques of Jules Bastien-Lepage, Édouard Manet, and Gustave Caillebotte. In April 1882 he left for Grèz-sur-Loing, the Scandinavian artists' colony outside Paris, with his colleagues Christian Skredsvig, Karl Nordström*, and Carl Larsson. Krohg and Nordström were especially close friends and eagerly shared their ideas about new artistic trends.

As in Nordström's *Garden in Grèz* (cat. no. 71), the vista seen through the open window appears to be the garden of the Pension Laurent, where Nordström stayed during his Grèz sojourn. Nordström recalled of this portrait: "We had studied the Impressionists at an exhibition in Paris and we were filled with the new ideas. Krohg saw me one day at the open window wearing my blue suit silhouetted against the garden. He asked me eagerly to stand still in my pose, fetched a canvas... and in a few seconds the work was in full action" (Oscar Thue, *Christian Krohgs portretter*, Oslo, 1971, p. 25).

The portrait bears a striking structural similarity to Caillebotte's *Homme au Balcon, Boulevard Haussmann* (1880; private collection, Switzerland), which was shown at the 1882 Impressionist exhibition (see Kirk Varnedoe, 1979). Caillebotte had extended the German Romantic tradition of the open window as a metaphor of contrast between enclosure and escape, but had replaced the wild, untamed Romantic vision of nature with the anonymity of the metropolis. Krohg's portrait is an intermediary; his bourgeois garden is a transition between the natural landscape and Caillebotte's city. [SRG]

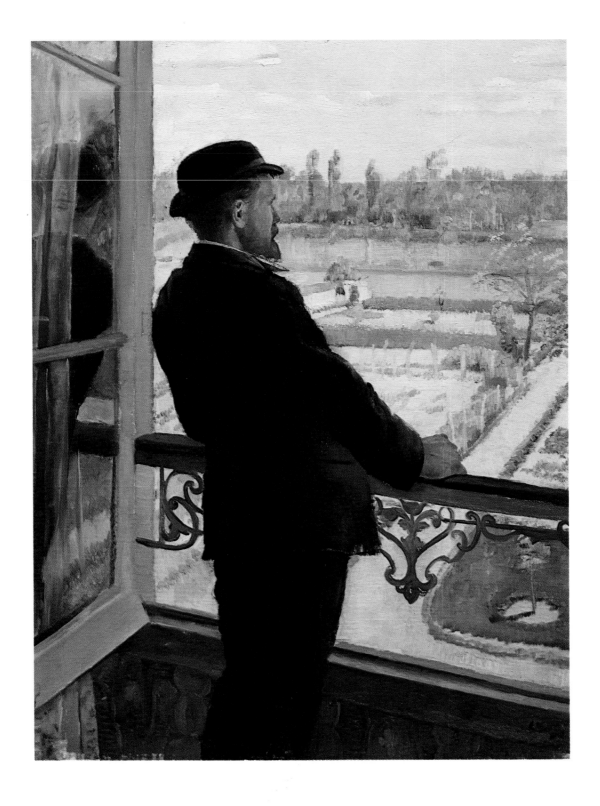

54
Sleeping Mother 1883
Sovende mor
107.5 × 141.8 (42¼ × 55⅛)
Signed lower right: "C. Krohg/Skagen 1883"
Rasmus Meyers Samlinger, Bergen

The mother by her child's cradle was a popular motif in scenes of rural life throughout the nineteenth century. The Düsseldorf painters, both German and Scandinavian, used it, and it was also common in French art. In general, these are scenes of easy sentimentality that illustrate the traditional role of woman as mother in a cheerful domestic environment. (For a further discussion of this theme in French art see *Mari et Femme dans la France rurale traditionnelle,* Paris: Musée National des Arts et Traditions Populaires, 1973, pp. 34-36.) In taking it over, Krohg treated the theme with a startling Realism that overthrew many of the standard associations that had attended it.

Sleeping Mother was begun during Krohg's third visit to Skagen in 1883; after several studies, this canvas was completed the following November. The models are Tine Gaihede and her child, and during the initial stages of the composition, Tine's husband, Rasmus Gaihede, was included lying on the bed (biblio. ref. no. 27, pp. 95–96.). The palette is uncharacteristically brilliant, perhaps reflecting Krohg's 1881–82 visit to Paris; the rich breadth of color and impasto in areas such as the bedclothing made a strong impression on his student Edvard Munch (see cat. no. 62). Overall, the composition demonstrates the same concerns found in Krohg's earlier Skagen works. The scene is given dramatic impact by abrupt cropping, and the immediate foreground is aggressively punctured by the table on the left, a device also found in *The Net Mender* (cat. no. 51).

This painting has frequently been compared to Krohg's 1880 *Daybreak* (see below, left) which shows a working girl fallen exhausted over her sewing in the morning light. *Sleeping Mother,* however, is much bolder, as Krohg deliberately stripped it of the sweetness that characterized the scene of the young girl. Tine Gaihede is shown at an awkward angle, closed in by the frame, her back painfully bent and her head buried in the pillow. Similarly, the child is drawn from the least picturesque view, its doll-like head strangely foreshortened. The stained table, the half-eaten porridge that attracts flies, and the intensely crowded interior all convey a sense of squalor.

Krohg uses these details to challenge the conventions of the theme. Instead of presenting a rosy image of domestic harmony, he gives us a sober examination of rural life. The mother is depicted not as a benign and watchful guardian, but as worn out by family chores; her hands barely hold her knitting and the cradle. Krohg used the same approach in many of his paintings: the themes were part of popular traditions, but his Realist treatment of them created potent, contemporary images. [ADG/OT]

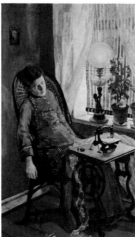

Christain Krohg
Daybreak 1880
Daggry
135.0 × 80.8 (53⅛ × 31¾)
*Statens Museum for Kunst,
Copenhagen*
Weariness by exploitation in the city, as opposed to the exhaustion of the rural *Sleeping Mother,* is the subject of *Daybreak;* this young seamstress has fallen asleep over her chores in the night.

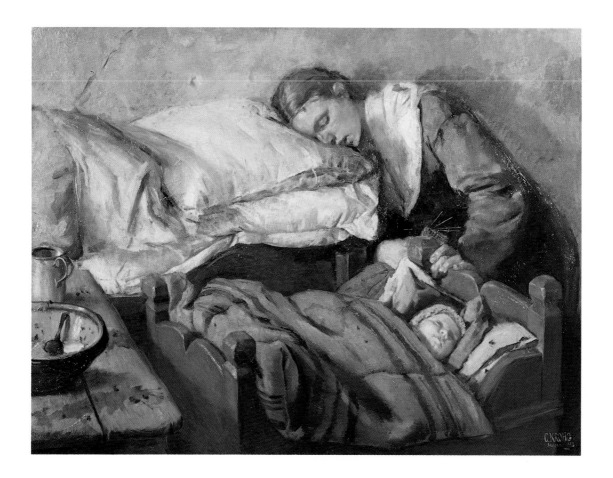

55
Portrait of Gerhard Munthe 1885
Maleren Gerhard Munthe
150.0 × 115.0 (59 × 45¼)
Signed lower right: "C. Krohg/85"
Nasjonalgalleriet, Oslo

Krohg's portraits of the 1880s reveal a sensibility different from that seen in his works dealing with social issues, such as *The Net Mender* (cat. no. 51) and *The Sick Girl* (cat. no. 52). But these portraits represent another aspect of, rather than a departure from, his interests and artistic style.

Krohg and Gerhard Munthe (1849–1929) met in 1870 when both were students at Johan Frederik Eckersberg's art school and the Royal Academy of Drawing in Christiania. Munthe went on to study in Düsseldorf in 1874 and in Munich from 1877 to 1882. In 1883 he settled in Norway, remaining there except for occasional trips to Paris. With his fellow Norwegian Frida Hansen, he led a revolution in tapestry design. Although aware of the works of the English Arts-and-Crafts artist William Morris, Munthe's aim was to create a school of decorative arts based on his own national traditions, and he made detailed studies of Norwegian folk art as early as the 1870s. Often using subjects taken from Norwegian sagas, he created cartoons with stylized figures for large tapestries that were executed by his wife Sigrun or by professional weavers.

Krohg and Munthe never became close friends. By all accounts Munthe was far to the right of Krohg's bohemian circle, a witty and exclusive conservative. In this spirited portrait, Krohg has captured these characteristics in Munthe's stance, gesture, and glance.

Manet's influence—seen most strikingly in the use of black—is evident here and dominates in the majority of Krohg's portraits of the 1880s. This work, with its seemingly slick Parisian setting, was actually painted in Copenhagen and depicts the interior of the Grand Café. Amid the dissolution of light and form in the smoky background, the profile of the Norwegian marine painter Reinholdt Boll is visible at the left. [WPM/OT]

PEDER SEVERIN KRØYER Denmark 1851-1909

Peder Severin Krøyer, born in the fishing town of Stavanger, Norway, was the illegitimate son of Ellen Celia Giesdahl. He was brought up in Copenhagen by his uncle, the eminent zoologist Hendrik N. Krøyer. By age ten he had proven his artistic talent in scientific illustrations, and in his early teens he entered Copenhagen's Royal Academy of Fine Arts. In 1872 he exhibited several portraits there and was awarded a prize the following year.

Krøyer made his first trip abroad in 1875, visiting Berlin, Munich, Dresden, and the Swiss Tyrol. In 1877, after visits to the Netherlands and Belgium, he entered the Paris studio of Léon Bonnat. Following Bonnat's advice, he visited Madrid in 1878 to see the work of the Spanish masters. In 1879 he went to Brittany and in 1880 to Italy. He returned to Denmark in 1881 after seeing his works in the Paris Salon.

At Michael Ancher's invitation, Krøyer went to Skagen in 1882, establishing a pattern he followed for the rest of his life: he travelled frequently, becoming the true cosmopolitan artist, but always returned to Skagen whenever possible. In 1887 he was named a member of the Danish academy, and in 1889 he was awarded full Danish citizenship and married Marie Triepcke, a former student.

During the 1880s Krøyer established himself as Denmark's foremost *plein airiste* and also became a portraitist of international repute. He was named a member of the Swedish Royal Academy of Fine Arts in 1899 and was awarded honorary medals at both the 1889 and 1900 Paris World Expositions.

Toward the end of his life Krøyer suffered from the same manic-depressive nervous disorder as his mother, and had attacks which prevented him from working. In 1909 he travelled to Venice to see an exhibition of his work; on his return to Skagen he died. [ADG]

56

Sardine Cannery at Concarneau 1879
Et sardineri i Concarneau
101.5 × 140.5 (40 × 55¼)
Signed lower right: "S. Krøyer/Concarneau 79"
Statens Museum for Kunst, Copenhagen

This painting of a Concarneau cannery was executed during the fall of 1879 while Krøyer was visiting Brittany. He had just left Paris, where he had been studying for two years under Léon Bonnat. In a letter to the Danish collector Heinrich Hirschsprung dated October 9, 1879, he described this work: "The girls and matrons sit along a long table filled with sardines... through some small openings in the roof the sunlight falls and creates a wonderful feeling." In the same letter he said that he wished to paint in the manner of José Ribera and Diego Velázquez, artists whose works he had studied the previous year in Madrid (Mentze, 1980, p. 80).

Both subject matter and style here demonstrate Krøyer's early allegiance to Realism. Concarneau, less than ten miles from Pont-Aven, was then one of Brittany's major port towns, the center for the fishing and canning industry which had rapidly expanded since the beginning of the nineteenth century. By 1877 at least 1,200 boats operated out of the harbor there, and approximately 13,000 people were employed in the process of boiling, salting, canning, and bottling the huge quantities of fish (Fred Orton and Gisela Pollock, "Les Données bretonnantes: La Prairie de répresentation," *Art History*, Vol. 3, September 1980, p. 324). While Krøyer's painting does not encompass the vast scale of the Concarneau industry, his plunging perspective conveys the ritual assembly-line nature of such work.

Such scenes of industrial life were rare in the work of French artists painting in Brittany at this time. Since the 1850s a number of French artists had come to Brittany to depict scenes of peasant life, rediscovering national roots in the traditions preserved among the rural populace. These artists, however, concentrated on the religious life of the province, an approach typified by such paintings as François Bonvin's *The Poor's Bench: Remembrance of Brittany* (1864; Musées d'Alençon) and Jules Breton's *The Great Pilgrimage* (1868; National Museum of Cuba, Havana). This attitude persisted in the 1880s in the work of both Pascal Dagnan-Bouveret and the Pont-Aven school.

Although Krøyer's *Cannery* must be viewed as distinct from this French tradition, it falls easily into the same category as paintings by other European Realists. The German Max Liebermann's *The Vegetable Peelers* (1872; private collection, Winterthur) is strikingly similar to *Cannery*, as are the Dutchman Jozef Israels' scenes of peasant laborers. These artists (among many other German, Austrian, and Northern Europeans) had gained attention in France because of the international exhibitions at the 1878 Paris World Exposition, and Krøyer would have been able to see their work during his European travels.

Krøyer's involvement with Realism lasted for several years. In 1880 he depicted another scene of work, *The Italian Hatmakers* (Den Hirschsprungske Samling, Copenhagen), which was an immediate *succès de scandale* when exhibited in Paris and Copenhagen. His approach, however, lacks the force of the major Realists, for *Cannery* is finally a tourist's view: the women appear picturesque in their native costume, and the active variety of the figure groupings belies the true monotony of their labor. [ADG]

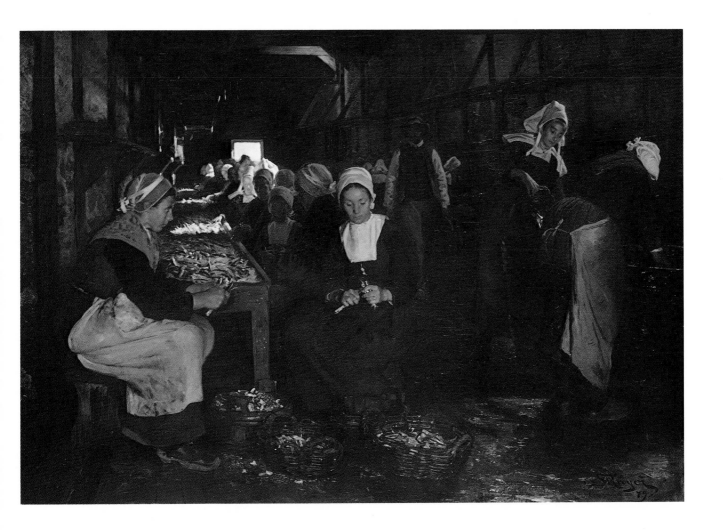

57

In the Store During a Pause from Fishing
1882
I købmandens bod, nar der ikke fiskes
79.5 × 109.8 (31⅛ × 43⅛)
Signed lower left: "S. Krøyer/Skagen 82"
Den Hirschsprungske Samling, Copenhagen

Krøyer first came to Skagen, the Danish fishing village turned artists' colony, in the summer of 1882. He had been invited by fellow painter Michael Ancher, and like many of Skagen's visiting artists, he stayed at the hotel owned by Erik Brøndum, the father of Michael's wife Anna Ancher*. A few days after his arrival Krøyer began this painting.

Everything about the composition emphasizes the distance between the artist and his subject. The bar fills the foreground and denies access to the main figure grouping. The two figures on the viewer's side of the counter are set off by distance and by cropping, and the only contact offered is the glances across the space made by several of the fishermen. Krøyer maintains what may be called the "tourist's-eye view" that can also be found in his *Sardine Cannery at Concarneau* (cat. no. 56). Indeed, the sharp sunlight, the brownish palette, and the plunging space are all devices found earlier in *Cannery*. His use of light in the present scene, however, is far more advanced; here it both punctuates and unifies space, heralding his move toward the Naturalism that characterized his work throughout the 1880s.

Michael Ancher was apparently aghast when he heard that Krøyer had set up easel in the hotel shop, and he wrote to Krøyer on November 9, "You have painted the shop at my in-laws. Closer than that you should not go or I shall be forced to leave town" (Mentze, 1980, p. 104). It is hard to see what could have caused offense in this picture. On the other hand, Krøyer's urbane and detached conception fails completely to render the fisherfolk as either picturesque or heroic (compare the dramatized grizzliness of Krohg's Skagen picture *The Net Mender*, cat. no. 51). He chooses a moment of idleness and depicts the mundane world of their interaction with commerce instead of isolating their struggle against the sea. Thus, his first picture at Skagen violates the more folk-oriented tenor of traditional Skagen imagery by adopting a cooler, more reportorial stance. [ADG]

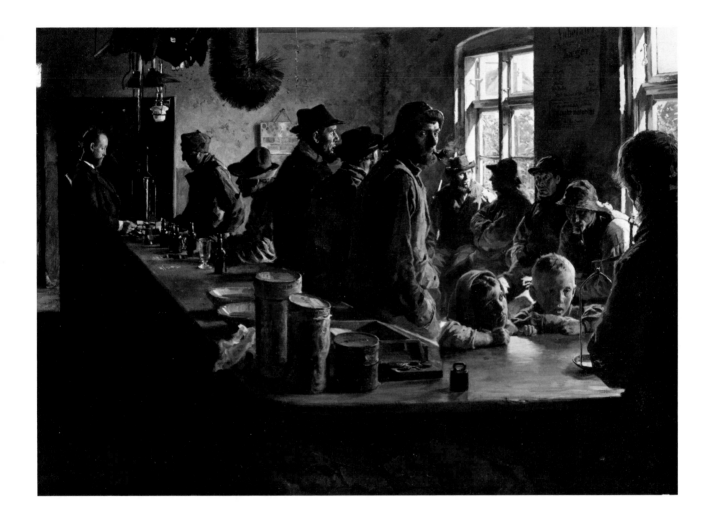

58
The Artists' Luncheon 1883
Kunstnerfrokost
82.0 × 61.0 (32¼ × 24)
Signed across bottom:
"S. Krøyer pinx. Skagen 1883"
Skagens Museum

During his second visit to Skagen in the summer of 1883, Krøyer painted this celebration of the artists' community there. The figures are identified by the names inscribed at the bottom of the canvas. Clockwise from the left foreground they are Charles Lundh, Eilif Peterssen*, Vilhelm Peters, Michael Ancher (standing), Degn Brøndum, Johan Krrouthén, Oscar Björck, and Christian Krohg* (in the right foreground). The setting is the dining room of Erik Brøndum's hotel (see also cat. no. 57).

Krøyer was particularly attracted to this type of informal group portraiture and did a number of banquet and luncheon themes. He had hit upon this formula with his 1879 *Artists' Lunch in Cernay-la-Ville* (Skagens Museum), in which thirteen members of the Breton artists' community are gathered around a broad table. The Skagen *Artists' Luncheon* is, however, a bolder painting in several respects. Krøyer pushes the figures into the immediate foreground, depicting Lundh's back rather than relegating him to one side. The composition is more bluntly cropped, a technique probably learned from Krohg, and the flow of light across the room is handled with a sophistication and a newly vibrant palette that are indebted to contemporary French art.

This painting holds a special place in the history of the Skagen community. It formed the core of an elaborate decoration for the Brøndum hotel's "Artists' Room," a dining room in which were hung local scenes as well as portraits of all the members of the colony, including painters, writers, and musicians. These were executed by Krøyer and others in an ongoing project. Krøyer initiated the enterprise after the example of a room he had seen at Versailles, and ultimately there were eighty-one paintings in the hotel dining room, carefully arranged in a balanced scheme on all four walls. While most of the works were done in the 1880s and early 1890s, the last contribution was made in 1925.

Krøyer painted another Skagen luncheon in 1888, *Hip, Hip, Hurrah!* (Göteborgs Konstmuseum). In it he depicted the exuberant moment of a toast, the artists and their wives gathered under an arbor in dappled sunlight. Although many of the same artists from *The Artists' Luncheon* were included, a glittering, well-dressed company had replaced the serious gathering of 1883. [ADG]

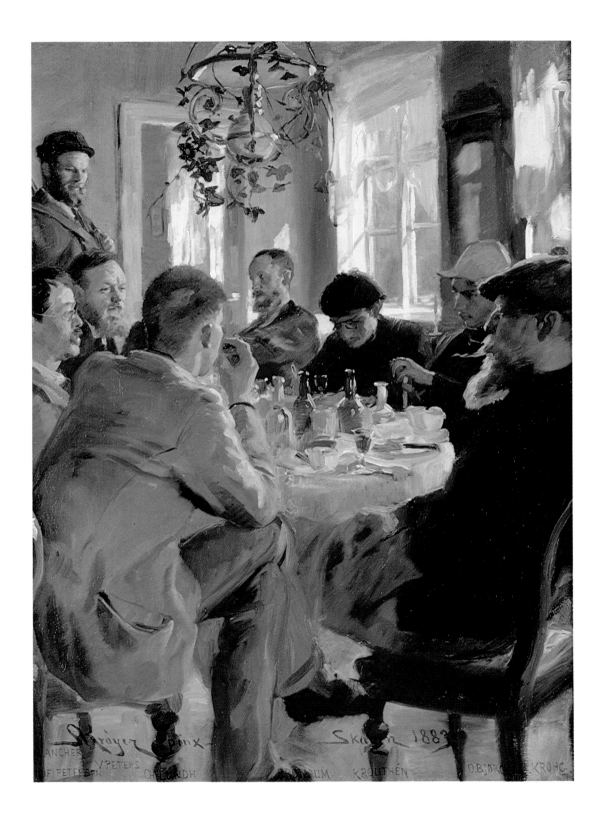

59

Summer Evening on the South Beach at Skagen 1893
Sommeraften på Skagens sønderstrand
100.0 × 150.0 (39⅜ × 59)
Signed lower left: "S. Krøyer Skagen 93"
Skagens Museum

Krøyer's *Summer Evening on the South Beach at Skagen* is representative of a genre of landscape painting that came into vogue in the late 1880s and early 1890s. Appropriately named Blue Painting (biblio. ref. no. 72, pp. 52–64), this genre is distinguished by its seemingly unreal mauve-blue palette and flowing composition. Although it was based primarily on the example of James McNeill Whistler and the French Synthetists, the style was also promoted by the specific atmospheric conditions of Scandinavia.

In the long Nordic midsummer evenings, the twilight forms what is known as the blue hour, roughly at 10 p.m., when the low sun dissolves the atmosphere into a blue haze. This phenomenon provided a northern equivalent to the misty nocturnes of Whistler's London and the remote light of Pierre Puvis de Chavannes' Arcadia.

Krøyer painted many scenes in this manner, for they satisfied both his need to be a part of the cosmopolitan mainstream and his preference for *plein-air* painting in Skagen. He painted his first variations on the theme of a woman on the strand in 1891 and continued to rework the composition up until his death in 1909 (Mentze, 1969, p. 207). The models here are his wife Marie Krøyer, a renowned beauty, and the painter Anna Ancher. Krøyer photographed their pose on the beach and later copied it in the studio (the photograph has been preserved in the Skagens Museum). In two small studies for the painting (both in Den Hirschsprungske Samling, Copenhagen) the figures were placed in the distance rather than the middle ground. Here the women dominate the scene, their elegant dresses of summer white draped with an Art Nouveau grace, and their elongated figures drawn with a sinuous delicacy. The scene is a world removed from that of *In the Store During a Pause from Fishing* (cat. no. 57). Many of the Skagen artists followed Krøyer's example, and the rustic image of fisherfolk was supplanted at Skagen by the broad, luminous tones of paintings devoted to mood, nuance, and decoration. [ADG]

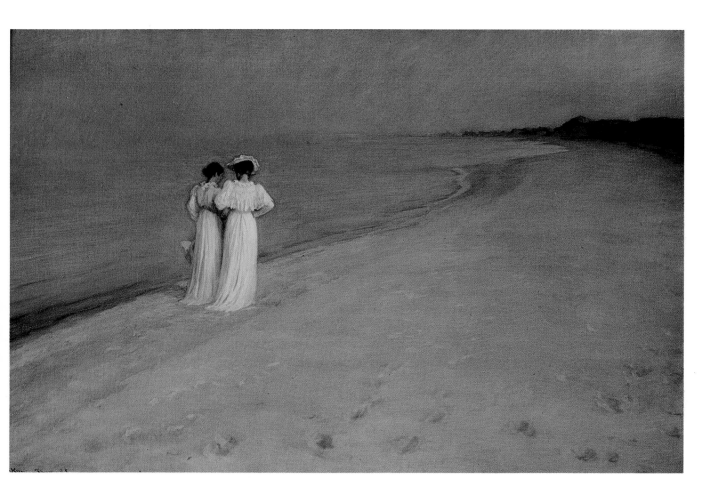

BRUNO LILJEFORS Sweden 1860-1939

Liljefors' lifelong activity as a hunter motivated both his close study of animal life and his early decision to become an animal painter. He entered the Royal Academy of Fine Arts in Stockholm in 1879 and was influenced there by his friend Anders Zorn*. In 1882 he studied in Düsseldorf with the animal painter C. F. Deiker and then journeyed to Italy and France. He joined the circle of Swedish artists in Paris and was particularly taken with the light, color, and compositional novelties of Impressionism. He exhibited his work widely and with success at the Paris Salons, the 1891 Munich International, the 1893 Chicago World's Fair, and the 1903 St. Louis Louisiana Purchase Exposition.

The banker Ernest Thiel was Liljefors' most important patron, although in 1896 Prins Eugen of Sweden arranged for a trust fund to allow the artist to work without financial worry. Liljefors eventually purchased the Bullerö archipelago near Stockholm and there studied flocks of migratory birds, which he represented in large, brilliantly colored canvases. His art was based on a scrupulous knowledge of nature, aided from the 1880s onward by photographs he made for preparatory studies. He was also an inveterate caricaturist, a powerful portraitist, and an occasional sculptor of the human figure. [EB/AC/GCB]

60
Dovehawk and Black Grouse 1884
Duvhök och orrar
143.0 × 203.0 (56¼ × 79⅞)
Signed lower left:
"Bruno Liljefors./Ehrentuna Upsala/1884."
Nationalmuseum, Stockholm

With *Dovehawk and Black Grouse* Bruno Liljefors made his debut at the Paris Salon of 1884. The next year the same painting became his first major work to be shown in Scandinavia, in *From the Banks of the Seine,* an independent exhibition organized by the opponents of Stockholm's Royal Academy of Fine Arts.

Much of Liljefors' work of the 1880s records the inevitable violence that accompanies the fight for survival in nature. He depicted the predators of the wilderness—eagles, foxes, hawks—as well as civilization's hunters—cats, dogs, and men. Just as frequently he painted the forces of life—such as eagles or foxes feeding their young—and he executed a number of paintings revealing the camouflage of various species. He was an avid caricaturist and studied the characteristic poses, gestures, and facial expressions of birds and game in order to accurately portray the psychology of animals. His interest in the primitive instincts that link humans and animals related to Darwin's theories and the late nineteenth-century phenomenon of psychic naturalism.

Liljefors painted *Dovehawk and Black Grouse* in the winter of 1883–84 while living in a farmer's cottage at his ancestral village of Ehrentuna. He later recalled: "Black grouse were unusually plentiful that winter in the meadows close to my hideaway. The wet autumn had caused the oat harvest to sprout and rot where it lay in the fields, attracting huge flocks of these birds. Between meals they encamped among tufts and bushes round the edge of the land. The goshawks came in turn to live off the grouse and the idea for the picture came to me during the many occasions that I was out there hunting."

Birds that Liljefors shot and mounted served as models for the painting's central scene, arranged like a still life and set within a landscape painted partially out-of-doors. The sharply detailed rendering of the foreground group contributes to the sense of disjuncture from the background, where the snow blurs any suggestion of perspective or depth and the birds are depicted in strict profile. Although Liljefors expressed the desire to record nature with the utmost fidelity, there is an overall decorative patterning and flattening of space here, betraying the influence of Japanese prints he would have seen in Paris a few months before. [EB/GCB/AC]

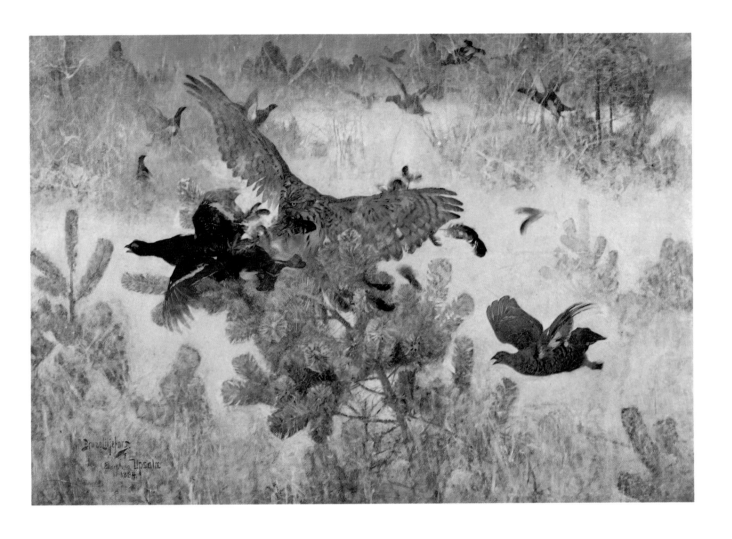

61

Horned Owl Deep in the Forest 1895
Uven djupt inne i skogen
166.0 × 191.0 (65⅜ × 75¼)
Signed lower left: "Bruno Liljefors.–95"
Göteborgs Konstmuseum

Liljefors was captivated by the figure of the horned owl turned to face the viewer. Beginning with an ink drawing of 1889 (Liljefors Museum, Uppsala), he repeated the motif in this 1895 painting and in an 1896 picture of an owl set against a stark seascape. He also depicted flying horned owls hunting small animals in *Flying Owl (circa* 1900; Thielska Galleriet, Stockholm) and devoted two chapters of his book *Det vildas rike,* published in 1934, to the owl's behavior and hunting ability.

Horned Owl Deep in the Forest was executed early in 1895 while Liljefors was staying in the small attic of the Hotel National in Copenhagen. It is marked by a spiritual seriousness and psychological intensity characteristic of the Neo-Romantic or National Romantic style then popular in Norway and Sweden. For Liljefors and his critics the owl represented the Nietzschean ideal of the lone, contemplative hunter who is completely at home in the wild, desolate landscape. The owl sits on a ridge close to the picture plane, its feathers nearly indistinguishable from the mesh of dark, partially formed trees in the background. The vibrant forest echoes the brooding mood of the poised bird, an intentional link between macrocosm and microcosm that was characteristic of Liljefors' work of the nineties. Detailed studies of a bird's wing, for example, often served the artist as the basis for the form, texture, and coloring of the surrounding landscape. Individual creature and natural environment were thus inextricably bound in a formal and spiritual unity.

When this painting was first exhibited, the critics noted a change in Liljefors' style from the 1880s to the 1890s: "From the dainty idylls with small birds and amusing fox families with which he first attracted attention some ten years ago, to *Deep in the Forest*—what an intensification and concentration of force, what a scale of moods, from the sounds and thousand colors of day to this representation of night and storm, of chasing clouds and bending spruce tops in which the horned owl sits as the incarnate demon of Nordic nature" (Karl Wåhlin, "Konstutstallninger i Stockholm," *Ord och Bild,* 1895, p. 3). [EB/BF/AC]

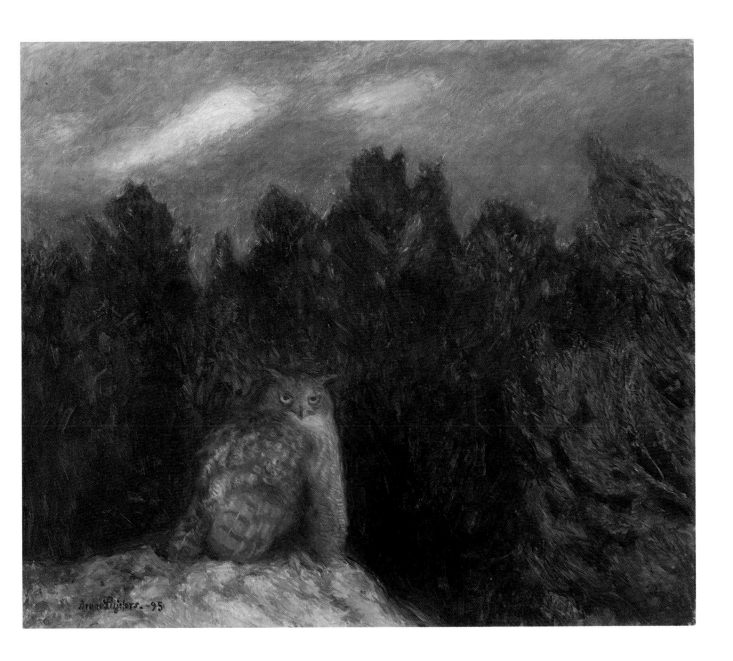

EDVARD MUNCH Norway 1863-1944

Edvard Munch, the myth, lives in a hellish world of cataleptics, vampires, and black-shrouded angels of death. Edvard Munch, the man, was born, the second of five children, into one of the foremost intellectual families of Norway in the rural town of Løten in 1863. One year later, Captain Christian Munch, a military physician, moved his family to Christiania, where Munch's mother Laura Catherine Bjølstad and his sister Sophie died of tuberculosis. Munch's younger brother Peter Andreas was to succumb to tuberculosis in 1895.

Munch entered engineering school in 1879, but quickly changed course, enrolling at the Christiania Royal Academy of Drawing in 1880 and concurrently studying art history at the University library. The conservatism of the academy prompted him and several other young artists to desert in 1882 and move into the studio building "Pultosten" where Christian Krohg* painted. Krohg, just back from his extended stay in Paris, introduced Munch to nationalistic appreciation and mainstreams in current European art. In 1883, Munch debuted at the Christiania Autumn Exhibition and then attended Fritz Thaulow's "Open-Air Academy" in Modum. Thaulow became his strongest supporter, purchasing *Morning* (1884; Nasjonalgalleriet, Oslo) from the 1884 Autumn Exhibition and securing the scholarship that first enabled Munch to visit Paris in 1885.

For the next few years, Munch was immersed in the politically and morally radical circle of Christiania bohemians that included such progressive Norwegians as the writers Hans Jaeger and Jonas Lie and the painters Christian Krohg and Karl Gustav Jensen-Hjell*. These formative years saw the genesis of his lifelong preoccupations: human biological and psychological patterns.

Munch's initial one-man exhibition was held in April 1889, and was followed by the first of his many summers in Aasgaardstrand on the Christianiafjord. In October he travelled to Paris on a state fellowship, enrolling in Léon Bonnat's studio and visiting the World Exposition and Theo Van Gogh's gallery. Shortly thereafter he received the devastating news of his father's death, which contributed to a physical collapse in 1890. (He suffered another breakdown in 1908.) Returning to Paris on an unprecedented third state scholarship in 1891, he began moving away from his Krohg-inspired Naturalism to a Synthetic art more resonant with inner life.

After his 1892 one-man exhibition in Christiania, the Berlin artists' circle invited Munch to exhibit there. His paintings scandalized the city, and when the exhibition closed within days a group of artists led by Max Lieberman (1847-1935) withdrew from the circle, later forming the Berlin Secession. Although he continued to visit Paris and spend summers in Norway, Munch remained in Berlin and fell in with the bohemian writers and artists that published the periodical *Pan*, including playwright August Strindberg (1849-1912), poet Stanislaw Przybyszewski (1868-1927), and critic Julius Meier-Graefe (1867-1935). He was also introduced to etching and lithography, which informed his painting. During this period he began to assemble his ambitious, protean ensemble of paintings entitled *The Frieze of Life*. By now a fully Symbolist painter, he exhibited with the Finnish Symbolist Akseli Gallen-Kallela* in 1895.

Munch returned temporarily to Paris in 1896, moving in the circles of Strindberg and the French poet Stéphane Mallarmé, and exhibiting in Samuel Bing's Galerie de l'Art Nouveau. He experimented with color lithography and the graphic technique of woodcut, profiting from the pioneering decorative work of Paul Gauguin and Félix Vallotton. He was at the height of his creativity, exploring the psychological potential of color and line.

By the turn of the century Munch was in a state of mental exhaustion, suffering from alcoholism, yet still creatively inspired. In 1902 his "mature" *Frieze of Life* was exhibited at the Berlin Secession. He also designed sets for Norwegian and Parisian theater, and in 1908 won the commission for the Oslo University Assembly Hall (Aula) murals. His work became infused with the bright northern sunlight and muscular health of Norwegian nationalist philosophy.

In 1916, the year his murals were unveiled, Munch purchased Ekely House outside of Oslo, where he remained for the rest of his life. An internationally recognized artist who had exhibited in virtually every major city in Europe and was revered by the German Expressionist painters, he lived in near isolation until his death in 1944 at the age of eighty-one. [PGB]

62

Inger on the Beach (Summer Night) 1889

Inger på Stranden (Sommernatt)
126.4 x 161.7 (49¾ x 63⅝)
Signed lower left: "E Munch 1889"
Rasmus Meyers Samlinger, Bergen

Edvard Munch painted *Inger on the Beach*, for which his sister Inger modelled, during the first of his many summers in Aasgaardstrand on the Christianiafjord. With its softly undulating coastline, atmospheric blue twilights, and the romance of its nearby Viking burial sites, Aasgaardstrand lured an annual summer coterie of Christiania artists and writers. In the summer of 1889 Hans Heyerdahl (1857–1913) and Christian Krohg* lived in the quaint fishing village in daily contact with Munch.

While Krohg's free brushwork, flattened pictorial space, and attachment to the sea impelled Munch's work that summer, Munch's eradication of any reference to a horizon line and his muted palette of earth tones and silvery blues reflect his interest in Pierre Puvis de Chavannes. In 1884, the critic Andreas Aubert had interpreted Puvis's *The Sacred Grove* (1884; Art Museum, Lyon) as a spiritual balance between human emotion and natural environment embodying musical harmony. Munch adapted this notion of a psychological veil extending from nature to enfold its inhabitants to create the iconic image of his sister in the landscape. Although critics attacked the stony silence of Inger when the painting was exhibited at the 1889 Autumn Exhibition in Christiania, it is this aspect of the work,

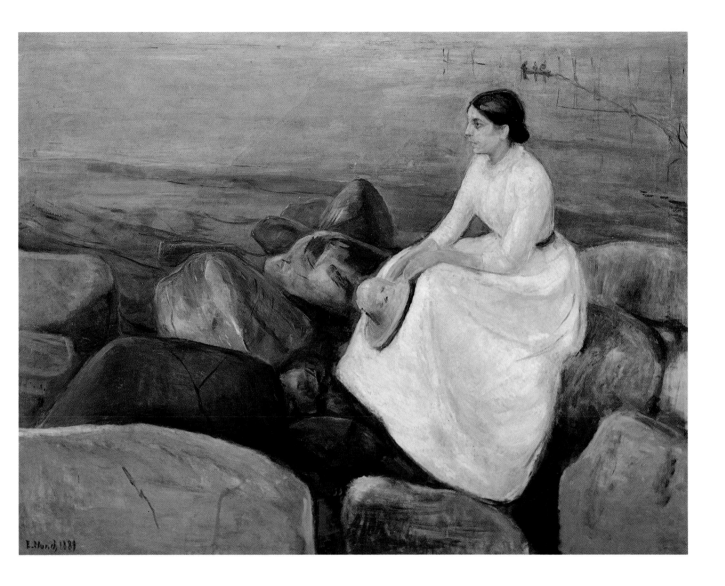

indicating Munch's growing psychological interests, which captivates our imagination.

As Robert Rosenblum points out (biblio. ref. no. 13, p. 107), Inger is an adaptation of a persistent motif in Northern Romantic painting, the lone figure in an internal dialogue with nature. Yet rather than actively contemplating the endless expanse of water, as does the woman in Anselm Feuerbach's *Iphegenia* (1862; National Museum, Darmstadt), a widely circulated image of the 1880s, Inger is passive and self-absorbed. Munch likens her to the rocks on which she sits, linking her to the earth and sea. In such later works as *Summer*

Night's Dream (The Voice) of 1895 (cat. no. 66), the image of a virginal white-clad female on the Aasgaardstrand shore becomes erotically charged.

In the summer of 1892 Munch radically reinterpreted *Inger on the Beach* in *Melancholy (The Yellow Boat)* (Rasmus Meyers Samlinger, Bergen), transforming the fishing boat in the background into the focal point for the anguish radiating from the figure seated in the extreme foreground. Thus transposed into an expressionistic foil, the Aasgaardstrand beach became the setting and unifying element of Munch's *Frieze of Life* paintings of the 1890s. [PGB]

63
Night (Night at St. Cloud) 1890
Natt
64.5 x 54.0 (25⅜ x 21¼)
Signed lower right: "E. Munch"
Nasjonalgalleriet, Oslo

With the aid of a state fellowship Munch left for Paris in October 1889 to study in the atelier of Léon Bonnat. On December 4 he learned of his father's death and plunged into depression and total self-absorption. Near the end of the month he left the city for the suburb of St. Cloud, where, in the solitude of his apartment, he immersed himself in recollections of the past. He recorded the painful experience of these memories in a diary and in the subjective expression of *Night*.

The painting is, at once, a representation of the artist deep in thought and an evocation of the melancholy mood produced by his contemplation of the past. Although *Night* is autobiographical, Munch's only friend at the time, the Danish poet Emmanuel Goldstein, probably posed for the figure. With his head resting heavily upon his hand, he gazes outside at the evening light and the boats on the Seine. The oppressive blue interior is a metaphor of Munch's psychological insularity, set in direct opposition to the world beyond the window. Forms are generalized and flattened, and the whole composition is enveloped in a hazy, lavender-blue atmosphere. A comparison with Harriet Backer's *Blue Interior* (1883; cat. no. 3) reveals the difference between a Naturalist's descriptive use of color and Munch's emotive exploitation of blue as a symbol of sadness, silence, and death. Munch also referred to the painting as *Symphony in Blue*, attesting to the influence of James McNeill Whistler, who used musical terms in many of his titles. The broad, thin handling of paint and the suggestive abstraction of forms reflect current French trends.

In a comprehensive article on the painting, Reinhold Heller (1978, pp. 80–105) shows that *Night* is a milestone in the development of the Symbolist movement in Scandinavia. When it was first exhibited in the Christiania Fall Exhibition of 1890, the progressive critic Andreas Aubert aligned it with the new European aesthetic of Decadence: the cultivation of the self and a neurasthenic sensibility. *Night* continued to draw attention from Munch's contemporaries. By 1893 he had orders for four copies, and he repeated the image, in reverse, for an 1895 drypoint and aquatint entitled *Moonlight* (Schiefler, 1923, #13). [EB]

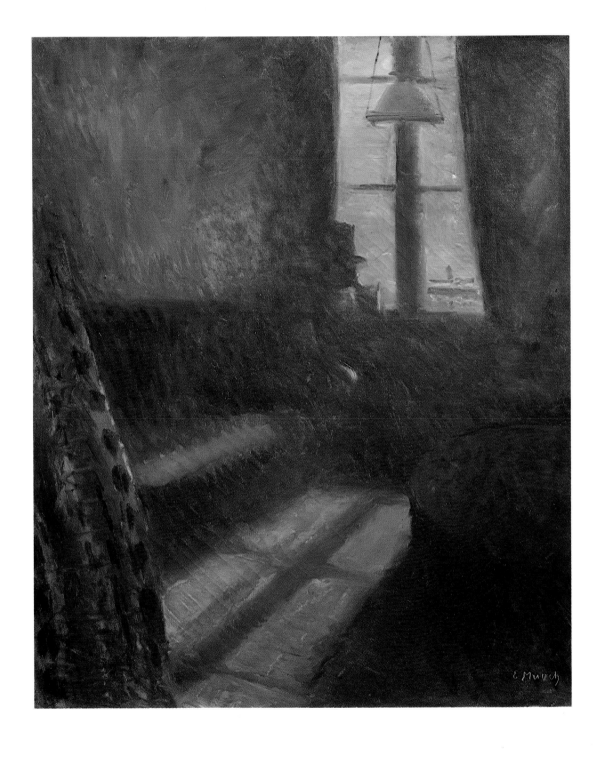

64

A Spring Day on Karl Johan Street 1890
Vardåg på Karl Johan
80.0 x 100.0 (31½ x 39⅜)
Signed lower left: "E. Munch 91"
Bergen Billedgalleri

A Spring Day on Karl Johan Street, like *Night* (cat, no. 63), belongs to a period of experimentation in Munch's career, 1889 to 1892, during which he reacted against his native training by assimilating current French styles. In *Spring Day* he uses a Neo-Impressionist technique that he observed firsthand in Paris, where he could have seen the work of Georges Seurat and Camille Pissaro at the Salon des Indépendants of March 1890. The quality of space and light and the blurring of human figures are similar to Vincent Van Gogh's *Boulevard de Clichy* of 1888 (Rijksmuseum Vincent Van Gogh, Amsterdam). Munch's division of colors does not conform to Seurat's strict method, nor is his application of paint consistent across the canvas. Nonetheless, his Pointillism effectively creates the sense of shimmering light on the open street.

Munch painted the picture in May 1890 upon his return from Paris to Christiania and just before he left to spend the summer in Aasgaardstrand. *Spring Day* was included in the Christiania Autumn Exhibition of 1890, where Munch assigned to it the highest price among the ten paintings he exhibited. The signature and incorrect date of 1891 were added by the artist years later, perhaps on the occasion of his 1927 retrospective in Oslo (Boe, 1970, p. 132).

Munch depicts the main avenue of Christiania, the official promenade for the city's bourgeoisie. It is seen from Lovebakken, or Lion Hill, the park in front of the Houses of Parliament, and the view is towards the Royal Palace, the shimmering monolith at the end of the vista. As early as 1884, with *Afternoon Mood at Olav Reyes Place* (Nationalmuseum, Stockholm), Munch had depicted an overview of the city's streets. It was not until 1889, however, that scenes of street life became a favorite subject of the artist. Here the central figure of a woman with her back to us and her head obscured by her umbrella commands special attention. Her stiff pose and hieratic placement, and the somber blue and intense red of her attire, stand out amidst the random passersby and the overall light palette of the canvas.

It is possible that the emphasized, yet inaccessible figure represents Munch's former lover, Mrs. Heiberg. His St. Cloud diaries display an obsession with memories of their meeting on Karl Johan Street, and in a study for the picture (1890; Munch-Museet, Oslo), an identical figure is watched by a top-hatted man who leans ominously towards her. This theme of frustrated desire, loneliness, and anonymity amidst a crowded street is explicit and more fully developed in *Evening on Karl Johan Street* (1892; Rasmus Meyers Samlinger, Bergen). [EB]

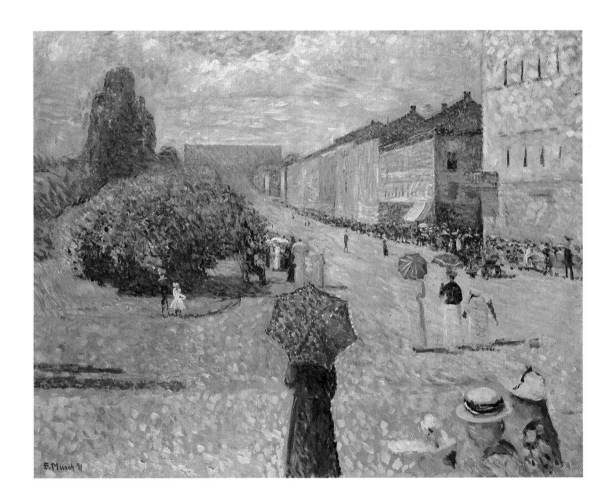

65
Moonlight 1893
Måneskinn
140.5 x 135.0 (55¼ x 53⅛)
Signed lower right: "E. Munch"
Nasjonalgalleriet, Oslo

In 1893, after spending a frenzied year in the rebellious milieu of Berlin, Munch retired to his summer sanctuary in Aasgaardstrand. That summer, during which he painted *Moonlight,* he wrote to the painter Johan Rohde in Copenhagen that he had begun to formulate the *Frieze of Life*—"a picture series...the subject will be love and death."

Several studies for *Moonlight* exist, beginning with *Inger in Aasgaardstrand* (Munch-Museet, Oslo), a portrait done in 1891-92. In these studies Munch's sister, dressed in white, stands before a picket fence that penetrates diagonally into the pictorial space. In *Moonlight* the artist takes the diagonal elements of Inger's portrait and makes them parallel the picture plane. The flattened, rigorous formulation of space, defined by strong horizontal and vertical elements, is the aspect of Munch's attraction to Seurat that survived his 1891 flirtation with Neo-Impressionism. The elegantly flowing Art-Nouveau lines of the tree and the woman's shadow flanking the edge of the house relieve an otherwise rigid composition. Suspended in the midst of the painting, the quasi-devotional woman is shrouded in darkness.

The female frontal figure plays a significant role in Munch's painting of the mid-nineties. In a style similar to that of the Dane Jens Ferdinand Willumsen, with whom he exhibited in 1892, Munch weaves tension between the woman and her audience into *Moonlight* by giving her a confrontational gaze and depriving her of dramatic gesture. She appears to stare fixedly out of the canvas, yet the suggestion of an arm in the left foreground, perhaps implying the presence of another person, shifts the psychological charge of the composition.

Since he was working serially during the summer of 1893, Munch may have created *Moonlight* and an early version of *Summer Night's Dream (The Voice)* (cat. no. 66) as companion pieces, contributing to a personal iconography of female sexuality. He equates the woman's face of *Moonlight* with the moon's reflection in the window behind her, defining her through her cyclical, biological identity. Together, *Moonlight* and *Summer Night's Dream* present woman in her sexual relation to man: *Moonlight* is a study of sexual restraint and *Summer Night's Dream* embodies sensual awakening. The two women, respectively the "Widow/Mother" and the "Virgin" (Heller, 1978, p. 79), are fused with Munch's third aspect of woman, the "Whore," into the programmatic *Sphinx (Woman in Three Stages)* of 1894-95 (Rasmus Meyers Samlinger, Bergen) and *The Dance of Life* of 1899 (cat. no. 69).

The woman in black, radiating light into the surrounding darkness, personifies the Nordic summer night as Munch then perceived it—vaguely sinister and pregnant with mystery. The inscrutable figure in *Moonlight* is restated in *Dagny Juell Przybyszewski* (Munch-Museet, Oslo), also of the summer of 1893, and as Inger in *Death in the Sickroom* (1895; Nasjonalgalleriet, Oslo). [PGB]

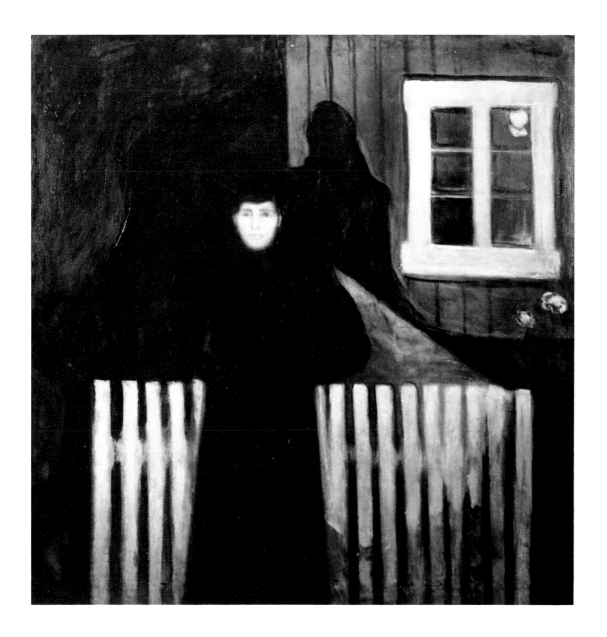

66 *Detail reproduced in color on front cover*
Summer Night's Dream (The Voice) 1893
Sommernatt (Stemmen)
96.0 × 118.5 (37¾ × 46½)
Not signed
Munch-Museet, Oslo

In 1893 Munch began the series of paintings titled *The Frieze of Life*. The individual paintings comprised a sequence of psychological states associated with the mysteries of life, love, and death. *Summer Night's Dream* was the first of the *Frieze* paintings, exhibited initially in December 1893 in Christiania in a sequence with *The Kiss, Love and Pain (The Vampyre), The Madonna, Jealousy,* and *The Scream,* and later in the "mature" *Frieze of Life* at the 1902 Berlin Secession exhibition. This painting and a second version (1893; Museum of Fine Arts, Boston) have carried a number of titles, including *In the Forest* (Stockholm exhibition, 1894), *Evening Star* (Berlin, 1902), and *The Voice.*

The setting for *Summer Night's Dream* is the mysterious blue twilight of the Aasgaardstrand beach on the Christianiafjord, which Munch saw as a unifying element in *The Frieze of Life* (see cat. no. 69). The painting's title engenders associations with St. Hans' Night, the Nordic celebration heralding the return of summer and light, a moment of frenzied revelry and abandonment of social norms. The wooded shores of the Norwegian fjords were traditional meeting places for lovers on St. Hans' Night, while boats bearing celebrants filled the water. As the poet Franz Servaes described the setting in 1894: "Here the sexual will rises stiffly for the first time during a pale moonlit night near the sea, the girl roams among the trees, her hands cramped together behind her, her head tossed back and her eyes staring wide and vampire-like. But the world is a mixture of the misty and the glaring, of sexual fantasy and revulsion" (Heller, 1973, p. 46).

The theme of *Summer Night's Dream* is drawn from Munch's own experience, recalling the moment before his first kiss when he stared into the beckoning eyes of his partner. The expectant pose of the virginal figure is undermined by the threatening force of her sexual yearning. She looms aggressively in the foreground, demanding a subjective response from her audience: arousal, expectation, or the reaction of Munch and his contemporaries to her—fear and repulsion. This Schopenhauerian interpretation of woman, in which eroticism is inextricably bound with destruction, runs throughout *The Frieze of Life* and has been likened to such emblems of the European Decadent movement as Max Klinger's graphic cycle *A Love* (1887).

The woman in this version of the motif is larger and more boldly executed than in the Boston version, giving her a greater sexual charge. The geometric regularity of the trees and the glimmering shaft of the moon's reflection on the water echo her rigid domination of the canvas. Complementing the otherworldly figure in *Moonlight* (cat. no. 65), she is integrated into the taut landscape, sharing in the pulsating, erotic mood of the summer night. [EB/PGB/AC]

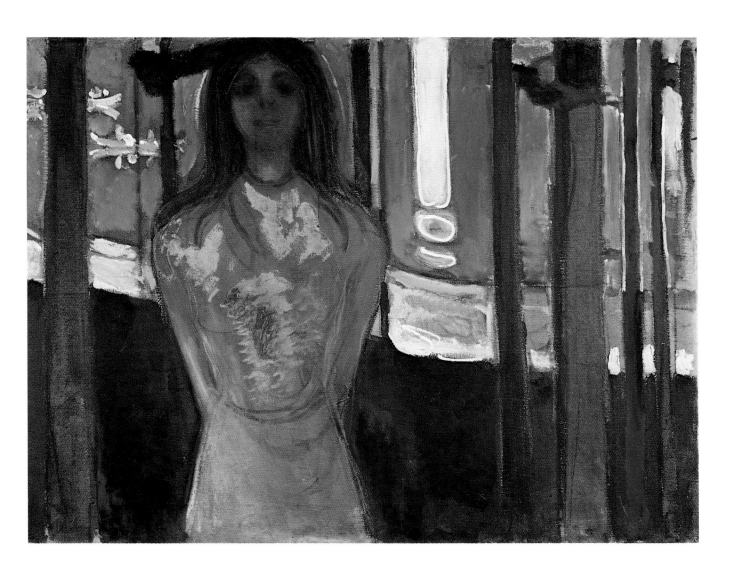

67
Self-Portrait with Cigarette 1895
Selvportrett med sigarett
110.5 × 85.5 (43½ × 33⅝)
Signed lower left: "E. Munch 1895"
Nasjonalgalleriet, Oslo

While *fin-de-siècle* Europe experienced an upsurge of spiritualism and occultism, Edvard Munch was living in Berlin, engaged in a cult of "pathological eroticism" with poet Stanislaw Przybyszewski, playwright August Strindberg, critic Julius Meier-Graefe, and author Richard Dehmel. This group crystallized in 1893, when they convened nightly at "The Black Pig" cafe to discuss Symbolist Paris, the femme fatale, and the newly emerging field of psychology. In a shared spirit of idealism, each member of the "Black Pig" circle fought to express his most fundamental psychic impulses: Przybyszewski in his confessional novels about the sexual unconscious, Strindberg in his experiments in self-induced madness, and Munch in his painting.

Self-Portrait with Cigarette dates from this impassioned period of self-analysis. Munch's fluid handling of diluted color washes creates a mysterious atmosphere that surrounds and in places absorbs the figure. Echoing the Rembrandt self-portraits he so admired, Munch's face and the hand holding the cigarette are contrasted to the background by theatrical light from below.

The painting differs markedly from its initial conception. In a charcoal sketch (see below) also dating from 1895, Munch's dissipated figure is distorted in a mirror to his left while he thrusts forward his enlarged, skeletal hand holding a cigarette. The art historian Gösta Svenaeus (1975, p. 96ff.) has linked this gesture to a morbid figure from Francisco Goya's *Los Caprichos* (Plate 49, *Hobgoblins*), which Munch knew through the Danish painter and critic Johan Rohde. This explicit identification with death is missing in the painted version of *Self-Portrait with Cigarette,* although it is transferred to the lithograph *Self-Portrait with Skeleton Arm* (Munch-Museet, Oslo) of the same year. In an early stage of the painting, still visible at the bottom of the canvas, it appears that Munch may have intended to sketch his hands clenched in the vicinity of his groin—a gesture likely relating with the "Black Pig" obsession with sexual impulses. Munch later reiterated such a sexual innuendo by provocatively imposing his signature on his lower abdomen in *Self-Portrait in Hell* (1906; Munch-Museet, Oslo).

Self-Portrait with Cigarette is a portrait of the artist as bohemian. In the radical Christiania of the eighties, which spawned Christian Krohg's *Portrait of Gerhard Munthe* (cat. no. 55), Munch developed a typology of bohemianism centering on the cigarette. Beginning with two portraits of Karl Jensen-Hjell* and continuing with portraits of Przybyszewski (1895; Munch-Museet, Oslo) and Henrik Ibsen (1906–10; Munch-Museet, Oslo) and his lithographic *Self-Portrait with Cigarette* of 1908 (Munch-Museet, Oslo), he expanded his personal iconography of the cigarette, increasingly strengthening the expressive quality of smoke.

Following an 1895 lecture on Munch in Christiania, a student, basing his argument on *Self-Portrait with Cigarette,* attacked Munch as being obsessed with mental illness. The debate that ensued contributed to the public's already ingrained view of the artist as mentally unbalanced. The painting remains one of the most riveting images in Munch's prodigious body of self-portraiture. [PGB]

Edvard Munch
Self-Portrait with Cigarette
circa 1895
Charcoal and pencil on paper
Location unknown

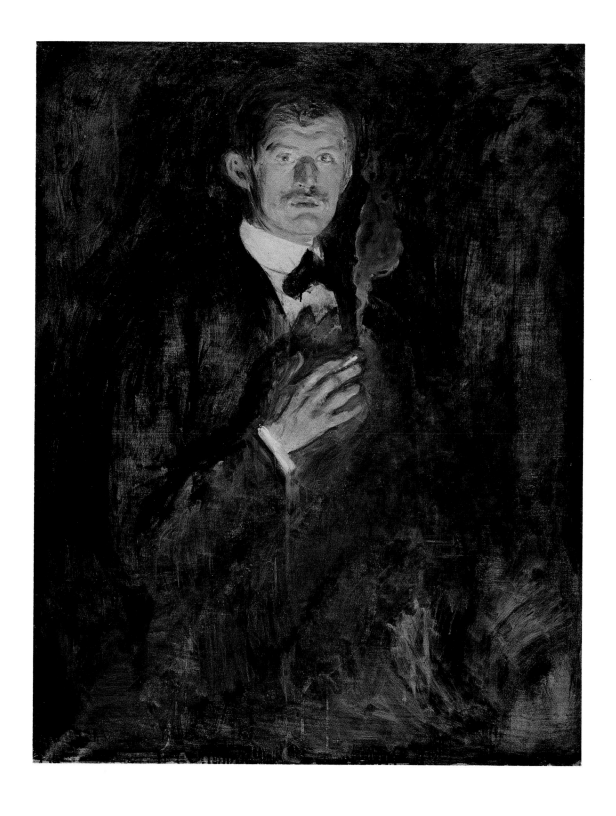

68
Melancholy (Laura) 1899
Melankoli (Laura)
110.0 × 126.0 (43¼ × 49⅝)
Not signed
Munch-Museet, Oslo

Edvard Munch's sister Laura, diagnosed as melancholic while still a girl, suffered bouts of severe depression throughout her life. One such crisis in 1895 inspired the artist to do a series of sketches that became the basis for *Melancholy (Laura)* in 1899. This painting is a poignant example of his fascination with extreme or aberrant mental conditions. Unlike Halfdan Egedius in *The Dreamer* (cat. no. 10), he does not resort to the standard Romantic physiognomic typology to evoke melancholia. Rather, ambiguities of space and color act as visual equivalents of Laura's morbid mental condition.

Laura is the very avatar of psychological isolation, seated unsteadily in a room that is a symphony of spatial ambiguities. The precipitously climbing angles of the floor and foreground tabletop, along with the vertical line describing the juncture of two walls, telescope the pictorial space into one flat, pulsating plane. The spatial organization suggests that Laura is seated at the center of the room, yet the sunlight flooding through the windows hits the wall to her left without casting her shadow. The atmosphere of the room heats the wintry light of the exterior world into an acid yellow as it enters the windows, accentuating the irrationality of Laura's surroundings.

Munch's strategy of "atmospheric realism," which Stanislaw Przybyszewski earlier called his "psychic Naturalism" (1894, p. 103), fuses sitter and environment into a continuous emotional medium. This sensibility has its roots in Édouard Vuillard's Intimist interiors of the early nineties. The art historian Gösta Svenaeus (1968, p. 203ff.) draws a striking comparison between *Melancholy* and Vuillard's color lithograph *Interieur à la Suspension,* which was exhibited and published by the Parisian dealer Ambrois Vollard in 1899 and was the fourth print in Vuillard's suite *Paysages et Interieurs.* Vuillard worked on this suite in the studio of August Clot, where Munch pulled his lithographs, and Vuillard's print stimulated Munch's own composition, particularly the tablecloth patterning in the foreground. Munch intensifies the already suggestive design by modelling it after the tinted coronal brain sections which were used to illustrate neurological abnormalities in contemporary medical publications (see example at left). This neuroanatomical allusion functions as a specific exterior reference to Laura's internal mental condition, reinforcing the disorienting effect of the room.

Munch included *Melancholy (Laura)* in the 1918 *Frieze of Life* exhibited at Blomqvist's Gallery in Christiania. Although not conceived as a component of the frieze, *Melancholy* reflects Munch's Symbolist concern with the materialization of invisible impulses, and with psychological, not representational, portraiture. [PGB]

Horizontal section(s) of the cerebrum, displaying the islets of sclerosis in different regions Plate II of:
Jean Martin Charcot, *Lectures on the Diseases of the Nervous System* (The New York Academy of Medicine, 1962), facsimile of the 1881 London edition.

Munch and his circle in Berlin hailed neurology and psychology as points of convergence between material science and mysticism. They adopted technical language and medical illustrations of nerve fibers and brain sections as emblems for their Romantic theories of the unconscious.

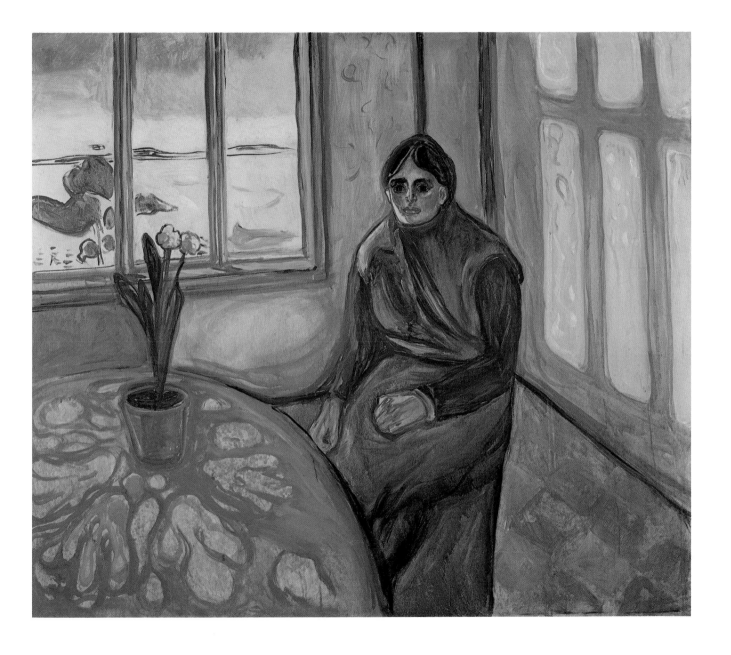

69
The Dance of Life 1899–1900
Livets dans
124.5 × 190.5 (49¼ × 74¾)
Signed lower left: "E. Munch 99."
Upper right: "E. Munch 1900"
Nasjonalgalleriet, Oslo

The Dance of Life, painted in 1899 and reworked in 1900, was Munch's last major contribution to *The Frieze of Life,* summarizing its subjects into a monumental allegory of human life. Its theme is shared by *Moonlight* (cat. no. 65) and *Summer Night's Dream* (cat. no. 66) and is intimately linked to *Sphinx (Woman in Three Stages)* (1894–95; Rasmus Meyers Samlinger, Bergen).

The Dance of Life illustrates the temporal progression of woman's sexuality. At the center of the composition a red-clad female freely dances with a young man whom Munch identified as a priest. To the left stands a virginal figure on the brink of her sexual awakening, and to the right, a haggard woman wearing the black dress of widowhood. The background, in Munch's words, "is a mass of whirling people—fat men biting women on the neck" (Stang, 1977, p. 111) under a mesmerizing full moon reflecting on the water off the Aasgaardstrand shore. The setting for this cycle of anticipation, fulfillment, and desolation is St. Hans' Night (also the painting's original title), the fusion of Nordic religious and secular celebrations marking the summer solstice.

The Dance of Life and the whole of the frieze embody the ambitious spirit of *fin-de-siècle* Europe. An urge to create panoramic narrative cycles, reflecting a utopian search for universal truths, came to fruition in such works as Auguste Rodin's *The Gates of Hell* (1880–1917) and Paul Gauguin's *Where do we come from? Who are we? Where are we going?* (1897; Museum of Fine Arts, Boston). The strident words of Munch's 1889 St. Cloud manifesto reveal his desire to reinterpret the "sacred" in a post-Christian, post-Darwinian era. There Munch said, in terms that directly prefigure the images of *The Dance of Life,* that men and women at the moment of sexual union "were not themselves: they were merely one link in the endless chain that joins one generation to the next. People should understand the sacred, awesome truth involved, and they should remove their hats as in church..." (Stang, 1977, p. 74). Seeking a foil for Symbolist transpositions of religious imagery, Munch began to explore in 1893 the triptych format that he would later make implicit in *The Dance of Life.* (Heller, 1970, p. 72 ff).

Love and death play central, interdependent roles in Munch's pessimistic theology. In notes of 1898 (Zurich, 1976, p. 13–14) he linked *The Dance of Life* with the drawing *The Empty Cross* (1897–99; Munch-Museet, Oslo) and the painting *The Inheritance* (1898; Munch-Museet, Oslo), a sexual reinterpretation of Madonna iconography. Like Henrik Ibsen's play *Ghosts* (1881), *The Inheritance* deals with venereal disease and refers to the legacy of destruction stemming from past sins.

The Dance of Life at once underscores the transience of life symbolized by the act of love, and the inevitability of its cyclical repetition. *Dance on the Shore* of 1906 (Munch-Museet, Oslo) repeats the composition, now organized into an actual triptych whose *predella* incorporates motifs from *The Kiss, Sphinx,* and *The Inheritance,* recapitulating, like *The Dance of Life, The Frieze of Life* in an abbreviated format. [PGB]

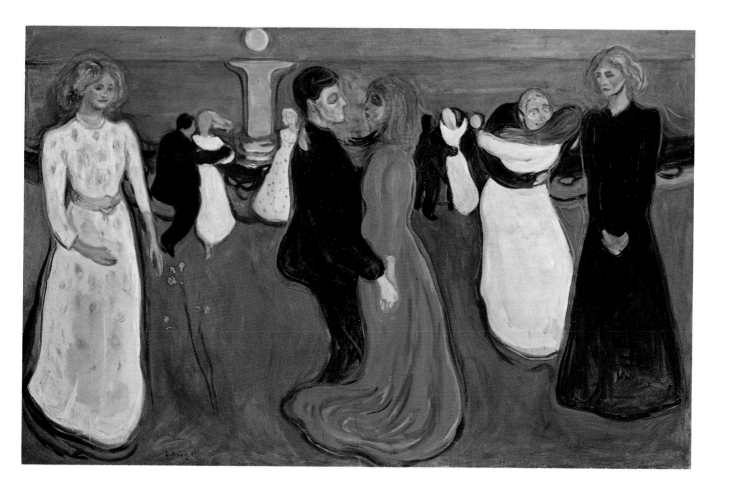

EJNAR NIELSEN Denmark **1872-1956**

Born in Copenhagen in 1872, Ejnar Nielsen studied at the Danish Royal Academy of Fine Arts from 1889 to 1893, when he made his debut at the spring exhibition in Charlottenborg Palace. He also took classes at Kristian Zahrtmann's school in the spring of 1895 and the winter of 1895-96. Perhaps his most important artistic model, however, was the Danish Symbolist painter Jens Ferdinand Willumsen.

From 1894 to 1900 Nielsen worked alone in the central Jutland town of Gjern, where he produced some of his most important works. Among them are the 1896 painting *The Sick Child* and the 1897 work *In His Eyes I Saw Death* (both in the Statens Museum for Kunst, Copenhagen), as well as *The Blind Girl* of 1896-98. Nielsen's interest in the pathos and nobility of these simple people continued in his illustrations for the novels *The Old Man's Child* (1900), by Karl Larsen, and *Kirsten's Last Journey* (1901), by Johannes Jensen.

Nielsen made his first trip abroad in 1900. In Paris from 1900 to 1901, stimulated by his earlier contact with Willumsen, he was particularly attracted to the work of the Gauguin-influenced *Nabi* painters and to the art of Pierre Puvis de Chavannes. He married in 1901 and spent 1902 living in Italy—Verona, Venice,

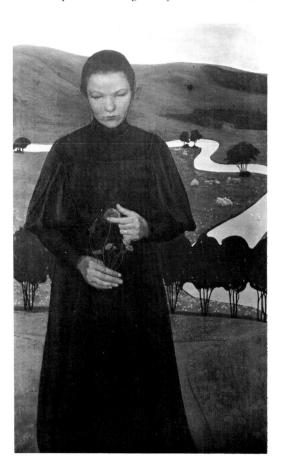

Pisa, Milan, and Florence—where he developed an interest in Quattrocento painting (particularly that of Andrea del Castagno), which influenced his art upon his return to Gjern in 1903. During that year he won his first Eckersberg medal for *The Pregnant Woman* (Göteborgs Konstmuseum), which reflects a new, broader, more spiritually concentrated style. Nielsen returned to Italy and France from 1905 to 1911 and made short visits to Brittany in 1908 and Lapland in 1909. He married a second time in 1908.

Nielsen remained based in Gjern until 1927. He became increasingly concerned with large-scale decorative commissions, making studies for a mosaic for the Copenhagen town hall from 1927 to 1930 (a project he never carried out) and painting a mural for the state hall in Portrum from 1932 to 1939. An active and vital presence in the Danish art community until his death, he served on the board of directors of the Royal Academy of Fine Arts from 1914 to 1920 and was a member of the governing body of Den Hirschsprungske Samling from 1925 to 1931. In 1927 he was honored by the Artists' Society with a comprehensive retrospective in Charlottenborg Palace. [SMN]

70

The Blind Girl 1896–98
Den blinde
131.5 x 79.2 (51¾ x 31⅛)
Signed lower right: "Ejnar Nielsen/Gjern 1896–98"
Den Hirschsprungske Samling, Copenhagen

Nielsen's commitment to the truth (an extension of the bitter Realism developed in the 1880s by Jens Ferdinand Willumsen, Johan Rohde, and Harald Slott-Møller*) was united with his Symbolist vision in a series of paintings completed in Gjern from 1894 to 1898. Among them was *The Blind Girl*, whose dominant theme is life as seen under the shadow of death. Nielsen found in the simple people of Jutland a fundamental ennobling perseverance in the face of life's struggles. Like Van Gogh, the Swiss painter Fernand Hodler, and a number of other artists of the 1880s and '90s, he painted the old, the poor, and the sick in his search for a common human destiny.

The unified tonalities of *The Blind Girl* foreshadow Nielsen's attraction to Pierre Puvis de Chavannes. The image may be related to Emmanuel Swedenborg's notion of second sight, a Romantic tradition that flourished in Symbolism, according to which one must lose one's awareness of material surroundings in order to see across great distances of time and space into the soul and divinity. Nielsen has replaced some of the girl's lost visual impressions with experiences gained through touch. She cradles in her hand a dandelion, which, in its state of decay, is the ultimate symbol of evanescence and fragility. The landscape that stretches out behind her becomes the projection of ideal vision liberated from simple sensual perception and connected to a larger reality. [SMN]

KARL NORDSTRÖM Sweden **1855-1923**

Karl Nordström received his earliest training at the
Royal Academy of Fine Arts in Stockholm, where he
studied from 1875 to 1878 under E. Perséus. He left
academic art after failing to pass from the introductory
course to the advanced level. Travelling to Paris in 1881,
he moved in 1882 to the village of Grèz-sur-Loing,
southeast of Paris, with fellow countryman Carl Larsson
and the Norwegian painter Christian Krohg*. Having
had no success at the Paris Salon, he returned to
Stockholm in 1886 and began painting scenes of
Swedish nature, particularly winterscapes. In that same
year the Artists' Union was founded with Nordström
serving as president.

National Romanticism flourished in Sweden
throughout the 1890s, and Nordström—spurred by that
movement's revaluation of the indigenous
landscape—developed a deeper and more subjective
appreciation of the Swedish countryside in the course of
the decade. In 1890 and '91 he executed his first
"mood" pictures, in which he sought to capture the
somber Swedish twilight. In 1892, he painted the
barren, rocky coast of his native district, Bohuslän, and
in 1893 he moved to Varberg, where he formed the
Varberg school of Swedish Symbolism with Nils Kreuger
and Richard Bergh*. He left Varberg in 1895 for
Stockholm, thereafter dividing his time between the
capital and Bohuslän, and remaining active as leader of
the Artists' Union. [SRG/GCB]

71

Garden in Grèz 1884
Trädgårdsmotiv från Grèz
108.5 x 73.5 (42¾ x 28⅞)
Signed lower left: "Karl Nordström/Grèz 84."
Göteborgs Konstmuseum

Garden in Grèz falls within Nordström's French period,
when he adopted a modified Impressionist technique.
The subject is the garden and wall at the Pension
Laurent, a hotel in the Paris suburb of Grèz-sur-Loing.
Stone buildings and a wall are seen in the distance
across the cool, grassy expanse of garden. Bathed in
vaporous white light, the structures dissolve into a
myriad of gray, slate, and blue tones. Nordström, more
radically Impressionist than most of his Scandinavian
compatriots, was criticized by the Swedish press for his
shimmering surfaces. His colleague and friend Richard
Bergh* wrote of Nordström's Grèz period: "He painted
what he found outside the door of the pension where
he stayed...he studied light effects, discovered the laws
of color contrasts, and found that the different objects of
nature never appear independent of each other when
embraced by the same atmosphere." [SRG/BF]

72

Varberg Fort 1893
Varbergs fästning
62.0 x 88.5 (24⅜ x 34⅝)
Signed lower right: "KN 93"
Prins Eugens Waldemarsudde, Stockholm

Losing Finland to Russia in 1809 after a 447–year
association, Sweden was joined from 1814 to 1905 in
an ambiguous and antagonistic union with Norway,
which it won from Denmark. Industrially
underdeveloped and socially restrictive, Sweden was
unable to support the doubling of its population
between 1800 and 1900. The lack of opportunities
spurred emigration to America in numbers that
exceeded those of any other Scandinavian country.
Faced with concern over Russian expansion and

Norway's insistent push for self-determination, Sweden
feared for its national survival. The government
responded by attempting to "Americanize" Sweden
through modernization and cultivation of rough
northern land. The 1890s gave birth to increased
nationalism, and National Romantic art and literature
grew throughout the decade.

The unspoiled Halland province, in which the
Varberg School flourished from 1893 to 1895, provided
a vehicle through which Nordström, Nils Kreuger, and
Richard Bergh* could express their personal and
subjective visions of Swedish nature. Forming a nexus
between nationalism and Symbolism, *Varberg Fort*
depicts a medieval stronghold of the Vasas, the ruling
family during Sweden's Golden Age of the sixteenth
and seventeenth centuries. Articulated in a thin, loose
technique and reduced to a series of abstract forms, the
citadel is compressed into a shallow, two-dimensional
space that reflects the influence of Gauguin, whose
work Nordström saw in Copenhagen in 1892. Twilight
bathes the fort in blue—a conception akin to that of
Albert Edelfelt's *Särkkä* (cat. no. 9) from the same
period. In the many views Nordström executed of the
fortress, he celebrated the inherent strength of
Sweden [SRG/GCB]

EILIF PETERSSEN Norway 1852-1928

Peterssen began his artistic training in 1869 at Johan Fredrik Eckersberg's painting school in Christiania, and in 1871 he studied at the Danish Royal Academy of Fine Arts in Copenhagen. He spent the next two years in Karlsruhe, where he studied with Hans Gude and Wilhelm Riefsthal. After visiting London and Paris, he moved in 1873 to Munich, where he studied history painting with Wilhelm Diez and came under the influence of Franz von Lenbach. He left the Munich academy in 1874 and won acclaim in 1876 for the painting *Christian II Signing the Death Sentence of Torben Oxe* (Nasjonalgalleriet, Oslo). Returning to Christiania in 1878, he wrote that his success in Munich had made life and art too easy for him.

Peterssen continued to travel widely in Europe, visiting London, Paris, and Venice. From 1879 to 1883 he lived in Rome most of the time but was a frequent summer visitor to the artists' colony in Skagen (see cat. no. 58). In 1883 he settled in Christiania, where he became a member of the Art Association and served on its board from 1885 to 1888 and from 1894 to 1895. He travelled to Normandy and Italy in 1896 and 1897.

Peterssen was a popular teacher and an artist of diverse talents. During the Munich period, history paintings accounted for most of his work. In Italy he began to concentrate on open-air paintings of genre subjects, and from the 1880s on, landscapes and genre made up the major part of his production. Early in the twentieth century he carried out several mural commissions of religious themes. [RH/OT]

73

Meudon Landscape 1884

Landskap från Meudon
38.5 x 46.5 (15⅛ x 18¼)
Signed lower right: "Eilif Peterssen–Bas Meudon '84"
Nationalmuseum, Stockholm

Peterssen's interest in depicting light effects in a landscape goes back at least as far as his oil sketch *The Death of Corfitz Ulfeldt* (1873; Nasjonalgalleriet, Oslo), in which he placed the characters at the edge of a forest beneath a lowering sky. In the 1880s his attention turned from historical subjects to pure landscape, often painted outdoors. Although this canvas is dated during the period Peterssen lived in Christiania, he may have painted it on one of his trips to Paris. His inscription indicates that the site is Bas Meudon, the industrial section of Meudon, a suburb west of Paris. Instead of depicting the main tourist attractions of the Forest of Meudon or the Terrace with its renowned Parisian views, he focused from a low viewpoint upon an ordinary fence with a light-filled vista of buildings in the distance.

Occupying much of the composition, the fence both encloses the viewer in the narrow space of the foreground and yields a full view of the buildings beyond. The opening between the two parts of the fence and the stairs that lead back and to the left offer additional "escapes" to the area below. The close-up cropped view and the use of the fence as a decorative screen are related to Akseli Gallen-Kallela's *A Loft at Hoskari, Keuruu* (cat. no. 21) in that they suggest an attention to the spatial and framing devices of advanced French painting. [RH/OT]

74
Summer Night 1886
Sommernatt
133.0 x 151.0 (52⅜ x 59½)
Signed lower left (in monogram): "Eilif P 86"
Nationalmuseum, Stockholm

During the summers of 1886 and '87 Peterssen joined Kitty Kielland*, Erik Werenskiold, Gerhard Munthe, and Christian Skredsvig at the farm of Fleskum near Christiania. Painted the first summer, this work shares the group's common concern of depicting a mood by means of a relatively naturalistic view of the Norwegian landscape. Peterssen has shown a corner of the lake at Baerum from a high viewpoint in a deceptively casual, "snapshot" composition. The tree at the right, firmly rooted at the shoreline, is cropped by the upper edge of the frame. This device occurs in such earlier Norwegian landscapes as Johan Christian Dahl's *From Praesto* (1814; Nasjonalgalleriet, Oslo).

The cropped tree extending almost the full height of the work also suggests the influence of Japanese art. Grounded by this strong tree and the nearly tangible underbrush of the foreground, the viewer steps comfortably into a realistic scene. However, only a small area of sky is visible at the top center of the work; the rest of the sky and the crescent moon are only reflections in the glassy surface of the lake. This water/sky filling a large proportion of the canvas conveys an unsettling, upside-down feeling.

The art historian Marit Lange has stressed the significance of Peterssen's encounter with the art of Pierre Puvis de Chavannes in the Salons of 1884-86. She sees Puvis's *The Sacred Grove* (*circa* 1884; Art Institute, Chicago) as the inspiration for Peterssen's new concentration upon bodies of reflecting water and for his use of a high horizon line and a static scene to portray the mood of the Nordic summer night. Peterssen's debt to Puvis is even more evident in *Nocturne* (see below), a work of the following year that adds to the *Summer Night* landscape a languid female nude adapted from Puvis's *Autumn* of 1864 (biblio. ref. no. 67, p. 84–86).

The later addition of a nude with Symbolist overtones suggests that *Summer Night* may have meaning beyond the depiction of an idyllic scene from nature. In the literary tradition of treatments of the Scandinavian summer night, there are many examples that include an intimation of death amidst the joy and beauty of the season. In Strindberg's drama *Midsummer* (1900), revelers dance amid gravestones on Midsummer night. Edvard Munch* summed up the influence of his paintings on Ibsen's *When We Dead Awaken* (1899) with the statement that the play takes place "...all in a light summer's night where life and death walk hand in hand" (quoted in Washington, 1978, p. 244). In Peterssen's beautiful, contemplative painting the fallen birch tree and the vigorous tree at the right may symbolize the cycle of the seasons—decay and regeneration.

A second version of this canvas (location unknown; reproduced in biblio. ref. no. 67, p. 77) was done in 1886. There are two other versions of *Nocturne* (1887; Nasjonalgalleriet, Oslo and 1889; Stavanger Faste Galleri). [RH/OT]

Eilif Peterssen
Nocturne 1887
Skogsnymf
200.0 × 250.0
(78¾ × 98½)
Nationalmuseum, Stockholm

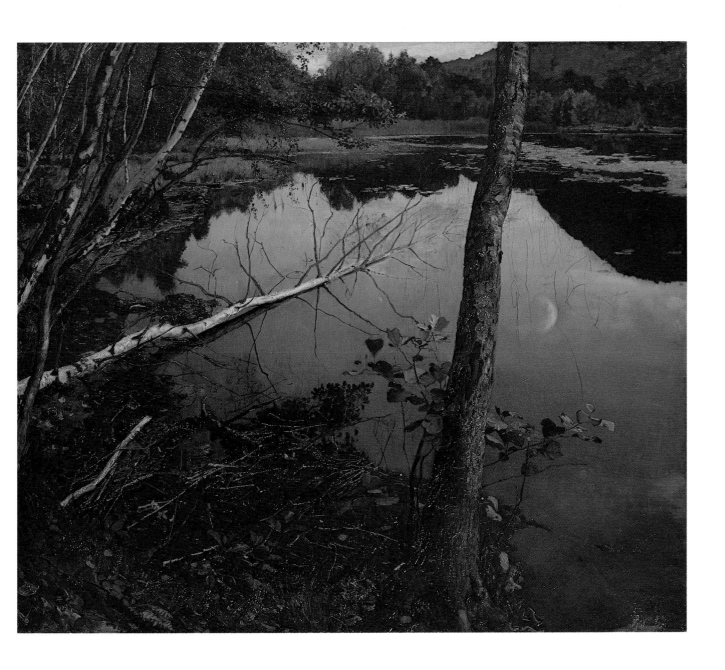

LAURITS ANDERSEN RING Denmark **1854-1933**

Laurits Andersen Ring is considered one of the most important visual chroniclers of peasant life in late nineteenth-century Denmark (Madsen, 1946, p. 360). He adopted the surname Ring in 1896 after the village in southern Sjaelland in which he was born. His father Anders Olsen earned a living as a farm laborer and a wheelwright; his mother was descended from generations of serfs. Ring began an apprenticeship to a housepainter in the nearby village of Praestø in 1869. He helped to restore large estate houses, and it was there that he first saw paintings hanging on the walls. From 1873 to 1877 he lived in Copenhagen, attending classes in the winter and supporting himself as a journeyman painter in the spring and summer. He studied for two years at the technical school and in 1875 entered the Royal Academy of Fine Arts, where he spent six semesters in preparatory drawing classes taught by Frederik Vermehren (1823-1910) and J. A. Kittendorf (1820-1902). He left the academy dissatisfied in December 1877.

Ring returned home and taught himself to paint, beginning in the early 1880s with pictures of his friends and family in interiors. He made his debut at Charlottenborg Palace in 1882 with *The Christmas Visitor* (Den Hirschsprungske Samling, Copenhagen). The following year his father died, initiating a decade of economic and personal hardship during which he lived a transient existence, migrating between Copenhagen and smaller villages nearby. Although he attended Peder Severin Krøyer's* school for four months in 1886, the major influences on his Naturalistic style were the French painters Jules Bastien-Lepage and Jean François Raffaelli. One of his few supporters during these years was the critic Karl Madsen, who advocated the nationalistic subject matter depicted by Ring. They travelled together to France, Belgium, and the Netherlands in 1889. Marriage to Sigfried Kähler in 1896 brought stability to the artist's life and work. His oeuvre is divided according to the periods of residence he spent in various small towns: 1898 to 1902 in Frederiksvaerk, 1902 to 1914 in Baldersbronde, and 1914 to 1933 in Roskilde. Ring outlived his younger wife by ten years and died in St. Jørgensbjerg near Roskilde. [EB]

75
The Lineman 1884
Jernbane vagten
57.0 x 46.0 (22⅜ x 18⅛)
Signed lower left: "L.A. Ring/Juni 1884"
Nationalmuseum, Stockholm

Ring rejected the cosmopolitan art center of Copenhagen and dedicated his life to the unbiased recording of the rural environment he knew best. His self-taught style and unclassical draftsmanship were well suited to depict the primitive conditions of peasant life and the lined faces and bent postures of the tillers of the soil. Like his compatriot and literary counterpart, the novelist Henrik Pontoppidan (1857-1928), Ring neither idealized nor was condescending to the peasants, but simply accepted them. Pontoppidan's novels described the "passionless Danish folk with the pale eyes and timid soul" with a Social Realist's eye: "Thus it had always been in Denmark. One generation after the other grew up red-cheeked and clear-eyed, free-minded and strong; one generation after the other has sunk into the grave, broken, bent, always vanquished" (quoted in J.G. Robertson, "Henrik Pontoppidan," *The Contemporary Review* 117, n. 8, 1920, p. 377).

Ring's subjects included the mundane chores of farm laborers, scenes of families on their way to church, and portraits of the aged and of children born to a harsh existence. In *The Lineman*, however, he moves beyond the expression of a simple genre scene to bare an explicit ideological statement. It is one of the few works in which he represents the changes that the onslaught of modernization brought upon the peasants. Industrial expansion usurped both the land and the role of the rural worker, a transformation depicted in this picture of a peasant working as a lineman. The encounter of the common laborer and the oncoming train creates a symbol of the old way of life versus the new, of wooden shoes against iron track. Although the first railroad appeared in Denmark in 1843, it was not until the last third of the nineteenth century that its effects were felt. Modernity exploded into the consciousness of primitive peasants, and centuries of unaltered existence changed overnight. Here Ring portrays the inevitable confrontation of man and machine. In the stooped shoulders of the lineman there is a sense of resignation and defeat. [EB]

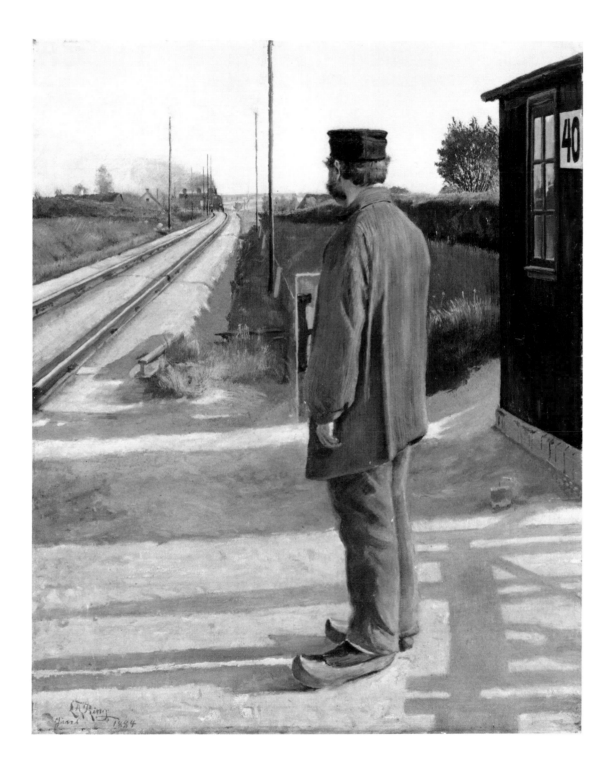

76

Evening. The Old Woman and Death 1887
Aften, den gamle kone og døden
121.0 x 95.0 (47⅝ x 37⅜)
Signed lower left: "L.A.Ring 87"
Statens Museum for Kunst, Copenhagen

Ring strayed from the path of Naturalism during the years 1887 to 1894. His work was tinged with a melancholy Symbolism prompted by the deaths of his father and brother, and by economic and personal insecurity. His preoccupation with death was often manifested in his paintings through subtle analogies between the transience of human life and the cycles of nature. In *Evening*, however, he created an explicit allegory, reviving the Northern medieval tradition of the Dance of Death in a manner similar to Richard Bergh in *Death and the Maiden* (cat. no. 4) and Edvard Munch* in *Death at the Helm* (1893; Munch-Museeet, Oslo). Ring depicts an old peasant woman sitting wearily upon her burdensome load. The approaching end of her life is implicit in the setting sun, the infinite expanse of horizon, and the long road that curves out of sight. Her moment of repose will be cut short by the ghostly specter of Death, which hovers above her, brandishing a scythe. The motif of a peasant woman sitting by the side of the road, surrounded by an evocative landscape, but without the figure of Death, was also used by Munch in his 1888 painting *Evening: Loneliness* (Sigval Bergessen d.y. Collection, Oslo).

Prior to *Evening* Ring worked exclusively in *plein air* and with a light-colored palette. He composed this work however, in the studio, beginning with a study of a skeleton in the atelier of Peder Severin Krøyer*. The reduced tonal range and somber coloration reveal the influence of Vilhelm Hammershøi*, an artist Ring admired greatly and with whom he felt a particular affinity during this introspective period (Hertz, 1935, p. 208).

Ring knew Jean Francois Millet's *The Woodcutter and Death* (Ny Carlsberg Glyptotek, Copenhagen), a similar scene of a peasant's liberation from hard labor by the personification of death. The direct inspiration for Ring's image of an ethereal yet omnipresent thief, however, was Henrik Pontoppidan's tale of peasant life and death entitled *Knokkelmanden*, published in 1887. Like Ring, Pontoppidan presents death as "an ominous shadow in an otherwise straightforward rendering of peasant existence" (Hertz, 1934, p. 208). [EB]

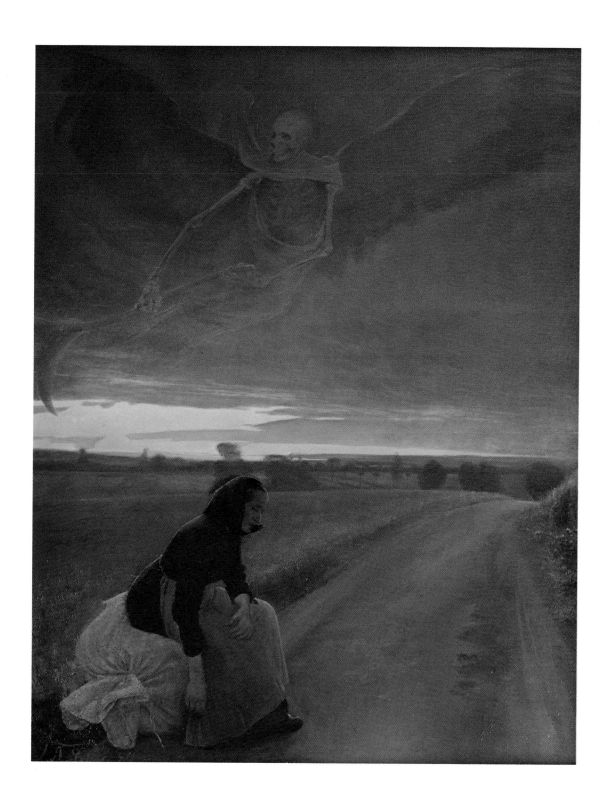

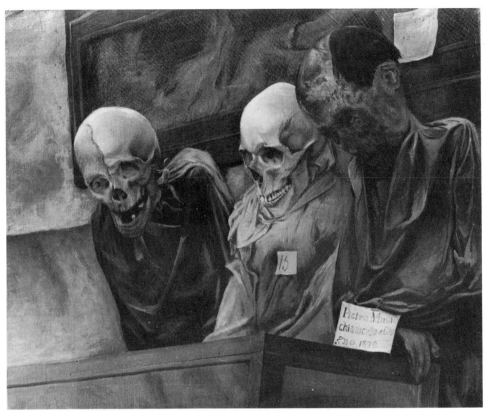

77

Three Skulls from the Convent of the Capuchins at Palermo 1894
Tre dødningehoveder fra Convento dei Cappucini ved Palermo
55.0 x 62.0 (21⅝ x 24⅜)
Signed lower right on box frame: "Palermo 22/2 1894/L.A.Ring"
Statens Museum for Kunst, Copenhagen

In October 1893, using his meager savings and money from the sale of a few paintings, Ring made his first trip to Italy. Just as he had done on his trip to France, Belgium, and the Netherlands in 1889, the self-taught Ring took the opportunity to paint copies of old masters—Hans Memling, Hans Holbein, and Filippo Lippi (biblio. ref. no. 21, p: 552). He also continued his focus on peasant life by painting scenes from villages in southern Italy.

Pieter Bruegel the Elder's *The Parable of the Blind* (1568; National Museum, Naples) made a particular impression on Ring, and he copied it while in Naples. Both the peasant figures and the theme of life's futility appealed to him, and inspired the idea of a large programmatic painting devoted to the Dance of Death—a plan he never realized. At the same time he read about the catacombs at the convent of the Capuchins in Palermo, where bodies of men, women,

and children, having been left in a sealed room for six months to partially desiccate, were stacked and displayed in separate rooms, each skeleton identified by a tag with its name and occupation (Hertz, 1934, p. 274).

Ring travelled to the convent to depict this grisly apparition, an image laden with moral implications. In the painting, he views the skeletons of three monks (identified by their tags) at close range from below, forcing confrontation with the gruesome spectacle. The bodies are in different stages of decomposition; the one on the right still retains its skin and hair. He appears as a mute corpse, while those beside him laugh and leer, reminding viewers of their own inevitable fate.

Although depicted in a highly realistic style, *Three Skulls* shares a mocking tone and macabre theme with James Ensor's expressionist distortions of faces, masks, and skulls in such images as his *Masks and Death* (1897; Musée des Beaux-arts, Liège). [EB]

HELENE SCHJERFBECK Finland 1862–1946

Helene Schjerfbeck has a unique position in Finnish art. Although ill health ultimately forced her into the life of a recluse, she was nonetheless an important exponent of Scandinavian internationalism and an essential participant in the orientation of Finnish art towards Paris in the 1880s. Born in 1862, Schjerfbeck began her art training at the age of eleven at the Finnish Artists' Association and later continued at Adolph von Becker's private academy from 1877 to 1880. Her work from this period embraced a wide range of subjects, including scenes from Finnish history. Except for this early treatment of historical subjects, however, her art was never again involved with a demonstration of nationalistic values.

In the early 1880s Schjerfbeck won a number of different national fellowships that permitted her to work and study abroad. She was in Paris from 1880 to 1882 and again in 1883 and '84, studying under Léon Bonnat, Jean Léon Gérôme, Gustave Courtois, and Pascal Dagnan-Bouveret. The intervening year, 1882–83, she spent at the academy in St. Petersburg, where she studied under the Russian academician Chistyaku. The most significant influences on her art in the 1880s were Jules Bastien-Lepage and, later, Pierre Puvis de Chavannes. Like many art students of her generation, she was impressed by Bastien-Lepage's entries in the Salons of 1880 and '81, and she studied briefly with him during these years. The free handling and candor of her painting *The Convalescent* (1888; Ateneumin Taidemuseo, Helsinki), which was exhibited at the Paris World Exposition of 1889, attest to this association. In 1889, the year that Puvis de Chavannes broke with the official Salon and founded the Salon du Champs du Mars, Schjerfbeck studied at his atelier and began to explore the principles of reduction and simplification in the creation of an expressive mood.

The 1890s were not very productive for Schjerfbeck. Except for travel to Paris, St. Ives, and Italy in 1889–90, and to Vienna and Italy in 1894, she concentrated her energies on teaching at the Finnish Artists' Association. In 1903 she retired from Helsinki to the rural sanctuary of Hyvinge. The restrained, ascetic color characteristic of her work at the beginning of the century (which was at least partially inspired by Puvis de Chavannes, James McNeill Whistler, and Vilhelm Hammershøi*) gradually became bolder and more luminous. This development is particularly apparent in the remarkable series of self-portraits she produced until her death in 1946. [SMN/SSK]

78
The Seamstress 1903
Ompelijatar (Tyoelaeisnainen)
95.5 × 84.5 (37⅝ × 33¼)
Signed lower left: "H S 1903"
Ateneumin Taidemuseo, Helsinki

The austere simplicity and linear elegance of *The Seamstress* attest to Helene Schjerfbeck's involvement with the Classicizing goals of James McNeill Whistler, Pierre Puvis de Chavannes, and the Pre-Raphaelites. However, the limited aesthetic of abstract Classicism failed to satisfy Schjerfbeck. Certainly *The Seamstress* is related in means and intent to Whistler's work of the 1870s, particularly such single-figure portraits as *Arrangement in Grey and Black No. 1: The Artist's Mother* (1872; Louvre, Paris), which Schjerfbeck would have seen at the Salon of 1883. But the strength and pathos of *The Seamstress,* the subject's more concentrated pose, and the greater angularity of the faceting of facial planes are quite different from Whistler's compartmentalized spatial elegance.

Schjerfbeck often reworked the same composition into several versions in her search for a reduction of formal means and a concentration of psychological expression. She ultimately confined herself to a narrow range of female subjects at a time when the issue of women's rights, status, and identity was crucial. Although *The Seamstress* is related to an iconographic tradition in Victorian painting that depicts the appalling condition of female employment, it is neither narrative nor didactic. This isolated woman projects a sense of woman's strength complete within herself. [SMN/SSK]

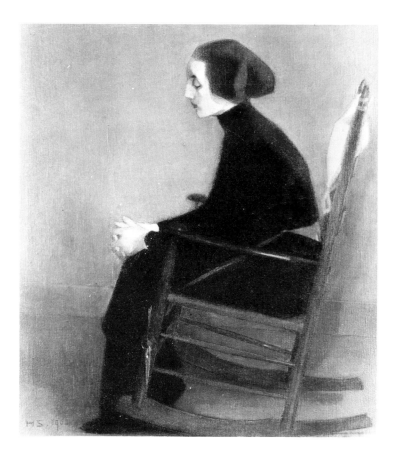

HARALD SLOTT-MØLLER Denmark 1864–1937

Harald Slott-Møller, a leader in Danish painting and decorative arts and a founding member of the Free Exhibitions, experienced meteoric success in the 1880s as a Naturalist, only to turn in the 1890s to an idiosyncratic Symbolism that led to the eventual decline of his reputation. This path closely paralleled the career of his influential friend Jens Ferdinand Willumsen (1863–1927).

Slott-Møller attended Copenhagen's Royal Academy of Fine Arts from 1881 to 1883. Dissatisfied with the academy's conservatism, he entered the Artists' Study School and left three years later as Peder Severin Krøyer's* leading student. The eminent critic Karl Madsen followed his career from his debut at the 1886 exhibition in Charlottenborg Palace. With the unveiling of *The Poor: The Waiting Room of Death* in Copenhagen's Great Northern Exhibition of 1888, he was hailed as the leading Naturalist painter of his generation.

In May of 1888 Slott-Møller married Agnes Rambusch (1862–1937), a fellow artist from Krøyer's school. They travelled to Italy in the winter of 1888–89

and were immediately entranced by Trecento and Quattrocento painting. Harald reacted strongly against Naturalism after 1890, impelled by three factors: the medievalizing tendencies of his wife's painting, the spiritual qualities he perceived in Italian art, and the pilgrimages he made to London in 1896–97, 1899, and 1900 to view the work of Dante Gabriel Rossetti. Further trips to Italy and his association with the Grundtvigian religious movement strengthened his conviction about spiritual, stylized painting. In 1917 he published his theories in *Kunstens Kilder (The Sources of Art;* Copenhagen: H. Hagerup Forlag), stating his belief in the sovereign influence of Christianity on art.

In the 1890s Slott-Møller was a sought-after portraitist and a strong proponent of the Neo-Romantic artisans' movement, engaging in bookbinding, wall decoration, jewelry design, ceramics, and furniture decoration. After 1910, the Slott-Møllers isolated themselves personally and artistically, continuing to paint in a Pre-Raphaelite-derived style until their deaths in 1937. [PGB]

79

The Poor: The Waiting Room of Death
1888
Fattigfolk. I dødens ventevarelse
131.0 × 184.5 (51½ × 72⅝)
Signed lower left: "Slott-Møller"
Statens Museum for Kunst, Copenhagen

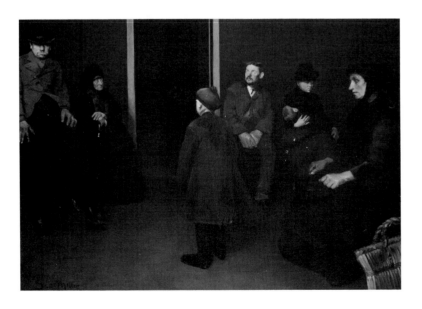

Harald Slott-Møller painted this gripping and controversial painting as a response to social conditions in Copenhagen. In the late 1880s the peasantry, migrating to the city from their native countryside, confronted unemployment and wretched living conditions in the rapidly expanding Danish capital. Concurrently, Copenhagen became an important center for socialist ideology. Such radical periodicals as Edvard Brandes's *Politiken* and Louis Pio's *Socialistiske Blade* were published there, and Brandes's brother Georg preached social commitment from the lecterns of the university (see cat. no. 80).

By focusing his artistic sensibilities on the urban poor, Slott-Møller was an anomaly in the generation of Naturalist painters trained under Peder Severin Krøyer*—a group primarily concerned with rediscovering the people and places of the picturesque Danish countryside. In the late 1880s Erik and Frants Henningsen were among the few urban genre artists working in Denmark, creating anecdotal illustrations for Copenhagen newspapers akin to Jean François Raffaelli's *Les Types de Paris* of 1889. Although influenced by the Henningsens' sentimentalized reportage, Slott-Møller's painting rejects the anecdotal and picturesque in favor of a didactic social Realism fused with morbid symbolic content.

In a monumental allegory of urban psychic despair, Slott-Møller portrays a group of indigents passively awaiting death. They are spiritually as well as materially impoverished, stripped of volition and dignity as they sit in an anonymous, stark room in static attitudes of introspection. The door at the center of the composition reveals a figure of Death personifying the aphorism "Death is the poor's only doctor." The figure emerges from impenetrable darkness, beckoning to the ragged boy already responding to his call.

Slott-Møller seems to have felt that the figure of Death was too literal and evident, and partially painted

it out. This symbolic element in *The Poor,* related to such images as Jean François Millet's *The Woodcutter and Death* (1859; Ny Carlsberg Glyptotek, Copenhagen) and Laurits Andersen Ring's *Evening. The Old Woman and Death* (cat. no. 76), was criticized at the 1888 Great Northern Exhibition. "This *memento mori,*" said one critic, "is completely misplaced and carries with it no more mysticism than a poison label on a pharmacy bottle."(*Ny Jord,* 1888, p. 383, quoted from Peter Michael Hornung, *Skildringer af Bønder, fishere og byproletariat, i perioden fra Realismens gennembrud til tiden omkring Første verdenskrig,* M.A. thesis, University of Copenhagen, 1981)

As a combination of social Realism, psychological alienation, and morbid allegory, this painting stands midway between such urban-critical pictures as Christian Krohg's* *Albertine in the Police Doctor's Waiting Room* of 1887 (see page 63) and such fully realized Symbolist images as Edvard Munch's* *Death in the Sick Room* of 1893 (both in the Nasjonalgalleriet, Oslo). [PGB/KM]

80
Georg Brandes at the University of Copenhagen 1890
George Brandes i Københavns Universitet
94.5 × 82.0 (37⅜ × 32¼)
Signed lower left: "Harald Slott-Møller"
Det Kongelige Bibliotek, Copenhagen

Georg Brandes at the University of Copenhagen was the first and most riveting of Slott-Møller's portraits of leading personalities. As in his psychologically probing 1907 portrait of poet Helge Rode (National Museum, Frederiksborg), he typically painted his sitters in outdoor settings, subsuming them into a symbolic relationship with their landscape. The portrait of the critic Brandes, one of Denmark's foremost intellectuals, places him in his own milieu at the podium of a university lecture hall.

Slott-Møller began attending Brandes's famous lectures at the university while studying under Peder Severin Krøyer* at the Artists' Study School. He was strongly influenced by Brandes's aesthetic, social, and literary theories (see Sven Møller Kristensen's essay beginning on p. 52), which were reflected in *The Poor: The Waiting Room of Death* (cat. no. 79). Brandes, involved in the Danish artistic community, developed a friendship with Slott-Møller that gave the young artist insight into the scholar's personality.

Slott-Møller's portrait captures the pathos rather than the greatness of Brandes, who, despite his international reputation, was nonetheless the target of anti-Semitic sentiment. Viewed from below, as if by a member of the university audience, he appears vulnerable and is dwarfed by the looming podium and overhead light fixtures. Instead of ennobling Brandes's features, the raking light emphasizes the sensitive furrowing of his brow and the dark recesses under his eyes.

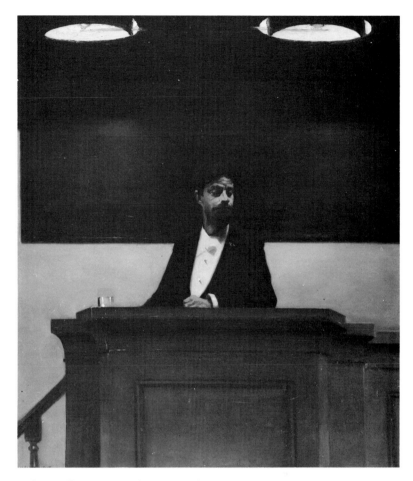

Slott-Møller's portrait of Brandes and Eero Järnefelt's *Portrait of Professor Johan Philip Palmén* (cat. no. 44), both of 1890, represent polar opposites within a shared goal of *portrait de milieu*—defining the sitter by his environment. Järnefelt's highly decorative, synthetic style enriches Palmén's portrait through its color, movement, and delightful spatial ambiguities. Slott-Møller, on the other hand, rigorously simplifies his palette and compositional elements to evoke a stark, sympathetic reading of Brandes.

The reduced, severely ordered composition and high degree of stylization in the Brandes portrait create an interesting parallel to the work of the Parisian artist Félix Vallotton (1865–1925). Slott-Møller's bold use of black paint, especially praised by critic Karl Madsen, was a precursor of Vallotton's paintings and woodcuts of the later nineties. Travelling the same road toward graphic simplicity in 1890, Vallotton would begin a prolific outpouring of woodcuts in 1891, while Slott-Møller turned, in the same year, to Romantic Italian landscape painting, leaving behind the moody palette and simplified means of the Brandes portrait. [PGB]

HARALD SOHLBERG Norway **1869–1935**

Harald Sohlberg was born in Christiania, the son of a prosperous fur merchant. In 1885, at his father's request, he was apprenticed to a decorative painter, enrolling in the Royal Academy of Drawing at the same time in order to learn the skills necessary for his new profession. In 1890 he became the private pupil of Sven Jorgensen, an eminent painter of rustic scenes. From the beginning Sohlberg revealed a profound and highly original feeling for landscape. Throughout most of 1891 he worked alone in nature, first at Nittedal, a rural retreat north of the capital, and then during the summer at Ostre Gausdal, where with Thorvald Erichsen (see cat. no. 16) he experimented with Pointillism.

In the autumn of 1891 Sohlberg joined a group of young painters, including Halfdan Egedius*, who were working under the supervision of Erik Werenskiold and Eilif Peterssen*. During this period his feeling for the symbolic power of landscape began to mature. He then studied briefly at Kristian Zahrtmann's school in Copenhagen, returning in late May of 1892 to Christiania, where he remained for the next three years. At this time he attended both the Royal Academy of Drawing and Harriet Backer's* school of painting, and was often in the company of Egedius, Gustav Vigeland, and Ludwig Karsten. In 1894 he exhibited his first major canvas, *Night Glow* (Nasjonalgalleriet, Oslo), at the state exhibition of art, where it made a profound impression on his contemporaries, particularly Jens Thiis. He was subsequently awarded a scholarship to study in Paris in 1895–96 and then at the Beaux-Arts Academy in Weimar, where he concentrated on landscape painting under his compatriot Fridtjof Smith.

Sohlberg married in 1901 and lived with his wife in the mountains of central Norway. There he began his major canvas *Winter Night in the Rondane* (1914; Nasjonalgalleriet, Oslo). After living in the bleak copper mining town of Røros from 1902 to 1905, he returned to Paris for four months during 1906 and then settled in Kjerringvik, a small village on the Christianiafjord. In 1910 he moved to Christiania permanently and spent the year 1913–14 completing *Winter Night in the Rondane*, which was exhibited at the Norwegian Jubilee Exhibition of 1914 and San Francisco's Panama Pacific Exhibition of 1915, winning a gold medal at both. He continued to paint the eastern and central uplands of Norway until his death in 1935. [SMN/MM]

Niels Emil Severin Holm
View of the
Straits of Messina
from a Country House
1859
82.0 × 132.0 (32¾ × 52)
Museum of Fine Arts, Boston
Arthur Gordon Tompkins
Fund

Painted decades earlier by a little-known Danish artist, this juxtaposition of a just-abandoned domestic terrace and a beckoning Sicilian vista has an uncanny similarity to Sohlberg's *Summer Night*. Representing two sides of the Scandinavian imagination—the opposing lures of Mediterranean sunlight and Nordic evening—these pictures demonstrate the persistence of Romantic viewpoints, and the special intermingling of crisp Realism and poignant moodiness, in Northern painting of the nineteenth century.

81
Summer Night 1899
Sommernatt
114.0 × 135.5 (44⅞ × 53¼)
Signed lower right: "Sohlberg/1899"
Nasjonalgalleriet, Oslo

Summer Night, a vast and silent landscape painted from the balcony of a house high on the Nordestrand ridge southeast of Christiania, is the culmination of Sohlberg's aspirations throughout the 1890s. In certain ways it is a restatement of *Night Glow* (Nasjonalgalleriet, Oslo), the painting with which he made his debut in 1894 and which also depicted the power and intensity of the Nordic summer night. *Summer Night* is, however, more complex than any of Sohlberg's earlier works. It is a painting of hidden worlds and unfolding mysteries. The deserted gala table for two is set within a frame of flowers behind which the opened veranda door reflects the endless panorama of woodland, fjord, island, and hills. The tension between the meticulous foreground detail and the broad washes of the immense landscape beyond reveals the underlying separation between two different realms of experience—the intimate and the transcendental. Sohlberg's dialogue of near versus far (or human versus natural) characterizes a Romantic attitude towards nature and "contrasts what [August Wilhelm] Schlegel called the 'poetry of possession'—the intimate interior—with the 'poetry of desire'—the tempting space outside" (L. Eitner, "The Open Window and the Storm-Tossed Boat," *Art Bulletin*, 36, 1955, p. 286).

Although *Summer Night* is devoid of human presence, the table set for two and the abandoned hat and gloves of a woman contribute to an atmosphere of silence in which the presence of the departed lovers still echoes. The painting resounds with the solemnity of a ritual just completed and, in fact, is thought to commemorate the evening of Sohlberg's engagement. The details of the hat and gloves amplify the summer night's palpable sense of mystery as well as its association with love, courtship, and awakening sexuality. Their abandonment suggests both the culmination of the evening and a haunting sense of transience. Such undercurrents of eroticism link *Summer Night* with the personal dream quality of Edvard Munch's work of the early 1890s, particularly *Summer Night's Dream (The Voice)* of 1893 (cat. no. 66). Yet Sohlberg stressed the decorative potential of his subject in a manner quite different from Munch. The thinly laid colors—glowing blues, whites, reds, and blacks—and the severe, compact lines of *Summer Night* recall lustrous enamels or glass mosaics.

The motif of the terrace was so important to Sohlberg that he began a large oil of the same location in winter. He never completed this other work, however, and only a large oil study exists (Nasjonalgalleriet, Oslo). There are no signs of festivity in the deserted winter scene, and the suggestion of transience, or even death, that is just hinted at in *Summer Night* there becomes more overt. [SMN/MM]

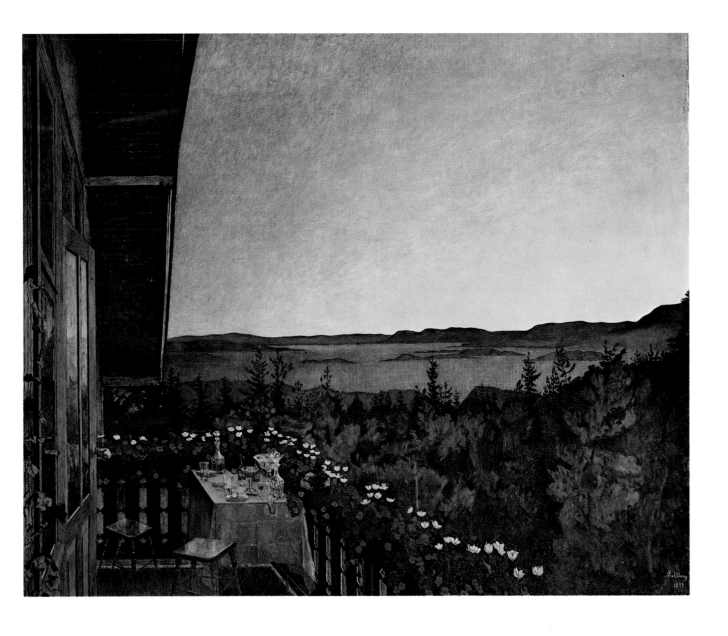

82
Night 1904
Natt
113.0 × 134.0 (44½ × 52¾)
Signed lower right: "Sohlberg/Røros 1904"
Trøndelag Kunstgalleri, Trondheim

In March 1902 Sohlberg and his wife moved to the small Norwegian copper mining town of Røros, high on the mountain plains, where they remained for the next three years. Sohlberg chose Røros because of his desire to paint an industrial setting, a motif that had interested him since 1897–98 when he painted *From a Working District in Christiania* (destroyed, but an oil study survives in the Nasjonalgalleriet, Oslo). He found his subject almost immediately in the late-Baroque church that dominated the stark town.

The Norwegian novelist Johan Falkberget, who was also living in Røros at about this time, described the church's sad and desolate graveyard as a desert of bleak sand, small stones, and rusty crosses. In *Night* it is depicted, in Sohlberg's words, as a "frontier between the abodes of the living and the dead." Towering over the countless crosses of the cemetery, the church itself is frontal and strictly centralized, a compositional manipulation altering its actual position. Just behind the church stand rows and rows of humble miners' cottages enveloped by the velvety dusk. The red flowers placed on the freshly dug grave in the foreground are the only bright spots of color—in the artist's words, "a contrast to everything forgotten and decayed." The entire composition is a monument to the generations of hardworking people and their long-forgotten dead.

When Sohlberg first began working on this painting, he was touched by events that forced him to think about death. In the late fall of 1902 he was called to his mother's deathbed, and soon afterwards news came that his younger brother, Einar, had been killed in the Boer War. Since he had never before experienced the death of anyone close to him, these two losses were especially shocking.

Although *Night* developed slowly through various phases, there is only one extant sketch (Nasjonalgalleriet, Oslo). It is such a complicated composition, and Sohlberg generally worked with so many preliminary studies, that it seems reasonable to assume that several others have disappeared or been destroyed. Dated 1903, this one oil sketch appears to have been painted on location and closely resembles the finished work. Another drawing, a photo of which turned up in Sohlberg's papers, also includes all of the elements of the final version except the open grave covered with flowers, which is outlined but not completed (Arne Stenseng, *Harald Sohlberg*, Oslo, 1963, pp. 71–72).

The churchyard was a popular German Romantic motif, and it appears frequently in the work of Caspar David Friedrich (1774–1840), often with the open grave. Similarities between Sohlberg's work and Friedrich's include the tendency towards a symmetrical, centralized distribution of forms with hieratic and pantheistic overtones, as well as tension between intimate and cosmic dimensions. Friedrich had been rediscovered at the turn of the century by the Norwegian art historian and critic Andreas Aubert, whom Sohlberg had come to know in 1895–96 while living in Paris, and with whom he corresponded until 1906 (Stenseng, 1963, p. 218). In studies of Johan Christian Dahl in 1893 and 1894 Aubert had treated Friedrich extensively, and Sohlberg would certainly have seen any number of works by Friedrich during his year in Germany. [SMN/MM]

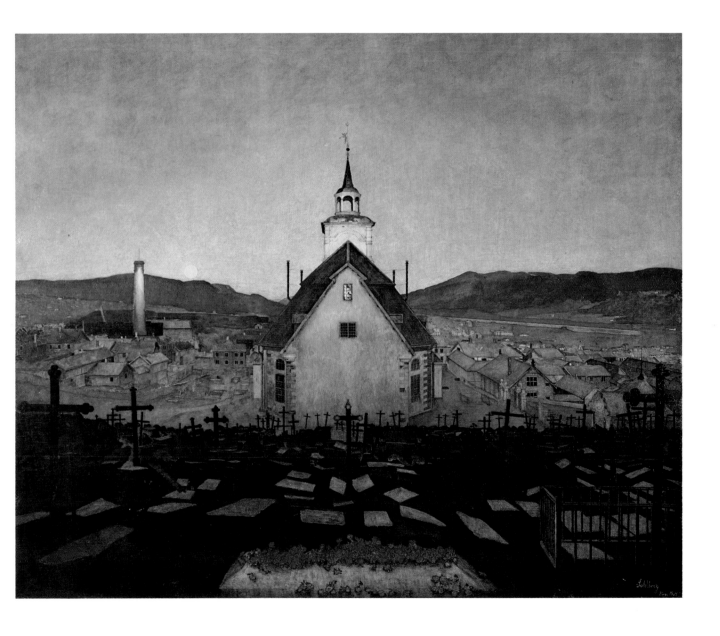

83

Flower Meadow in the North 1905
En blomstereng nordpå
96.0 × 111.0 (37¾ × 43¾)
Signed lower right: "Sohlberg/05"
Nasjonalgalleriet, Oslo

In the summer of 1904 Sohlberg and his wife moved several miles north of Røros to the farm Gullikstad. There Sohlberg painted two of his most important works—*Flower Meadow in the North* and *The Highway* (Carsten Lyng, Oslo). Seen together, these paintings form an interesting dialogue about the pastoral beauty of rural life and the insidious onslaught of "progress." *Flower Meadow* is a paean to the untouched landscape of the north country. The only signs of human presence in this immense sea of marigolds are the house and barn on the far left, which are submerged in the grandeur of nature. *The Highway* is far more dramatic. The landscape is no longer serene but glows with vivid color and is cut by telephone poles on the desolate road—symbols of the industrialization that had long interested Sohlberg and had prompted his initial work at Røros.

Flower Meadow has the jewel-like intensity and magic Realist quality of Sohlberg's earlier canvases. The precise rendering of the marigolds in the foreground is extraordinary, as is the abrupt shift to the generalized, softened landscape forms in the distance. This tension reveals the same interpretation of nature previously seen in *Summer Night* (cat. no. 81) and *Night* (cat. no. 82) but without the more obvious symbolic references included in those earlier works. Here nature is enveloped in a hushed, reverent silence. The simplified and symmetrical composition—which Sohlberg also explored in *Night* and is characteristic of his work after 1900—has distinct religious implications, although there is no longer a church at the center as in *Night.*

When Sohlberg ended his immensely productive Røros period and left Gullikstad in November 1905, *Flower Meadow,* for which he had made many studies from nature, was not yet completed. He arranged to have the canvas sent to him in France and there finished some of the details. The painting was exhibited in the annual Autumn Exhibition in Christiania in 1906 and received much critical acclaim. [SMN/MM]

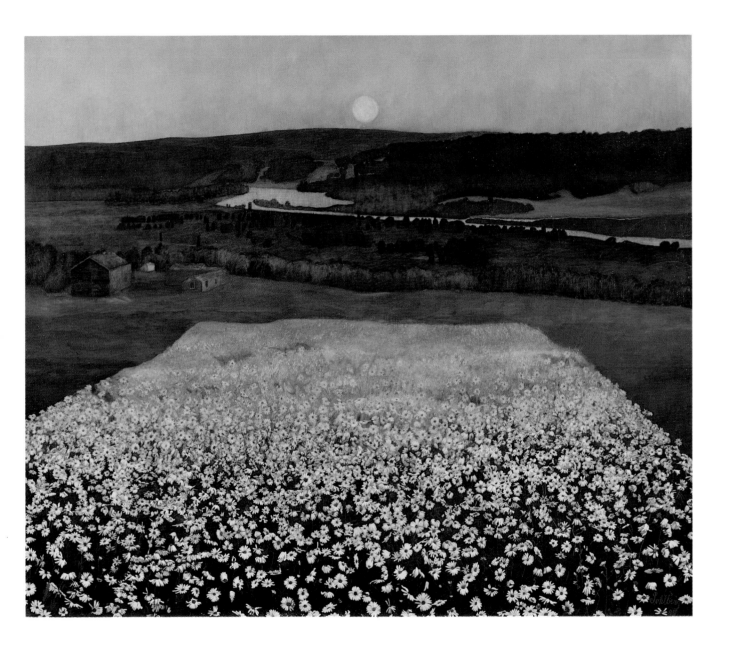

LOUIS SPARRE Finland 1863–1964

Count Louis Sparre was born at the Villa Teresita in Gravellona, Italy, of a Swedish father and an Italian mother. In 1875 he was sent to school in Sweden. Although he had originally intended to become an architect, after a year at Stockholm's Royal Academy of Fine Arts (1886–87), he went to study painting at the Academie Julian in Paris. There he met Paul Sérusier, Pierre Bonnard, and Maurice Denis, as well as a number of Scandinavian artists. One in particular, the Finn Akseli Gallen-Kallela* (then known as Axel Gallén), became a close friend and strongly influenced the direction of his work.

Sparre studied in Paris until the summer of 1889, when he travelled with Gallen-Kallela to Visuvesi and Keuruu in the backwoods border region of Finland called Karelia. He returned to Karelia the following year, joining Gallen-Kallela and his wife Mary Slöör on their honeymoon. In exploring both sides of the Finnish-Russian border, the three studied Karelian customs, utensils, and costumes. Sparre later wrote and illustrated a book about these trips entitled *Bland Kalevalafolket ättlingar* (1930, Porvoo).

In 1891 Finland became Sparre's adopted homeland. Settling close to Helsinki, in Porvoo, he married Eva Mannerheim, a bookbinding designer and the sister of the Finnish soldier and statesman Baron Carl Gustaf Emil von Mannerheim. The couple collaborated on such projects as an edition of Johan Ludvig Runeberg's *The Elk Hunters* (1892), for which Eva designed the leather binding and Louis provided the etchings. During Sparre's years in Finland, painting became secondary to him, as he became increasingly involved with decorative arts. He shared with Gallen-Kallela a passion for Finnish folk art, and together they moved to create a fine art based on these traditions.

In 1896 Sparre travelled in the Netherlands, Belgium, France, and England. The English Arts and Crafts movement, especially William Morris's ideas on functional aesthetics, had a great effect on him, and in London he visited such centers of decorative arts as Liberty's. The following year he established the Iris workshop in Porvoo, with the stated intention of producing beautiful and functional furnishings in modernized versions of traditional Finnish designs.

In 1898 Sparre persuaded A.W. Finch, an important advocate of the Arts and Crafts Movement, to run the ceramics department at Iris. Finch, who had abandoned painting in 1890 to devote himself to decorative arts and was a founder of the Belgian group *Les Vingt,* provided the workshop with a more international element.

The establishment of Iris was pivotal to the development of both Finnish and Scandinavian decorative arts and design in the twentieth century. At the Paris World Exposition of 1900, the Finnish Pavilion included an Iris room that contained ceramics made by Finch and furniture designed by Sparre and Gallen-Kallela after traditional national forms and decorations. Critics praised Sparre's productions for combining naturalism and "honesty" with international elements and styles. Years later a French minister offered France's aid to Sparre's brother-in-law Baron

von Mannerheim during the campaign for Finnish independence from Russia, explaining that he had been so profoundly impressed by the pavilion of 1900 that he had never forgotten Finland.

Like William Morris, Sparre never created for "the people" and never gave much thought to expense. By 1902 Iris was in such financial difficulty that it had to be closed. Although Sparre continued to design furniture and decorative objects until his departure for Sweden in 1908, he devoted himself primarily to painting for the rest of his long life. [WPM/SSK]

84
First Snow 1891
Ensi Lumi
90.0 × 111.0 (35½ × 43¾)
Signed lower left: "Louis Sparre/1891"
Ateneumin Taidemuseo, Helsinki

First Snow was painted at Rimmi Farm in Ruovesi, on the shore of Lake Helvetinjärvi. The painting originally included a male figure outside the window and was entitled *Dinner.* Sparre's alterations to the scene, perhaps made in response to criticisms by his fellow Finnish artist Albert Eldelfelt*, signal his reorientation from Realist preoccupations toward a greater concern with mood and inner life.

The scene appears to have been initially conceived, like Sparre's early paintings of the border area of Karelia, as a quasi-documentary study of the crafts and customs of the Finnish peasantry. However, in eliminating the more legible narrative of the first version, and in concentrating on the foreboding of winter's onset, Sparre focused not on external aspects of the culture but on the psychological resonances of life lived close to the rhythms of nature.

At the beginning of the long winter, in an oppressively dark interior, the family members are shown not huddled together for mutual support and security, but withdrawn into separate cells of stunned silence. The subject of death in nature's cycle, the breakdown of interpersonal communication, and the concentration on the alienating privacy of instinctual inner states mark *First Snow* as a departure from the more straightforward enthusiasm with which Sparre and his countryman Akseli Gallen-Kallela* first approached rural life. [WPM/SSK]

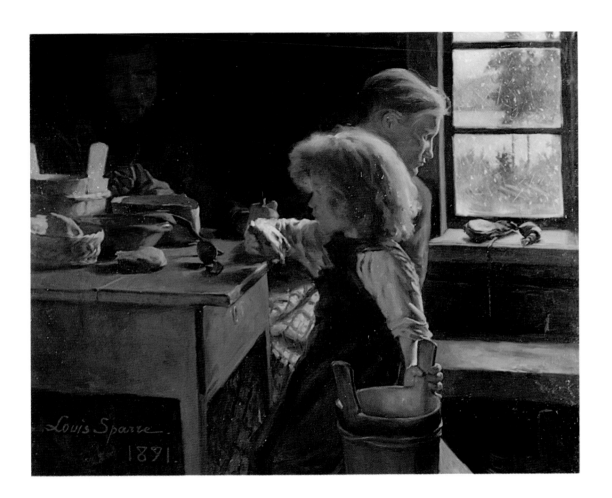

ELLEN THESLEFF Finland 1869–1954

In Finland during the latter decades of the nineteenth century, women artists could pursue their careers without the strictures that were still prevalent, for example, in the French academic system. As a result, Ellen Thesleff's career began like that of most Finnish artists of her generation. Her earliest instruction was at Adolph von Becker's academy from 1885 to 1887, followed by two years of study at the Finnish Artists' Association. Dissatisfaction with the limits of academic training led her to private instruction at the art school of Gunnar Berndtson (1854–1895), where from 1889 to 1891 she was introduced to the principles of French Naturalism and *plein-air* painting that Berndtson had assimilated in Paris during the 1880s.

Thesleff studied in Paris at the Academie Colarossi under Gustave Courtois and Pascal Dagnan-Bouveret from 1891 to 1893. As early as 1892, in the painting *Thyra Elizabeta* (private collection, Helsinki), she began to gravitate towards Symbolism, perhaps under the influence of the Finnish painter Magnus Enckell (1870–1925), who seems to have been the spiritual leader of the young generation of Finnish-Swedish artists then in Paris. Parisian mysticism, particularly the ideas of Sâr Péladan and Édouard Shuré, were of great importance to her at this time. She admired the frescoes of Pierre Puvis de Chavannes, Leonardo Da Vinci, and Sandro Botticelli, and the black and gray tonality of Eugène Carrière in her development of a monumental decorative style which, like that of her countrywoman Helene Schjerfbeck*, was not in the service of National Romanticism.

In 1894 Thesleff travelled to Italy, which she would later refer to as her spiritual homeland, and to which she returned frequently throughout the early twentieth century. Influenced by the Swiss painter Arnold Böcklin and by the work of the Quattrocento Florentine masters, her art developed a refined color lyricism. Although she began to introduce greater color contrast and freedom into her landscapes after 1910, her portraits retained the ascetic tonality, the values of balance and permanence, that she had embraced in the 1890s when Symbolism first led her to a harmonious Classicism. [SMN/SSK]

85
Spring Night 1894
Maisema, Kevätyö
38.0 x 46.5 (15 x 18¼)
Signed lower left: "E.T./94"
Ateneumin Taidemuseo, Helsinki

Spring Night, a small landscape painted near the artist's summer house in rural Finland, was shown at the 1894 Exhibition of Finnish Artists, which introduced Symbolism to the Finnish public and also included Akseli Gallen-Kallela's *Symposion* (cat. no. 26). Painted after Thesleff's years in Paris under the influence of James McNeill Whistler, Pierre Puvis de Chavannes, and French Symbolism, *Spring Night* begins to move from the description of a fragment of nature to an overall evocation of mood.

As in Kitty Kielland's *After Sunset* (cat. no. 50), the treatment of landscape has become more synthetic and less a transparent depiction of reality. Motivated by a feeling of great intimacy with nature, Thesleff renews the spirit of Romanticism with her personal expression of the mood of awakening spring. The silvery gray harmonies of the quiet and deserted landscape resonate with mysterious light, against which the dark tree branches form a screen of delicate, yet emphatic verticals connecting foreground and background.

The subtle nuances of tone and form and the use of an evening motif were common in the idealistic mood landscapes of the 1890s in Finland. A similar type of lyrical landscape painting, based on a yearning to be close to the land, occurred throughout Northern Europe at this time, particularly in the German artists' colonies in Worpswede and Munich. [SMN]

86
Violin Player 1896
Viulunsoittajatar
40.0 x 43.0 (15¾ x 17)
Signed lower right: "E. Thesleff 96"
Ateneumin Taidemuseo, Helsinki

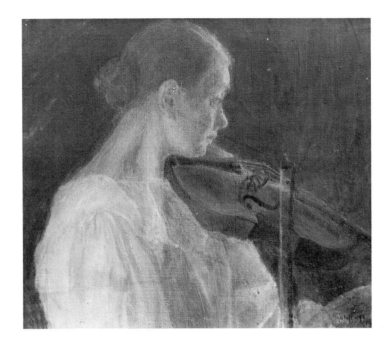

The Mediterranean idealism embraced by Sâr Péladan in his reviews of the Paris Salons in the 1880s and in his creation of the Salon de la Rose + Croix in 1892 called for "beauty, nobility, and lyricism." In response to this Classicizing impulse in French Symbolism, Ellen Thesleff painted *Violin Player* in 1896, two years after her first journey to Italy. As did her contemporaries Pekka Halonen* and Magnus Enckell, Thesleff often used the motif of the violin player during this period, particularly in her portraits of her sisters. This motif recalls the Symbolist notion of correspondence between the visual arts and music. The image of a woman lost in the music of her violin also suggests the later nineteenth-century association between sound and the inner consciousness.

The Violin Player is closest to the Intimist themes and soft modelling of Eugène Carrière. By the end of the 1880s Carrière had evolved from Naturalism and was focusing his attention on monochromatic mists. His reintroduction of sfumato drew praise from critics and created a sense of mystery in the dissolution of form which greatly appealed to the younger generation of Finnish painters. Although Thesleff renounced color in *Violin Player*, the refined contours of the figure still emerge from the shadowed and generalized ground in a manner reminiscent of Carrière's belief that art should reflect, through the harmony of lines and colors, a more elevated spiritual reality.　[SMN/SSK]

THÓRARINN B. THORLÁKSSON Iceland 1867–1924

Thórarinn B. Thorláksson, who became his country's pioneering artist, lived in northern Iceland until he moved to Reykjavík in 1885. There he studied bookbinding and from 1887 to 1895 served as head of a bookbinding factory. Though professional painters were unknown in Iceland at that time, he attended drawing classes with Thóra Pétersdóttir Thoroddsen and in 1895 travelled to Copenhagen to begin studies at the Danish Royal Academy of Fine Arts. He later left the academy to study in the private school of Harald Foss (1843–1922), a landscapist who worked in the tradition of Danish painting of the 1840s. Upon his return to Reykjavík in 1900, he had his initial showing, the first exhibition by an Icelandic artist ever held in Iceland.

In 1903 Thorláksson married Sigrídur Snaebjörnsdóttir. He began to teach drawing in 1904 at the newly founded technical school and served as headmaster from 1916 to 1923. From 1912 on he also owned a book and stationery shop. Meantime he was active in promoting his art and the art of his countrymen, both at home and abroad. In November 1910 he and Ásgrímur Jónsson* participated in an exhibition at Blomquist's in Christiania: Thorláksson showed eighteen works; Jónsson, fourteen. With Matthías Thórdarsson, the director of Iceland's National Museum, Thorláksson founded the Art Association (Listvinafélag) in Reykjavík in 1916. He also was instrumental in the establishment of Listvinahús, the first exhibition hall in Iceland. Although the still Icelandic landscape provided him with subject matter for the majority of his works, he painted interior scenes, still lifes, and portraits as well. [RH/BN]

87
Thingvellir 1900
57.5 x 81.5 (22⅝ x 32)
Signed and dated bottom left corner
Listasafn Íslands, Reykjavík

Painted in 1900, this view of the grassy lava plain of Thingvellir was shown the same year in Thorláksson's exhibition in Reykjavík (see review, "Myndasýning," *Ísafold*, December 19, 1900, p. 311.) Here Thorláksson employed the structures of Danish painting he had learned under Harald Foss, who had been a pupil of Vilhelm Kyhn (1819-1903) and had worked with Peter Christian Skovgaard (1817-1875). The diagonal body of water receding into space and the relatively flat plain with a row of hills in the background would seem to indicate that he had absorbed the conventions of Skovgaard's paintings of the Jutland landscape. However, the suppression of detail, the moody lighting effects, and the boxlike church and parsonage seem quite removed from both the Danish landscape tradition and from Thorláksson's own minutely rendered interior scenes. These elements may have their sources in his early work and in the native Icelandic amateur style of Jon Helgason (1866-1942) or Thorsteinn Gudmundsson (1817-?).

Thorláksson painted this site many times from different viewpoints. In this depiction the dim lighting, the virtual dissolution of the background hills in atmosphere, and the stillness of the two Icelandic horses impart a mystical quality to the rather ordinary landscape. Approximately thirty miles from Reykjavik, the Thingvellir lava plain is of paramount importance in Icelandic history. In the year 930, chieftains of each local assembly or *thing* gathered there to adopt a uniform code of law and to establish a national assembly or *Althing*. For the next four hundred years—until Iceland was annexed first by Norway, then by Denmark—the *Althing* convened at Thingvellir for two weeks each June.

Thorláksson's interest in Thingvellir as a subject for his painting unites him with the contemporary nationalistic concerns of other Scandinavian artists. During the nineteenth century Iceland's position as a colony began to change. Early in the century the original *Althing*, then defunct, had become a symbol of Iceland's Golden Age and its lost independence (Ólafur Grímsson; quoted in biblio. ref. no. 55, p. 20). In response to petitions by the Icelanders, the king of Denmark in 1874 granted a constitution, sharing his power to govern Iceland with the reinstated *Althing*. Thereafter, part of each annual session of the *Althing* was devoted to consideration of constitutional revisions that would permit Iceland even greater independence. Revisions were passed by both chambers in 1885, '86, '93, and '94, but were vetoed by the Danish king (biblio. ref. no. 51, p. 426). Thorláksson surely would have known that the site he chose in 1900 was associated with this struggle and that it was the birthplace of the world's oldest parliament. [RH/BN]

88
Woman at a Window 1899
Kona vid glugga
61.0 x 61.0 (24 x 24)
Not signed
Mrs. Laufey Snaevarr, Reykjavík

Part of a long tradition of views of an artist working by a window, this canvas is both a study of a particular artist and a statement on the practice of art. Although the sitter has not been identified, her highly individualized features suggest that the painting must be a portrait. Thorláksson places the young woman in an environment that is not only believable but also one that allows him to create an academic ''presentation piece''—a demonstration of his own artistic abilities and an inventory of the arts of drawing, sculpture, and architecture.

Thorláksson skillfully portrays delicate effects of backlighting and the interposition of atmosphere. He includes the human figure, landscape elements, still life, and drapery, and depicts the varied textures of skin, hair, wood, paper, leaves, cloth, and crockery. There is also opposition between interior and exterior: the warm tones of the room versus the grayed tones of the snowy world outside; the green, cultivated ivy versus the gray branches of the trees beginning to bud. Likewise, the woman's soft features are silhouetted against the light and are contrasted with the cast of a satyr hung casually upon the window frame. (Copied in academic drawing classes to teach representation of light and shade, plaster casts of sculpture were a common artist's tool.)

The picture bears the strong imprint of Danish art in its air of bourgeois domestic well-being and contrasts sharply with Thorláksson's landscape work in Iceland. [RH/BN]

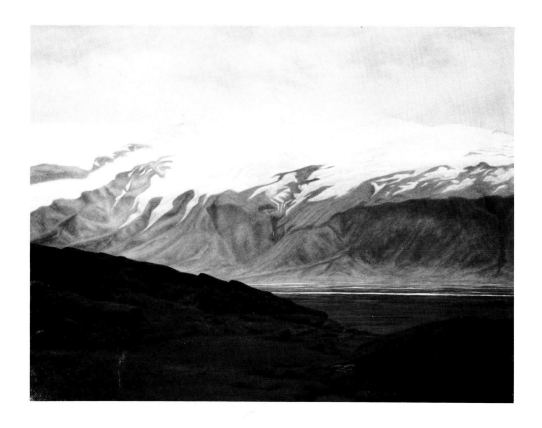

89
Eyjafjalla Glacier 1903
Eyjafjallajökull
93.0 x 120.0 (36⅝ x 47¼)
Signed and dated bottom left corner
Hilmar Gardars, Seltjarnarnesi

The major part of Thorláksson's oeuvre is devoted to calm meditations upon the variety and mystery of the Icelandic landscape—its volcanoes, glaciers, fjords, meadows, lava fields, and "lunar" plateau lands. He experimented with different viewpoints, depicting the landscape directly from eye level, from behind a screen of vegetation, or from a nearly bird's-eye view.

In this painting he portrays the Eyjafjalla glacier in southern Iceland from the vantage point of a high mountain ridge looking across a valley. The spectator is set down upon a shelf of rough lava-formed clumps of earth covered with grass. At the center of the green expanse, a wedge-shaped area of smoother ground forms a path that leads to the right and down the side of the cliff. Opposed to the lush foreground is the barrenness of the mountain in the background. Though the picture is convincing as a topographical description, Thorláksson has also suffused the mountain with atmosphere, endowing it with a velvety surface and emphasizing the ragged shapes that form the border of the glacier. [RH/BN]

NILS GUSTAV WENTZEL Norway 1859–1920

Nils Gustav Wentzel was recognized as one of the most gifted Naturalist painters of his generation. In 1880, when the conservative Christiania Art Association rejected Wentzel's first submission, his defenders Erik Werenskiold and Fritz Thaulow organized the Norwegian artists' rebellion that led to the first annual Artists' Autumn Exhibition in 1882.

Wentzel was born into a long and venerable line of craftsmen. His father was a carpenter, and for several generations the Wentzels had been glassblowers. Gustav, assuming a bricklayer's apprenticeship in 1875, hoped eventually to become an architect. A sudden change of heart in 1879 led to his enrollment in Knut Bergslien's studio and the Royal Academy of Drawing, where he developed the detailed interior genre painting that established his reputation.

Wentzel took his first trip to Paris in the spring of 1883, later attending Thaulow's "Open-Air Academy" in Modum. In the autumn he settled into the bohemian milieu of sculptor Rolf Skjeft's Christiania studio, where the young generation of Norwegian Naturalists, including Edvard Munch* and critic Andreas Aubert, congregated.

Wentzel returned to Paris in the following year, studying under Adolphe Bouguereau and at the Academie Julian. He made a third trip to the French capital on a government grant in 1888, and the following May, while studying there under Alfred Roll and Léon Bonnat, he married Christine Marne (Kitty) Baetzmann.

Back in Norway in 1890 Wentzel was swept into the Neo-Romantic movement, shifting his vision from interior genre to Whistlerian landscape painting. With the exception of two extended periods of travel—to Germany, Italy, and France in 1901–02, and to Germany in 1910–11—he and his wife isolated themselves in the remote southern districts of Telemark and Hardanger, where Wentzel had first travelled in 1880. To offset his poverty during these years, he mass-produced second-rate snow scenes, leading to a decline in his reputation. He moved to Lom, near Vaga, in 1911 and died there nine years later. [PGB/OT]

90
Breakfast I 1882
Frokost I
100.5 × 137.5 (39½ × 54⅛)
Signed lower right: "N. Gustav Wentzel/Kristiania 1882"
Nasjonalgalleriet, Oslo

Wentzel painted *Breakfast I* during the one-year interval between his formal study in Christiania and his initial trip to Paris. Recording a Christiania working-class interior with the scrupulous eye of an ethnographer, he organized the space into a continuous suite of still-life arrangements. He utilizes a Balzacian narrative method of atmospheric Realism, the rich accretion of mundane details, to define the interior environment and its inhabitants. It has been suggested that the setting is his parents' home.

Wentzel's orchestration of two rooms filled with characteristic detail reflects his interest in seventeenth-century Dutch interiors. The window shade in the far room, hand painted with an image of Our Savior's Church in Christiania, allows light to filter through the window while impeding access to the outside. Within this comforting enclosure, the figures are intent upon their mealtime preoccupations: the woman cuts bread, the child eats, and the husband retires to the adjacent room, his back partially visible through the doorway.

All of the objects in this tight interior, painted in a German academic style, speak of the family's daily use: the beaten copper kettle, the rumpled daybed, the worn bathrobe, and the child's coat and hat. The room, once well-appointed with elegant lavender-and-gilt wallpaper and mahogany furniture, now suffers from neglect. The portrait and landscape paintings surrounding the cracked mirror to the left have become convenient resting places for the man's pipes and pocket watch, rather than objects of aesthetic value.

Breakfast I was the pinnacle of Wentzel's early Realist style. After his second trip to Paris he painted *Breakfast II*, originally entitled *Morning Mood* (1885; Nasjonalgalleriet, Oslo), a recapitulation of the earlier composition. Rather than defining the environment through its details, he celebrated the nuances of light, suggesting the influence of James McNeill Whistler and Claude Monet. The Impressionist-inspired second version earned him a second-class medal in the Paris World Exposition of 1900. [PGB/OT]

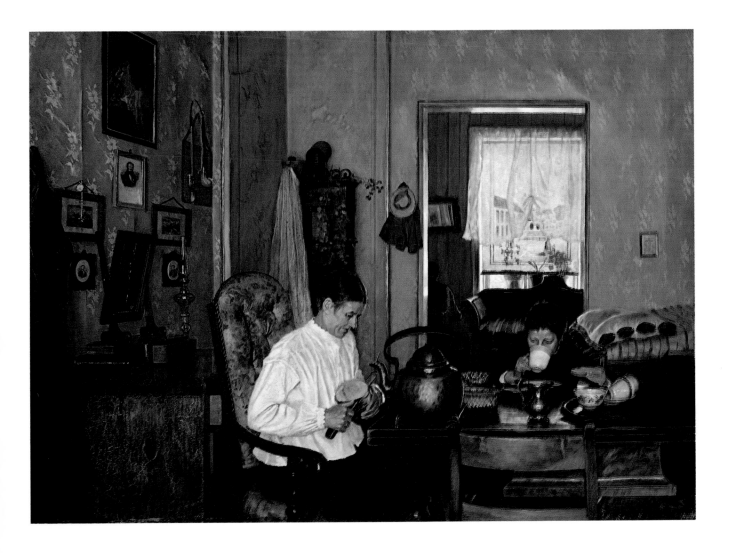

CARL WILHELMSON Sweden 1866–1928

Carl Wilhelmson was born in Fiskebäckskil, a fishing village in the Bohuslän region on the Swedish coast. In 1875 his family was reduced to poverty when his sea-captain father drowned. At the age of fifteen, he moved to Gothenburg, a prosperous port, where he worked as a lithographer and later entered the Valand art school, studying under Berndt Lindholm (1841–1914) and Carl Larsson (1853–1919).

In 1890, Wilhelmson moved to Paris, where he stayed for five years and supported himself by working as a mechanical draftsman. He was particularly impressed by the work of Paul Gauguin and Georges Seurat, and he took classes in the studios of Jules Lefebvre, Tony Robert-Fleury, and Benjamin Constant. He returned to Sweden every summer during these years, and in 1896 settled in Gothenburg. From 1897 to 1910 he taught at Valand.

Although Wilhelmson's themes were exclusively Scandinavian, he made study trips to Spain in 1910, 1913, and 1921, and visited England in 1924. In 1910 he moved to Stockholm, where in 1912 he opened his own school of painting. He became a professor at Stockholm's Royal Academy of Fine Arts in 1925 and was named a member in 1928. He died in Gothenburg. [ADG/GCB]

91
The Daughter on the Farm 1902
Gärdens Dotter
130.0 × 90.0 (51⅛ × 35½)
Signed lower left: "C. Wilhelmson"
Göteborgs Konstmuseum

In the summer of 1902 Wilhelmson was the guest of his student Anna Sahlström on her family's farm at Torsby in the Swedish province of Värmland. There he painted *The Daughter on the Farm* with Anna as his model. Wilhelmson's painting encompasses a way of life and pays homage to the prosperous farming class. In the background, he opens the view out to the fields, stressing the dependence of this society on the land. Anna is shown wearing the dignified black of Sunday dress. The surrounding interior is not poor, but it conveys an austerity echoed by Anna's rigid pose. Indeed, both woman and environment appear to embody a puritanical ethos of work and moral rectitude.

From his earliest years in Gothenburg, Wilhelmson had been concerned with scenes of local interest. During his stay in Paris he had, like many of his contemporaries, been attracted to Brittany. On his return to Sweden, he devoted a large part of his oeuvre to fishermen, farmers, and peasants, converting these themes into nationalistic icons. These people are rarely shown at work or conversing; instead Wilhelmson characteristically depicts them as calmly, solemnly withdrawn into themselves. This sense of taciturn inwardness, which sets Wilhelmson's rural imagery apart from that of earlier Realist artists in Scandinavia (see, for example, cat. nos. 51 and 56), is especially strong in *The Daughter on the Farm*.

Anna's exceptionally large and expressive hands—seemingly too powerful for her brittle frame—are pointedly crossed and inactive. The posture is static but not relaxed; her eyes fail to meet the viewer's, despite the fact that she stares forward fixedly. Self-consciously posed, physically prominent, and meticulously detailed, this young woman is still psychically distant and wears an ambiguous expression. In her combination of grave probity and tense stiffness, she seems to belong to those people of the soil who presented themselves to the camera of the German photographer August Sander twenty years later (see August Sander, *Antlitz der Zeit*, 1929). Strongly individualized, her portrait is, as the title indicates, a type-image—an appreciation of a way of life and a frame of mind. [ADG/BF]

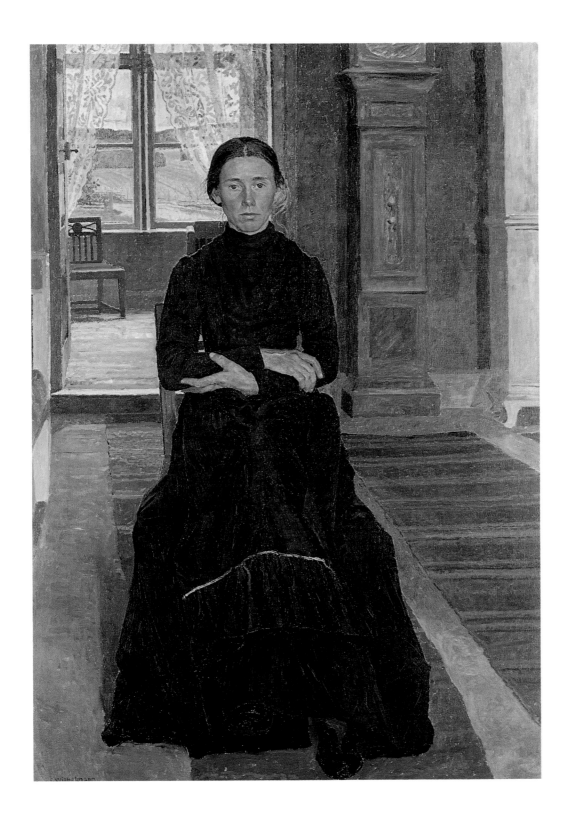

ANDERS ZORN Sweden 1860–1920

Zorn spent his childhood in Mora on the farm of his impoverished grandparents. From 1875 to 1881 he attended the Royal Academy of Fine Arts in Stockholm, where he pursued an eccentric course of study, and—inspired by the watercolors of Egron Lundgren (1815–1875)—concentrated upon developing his watercolor style. In 1881 he and Ernst Josephson toured London, Paris, and Spain—the first of countless trips he made to foreign countries in order to seek new subjects and lighting effects as well as contact with the art of the old masters. From 1882 to 1885 he lived in London and achieved some success as a portrait painter.

Zorn married Emma Lamm in 1885, and the two spent the winter of 1887–88 with James McNeill Whistler and Helene Schjerfbeck* in the artists' colony of St. Ives, where he began seriously to devote himself to oil painting. In 1888 the couple settled in Paris, and he became part of an influential artists' circle that included Antonin Proust, Albert Besnard, and Auguste Rodin. His studio on the Boulevard de Clichy also became a gathering place for other Scandinavians, including Christian Krohg*, Albert Edelfelt*, and Akseli Gallen-Kallela*. In this period Zorn experimented with Impressionist ideas and carefully studied the brushwork of Édouard Manet.

In 1896 Zorn moved back to his native Mora. When not travelling, he and his wife involved themselves directly in the community and studied and collected indigenous art. Internationally successful, he continued to execute oils, watercolors, etchings, and sculpture. The subjects of his mature works (excluding etchings) are mainly portraits, nudes, and genre subjects in roughly equal proportions. [RH/GCB]

Édouard Vuillard
The Ferryman 1897
Le Passeur
Oil on board
54.6 × 74.9 (21½ × 29½)
Musée d'Orsay,
Paris

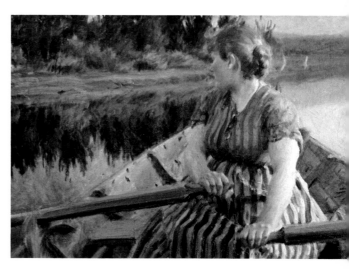

92
Midnight 1891
Midnatt
69.0 × 102.5 (27⅛ × 40⅜)
Signed lower right: "Zorn/Mora 91/Midnatt"
Zornmuseet, Mora

Zorn painted this view of a woman rowing on Sweden's Lake Siljan during the last week of June 1891 while on a visit from Paris to Mora. He exhibited it that fall at the Stockholm exhibition of the Artists' Union, of which he was a member from 1886 to 1903, and in Paris at the 1892 Champ de Mars Salon.

Throughout his career Zorn was absorbed with problems posed by different kinds of lighting. He first depicted the light summer night, a favorite theme of nineteenth-century Scandinavian artists, in *To the Dance* (1880; Ebildslätt, Orust). In keeping with the associations carried by the Scandinavian summer night, the apparent solitude of the woman in *Midnight* and the viewer's close confrontation with her unreadable expression give the action and its setting an air of mystery.

By 1891 the motif of a figure in a boat which is "cropped" by the picture plane had become common in European painting and in Zorn's work. He first used it in 1883 in the etching *Mary on the Thames*, which may have derived from James Tissot's painting *Young Woman in a Boat* (1870; location unknown, reproduced in M. J. Wentworth, *James Tissot: Catalogue Raisonné of His Prints*, Minneapolis Institute of Arts, 1978) or from Tissot's etching *The Thames* of 1876 (Lawrence, p. 35). Zorn's *Midnight* may, in turn, have inspired the cropped boat, the backward glance, and the moody light of Édouard Vuillard's *The Ferryman* (illustrated at left). Both works convey a scarcely definable sense of foreboding. [RH/GCB]

93
Self-Portrait 1896
Självporträtt
117.0 × 94.0 (46 × 37)
Signed lower right: "Zorn/1896"
Nationalmuseum, Stockholm

Painted during the last winter Zorn lived in Paris and
first shown at the 1896 Champ de Mars Salon, this
self-portrait was the result of months of
experimentation. Preliminary drawings show the model
much closer to the artist; Zorn repainted the canvas
several times before finally moving her into the
shadowy background. The broad, loose brushwork and
attention to solid form reveal Zorn's study of
Rembrandt, Hals, and the French Impressionists and the
influence of his German artist friend Max Lieberman.
Zorn was noted for executing paintings using a sober
color scale limited to white, ochre, vermilion, and ivory
black—the four colors used to paint this canvas and the
ones represented on his palette in the picture.

Armed with palette, pigments, brushes, and cigarette,
and attired in the dashing artist's costume of smock and
ascot with stickpin, Zorn takes a break from painting.
He generally employed professional models for his
paintings of nudes, and they would entertain him by
singing as he worked. The model here is an Italian
woman with long red hair, which Zorn described as
covering her like a winter cloak (letter to I. S. Gardner,
paraphrased in Lawrence, p. 68).

Though the compositions vary among Zorn's portraits
of artists and their models—other examples include
etchings of Augustus Saint-Gaudens and Albert
Besnard—each makes clear that the artist is in the
position of power. Here, Zorn's bulky figure fills fully
one-third of the image, and he confronts the viewer as
bright daylight illuminates his smock. The smaller figure
of the model, wrapped in her hair, slouches in a chair
pushed into the dim corner. The darkness between the
two and the pattern of the parquet boards tilting down
toward the artist's corner create a psychological distance
and tension. This work provides a sharp contrast to the
oblique view of the aging Vilhelm Hammershøi in his
Self-Portrait of 1911 (cat. no. 37), and Zorn's
down-to-earth physicality opposes the vaporous,
otherworldly depiction of Munch's *Self-Portrait with
Cigarette* (cat. no. 67).　[RH]

94

Midsummer Dance 1897
Midsommardans
140.0 × 98.0 (55⅛ × 38⅝)
Signed lower right: "Zorn 1897"
Nationalmuseum, Stockholm

In 1896, the summer after Zorn's return to his native Swedish province of Dalarna, Prins Eugen* attended the local Midsummer festival and suggested that Zorn paint the subject. His first response was a rapid oil sketch of horizontal format (Zorn Museum, Mora); the following year he executed this version, which was awarded the Medal of Honor for painting at the 1900 World Exposition in Paris. On commission from the American industrialist Charles Deering, he also painted a smaller replica in 1903.

The painting is part of a rich tradition in Scandinavian art and literature of treatments of the Midsummer festival. Celebrated on or around June 23—one of the longest days of the year—Midsummer was a major holiday in Norway and Sweden. It was especially popular in rural areas where people flocked to the villages to dance around the maypoles in the bewitching light of the summer night. Ibsen (*St. John's Night,* 1852) and Strindberg (*Midsummer,* 1900) used the Midsummer festival as the setting for their works dealing with nationalism. Among the Swedish painters who depicted the festival earlier in the century was J. W. Wallander (1821–1888), whom Zorn admired for his rural scenes. Wallander's and other mid-century artists' paintings of the subject usually presented a detached view of many figures dancing across a stage-like space. Careful attention was given to details of costume, architecture, and foliage. Zorn, too, was fascinated by native peasant costume, and he respected local variations to the extent of refusing to paint a model in garb from outside her native district. However, he was more concerned with conveying the extraordinary light and mood of the celebration than with recording intricate embroidery or the individual leaves of the maypole decorations. His broad handling of paint may result in a suppression of such details, but the placement of the main couple invites the viewer's participation in the dance. With vastly different aims, Edvard Munch later used the Midsummer festival as a point of departure for *The Dance of Life* (cat. no. 69), in which flattened figures symbolize the eternal cycle of life and love.

With increasing industrialization and the displacement of the population to the cities, there was a concern in the 1890s for the preservation of the vanishing peasant culture. Zorn's friend and fellow Dalarnan, Erik Axel Karlfeldt, was the major representative of this trend in poetry, and through his poems Dalarna came to be known as the area which had preserved most carefully a traditional Swedish way of life (biblio. ref. no. 81, p. 616). Zorn's own deeply rooted interest in his native culture extended to support, encouragement, and manipulation of the local arts and folk events. Apparently the custom of setting up a maypole had lapsed in his area, and he persuaded the villagers to erect one for the 1896 celebration. In addition to collecting native silver, glass, tapestries, and paintings, he and his wife organized handicrafts classes and other activities for the young people of the area. The lead couple depicted in *Midsummer Dance* are said to be the winners of a dance contest sponsored by him (Boëthius, 1959, p. 122).

Zorn's most ambitious endeavor was the collection of antique Swedish buildings like the ones seen in the upper left-hand corner here. He was eventually able to create the hamlet of Gopsmor—a rural version of the Skansen architectural museum near Stockholm. In light of such extraordinary devotion to his heritage, it is easy to understand why he later said of this painting, "I consider this to be the work that contains the whole of my innermost feelings" (quoted in Boëthius, 1949, p. 354). [RH]

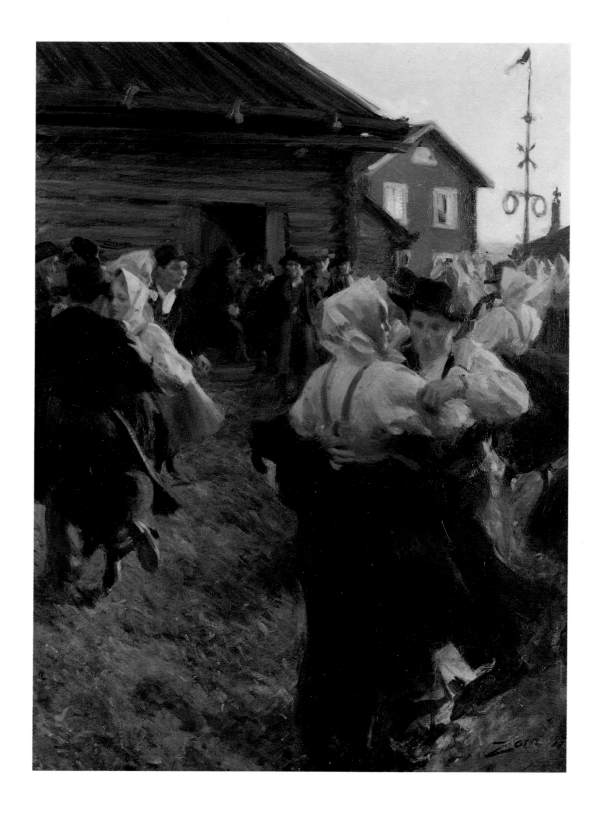

Selected Bibliography

GENERAL

1 Brussels, Musées Royaux des Beaux-Arts, *Le Symbolisme en Europe* (Rotterdam, Brussels, Paris, 1976).

2 Buffalo, Albright Art Gallery, *Exhibition of Contemporary Scandinavian Art*, by Christian Brinton (1913).

3 T. K. Dersy, *History of Scandinavia* (Minneapolis: University of Minnesota Press, 1979).

4 Mirian C. Donnelly, "The Arts and Crafts in the Scandinavian Countries," Abstract of paper given at 24th annual meeting of the Society of Architectural Historians, *Journal of the Society of Architectural Historians*, XXX (1971), p. 245.

5 Povl Drachmann, *The Industrial Development and Commercial Policies of the Three Scandinavian Countries* (London, 1915).

6 Düsseldorf, Kunstmuseum, *Düsseldorf und der Norden* (1976).

7 Jean Jacques Fol, *Les pays nordiques aux XIXe et XXe siècles.* (Paris: Presses universitaires de France, 1978)

8 B. J. Hovde, *The Scandinavian Countries 1720–1865: The Rise of the Middle Class* (Ithaca, 1948).

9 Carl Laurin, Emil Hannover, Jens Thiis, *Scandinavian Art* (New York: The American-Scandinavian Foundation 1922).

10 Bo Lindwall and Nils Gösta Sandblad, *Bildkonsten i Norden*, Vol. 3: *Nordiskt Friluftsmåleri, Nordiskt Sekelskifte* (Stockholm: Bokförlaget Prisma, 1972).

11 Børge Gedsø Madsen, *Strindberg's Naturalistic Theater. Its Relation to French Naturalism* (New York: Russell and Russell 1973).

12 Inga Rockswold Platou, "The Art Colony at Skagen, Its Contribution to Scandinavian Art" (PhD. diss., University of Minnesota 1968).

13 Robert Rosenblum, *Modern Painting and the Northern Romantic Tradition: Friedrich to Rothko* (New York: Harper and Row, 1975).

14 Margaretha Rossholm, *Sagan i Nordisk Sekelskifteskonst, en motivhistorisk och ideologisk undersökning* (Stockholm: K. L. Beckmans Tryckerier, 1974).

15 Ulrich Thieme and Felix Becker, *Allgemeines Lexikon der Bildenden Künstler* (Leipzig, 1907–1950).

16 O. G. Turville-Petre, *Myth and Religion in the North* (New York, 1964).

17 Henri Usselmann, "Complexité et Importance des Contacts des Peintres Nordiques avec L'impressionisme" (PhD. diss., The University of Gothenburg, 1979).

18 John H. Wuorinen, "Scandinavia and the Rise of Modern National Consciousness" in *Nationalism and Internationalism*, essays inscribed to Carlton J. H. Hayes (New York, 1950).

DENMARK

19 Margaretha Balle-Petersen, "The Holy Danes: Some Aspects of a Study of Religious Groups," *Ethnologia Scandinavica: A Journal for Nordic Identity* (Lund, June 1981).

20 Copenhagen, Statens Museum for Kunst, *Vor Hundert Jahren: Dänemark und Deutschland 1864–1900. Gegner und Nachbarn.* (1981).

21 *Dansk Biografisk Leksikon*, first edition (Copenhagen: J.H. Schultz 1932–1946).

22 *Dansk Kunsthistorie*, Vol. 1–5 (Copenhagen: Politikens Forlag, 1972–1975).

23 Frederikssund, J. F. Willumsens Museum, *J. F. Willumsen og den frie Udstillings første år 1891–1898* (1982).

24 Emil Hannover, *Dänische Kunst des 19. Jahrhunderts* (Leipzig: E.A. Seeman, 1907).

25 Herman Madsen, *200 Danske Malere og Deres Waerker* (Copenhagen: Aage Pioras Forlag, 1943).

26 Karl Madsen, *Kunstens Historie i Danmark* (Copenhagen: Alfred Jacobsen, 1901–1907).

27 ——, *Skagens Maleri og Skagens Museum* (Copenhagen: Gyldendalski Boghandel Nordisk Forlag, 1929).

28 Roald Nasgaard, "Willumsen and Symbolist Art 1888–1910" (PhD. diss., New York University, 1973).

29 Stewart Oakley, *A Short History of Denmark* (New York, 1972).

30 Paris, Maison du Danemark, *Les Peintres de Skagen 1870–1920*, by Knud Voss, 1980.

31 Vagn Poulsen, *Danish Painting and Sculpture*, (Copenhagen: Det Danske Selskab, 1976).

32 Skagens Museum, *Illustrerte Katalog* (1981).

33 Erik Zahle, *Danmarks Malerkunst fra Middelalder til Nutid*, third edition (Copenhagen, 1947).

Anna Ancher

Margrethe Loerges, *Portrait of Anna Ancher* (Copenhagen: Hernov, 1978).

Also Bibliography refs: 12, 20, 27, 30, 32.

Niels Bjerre

Dansk Biografisk Leksikon, Vol. 2, revised edition (Copenhagen, 1979).

Leo Swane, "Niels Bjerre," in *Vor Tids Kunst*, No. 19 (Copenhagen, 1935).

Also Bibliography refs: 15, 19, 25, 31.

Ludvig Find

Bibliography refs: 21, 23, 25.

Vilhelm Hammershøi

Alfred Bramsen, "Weltkunst. Der dänische maler Vilhelm Hammershøi," *Zeitschrift für bildende kunst*, N.F. 16 (1905), pp. 176–189.

Alfred Bramsen and Sophus Michaëlis, *Vilhelm Hammershøi, Kunstneren og hans Vaerk* (Copenhagen and Kristiania, 1918).

Copenhagen, Ordrupgaard Collection, *Vilhelm Hammershøi*. Essays by Hanne Finsen, Thorkild Hansen, Harald Olsen. Catalogue by Hanne Finsen and Inge Vibeke Raaschou-Nielsen (1981).

Julius Elias, "Vilhelm Hammershøi," *Kunst und Künstler* 14 (1915–1916), pp. 403–408.

H., "Aus der Neunten Austellung der Berliner Secession," *Kunst und Künstler* 2 (1903–1904), pp. 402–403; 405.

Ulf Linde, "Vilhelm Hammershøi: Fem porträtt," *Thielska Galleriet Katalog* (Stockholm, 1979), pp. 50–51.

William Ritter, "Vilhelm Hammershøi," *L'art et les artistes* 10 (1909–1910), pp. 264–268.

Poul Vad, *Vilhelm Hammershøi*, Kunst i Danmark (Copenhagen, 1957).

Vilhelm Wanscher, "Vilhelm Hammershøi," *Ord och Bild* 18 (1915), pp. 401–411.

Also Bibliography refs: 24, 25, 31.

Peder Severin Krøyer

V. Justrau, *P. S. Krøyer* (Copenhagen: G.E.C. Gads Forlag, 1922).

Ernst Mentze, *P. S. Krøyer: Kunstner af stort format-med braendte vinger* (Copenhagen: Det Schønbergske Forlag, 1980).

Also Bibliography refs: 12, 20, 27, 30, 32, 72.

Laurits Andersen Ring

Peter Hertz, *L. A. Ring* (Copenhagen, 1935).

Cai M. Woel, "L. A. Ring et Levnedsrids," *Dansk Kunst* II (Copenhagen: Arthur Jensens Forlag, 1937).

Also Bibliography refs: 21, 25, 26.

Harald Slott-Møller

V. Jastrau, "Harald Slott-Møller og Agnes Slott-Møller," *Små Kunstbøger*, No. 23 (Copenhagen, 1934).

Marcus de Rubris, "Artisti contemporanei: Harald Slott-Møller," *Emporium* 4, Vol. 58 (Bergamo, 1923).

Also Bibliography refs: 15, 20, 21, 25.

FINLAND

34 Brussels, Palais des Beaux-Arts, *Finlande 1900; Peinture, Architecture, Arts Décoratifs*, 1974.

35 Eino Jutikkala and Kauko Pirinen, *A History of Finland*, revised edition, trans. by Paul Sjöblom (New York, 1974).

36 Alf Krohn, ed. *Art in Finland: Survey of a Century* (Helsinki, 1953).
37 W. R. Mead, "Kalevala and the Rise of Finnish Nationality," *Folklore*, vol. 73 (Winter 1962), pp. 217–229.
38 Onni Okkonen, *Finnish Art* (Helsinki, 1946).
39 Oslo, National Gallery, *Finsk Malerkunst*, by Olli Vallkonen, 1980.
40 Hans Rosenhagen, "Finnländische Maler," *Die Kunst für Alle*, vol. 19, (1903–1904), pp. 206–213.
41 S. Saarikivi, K. Niilonen, H. Ekelund, *Art in Finland*, fifth edition (Helsinki, 1964).
42 Salme Sarajas-Korte, *Suomen varhaissymbolism i ja sen lähtet* (Helsinki: Otava, n.d.).
43 ——, *Vid Symbolisens käller, Den tidiga symbolismen i Finland 1890–1895* (Helsinki: Pietarsaari, 1981).
44 John Boulton Smith, *Modern Finnish Painting and Graphic Art* (London, 1970).
45 ——, "Painting and Sculpture" in *Finland, Construction and Creation*, H. Kallas and S. Nickels, ed. (London, New York, Helsinki, 1968).
46 ——, *The Golden Age of Finnish Art* (Helsinki, 1975).
47 Stockholm, National Museum, *Målarinnor från Finland, Seitsemän Suomalaista Taiteilijaa*, 1981.
48 J. J. Tikkanen, "Die Kunst in Finnland", *Die Graphischen Künste*, XXIX (1906).
49 B. Zilliacus, *Finnish Designers* (Helsinki, 1954).

Albert Edelfelt
Albert Edelfelt, Små Konstbocker, no. 12 (Lund, 1911).
Jukka Ervamaa, "Albert Edelfelt's *The View from Kaukola Ridge*," *Ateneumin Taidemuseo Museojulkaisu*, vol. 20 (1975–76), pp. 42–49 (English translation).
Salme Sarajas-Korte, "The Norwegian Influence in Finland in the early 1890s," *Ateneumin Taidemuseon Museojulkaisu*, vol. 21 (1977–78), pp. 45–48 (English translation).

Akseli Gallen-Kallela
Paul Kraemer, "Axel Gallen, Finnlands Grosser Maler," *Die Kunst für Alle*, vol. 23, (December 1917), pp. 77–80.
Niilonen, K., ed., *Kalela—Wilderness Studio and Home* (Keuruu, 1966).
Onni Okkonen, ed., *A. Gallen-Kallela Drawings* (Porvoosa, 1947).
Onni Okkonen, *Akseli Gallen-Kallelan Taidetta* (with an English summary), (Porvoosa, 1948).
Charles W. Stork, ed., *The Tales of Ensign Stål*, by J.L. Runeberg (Princeton: The American-Scandinavian Foundation, 1938).
Marc Treib, "Gallen-Kallela: A Portrait of the Artist as Architect," *Architectural Association Quarterly*, vol. 7, no. 3 (July/September, 1975), pp. 3–13.
Also Bibliography ref: 17.

Pekka Halonen
Outi Hämälainen, ed., *Pekka Halonen*, (Porvoosa, 1947), (with an English summary).

Eero Järnefelt
Stockholm, Nationalmuseum, *Finskt 1900* (1971).
L. Wennervirta, *Eero Järnefelt* (Helsinki, 1950).
Also Bibliography refs: 15, 36, 38, 40, 41, 46, 48.

Helene Schjerfbeck
H. Ahtela, *Helene Schjerfbeck. Kamppailu Kauneudesta* (Porvoo, 1951).
Eilif and Hanna Appelberg, *Helene Schjerfbeck. En biografisk konhivteckning* (Helsinki, 1949).
Gotthard Johansson, *Helene Schjerfbecks konst* (Stockholm, 1940).
Helene Schjerfbeck, Lubeck (ex. cat.), 1969.

Louis Sparre
Paivi Huuhtanen, "Louis Sparren suomalaisromanttiset maalaukset vv. 1889–1895," unpublished university study (Helsinki University, 1970).
Eva Mannerheim-Sparre, *Konstnärsliv Sparre-Minnen* (Helsinki, 1951). (Finnish: Taiteilijaelämää).
Also Bibliography refs: 15, 36, 41, 46, 48.

Ellen Thesleff
L. Bäcksbacka, *Ellen Thesleff* (Helsinki, 1955).
Ellen Thesleff, Helsinki (ex. cat.) 1969.

ICELAND
50 Björn Th. Björnsson, *Íslenzk myndlist á 19. og 20. Öld* (Reykjavik: Helgafell, 1964).
51 Knut Gjerset, *History of Iceland* (New York: The Macmillan Co., 1924).
52 Georg Gretor, *Islands Kultur und seine junge Malerei* (Jena: Eugen Diederichs, 1928).
53 *Íslenzk myndlist*, ed. Kristján Fridriksson (Reykjavik, 1943).
54 Oslo, Kunstnernes Hus, *Den offisielle islandske Kunstutstilling* (1951).
55 Richard F. Tomasson, *Iceland—The First New Society* (Minneapolis: University of Minnesota Press, 1980).
56 Waterville, Colby College Art Museum, *Icelandic Art*, by Selma Jónsdóttir, 1965.

Ásgrímur Jónsson
Ásgrímur Jónsson, text by Tómas Gudmundsson (Reykjavík, 1962), Second edition, with new pictures.
Ásgrímur Jónsson, text by Gunnlaugur Scheving (Reykjavík, 1949).
Ásgrímur Jónsson, Myndir og minningar, text by Tómas Gudmundsson (Reykjavík, 1956).
Ásgrímur og Thjodsögurnar, text by Einar Ólafur Sveinsson (Reykjavík, 1959).
Also Bibliography refs: 50, 53.

Thórarinn B. Thorláksson
Selma Jónsdóttir, *Oplysningsforbundenes kunsttillaeg* (Copenhagen, 1973).
Valtýr Pétursson, *Thórarinn B. Thorláksson* (Reykjavík, 1982).
Reykjavík, National Gallery of Iceland, *Thórarinn B. Thorláksson*, by Selma Jónsdóttir, 1967.
Also Bibliography refs: 50, 53, 56.

NORWAY
57 Henning Alsvik, Leif Østby, and Reidar Revold, *Norges billedkunst i det nittonde og tyrende århundrede*, 2 volumes (Oslo: Gyldendal, 1951–1953).
58 Jan Askeland, *Norwegian Painting: A Survey* (Oslo: Tanum, 1971).
59 Andreas Aubert, *Die Norwegische Malerei im XIX Jahrhundert* (Leipzig: Klinkhardt and Biermann, 1910).
60 ——, *Norsk kultur og norsk Kunst*, (Christiania, 1917).
61 Hilmar Bakken, *Gerhard Munthes Dekorative Kunst* (Oslo, 1946).
62 Harald Beyer, *Nietzsche og Norden* (Universitetet i Bergen, årsbok, 1958), Historisk-antikvarisk rekke.
63 Andreas Elviken, "Genesis of Norwegian Nationalism", *Journal of Modern History*, vol. 3, no. 3 (1931), pp. 365–391.
64 Oscar Falnes, *National Romanticism in Norway* (New York, 1933).
65 Eduard Gudenrath, *Norwegische Maler von J. C. Dahl bis E. Munch* (Berlin, 1943).
66 Anne M. Hasund Langballe, *Bibliography of Norwegian Art History* (Oslo: Universitetsforlag, 1976).
67 Marit Ingeborg Lange, "Fra den Hellige Lund til Fleskum, Kitty L. Kielland og den nordiske sommernatt," *Kunst og Kultur* 60, h. 2 (1977).

68 Sima Lieberman, *The Industrialization of Norway 1800–1920* (Oslo: Universitetsforlag, 1970).
69 Madison, Elvehjem Museum of Art, *The Art of Norway 1750–1914*, 1978.
70 Newcastle-Upon-Tyne, Laing Gallery, *Norwegian Romantic Landscape 1820–1920*, by John Boulton Smith, 1976.
71 *Norges Kunsthistorie*, (Oslo: Gyldendal Norsk Forlag, 1981–1982) Vols. 1–7.
72 Leif Østby, *Fra Naturalisme til Nyromantikk: 1888–1895* (Oslo: Gyldendal Norsk Forlag, 1934).
73 John Boulton Smith "Romantic Landscape Painters of Norway 1814–1914," *Apollo*, no. 104 (August 1976), pp. 114–119.
74 Hakon Stenstadvold, *Norske malerier gjennom hundre ar* (Oslo: Dreyers Forlag, 1943).
75 Jens Thiis, *Norske Malere og billedhuggere* (Bergen, 1907).
76 Sigurd Willoch, *Kunstforeningen i Oslo, 1836–1936* (Oslo: Blix Förlag, 1936).

Harriet Backer

R. Bowman, "The Art of Harriet Backer," *Scanorama*, Oct.–Nov., 1978.
Kristian Haug, "Norway's Great Woman Artist," *American Scandinavian Review* (1925), pp. 735–740.
Else Christie Kielland, *Harriet Backer 1845–1932* (Oslo, 1958).
Erling Lone, *Harriet Backer* (Oslo, 1924).
Nasjonalgalleriet. *Katalog over norsk malerkunst* (Oslo, 1968), no. 68–92, pp. 20–26.
Norske Mesterverke i Nasjonalgalleriet (Oslo, 1981), pp. 59–62.
Also Bibliography ref: 71.

Halfdan Egedius

W. Halfvorsen, *Halfdan Egedius* (Christiania, Copenhagen, 1914).
Kitty Kielland, "Halfdan Egedius," *Samtiden* 10 (1899).
Parmann Øistein, *Halfdan Egedius, Liv og Verk* (Oslo, 1979).
Einar Østvedt, "Egedius og Stadskleiv. Vennskap og Telemarks-kunst," *Kunst og Kultur* 23 (1937).
——, "Halfdan Egedius. Et vennskap og en korrespondanse," *På gamle stier* (Oslo, 1944).
Also Bibliography refs: 14, 15, 69, 71.

August Eiebakke

August Eiebakke to Andreas Aubert, May 17, 1891, University Library, Oslo.
Julius Lange, "Norsk, Svensk, Dansk Figurmaleri. Indtryk og Overvejelser," *Tilskueren: maanedsskrift for literatur* (1892).
Oslo, Kunstforening, *August Eiebakke*, by Kristian Haug, 1939.
Also Bibliography refs: 15, 74, 75.

Karl Gustav Jensen-Hjell

Simon Thorbjørnsen, "Glemte Kunstnere," *Kunst og Kultur* (1933).
Also Bibliography refs: 57, 67, 75.

Kitty Kielland

Gabriel Schanche Hidle, *Profiler og paletter i Rogalands kunst* (Stavanger, 1965).
Stavanger, Stavanger kunstforening, *Kitty L. Kielland. Minneutstilling*, 1976.
Also Bibliography refs: 57, 67, 69, 75.

Christian Krohg

Pola Gauguin, *Christian Krohg* (Oslo, Gyldendal Norsk Forlag, 1932).
Christian Krohg, Kampen for Tilvarelsen (Oslo-Glydendalske Boghandel Nordisk Fölag, 1920).
Oslo, National Gallery, *Christian Krohg 1852–1925: Norske Mesterverker i Nasjonalgalleriet*, by Oscar Thue (1981).
Leif Østby, *Norges billedkunst i det nittende og tyvende århundre*, Vol. 1 (Oslo, Gyldendal Norskforlag, 1951).

Oscar Thue, *Christian Krohg* (Oslo, Gyldendal Norsk Forlag, 1962).
——, "Christian Krohg-studier," *Kunst og Kultur*, LXIII (1965), pp. 193–197.
Kirk Varnedoe, "Christian Krohg and Edvard Munch," *Arts* 53 (April 1979), pp. 88–99.
Also Bibliography refs: 12, 27, 30, 32, 72.

Edvard Munch

Ray Asbjorn Boe, "Edvard Munch: His Life and Work from 1880–1920" (PhD. diss., New York University Institute of Fine Arts, 1970).
Das Werk des Edvard Munch (Berlin: Fischer, 1894). Essays by Stanislaw Przybyszewski, Willi Pastor, Franz Servaes, and Julius Meier-Graefe.
Henri Dorra, "Munch, Gauguin, and Norwegian Painters in Paris," *Gazette des Beaux-Arts*)November 1976).
Reinhold Heller, "Edvard Munch's *Night*, the Aesthetics of Decadence, and the Content of Biography," *Arts*, Vol. 53, No. 2 (October 1978).
——, *Edvard Munch: The Scream* (London: Penguin Press, 1973).
——, "The Iconography of Edvard Munch's *Sphinx*," *Artforum*, Vol. 9, No. 2 (October 1970).
Houston, Sarah Campbell Blaffer Gallery, *Edvard Munch*, by Peter W. Guenther, 1976.
Wladyslawa Jaworska, "Edvard Munch and Stanislaw Przybyszewski," *Apollo* 100, No. 152 (October 1974).
Johan Henrik Langaard and Reidar Revold, *Edvard Munch: Fra År Til År, A Year by Year Record of Edvard Munch's Life* (Oslo: Aschehorg and Co., 1961).
Carla Lathe, "The Group 'Zum Schwarzen Ferkel', A Study in Early Modernism" (PhD. diss., University of East Anglia, 1972).
Gustav Schiefler, *Edvard Munchs Graphische Kunst* (Dresden, 1923).
Ragna Stang, *Edvard Munch, The Man and his Work*, trans. Geoffrey Culverwell (New York: Abbeville Press, 1979).
Gösta Svenæus, *Edvard Munch. Das Universum der Melancholie* (Lund, 1968).
Gösta Svenæus, *Edvard Munch. In männlichen Gehirn* (Lund, 1973).
Washington, National Gallery of Art, *Edvard Munch, Symbols and Images*, 1978.
Zurich, Kunsthaus, *Munch und Ibsen*, by Pal Hougen, 1976.
Also Bibliography refs: 13, 14.

Ejnar Nielsen

Bibliography refs: 2, 14.

Eilif Peterssen

Kristian Haug, "The Art of Eilif Peterssen," *The American-Scandinavian Review* XIII, no. 9 (September 1925), pp. 524–531.
Håkon Stenstadvold, *Idekamp og stilskifte i norsk malerkunst 1900–1919* (Oslo: F. Bruns Bokhandels Forlag, 1946).
Also Bibliography refs: 57, 67, 69, 72, 74, 75.

Harald Sohlberg

Harald Aars, "Harald Sohlberg," *Kunst og Kultur*, IV (1913–1914), pp. 232–236.
Leif Østby, *Harald Sohlberg* (Oslo, 1936).
Arne Stenseng, *Harald Sohlberg. En kunstner utenfor allfarvei* (Oslo, 1963).
——, "Harald Sohlberg," *Norsk Biografisk Leksikon*, vol. XIV (1962), pp. 127–133.
Also Bibliography refs: 2, 57, 59.

Nils Gustav Wentzel

Hakon Kongsrud, "Gustav Wentzel 1859–1937," *Årbok for Gudbrandsdalen* (October 1959).
Oscar Thue, "Gustav Wentzel, Dagen derpå 1883," *Trondhjems kunstforenings Årbok* (1962).

SELECTED BIBLIOGRAPHY

Kitty Wentzel, *Gustav Wentzel* (Oslo, 1956).
Sigurd Willoch, "Gustav Wentzel," *Kunst og Kultur* (Oslo, 1927).
Also Bibliography refs: 69, 74, 75.

SWEDEN

77 Sven Alfons, Bo Lindwall, and Ragnar Josephson, *Svensk konstkrönika under 100 år* (Stockholm: Natur och Kultur, 1944).
78 Ingvar Andersen, *A History of Sweden* (New York: Praeger, 1956).
79 The Brooklyn Museum, *The Swedish Art Exhibition*, by Christian Brinton, 1916.
80 Donald R. Floyd, "Attitudes Toward Nature in Swedish Folklore" (PhD. diss., University of California, Berkeley, 1976).
81 Alrik Gustafson, *A History of Swedish Literature* (Minneapolis: University of Minnesota Press, 1961).
82 P. Lespinass, *Art et Esthetique: La peinture suédoise contemporaine* (Paris: Alcan, 1928).
83 Brita Linde, *Ernest Thiel och haus konstgalleri* (Stockholm, 1969).
84 London, Royal Academy of Art, *Exhibition of Works by Swedish Artists 1880–1900*, by Axel Gauffin (Stockholm: P. A. Norstedt, 1924).
85 Georg Nordensvan, *Svensk Konst och Svenska Konstnärer i nittonde Århundradet*. volume 2: *Från Karl XV till Sekelslutet* (Stockholm: Albert Bonniers Förlag, 1928).
86 G. Pareli, *La Peinture decorative en Suéde de la fin du 19e siècle* (Stockholm: Bonnier Förlag, 1933).
87 Sven Sandström, *Konsten i Sverige: Det sena 1800-talent bildkonst och miljökonst* (Stockholm: Almqvist & Wiksell Förlag, 1975).
88 Franklin D. Scott, *Sweden—The Nation's History* (Minneapolis, 1977).
89 Larry Emil Scott, "Pre-Raphaelitism and the Swedish 1890s" (PhD. diss., University of Washington, 1973).
90 Göran Söderström, *Strindberg och bildkonsten* (Stockholm, 1972).
91 Stockholm and Gothenburg, *Från seinens strand: Illustrerad Katalog* (Stockholm: Looström, 1885).
92 Stockholm, National Museum, *Konstnärsförbundet 1891–1920*, by Sixten Strömbom and Bo Wennberg (1948).
93 ——, *Oppenenterna av 1885*, by Sixten Strömbom (1945).
94 ——, *Svenskt Maleri from realism til expressionism* (Nationalmusei Utställningskataloger 84, 1942).
95 Sixton Strömbom, *Nationalromantik och radikalism: Konstnärsförbundets historia 1891–1920* (Uddevalla: Albert Bonniers Förlag, 1965).
96 Erik Wettergren, *The Modern Decorative Arts of Sweden*, trans. T. Palm (Malmo, 1926).
97 Nils G. Wollin, *Modern Swedish Arts and Crafts* (New York, 1931).

Björn Ahlgrensson

Arvika Konstförening, *Björn Ahlgrensson* (1979).
Also Bibliography ref: 87.

Richard Bergh

Richard Bergh, *Efterlämnade skrifter om konst och annat.* (Stockholm, 1921).
——, "En intervju med mig själf," *Ord och Bild* 3 (1894), p. 280–281.
Axel Gauffin, "Till minnet av Richard Bergh," *Studiekamraten* (1959), p. 12–23.
Tor Hedberg, *Richard Bergh. En studie.* (Stockholm 1903).
Gunhild Osterman, *Richard Bergh och Nationalmuseum. Några dokument.* (Lund, 1958).
Birgitta Rapp, *Richard Bergh konstnär och kulturpolitiker 1890–1915* (Stockholm: Tryck Gotab, 1978). Includes English summary.
Stockholm, National Museum, "Richard Bergh 1858–1919. Minnesutställning i Akademin för de fria konsterna." by Axel Gauffin, 1949.

Sixten Strömbom, Konstnärsförbundets historia (Stockholm, 1945).
Erik Wettergren, "Richard Berghs konst," Nationalmusei Årsbok I (Stockholm, 1919), pp. 25–42.

Prins Eugen

Prins Eugen, *Breven berätta (1886–1913)*, (Stockholm: P.A. Norstedt, 1942).
Axel Gauffin, *Konstnären Prins Eugen* (Stockholm: P.A. Norstedt, 1915; 2nd ed., 1947).
——, "The Landscape Paintings of Prince Eugen of Sweden," *The International Studio* 45 (January 1912), pp. 173–185.
Tor Hedberg, "Prins Eugen," *Konst og Kultur* 14 (1927), pp. 1–12.
Gotthard Johansson, "Prins Eugen som Stockholmsskildrar," *Samfundet Sankt Erik Årsbok* (1947), pp. 9–20.
Gustaf Lindgren, ed., *En bok om Prins Eugen* (Uppsala: J.A. Lindblad, 1948).
——, *Prince Eugen's Waldemarsudde, A Guide* (Stockholm, 1949).
——, *Waldemarsuddes konstsamling, konstverk förvärvade under åren 1889–1939* (Stockholm: P.A. Norstedt, 1939).
E. L. Nyblom, "Prince and Painter: Prince Eugen of Sweden," *The Studio* 91 (1926), pp. 36–37.
Georg Pauli, *Eugen: Målningar, Akvareller, Teckningar* (Stockholm: A. Bonnier, 1925).
Gunnar M. Silfverstolpe, *Prins Eugens konst* (Stockholm: Nordisk rotogravyr, 1935).

Gustaf Fjaestad

Bibliography ref: 15.

Eugène Jansson

K. Fahraeus, "Eugène Jansson," *Ord och Bild* (1915), pp. 467–480.
Tor Hedburg, *Tre svenska målargenier: Eugène Jansson, Herman Norrman, Sager-Nelson* (Stockholm: Albert Bonniers Förlag, 1923).
Carl G. Laurin, *Stockholm through Artists Eyes*, 2nd ed. (Stockholm: P. A. Norstedt & Söners Förlag, 1930).
Nils G. Wollin, *Eugène Janssons måleri* (Stockholm: P. A. Norstedt & Söner, 1920).
Also Bibliography refs: 15, 95.

Bruno Liljefors

Allan Ellenius, *Bruno Liljefors* (Uppsala: Bokförlaget Carmina, 1981).
Tor Hedberg, *Bruno Liljefors, en studie* (Stockholm: Aktie bolaget, 1902).
——, "Bruno Liljefors, a Swedish Painter of Animals," *The International Studio* 42 (1910), pp. 119–128.
Martha Hill, "Liljefors of Sweden, The Peerless Eye," *Audubon* 80, No. 5 (September 1978).
Leningrad, Hermitage and Gothenburg, Konstmuseum, *Anders Zorn, Bruno Liljefors* (1967).
Bruno Liljefors, *Det vildas rike* (Stockholm: A Bonnier, 1934).
Bo Lindwall and Lindorm Liljefors, *Bruno Liljefors* (Stockholm: Rabén och Sjögren, 1960).
Ernst Malmberg, *Larsson, Liljefors, Zorn: En Återblick* (Stockholm: P. A. Norstedt, 1919).
K. A. Russow, *Bruno Liljefors, an appreciation*, trans. A. Poignant (Stockholm: C. E. Fritze, 1929).

Karl Nordström

Bibliography refs: 77, 82, 84.

Carl Wilhelmson

Gothenburg, Konstmuseum, *Carl Wilhelmson västkustmålaren*, catalogue essay by Eric Jonsson (1974).

Anders Zorn

Karl Asplund, *Anders Zorn, His Life and Work* (London: "The Studio," Ltd., 1921).

Gerda Boëthius, *Anders Zorn, An International Swedish Artist: His Life and Work* (Stockholm: Nordisk Rotogravyr, 1954).

———, *Zorn: Swedish Painter and World Traveller*, trans. Albert Read (Stockholm: Rabén and Sjögren, 1961).

———, *Zorn: Tecknaren, målaren, etsaren, skulptören* (Stockholm: Nordisk Rotogravyr, 1949).

Loys Delteil, *Anders Zorn, Le Peintre-Graveur Illustré*, vol. 4 (Paris: Chez l'Auteur, 1909).

Erik Forssman, *Tecknaren Anders Zorn* (Stockholm: Natur och Kultur, 1959).

———, *Zorn i Mora* (Stockholm: Albert Bonniers Förlag, 1960).

Freiburg, Städtische Museen, *Anders Zorn 1860–1920*, by Erik Forssman, 1976.

Lawrence, Spencer Museum of Art, The University of Kansas, *The Prints of Anders Zorn*, by Elizabeth Broun, 1979.

Paris, Galeries Durand-Ruel, *Exposition Anders Zorn*, 1906.

Stockholm, National Museum, *Anders Zorn: Akvareller och teckningar från Zorns samlingar*, by Gerda Boëthius, 1939.

———, *Anders Zorn, 1860 Minneutställning 1960*, by Bo Wennberg, 1960.

Index to Lenders